Women and the Art and Science of Collecting in Eighteenth-Century Europe

Through both longer essays and shorter case studies, this book examines the relationship of European women from various countries and backgrounds to collecting, in order to explore the social practices and material and visual cultures of collecting in eighteenth-century Europe.

It recovers their lives and examines their interests, their methodologies, and their collections and objects—some of which have rarely been studied before. The book also considers women's role as producers, that is, creators of objects that were collected. Detailed examination of the artefacts—both visually, and in relation to their historical contexts—exposes new ways of thinking about collecting in relation to the arts and sciences in eighteenth-century Europe. The book is interdisciplinary in its makeup and brings together scholars from a wide range of fields.

It will be of interest to those working in art history, material and visual culture, history of collecting, history of science, literary studies, women's studies, gender studies, and art conservation.

Arlene Leis is an independent art historian who received her PhD from University of York.

Kacie L. Wills received her PhD in English from the University of California, Riverside, and is Assistant Professor of English at Illinois College.

Cover image: Bartolomeo Bimbi, *Portrait of Citrus Fruit*, 1727. Oil on canvas. Courtesy of Dell-Università degli Studi di Firenze.

The Histories of Material Culture and Collecting, 1700–1950
Series Editor: Stacey J. Pierson
University of London

The Histories of Material Culture and Collecting, 1700–1950 provides a forum for the broad study of object acquisition and collecting practices in their global dimensions. The series seeks to illuminate the intersections between material culture studies, art history, and the history of collecting. It takes as its starting point the idea that objects both contributed to the formation of knowledge in the past and likewise contribute to our understanding of the past today. The human relationship to objects has proven a rich field of scholarly inquiry, with much recent scholarship either anthropological or sociological rather than art historical in perspective. Underpinning this series is the idea that the physical nature of objects contributes substantially to their social meanings, and therefore that the visual, tactile, and sensual dimensions of objects are critical to their interpretation. This series therefore seeks to bridge anthropology and art history, sociology and aesthetics.

Collecting and Displaying China's "Summer Palace" in the West
The Yuanmingyuan in Britain and France
Louise Tythacott

Female Portraiture and Patronage in Marie Antoinette's Court
The Princesse de Lamballe
Sarah Grant

The Emergence of the Antique and Curiosity Dealer in Britain 1815–1850
The Commodification of Historical Objects
Mark Westgarth

Nordic Private Collections of Chinese Objects
Minna Törmä

Fashionability, Exhibition Culture and Gender Politics
Fair Women
Meaghan Clarke

Women and the Art and Science of Collecting in Eighteenth-Century Europe
Edited by Arlene Leis and Kacie L. Wills

For a full list of titles in this series, please visit www.routledge.com/The-Histories-of-Material-Culture-and-Collecting-1700-1950/book-series/ASHSER2128

Women and the Art and Science of Collecting in Eighteenth-Century Europe

Edited by
Arlene Leis and Kacie L. Wills

Routledge
Taylor & Francis Group

NEW YORK AND LONDON

First published 2021
by Routledge
52 Vanderbilt Avenue, New York, NY 10017

and by Routledge
2 Park Square, Milton Park, Abingdon, Oxon, OX14 4RN

Routledge is an imprint of the Taylor & Francis Group, an informa business

© 2021 Taylor & Francis

Library of Congress Cataloging-in-Publication Data
A catalog record for this book has been requested

ISBN: 978-0-367-85666-3 (hbk)
ISBN: 978-0-367-85667-0 (ebk)

Typeset in Sabon
by Apex CoVantage, LLC

We dedicate this book to our families

Contents

Illustrations

Tables

Plates

Contributors

Charis Ch. Avlonitou graduated from the National and Kapodistrian University of Athens (bachelor's degree) in 1992, the Aristotle University of Thessaloniki in 2003 (master's degree), and the Department of Plastic Arts & Art Sciences of the University of Ioannina in 2018 (thesis title: 'Collector and Collection, an Indivisible Unity: the Case of the Collector and Collection of George Costakis'). From 2006–2007, Dr. Avlonitou participated in the project for organizing and updating the collections of the State Museum of Contemporary Art (known today as MOMus) as its scientific supervisor. Between 2011 and 2018, Dr. Avlonitou participated in international conferences and gave lectures on art collectors and collections. During the same period, Dr. Avlonitou wrote articles and research papers about western art collections, specific collectors, and issues of European history of art. Dr. Avlonitou works at the Archaeological Museum of Thessaloniki as General Coordinator of the Ministry of Culture's Archaeological Receipts Fund in North Greece.

Kelsey Brosnan earned her PhD in art history from Rutgers University in 2018, with a dissertation entitled 'Seductive Surfaces: The Still Life Paintings of Anne Vallayer-Coster (1744–1818)'. She has conducted research on behalf of Christie's, Inc. Impressionist and Modern Art Department, the Department of Drawings and Prints at the Metropolitan Museum of Art, and the New Orleans Museum of Art. She has also taught in the Art History Department at the University of Vermont.

Nicole Cochrane is a postdoctoral research assistant at the University of Hull on the *Women, Land and the Making of British Landscape* project. In 2010, she was awarded her AHRC-funded PhD in heritage studies, titled 'Ancient Sculpture and the Narratives of Collecting: Legacy and Identity in Museum Space 1770–1900', from the University of Hull, which explored the collecting of ancient art in Britain across the eighteenth and nineteenth centuries, asserting the explicit and implicit role collectors play in the display and curation of antiquities in British museum contexts and how this continues to affect the way the public understands the ancient world.

Andrea Gáldy gained her PhD in art history and archaeology at the University of Manchester with a thesis on the collections of antiquities of Cosimo I de' Medici. She held post-doctoral fellowships with the Henry Moore Foundation and at Villa I Tatti, and taught for international university programmes in Florence. Andrea is a founding member of the international forum Collecting & Display and main editor of the series *Collecting Histories* (CSP).

Hanneke Grootenboer is Professor and Chair of History of Art at the Radboud University in Nijmegen, the Netherlands. Prior to that position, she was Professor of the History of Art and Head of the Ruskin School of Art (2014–2016) at the University of Oxford. She is the author of *The Rhetoric of Perspective: Realism and Illusionism in Seventeenth-Century Dutch Still Life* (University of Chicago Press, 2005), winner of the ASCA book prize, and *Treasuring the Gaze: Intimate Vision in Late Eighteenth-Century Eye Miniatures* (University of Chicago Press, 2014), winner of the 2014 Kenshur Prize for best interdisciplinary publication in eighteenth-century studies. Her articles on early modern visual art and material culture in a transhistorical perspective have been published in *The Art Bulletin* and *Art History*, among other venues. She is the recipient of a number of grants and fellowships, including from the Andrew Mellon Foundation, the Clark Art Institute, the Leverhulme Trust, and the Netherlandish Institute for Advanced Study in Amsterdam. Her recent book, entitled *The Pensive Image: Art as a Form of Thinking*, argues for a philosophical art history, and is forthcoming from the University of Chicago Press. She is a member of the editorial board of the *Oxford Art Journal*.

Anne Harbers has a master's degree in chemistry and an MBA. She spent 25 years working globally in biotechnology. In 2014, she completed her master's degree in art history at the University of Sydney, and has since published on topics relating to art, science and collecting. She is currently undertaking her PhD through Radboud University in The Netherlands, working on a seventeenth-century Dutch still-life and marine artist.

Erica Hayes is a digital scholarship librarian at Villanova University, where she leads Falvey Memorial Library's digital humanities programme. Prior to joining Villanova University, she was a North Carolina State University Libraries Fellow and the project manager on the Immersive Scholar Andrew W. Mellon Foundation grant. She holds a master of information science and a master of library science from Indiana University, Bloomington. Her research interests include eighteenth-century studies, scholarly communication, and cultural heritage materials and technologies. She is currently working on an ongoing digital research project, 'Exploring the Collections of Sarah Sophia Banks', with Dr. Kacie L. Wills at Illinois College.

Arlene Leis is an independent art historian/scholar working mostly on eighteenth-century collections and collecting practices. She is particularly interested in women's collecting and the inter-relations between art and science, and her research focuses predominantly on the collections of print culture and porcelain garnered by Sarah Sophia Banks and Lady Dorothea Banks. Arlene has organized numerous conferences and workshops, and presented her research at the Association of Art Historians Annual Conference, The American Society for Eighteenth-Century Studies' annual conference, Queen's House Greenwich, and she also participated in the Fashioning the Early Modern Project. Her work has appeared in *The British Journal for Eighteenth-Century Studies*, *Life-Writing Journal*, *Early Modern Women: An interdisciplinary Journal*, and *Konsthistorisk tidskrift/Journal of Art History*. She has also published book chapters and reviews. Arlene has received numerous awards and bursaries and held two post-doctoral fellowships: one at The Paul Mellon Centre for Studies in British Art, and another at the University of York's Humanities Research Centre.

Ryna Ordynat is a current PhD candidate in history at Monash University in Melbourne, Australia. Her thesis explores the artistic and feminine practice of album-making and its functions as a creative space in the life stages, experiences, education, upbringing, and relationships of eighteenth- and early-nineteenth-century elite British women and their families. Her research on albums has been supported in the past by the Paul Mellon Research Support Grant and the 'Past & Present' Travel Grant from the Royal Historical Society.

Anna Frances O'Regan is an Edinburgh-based paper conservator. Originally from Tasmania, Australia, she graduated in 2018 from Northumbria University with an MA in conservation of fine art specialising in works of art on paper. Anna also holds an MA in cultural heritage and a graduate diploma in museum studies from Deakin University, Melbourne, which she gained before relocating to the United Kingdom in 2013. Anna's MA dissertation focused on the conservation of eighteenth-century print rooms, and her contribution to the present volume is an expansion of that initial research. As an emerging conservator, Anna has held several short contracts, including two at the University of Edinburgh and an internship at the National Library of Scotland. She has worked on a freelance basis in London for the National Conservation Service and in Edinburgh for the Scottish Conservation Studio. Anna recently joined the National Galleries of Scotland's Professional Freelance Register and is on the Pathway to Accreditation. Alongside writing in her blog called 'A Passion for Prints', Anna published a review of the 2019 ICON Scotland Group's annual News and Ideas Exchange event in *ICON News*, and towards the end of 2019 her first co-authored, peer-reviewed article was published in the *ICON Journal*.

Madeleine Pelling received her PhD in history of art from the University of York in 2018. Her research focuses on material, literary, and visual culture in the eighteenth century, with particular emphasis on the history of collecting and women as antiquarians. She has published work in *Journal for Eighteenth-Century Studies, Women's History Review, Journal 18* and *Early Modern Women: An Interdisciplinary Journal*, and is currently preparing her monograph, *The Portland Museum: Collecting, Craft and Conversation, c. 1750–1786*, for publication. She has held postdoctoral fellowships at the Paul Mellon Centre for British Art, the John Rylands Research Institute at the University of Manchester, and the Institute of Advanced Studies in the Humanities at the University of Edinburgh, as well as short-term fellowships at the Royal Archives, Queen Mary University of London, and the Lewis Walpole Library at Yale University. She currently sits as an ECR member on the editorial board for *History*, journal of the Historical Association.

Lizzie Rogers completed her BA and MRes at the University of Hull, specializing in gender history and history of art. In September 2016, she began a PhD at Hull with a full scholarship from the AHRC Heritage Consortium and as a member of the Gender, Place and Memory Research Cluster. Her thesis is entitled *Women's Curiosity and Collecting in Britain 1680–1820: The English Country House as a Space of Female Enlightenment*, focussing on how elite women interacted with the Enlightenment through education and collecting objects within the country house. It is due for submission in November 2019. Alongside this, she is a gallery assistant at the University of Hull Art Collection and during the summer of 2017 completed

a Curatorial Internship at Stratford Hall, Virginia, researching and creating an online exhibition of the Margaret Law Collection. Lizzie is also interested in public history and heritage and runs her own blog, https://historylizzie.co.uk/, which focusses on art, history, literature, and museums.

Katharina Schmidt-Loske is head of the research centre of historical biology, Biohistoricum, at the Zoological Research Museum Alexander Koenig, Leibniz-Institute for Animal Biodiversity, Bonn. She studied biology in Münster, Bonn, and Frankfurt/Main, and earned her doctorate from the University of Bonn with a dissertation project entitled *Die Tierwelt der Maria Sibylla Merian* ('The Fauna of Maria Sibylla Merian: Species, descriptions, illustrations'). In her latest scientific work, she analysed floral and animal depictions in the *Tenture des Indes*. At the crossroads between science and art, the *Tenture des Indes* is among the most famous tapestry series of the Baroque period.

Irina Schmiedel is a postdoctoral researcher in the DFG-funded project on 'The Materiality of Knowledge Orders and the Episteme of Drawing: the Drawing Albums of Sebastiano Resta' at the Department of Art History at the Johannes Gutenberg University in Mainz. She has been a research assistant at the IZWT (Interdisziplinäres Zentrum für Wissenschafts und Technikforschung) at the University of Wuppertal and at the Department of Science Studies at Aarhus University. In 2016, she published the book *Pompa e intelletto. Formen der Ordnung und Inszenierung botanischen Wissens im späten Großherzogtum der Medici*, based on her PhD project on botany in the arts and sciences in the late Medici grand duchy in Florence. Her current research is dedicated to early modern collections of prints and drawings and on 'connoisseurship in the arts and sciences'.

Maria Antonietta Spadaro is an architect, art historian, and exhibitions curator. She was professor of art history at high school, undergraduate, and post-graduate levels at the school of the Lumsa University of Rome, Palermo office, and currently sits on the National Board of Anisa (National Association of Art History Teachers). Since 2005, she has been curating a cycle of conferences on women and art in Palermo, now in its 15th year. Maria Antonietta has collaborated on and published many books and essays on art history, including *Raphael and the Spasm of Sicily* (1991); *Dictionary of Sicilian Artists: Painting* (curator, 1993); *The Palazzo delle Poste in Palermo* (1993); *Palermo City of Art* (1998); *Learning from the City, Didactic Experiences of Cultural Heritage* (2000); *Palermo, Palazzo delle Aquile* (2004–2012); *O'Tama and Vincenzo Ragusa: Echoes of Japan in Italy* (2008); *Renato Guttuso* (2010); *Commemorate in Palermo: the Medals of Antonio Ugo* (2014); *Industrial Archeology Palermo* (2015); *Palermo, Art and History* (2016); *Arab-Norman Itinerary: the UNESCO Heritage in Palermo, Monreale and Cefalù*, (2017); *Alessandro Manzo: an Artist to Discover* (2018); and *Japan's Utopia in the West* (2019). She also writes art historical articles for art magazines and newspapers, and has published five children's storybooks set in historic locations around Palermo. Some of the exhibitions she has curated include: *Novecento Siciliano* (travelling exhibition 2003–2004: Minsk, Moscow, Barcelona, Palermo-Royal Palace); *Giovanni Lentini (1882–1948)* (Palazzo Sant'Elia, Palermo 2011); *Michele Catti (1855–1914)* (Palazzo Sant'Elia, Palermo 2013); *The Gaze and the Light* (photographic exhibition at Palazzo Sant'Elia, Palermo 2015); *O'Tama and Vincenzo*

Ragusa: A Bridge between Tokyo and Palermo (Palazzo Sant'Elia, Palermo 2017); and *O'Tama: Migration of Styles* (Royal Palace, Palermo, 2019–2020).

Kacie L. Wills holds a PhD in English from the University of California, Riverside. She is an assistant professor of English at Illinois College. In her teaching and research, she aims to emphasize non-traditional and interdisciplinary approaches to textual and archival material from the eighteenth and nineteenth centuries. Wills has recently been awarded the Keats-Shelley Association of America's Pforzheimer Research Grant and a Huntington Library Dibner Fellowship in the History of Science. She has published on Romanticism and the Pacific, Sarah Sophia Banks's African coins, and Romantic material culture.

Acknowledgements

The editors of this book would like to thank all the researchers who have contributed to this volume. We've enjoyed learning about your research, and feel you have all brought many interesting topics to light that are ripe for further inquiry. We have enjoyed editing your chapters and watching this book develop over the last year into what you see here. Thank you to our series editor, Stacey Pierson, who helped us to shape this project. From the beginning, Stacey provided direction and recognized the potential for this book. Thank you to our commissioning editor, Isabella Vitti, for guidance through this process, and to Katie Armstrong for checking in and making the publishing process go smoothly. Many thanks also to the anonymous reviewers of our proposal. Their insightful comments and suggestions helped to make this book what it is. It has been wonderful working with Routledge publishing, and every part of this process ran smoothly because of the professionalism of everyone involved.

We are also grateful to Illinois College for providing financial support for publishing costs. Thanks also to Dr. Lindsay Porter and Roberta Pusceddu for their assistance with translating some of the chapters and archival material in this book. We would also like to thank Dr. Claudio Gulli at Palazzo Butera, Palermo, Italy and Elena Mastrota at Arttour Palermo for arranging contacts with Sicilian scholars and museums that resulted in two of the chapters herein. Arlene Leis is grateful to Dr. Stephanie Miller and would like to thank her for sharing her knowledge of editing with her while she was writing her PhD at the University of York. Last, but certainly not least, the editors would like to thank our families and friends for their love, patience, and support as we brought this project to fruition.

Introduction: Women and the Cultures of Collecting

Arlene Leis and Kacie L. Wills

Going once, going twice, third and final call: Sold! Around two o'clock on Wednesday morning, 17 May 1893, a sale of fine exotic and European porcelain began at Christie's, London. The accompanying auction catalogue makes known that seventy-nine lots of predominantly 'old Chinese', 'old Nankin', and 'old Japanese' porcelain were offered for sale; these were followed by more lots exemplifying superior English and European wares, some produced by well-known manufacturers, including Minton, Crown Derby, Sèvres, and Dresden.[1] Other sales took place that morning with items like furniture. Piled on top of tables and arranged in cases were decorative art objects, textiles, rare relics, and enamels, amongst other things. Studying the annotated catalogue housed in the Christie's library today, the auction appears to have attracted a large, mixed crowd of potential buyers, including Arthur Liberty, founder of Liberty department store, and the politician and art patron, Lord Battersea—with both men bidding and buying voraciously. The competition was fierce. Women were also purchasing wares, and a Mrs. Radcliffe spent £15 on a seemingly fantastic, tall vase, 'painted with fabulous birds and trees, foliage [in blue and flowers in colour], red and gold borders on the shoulder'. Public auctions were favorite meeting places, and sales were frequent. As exciting sites offering a type of polite entertainment, auctions also attracted visitors from other countries, like the Australian impressionist artist, John Peter Russell, who appears to have travelled all the way from France to London to attend the event. During the nineteenth century, Impressionist artists were particularly inspired by Orientalism and the accompanying material culture, and they often collected a range of items as points of reference for their work, especially porcelain wares.

The Christie's catalogue briefly describes the contents of each lot offered in this sale. For example, listed under 'Old Chinese porcelain', is Lot 80, 'A pear-shaped bottle, enamelled [sic] with kylins and ornaments in colours-10 ½ in. high' that sold for £10. Other lots fetched higher prices, like Lot 121, listed under 'Old Nankin porcelain', 'A Tall Beaker, the body painted with subjects of mandarins with their attendants, clouds, trees and birds, the upper part with warriors in a landscape, rocks and trees—30 in. high', sold for £45 to a Mr. Larking. The sale catalogue stipulates that all Oriental porcelain on sale had been 'imported by the late Sir Joseph Banks, President of the Royal Society', who had accompanied James Cook on his first South Pacific voyage. However, the collection really belonged to the famous botanist and explorer's wife, Lady Dorothea Banks.

Without an accompanying catalogue or record of the collection, Christie's oversight in the attribution of Lady Banks's collection might be explained by a lack of knowledge of her collecting career. Indeed, Lady Banks's marital position strategically enabled her

to capitalize on her husband's contacts with the East India Company and botanist travellers to help build her collection of exotica. It is also possible that they advertised the porcelain wares as Sir Joseph's with hopes of tempting prospective buyers. If so, the strategy seems to have been effective, as all the items offered for auction sold. The pair of egg-shelled vases that the aforementioned John Peter Russell purchased for £14 made for a significant souvenir marking his London trip. To touch something that had been in bodily contact with someone in the past can be a moving experience. As someone originally from the Australian colony, Russell may have been interested in owning an object from Sir Joseph's (also known as 'the father of Australia') collection.

Christie's dismissiveness of the fact that this was Lady Banks's porcelain collection is not unique. Having never published work on her collection, perhaps Christie's had no knowledge of Lady Banks's prominent role in its assemblage. Importantly, however, recent research demonstrates that Lady Banks's porcelain collection and her husband's botanical collections were meaningfully interconnected but also distinct.[2] When Sir Joseph Banks died, he bestowed his extensive collection of botanicals to the British Museum, where they now form part of the Natural History Museum's foundational collection. When Lady Banks's sister-in-law, Sarah Sophia Banks, who assembled a significant collection of coins, tokens and ephemera, died, Sir Joseph donated part of the coin collection to the Royal Mint, and Lady Banks bestowed the rest of her collections of coins and ephemera to the British Museum, where they form part of the foundational collections of both the Prints and Drawings and Coins and Medals departments.[3] When Sir Joseph died, Lady Banks made sure his collections were gifted to the British museum, according to his wishes. However, when Lady Banks died in 1828, with no children of her own, her porcelain collection was passed along to her close nephew Sir Edward Knatchbull, ninth Baronet.[4] Instead of bequeathing the collection to a museum or library, he kept it. Perhaps it held sentimental value, or he took personal enjoyment in her collection of wares. Alternatively, he may not have appreciated the scientific expertise that went into assembling the collection or its cultural value, so he never bothered to offer it to a public institution. In turn, he passed the collection to his son, Lord Brabourne, and shortly after Brabourne's death, the collection was offered at auction. Giving the credit for building a large and important collection of wares like this to a man is yet another example of how during the nineteenth century, the significance of women's work and the relevance of women's contributions—in this case collecting—were becoming diminished, and women's legacies, whether intentionally or not, were lost.

Women and the Gendered Constructs of Collecting

The case of Lady Banks is revealing. It exemplifies one of the many ways in which women are absent from formal collecting records, and the ways that collecting—an activity seen as dominated by men—was propelled from one century into another. Identifying the contributions women made to the cultures of collecting during the eighteenth-century is no easy task as many women's roles and their collections have been forgotten or lost. However, this is changing as more scholars become interested in the topic of women's collecting and more private and public archives are searched. For example, through studying institutional records held in museums and auction houses like in the previous example, Karen Attar focuses her studies on library collections, noting that men dominated the activity; indeed, collections were gifted predominately by men, which is not surprising, as with a few exceptions, most eighteenth-century men legally held the purse strings.[5] However, Attar also brings to light numerous exceptions to the rule, showing

that, like men, women also collected a wide range of objects and paper items now housed in institutions, including extensive collections of books on subjects like food and drink, devotional books, children's books, books about women by women authors, ephemera, extra-illustration, musical scores, and popular music sheets.[6] Research carried out at the Victoria and Albert museum has also demonstrated that women played a prominent role in collecting, both numerically and as influencers. Catherine King and Dianne Sachko Macleod have brought to light numerous contributions women have made to private and public institutions, and they show that since the nineteenth century, those numbers are steadily increasing.[7] In contemporary collecting practices, as many women as men (if not more) collect. This compendium represents an interrogation into women's histories that will hopefully with continued research reveal the collecting practices of women from an even broader range of social categories including underrepresented groups.

The authors of this volume demonstrate that eighteenth-century collections have survived in many ways, even if, as in the case of the aforementioned Lady Banks, a collection's physical presence is no longer completely intact. Recently, Beth Tobin demonstrated convincingly, in her study of the Duchess of Portland's shell collection that is no longer extant, that textual evidence in the form of drawings, catalogues, letters, and diaries, amongst other items, are important evidence that attest to the social practices and the material and culture of natural history collecting.[8] On record, men have established more private museums than women or bestowed their homes and collections to nations more than women have. However, one of the problems with the ways collecting has been thought of is that women's collections and their collecting practices have so often been measured and valued in relation to the contents, methodologies, and collecting practices of men. As Kim Sloan makes clear in her edited work, *Enlightenment: Discovering the World in the Eighteenth Century*, during that time period a number of women had managed to enter what was usually considered a predominately male preserve, and she demonstrates that both women's and men's collecting contributions helped form the British Museum's Enlightenment Gallery.[9] Furthermore, Robert Huxley's essay elaborates on this point, and he argues that the reasons for collecting at that time were not always academic and men and women 'amateurs' built substantial private collections that form today's vast 'database'.[10] Some of the collections discussed in this compendium were bestowed directly to public institutions, while others were gifted to family members. Some of what remains survives in the forms that Tobin has uncovered. Where women have been instrumental in preserving the past assembled by their male relatives, this book also considers the fate of a collection when women passed their collections down to the men in their families. As the authors here show, women were not always absent from formal acquisition records, and when they are absent, it does not signal their insignificance.

Perhaps the genesis of this misconception lies in how the history of collecting is tied to the notion of European religious tradition, and to two Biblical male figures in particular: Noah and Adam. As John Elsner, Roger Cardinal, and others have demonstrated, Noah is often thought of as the first collector, and Adam as the one who classified the creatures God made.[11] The Garden of Eden and the universe were thought to be created by God, but the Ark marked man's first attempt to create his own world, as such, the Ark was considered the greatest construct of pure knowledge. Collectors such as Johann Kentmann, John Tradescant, and Anthanasius Kircher often incorporated the myth of Noah into their collecting methodology, referring to their own collections as 'arks', and this continued with artists and collectors well into the eighteenth century.[12] According to the myth of Noah, the collecting process, in which he gathers all animals that were doomed to die in the flood, becomes inseparable from the creation of a new and better world. As Elsner and Cardinal write, 'Noah is the ur-collector, who

successfully gathered and completed sets of animals, and his actions resonate with all the themes of collecting itself: desire and nostalgia, preservation and loss, permanence and the construction of complete systems that go against the destructiveness of time'.[13] This collecting origin story and its gendered implications of course excludes woman, Eve. As opposed to Adam, Eve is a figure of blame, lambasted for the fall of man. In conceiving this book, we have tried to shed light on the significant contributions to knowledge that women's relationships to collecting have made possible. We have done this in an effort to re-imagine the origins of collecting, the traditional histories that associate male collecting with Noah and his Ark. The chapters in this book take a position of inclusion, acknowledging and celebrating the roles women have played in the gathering and distribution of knowledge through art and science.

Another factor placing women at a disadvantage to their male counterparts in the history of collecting is the notion of 'princely collecting' and its association with 'princely rule': that is, that the notion of 'magnificence' was inseparable from the idea of 'good government' and concepts of kingship.[14] In response to this dominant concept, the authors of the important edited volume *Women Patrons and Collectors* take as their focus elite women from the sixteenth to the nineteenth centuries, and challenge the idea that 'princely collections' and 'princely rule' were synonymous.[15] Their volume makes a significant contribution, demonstrating that over diverse periods, aristocratic women have resisted this discrimination and built substantially elegant collections of their own, and like their male counterparts, strategically used the act of collecting to their own advantages. Women, too, formed exquisite collections of fine and decorative arts that were installed in elegant buildings and luxurious interiors. In addition to this broad ranging research, are more studies on eighteenth-century royal and aristocratic women and the important role their collections played in demonstrations of power.[16] In examining collections like those of Catherine II, Maria Carolina of Austria, and Anna Maria Luisa de' Medici, our volume continues to showcase the range and significance of women's acts of collecting in a 'princely tradition'. These women used their collections to garner authority, express sentiment, bestow a legacy, and showcase a range of taste that extended beyond gender expectations. Anna Maria Luisa, for instance, though known for her jewellery collection, is shown in this book to have also collected paintings of citrus fruits. This aspect of her collection showcases an interest in the intersections of visual art and natural science and shows how Anna Maria Luisa's collecting interests reached beyond expectations we may have of women's collections. Additionally, as the objects found in such 'princely' collections often blurred the line between art and science, so do many of the women's collections in this volume.

More recently, popular culture has situated the topic of art, science, and collecting within a gendered dichotomy that further cements these concepts as separate. For example, in *The Collector*, John Fowles's book about power, class, and control, the protagonist, Frederick Clegg, a working-class man who has recently come into money, is an amateur collector of butterflies who loves science. He has a desire to collect and preserve rare species. He uses his new money to build a butterfly collection and a dungeon, in which he captures, keeps, and ultimately kills his new specimen of desire, posh art student Miranda Grey. During one of their conversations, Miranda expresses her opposition to Frederick's love of science and collecting:

> I hate scientists, she said. I hate people who collect things, and classify things and give them names and then forget all about them. That's what people are always doing in art. They call a painter an impressionist or a cubist or something and then they put him in a drawer and don't see him as a living individual painter any more.[17]

The practice of scientific collecting, she suggests, erases an object's individuality and confines it into restrictive categories, and she interprets Clegg's collection as a form of massacre. While this book sets up woman as an embodiment of nature, a free spirit who resists classification, man is set up as the reasonable and classifying agent (as in the Biblical tale of Noah). Miranda's death at the end of the book speaks to the way that these two disciplines, art and science, are not only separate, but irreconcilable. This dichotomy between art and science and the effects on collecting extend beyond popular culture into the very systems by which we acquire knowledge. In their compendium *The Material Cultures of Enlightenment Arts and Sciences*, Adriana Craciun and Simon Schaffer examine material culture in order to re-think the rigid and traditional taxonomical structures of Carl Linnaeus. The studies in this book move away from an art/science dichotomy by acknowledging the agency of objects, and enabling the objects to define themselves outside of an externally-imposed categorical system.[18] Our volume also seeks to work against this dichotomy, examining women's collecting work in both natural history and the arts. Even though there is a rhetoric about what would have been acceptable for women to collect, especially in the eighteenth century, the chapters in our book demonstrate that there were ways for women to work around that rhetoric and to collect objects that would now be considered masculine. In fact, chapters like that on Sarah Sophia Banks's coin collection manuscript reveal that objects such as coins, which have been considered to be more commonly collected by men, were actually frequently collected and circulated by women of all social classes. This, importantly, shows that our gendered dichotomies are often constructs imposed in current times, which place more rigid divides on collecting than existed in the eighteenth century.

Collecting is a broad term, and therefore, in order to recover women's lives in relation to collecting practices, it might be more accurate to consider the types of objects they collected and the relationship they had to those objects. When considering gender and collecting, Susan M. Pearce argues convincingly that we must look further than the simple female/male polarizations and consider wider European social constructs. She notes that European collecting is linked to identity formations.[19] Pearce claims that for men, solidarity is one of the linchpins of social life; in contrast, women are faced with multiple self-images, which present them as whores, Madonnas, little girls, or house-holding adults. Through her research of various collections, she shows that women gather material that support these roles, though sometimes the same woman's vision of herself encompasses more than just one of these aspects.[20] Our book also demonstrates an eighteenth-century female/male rhetoric around collecting, as with Hanneke Grootenboer's case study on the dollhouse of Petronella Oortman, Arlene Leis's chapter on Olivia Lanza di Mazzarino's collection of fans, and Ryna Ordynat's case study on Anne Wagner's friendship album. These works showcase the traditional feminine constructs of collecting: feminine display, the material culture of gendered collecting, and female sociality.

The chapters in this book also complicate gendered expectations of collecting, showcasing the complex range of women's engagement with objects. We see this with Anne Harbers's and Andrea Gáldy's chapter on the Ladies's Society for the Physical Sciences of Middleburg, Kelsey Brosnan's chapter on Anne Vallayer-Coster, an artist thinking like a collector, and Lizzie Rogers's and Madeleine Pelling's chapters on women's written records of collected objects and their connection to sociability. Textual representations, such as surviving catalogues, further our knowledge of the social practices of collecting by representing the constant flux that went into building a collection. These surviving manuscripts also reveal the ways in which women manipulated collections:

that is, the way objects moved in and out of collections and travelled between men and women as gifts and objects of exchange. Another oft-overlooked aspect of women's contributions that our book presents are the contributions of women to collecting practices as professional producers. Women often worked closely with particular patrons, both male and female, to help them achieve their collecting goals, even if no evidence survives of the women having been collectors themselves. These social practices deepen our understanding of how women interacted with artistic and scientific collections.

The Art and Science of Collecting

The editors of this volume were struck by the absence of any combined attempt by specialists working on topics related to eighteenth-century women to focus on the realm of collecting within discussions of art and science (in a broad sense) practiced in different countries across Europe during this time.[21] This absence raises many questions. How are men and women's roles blurred and combined through collecting practices? What objects are women collecting, and how do they serve to broaden our understanding of women's roles in scientific and artistic discourse during this period? Do the meanings of these collected objects change with time? How do scientific and artistic practices merge in discourse around conservation of women's collections? Although the focus of our book is on women, it is not our intention to separate women's collecting from men's, as chapters in this book will demonstrate that often the two overlapped. Some of our chapters show that husbands and wives built collections together, sisters bolstered their brothers' projects, women artists collaborated with male collectors and produced artefacts men collected, and others bestowed their collections to male family members who took on the role of preservation. It is not too much to suggest that the resulting book is the first collective effort to devote itself specifically to the topic of women and their roles within the art and science of collecting in eighteenth-century Europe.

The authors in our compendium approach the subjects of women and collecting from a variety of academic backgrounds. This book includes chapters from scholars in the fields of science, art history, literary studies, and art conservation, among others. The broad range of disciplines represented by the authors demonstrates that eighteenth-century women played a significant role in fields of collecting where they have hitherto been thought to have little investment, but also that women's relations to collecting practice varied in ways that extended beyond acquisition, arrangement, and display. Women travelled to and documented collections they visited, disseminating the knowledge they gained by way of diaries and written letters. This textual information shows that some collections were formed for the purpose of study, while others marked friendships, working collaborations, or victories.

Recent scholarship has demonstrated that the practice of collecting enabled women to cultivate spaces for sociality and accomplishment, where art and science often intermingled.[22] Collecting practices allowed women to carve out a space for themselves in an astonishing variety of social circles; through collecting, women transcended the private/public dichotomy that constricted many women at the time, achieving an intellectual freedom made manifest in collections that blur the boundaries between the personal and the political, art and science, and 'high' and 'low' culture. Demarcated classes of 'high' and 'low' art have added to the dilemma of recognizing female

collectors, however. 'High' art, characterised by mediums like painting and sculpture, was expensive. Furthermore, the divisions put forth by art academies placed historical and mythological subjects (often nudes) at the top of a hierarchy of subjects; these were thought by some, generally men, 'inappropriate' for eighteenth-century women.[23] It would thus would be overly limiting to think of 'art' in the sense of only 'high' culture when discussing women's collections. The more money and power women had access to, however, the less these designations of 'appropriateness' mattered. Beyond this, elite women also cultivated collections of decorative, ephemeral, and fashionable objects, generally not deemed to fit within the realm of 'high' art. The range of objects women collected, and the varying manners of engagement with collecting, make it impossible to classify or standardize women's collecting practices. In this compendium we have, therefore, tried to account for this diversity.

Collections are built, catalogued, and systematically organized in many ways. As the authors here demonstrate, some collectors' overarching concerns lay in aesthetic value, and others' the scientific; often, but not always, the two overlap.[24] In this compendium, we will consider collections of aesthetic value, as well as women's contributions to collections of objects with value to natural history, entomology, and the establishment of scientific institutions.[25] Ann B. Shteir's research brings to light the rise of women's botanical collections during the eighteenth century, not only amongst the aristocracy but also with middle-class women. Naming botanical collecting the 'hidden enterprise' of women's work, Shteir introduces numerous women and their contributions to the field.[26] Within the development of these collections of scientific interest, the naming and renaming of plants, generally connected with men like the aforementioned Linnaeus and so popular during this period, was also engaged in by women. This volume will show further evidence of women's contributions to botanical studies. Maria Sibylla Merian, for example, labelled her botanical and entomological drawings with both the Latin and German vernacular; the founders of the Ladies' Society for the Physical Sciences formed a collection of instruments for carrying out a range of scientific experiments and for studying the universe. Women's use of these classifying systems was also extended to non-scientific objects, as in the way Sarah Sophia Banks applied these methods to everyday objects like coins. As a counterpoint to these, other chapters also demonstrate radically different methodological strategies employed by women in the construction of collections. These examples further show the complex relationship women collectors had with science and scientific systems of classification, generally associated with masculinity. These systems make their way into collections organized by women and are re-imagined by them to suit their own needs and goals.

Some of the authors here consider collections/collectors within formal or academic training and practices, while others focus on social, amateur, or self-taught methods. Others suggest an underlying darker side to collecting, such as women's significant roles in the promotion of empire, while anxieties relating to that legacy are also prevalent. Questions about the role of new technologies in the study of collections bring to light the potential for digital humanities work in the field of collecting studies. This collection of chapters attests to the interdisciplinary nature of collecting itself. While the focus might vary from chapter to chapter, all chapters embody shared characteristics; therefore, they resist straightforward classifications, and each could be easily assimilated within these chosen headings. It became clear in structuring this book that the very practice of collecting resists categorization, which has been long understood as one of the driving principles behind the practice.

Categorizing That Which Resists Categorization

To better highlight the field of women's collecting studies and place eighteenth-century women at the heart of collecting history, our volume is ordered into four parts. Dividing the chapters up into sections presents the reader with a variety of ways in which to think about questions pertaining to women and collecting in Europe by focusing on material culture, methodologies, place, and networks. In chapter-length essays and in-depth case studies of specific collected objects, this book will demonstrate how women garnered collections within a complex system informed by contemporaneous trends in the arts and sciences.

Formally, we invite readers to explore the many possibilities evoked in the longer chapters through a group of shorter case studies that consider a series of alternative objects of attention, thus opening up new directions for longer analyses of the subject of women and collecting in eighteenth-century Europe. The goal of the case studies is to expand our understanding of women's collecting in the period, to provide a glimpse into broader projects, and to instil a sense of excitement and possibility in this field of research. We aim to reinforce ways that female collectors in various countries are looking at things similarly or differently, and to provide an array of reading options. These case studies further demonstrate the argument of the book: that women used the practice of collecting as a vehicle for imaginative self-projection, producing enduring cultural legacies.

In the first part, 'Naturalia and Artificialia', we have brought together a collection of works by authors engaged with the changing boundaries of art and science. The history of the art-nature dichotomy in Europe is comprehensive and long-standing; it would be impossible to cover all of women's contributions during the eighteenth century in this one volume. Research shows that natural objects are transformed into material culture and exchanged within wider networks as scientific experiments, decorative artefacts, gifts, and commodities.[27] Our volume adds to these studies by further demonstrating the role women and collecting played within these scientific and artistic processes. Anne Harbers and Andrea Gáldy investigate the person of Jacoba van den Brande (1735–1794) and her important roles as founder and first director of the Ladies' Society for Physical Sciences of Middleburg, the Netherlands. As Harbers and Gáldy show, the Society, which ran successfully for over one hundred years, consciously established a scientific ethos in opposition to the more entertaining scientific salons women attended in France. Additionally, as opposed to the less regulated societies in France, the Ladies' Society of Middleburg was a formally-established institution.[28] The Ladies' Society built a working collection of scientific instruments that was housed alongside a collection of art, and they cleverly incorporated religious ideology as a way of participating in science on their own terms. Irina Schmiedel's case study uncovers the fascinating way art and natural history overlapped in the still life paintings of horticultural produce that Italian princess Anna Maria Luisa de'Medici (1667–1743) commissioned from painter Bartolomeo Bimbi for her collection of art. At first glance, Bimbi's pictorial document of natural curiosities is interesting for its formal properties. On further examination, the specific combination of a piece of citrus fruit depicted alongside a pepper can be seen to allude to flavour combinations used in Middle Eastern culinary practices, thereby suggesting Arabic influences on European horticultural practices. Importantly, the study brings to light the long-standing tradition of citriculture practiced in the Medici court. Next, Kelsey Brosnan shows how

artist Anne Vallayer-Coster's painting, *Still Life with Seashells and Coral*, highlights the artist's engagement with eighteenth-century discourse pertaining to the decorative and erudite values of shells in art works and in curiosity cabinets. Brosnan shows how in their preparation and arrangement, painters and collectors of shells shared similarities that blurred the boundaries between the natural and the artificial. Vallayer-Coster's *Sill Life with Seashells and Coral* also demonstrates how the artist maintained and challenged traditional ideas relating to female sexuality during her time.

In the second part of this book, 'Travel, Borders, and Networks', the authors turn toward the geographies of collecting. Katharina Schmidt-Loske's chapter examines provenance and the natural world of entomology as it is represented in the collections and artworks of Maria Sibylla Merian, who travelled between Germany and the Netherlands, and as far as Surinam, South America, to study, collect, and paint insects. Furthermore, Maria Sibylla's entomological pictures, which include both German and Latin words, broaden our understanding of the associations between the material and metaphorical natures of texts, place, botany, and entomology. Schmidt-Loske presents a newly-discovered list of pictures that can open new avenues for researching the provenance of Maria Sibylla's work. Erica Hayes and Kacie L. Wills present new research on Sarah Sophia Banks. Drawing on her catalogues, they prove that coin collecting was fairly popular amongst women at that time, and they examine the networks of women with whom Sarah Sophia exchanged, focusing in particular on a Miss Holroyd, with whom Sarah Sophia exchanged numerous coins from all over the world that reveal the women's shared interest in travel and empire. This research also opens up possibilities for further work in social network analysis, using digital methods to trace the relationships between women coin collectors in the eighteenth century. While the grand tour is generally regarded as a masculine experience, a traditional finishing school for elite young men, more research is being carried out on women and travel, noting that they also voyaged across continental Europe with family or chaperones.[29] Lizzie Rogers explores avenues of sociability and materiality through the intimate role of female friendship in the networks of travel associated with women's collecting practices. Henrietta Fermor, Countess of Pomfret, described her European journey in letters she wrote for the benefit of her friend, Frances Seymour, Duchess of Somerset, a type of armchair traveller. Additionally, Maria Antonietta Spadaro's research takes as a case study a newly-conserved portrait of Princess Charlotte, daughter of Queen Maria Antoinette of France, that was gifted to her aunt, Queen Maria Carolina of Augsburg. Spadaro focuses on the picture as a way of tracing the movement of Queen Maria Carolina's collections from Naples to Palermo after the French Revolution. These chapters illustrate the ways that women, through varied collecting practices, traversed borders and established networks that were both social and professional. In doing so, they highlight the shifting nature of national and domestic boundaries.

The impact of Brexit on the United Kingdom and continental Europe today is testament to how European borders continue to shift; naturally, with these shifts come implications for travel, residency, family, and notions of the nation-state. During the eighteenth century, Russia's relationship with Europe was constantly shifting, and Russia went through great transformations. Peter the Great was noted as having 'opened a window onto Europe', and, indeed, Russia appeared as an imperial laboratory of Europeanization.[30] Geographically, Russia expanded to the south and the west, and it cemented its status as a great European power by becoming a guarantor power

in the Treaty of Teschen between Prussia and Austria in 1779. However, as Charis Ch. Avlonitou's chapter demonstrates, the status of a European great power was not solely based on prestigious military victories. Catherine the Great's collecting practices served her political agenda, in which collecting became almost akin to military action, as if the empress were declaring a cultural war on her European neighbours with each painting of theirs that she purchased. The data-driven analysis by Avlonitou in this chapter mirrors current distant reading work in the digital humanities; it re-thinks humanities research in methodological and statistical terms.

The third section of this book explores the theme 'Displaying, Recording, and Cataloguing'. Madeleine Pelling engages with the overlapping interests of men and women in collecting, as she explores Mary Hamilton's writing about the art collections of David Garrick and Horace Walpole, analysing their social networks and considering how Hamilton's writing displayed and performed knowledge about collecting outside of established institutions or private collections, often not accessible to women. A case study by Nicole Cochrane considers commercial collaboration and the situation of men displaying collections of women's work through her analysis of the Coade Caryatid's place in the written recording and display of Sir John Soane's collection. Cochrane examines the Coade Caryatid's illustration of Sir John Soane and Eleanor Coade's shared investment in the reinvention and display of the past. Building upon this theme and considering the alternative display of collections, Hanneke Grootenboer's case study on the dollhouse of Petronella Oortman explores the role of the dollhouse, and its subsequent display in the painting by Jacob Appel, in collecting and recording a personal history of familial loss. Finally, Ryna Ordynat's case study emphasizes friendship and intimate relationships in the context of Anne Wagner's album. Each of these chapters complicates the ways women participated in collecting. These chapters examine the re-creation of antiquity for the modern collector, as well as the analysis of the ways that men's collections performed a type of knowledge, and the manner in which the objects women collected engaged in alternative practices of recording history.

In the final section of the book, 'Beyond Eighteenth-Century Europe', Anna Frances O'Regan's chapter on the Castletown House Paper Room and the display of the print collection garnered by Lady Louisa Conolly moves between the Paper Room as a thoughtfully-curated space in its time, and the curatorial attempts to preserve this space today by way of scientific intervention to situate the room in the eighteenth century and beyond. O'Regan's attention to the curation process especially highlights the overlapping of art and science that can be seen in this collection today. Bringing the collector from the past into the present, ultimately as a way of exploring eighteenth-century material culture beyond the eighteenth century, Arlene Leis takes as a study a collection of eighteenth-century folding fans that were collected by Olivia Lanza di Mazzarino in the twentieth century. The collection conveys ideas about fashionable femininity and a nostalgia for a lost era held by a diminishing aristocracy.

The purpose of this book is to explore the social practices and material and visual culture of women's collecting against the vibrant intellectual, social, and political background of eighteenth-century Europe. The editors of this book were interested in women's connection to, and the interrelations between, the practices of art, science, and collecting during this specific historical period, in which European imperial ventures were thriving, national manufacture was on the rise, scientific endeavours were focusing on gathering useful knowledge for the betterment of mankind, and the arts

were being promoted in a variety of ways, including the establishment of art academies. In the midst of this, women were carving out spaces for themselves in the arts and sciences and taking a stance as cultural consumers and promoters. Throughout the eighteenth century, we see a wide range of women beyond the aristocracy becoming involved in knowledge production in different cultural sectors. The chapters in this book show women exploring a variety of ways and means of collecting in the eighteenth century and defying gendered and disciplinary dichotomies and expectations. As we move into the latter portion of the century, we see the effects of borders shifting internationally, and of a period of revolution that had begun, especially in the wake of the suppressions by Napoleon. As the aristocracy lost its footing in much of Europe, historic European collections were being dismantled and sold to wealthy individuals in other parts of the globe. The nature of the political and social landscape of the end of the eighteenth century lent itself to new ways of thinking about collecting and the value of objects in those collections. It also opened up possibilities for women to play a more prominent role in scientific and artistic circles, in which they could establish their own ideas and methodologies of collecting that gave meaning to the spaces they inhabited and those they strove to occupy.

Notes

1. Christie's catalogue, Wednesday, 17 May 1893.
2. See, for example, Arlene Leis, '"A Little Old China Mad": Lady Dorothea Banks and her Dairy at Spring Grove', *The British Journal for Eighteenth-Century Studies* (Oxford: Wiley) 40, no. 2 (2017): 199–221; Emma Newport, 'The Fictility of Porcelain: Making and Shaping Meaning in Lady Dorothea Banks's "Dairy Book"', *Eighteenth-Century Fiction* (U of Toronto P) 31, no. 1 (2018): 117–142.
3. For research on Sarah Sophia and her collections of coins, medals and ephemera, see, for example: Catherine Eagleton, 'Collecting African Money in Georgian London: Sarah Sophia Banks and Her Collection of Coins', *Museum History Journal* 6, no. 1 (2013); Catherine Eagleton, 'Collecting America: Sarah Sophia Banks and the Continental Dollar of 1776' in The Numismatic Chronicle (1966-), vol. 174 (2014), pp. 293–301. Arlene Leis, 'Displaying Art and Fashion: Ladies Pocket-Book Imagery in the Paper Collections of Sarah Sophia Banks', *Kunsthistorisk tidskrift/Journal of Art History* 82, no. 3 (2013): 252–271; Arlene Leis, 'Ephemeral Histories: Social Commemorations of the Revolutionary and Napoleonic Wars in the Paper Collection of Sarah Sophia Banks', in Satish Padiyar, Philip Shaw and Philippa Simpson (eds.), *Visual Culture and the Revolutionary and Napoleonic Wars* (Abingdon and New York: Routledge, 2016), 183–199; Arlene Leis, 'Sarah Sophia Banks: A "Truly Interesting Collection of Visitor Cards and Co."', in Toby Burrows and Cynthia Johnston (eds.), *Collecting the Past: British Collectors and Their Collections form the 18th to the 20th Centuries* (Abingdon and New York: Routledge, 2018), 23–38; Anthony Pincott, 'The Book Tickets of Miss Sarah Sophia Banks', *Book Plate Journal* 2 (2004): 3–130; Gillian Russell,'Sarah Sophia Banks's Private Theatricals: Ephemera, Sociability, and the Archiving of Fashionable Life', *Eighteenth-Century Fiction* 27, no. 3–4 (2015): 535–555. See also Erica Hayes and Kacie L. Wills, Chapter 5 in this book.
4. Will of Dame Dorothea Banks, The National Archives, 8 July 1828, PROB 11/1742, www.nationalarchives.gov.uk/documentsonline/details-result.asp?queryType=I&result count=I & Edoc_Id=196308 (accessed 28 July 2012).
5. Karen Attar, 'Ossified Collections: The Past Encapsulated in British Institutions Today', in T. Burrows and Cynthia Johnston (eds.), *Collecting the Past: British Collectors and Their Collections from the 18th to the 20th Centuries* (Abingdon and New York: Routledge, 2019), 113–138. Men often stipulated in their wills where a collection should be bestowed, not leaving it to their wife. This is further complicated by the fact that women may have left their collections to male family members. Here Attar develops a line of thinking proposed by Russell W. Belk, which notes the male bias in collecting. Belk points out that

society often views collecting as an activity dominated by middle-aged, affluent males, while female collectors are seen more traditionally as contributing to activities of preservation, creation, and nurturance. See 'Collectors and Collecting', in Christopher Tilley, et al. (eds.), *Handbook of Material Culture* (London: Sage, 2006), 539.

6. Studying extra-illustration, Lucy Peltz, *Facing the Text* (San Marino: Huntington Library, 2017), has demonstrated the way Charlotte Sunderland expanded upon her husband's collection of extra-illustration after his death, turning the collection into a 'national work'. Furthermore, Pincott, 'The Book Tickets of Miss Sarah Sophia Banks'; Russell, 'Sarah Sophia Banks's Private Theatricals'; and Arlene Leis, 'Cutting, Arranging and Pasting: Sarah Sophia Banks as Collector', *Early Modern Women: An Interdisciplinary Journal 9*, no. 1 (2014): 127–140, have brought to light various items from the print collections of Sarah Sophia Banks: book plates, fashion plates, and admission tickets.

7. Susan M. Pearce, *On Collecting: An Investigation into Collecting in the European Tradition* (Abingdon and New York: Routledge, 1995), 207; Catherine King and Dianne Sachko Macleod, 'Women as Patrons and Collectors', *Grove Art* (2006), https://doi.org/10.1093/gao/9781884446054.article.T2022267.

8. Beth Tobin, *The Duchess's Shells* (New Haven: Yale UP, 2014).

9. Kim Sloan, 'Aimed at universality and belonging to the nation': the Enlightenment and the British Museum' in Kim Sloan (ed.), *Enlightenment: Discovering the World in the Eighteenth-Century* (London: The British Museum Press, 2003).

10. Robert Huxley, "Natural history collectors and their collections: 'simpling macaronis' and instruments of empire" in Kim Sloan (ed.) *Enlightenment: Discovering the World in the Eighteenth-Century* (London: The British Museum Press, 2003).

11. Roger Cardinal and John Elsner, *The Cultures of Collecting* (London: Reaktion, 1994).

12. For examples of how collectors throughout time have incorporated the idea of Noah as the first collector into their own collecting ethos, see, for example: Paula Findlen, *Possessing Nature: Museums, Collecting, and Scientific Culture in Early Modern Italy* (Berkeley, Los Angeles and London: U of California P, 1994), 88–92; Christoph Imscher, *The Poetics of Natural History: From John Bartram to William James* (New Brunswick and London: Rutgers UP, 1999); and Arthur MacGregor, *The Origins of Museums: The Cabinet of Curiosities in Sixteenth-and-Seventeenth-Century Europe* (Cambridge: Ashmolean Museum, 2017).

13. Cardinal and Elsner, *The Cultures of Collecting*, 'Introduction'.

14. Additionally, even in Charlotte Gere and Marina Vaizey, *Great Women Collectors* (London: Philip Wilson Publishers Ltd, 1999), collecting is defined as a process that must contribute to a woman's status.

15. Susan Bracken, Andrea M. Gáldy and Adriana Turpin, *Women Patrons and Collectors* (Newcastle upon Tyne: Cambridge Scholars Publishing, 2012).

16. The following authors have discussed elite and royal collections: Adreiano Aymonino, 'The *Musaeum* of the First Duchess of Northumberland (1716–1776) at Northumberland House in London: An Introduction', in *Women Patrons and Collectors* (Newcastle upon Tyne: Cambridge Scholars Publishing, 2012); Oliver Bernier, *The Eighteenth-Century Woman* (New York: MET Publishing, 1982); Orsolya Bubryák, 'The Treasure of Countess Erzsébet Rákóczi (1654–1707)', in *Women Patrons and Collectors* (Newcastle upon Tyne: Cambridge Scholars Publishing, 2012); Jennifer Germann, *Picturing Marie Leszczinska (1703–1768) Representing Queenship in Eighteenth-Century France* (Farnham and Burlington: Ashgate, 2015); Sarah Grant, *Female Portraiture and Patronage in Marie Antoinette's Court: The Princess de Lamballe* (Abingdon and New York: Routledge, 2018); Cynthia Miller Lawrence, *Women and Art in Early Modern Europe: Patrons, Collectors, ad Connoisseurs* (University Park: Penn State UP, 1997); Christina K. Lindeman, *Representing Duchess Anna Amalia's Bildung: A Visual Metamorphosis in Portraiture, from Political to Personal, in Eighteenth-Century Germany* (Abingdon and New York: Routledge, 2017); Joanna Marschner, David Bindman and Lisa L. Ford (eds.), *Enlightened Princesses: Caroline, Augusta, Charlotte and the Shaping of the Modern World* (New Haven: Yale UP, 2017); Kristoffer Neville and Lisa Skogh (ed.), *Queen Hedwig Eleonora and the Arts: Court Culture in Seventeenth-Century Northern Europe* (Abingdon and New York: Routledge, 2017); Clarissa Campbell Orr, *Queenship in Europe 1660–1815: The Role of the Consort 1660–1815* (Cambridge: Cambridge University Press, 2004). Judith Pascoe, *The Hummingbird Cabinet* (Ithaca: Cornell UP, 2006); Madeleine Pelling, 'Collecting the

World: Female Friendship and Domestic Craft at Bulstrode Park', *The British Journal for Eighteenth-Century Studies* 41, no. 1 (2018): 101–120; Douglas Rigby and E. Rigby, *Lock, Stock and Barrel: The Story of Collecting* (Philadelphia: J. P. Lippincott, 1944); Stacey Sloboda, 'Material Displays: Porcelain and Natural History in the Duchess of Portland's Museum', *Eighteenth-Century Studies* 43 (2010): 455–472; Rebecca Stott, *Duchess of Curiosities: Margaret, Duchess of Portland* (Welbeck: Pineapple Press, 2006); Heidi Strobel, *The Artistic Matronage of Queen Charlotte (1744–1818): How a Queen Promoted Both Art and Female Artists in English Society* (New York: Edwin Mellon Press, 2011); Michael Yonan, *Empress Maria Theresa and the Politics of Habsburg Imperial Art* (University Park: Penn State UP, 2011).

17. John Fowles, *The Collector* (London: Vintage, 2004), 55.
18. Adriana Craciun and Simon Schaffer (eds.), *The Material Cultures of Arts and Sciences* (London: Palgrave Macmillan, 2016). See also Arjun Appadurai, 'Introduction: Commodities and the Politics of Value', in *The Social Life of Thing: Commodities and Cultural Perspective* (Cambridge: Cambridge UP, 1986); Bill Brown, 'Thing Theory', *Critical Inquiry* 28 (2001): 1–22, 6–7; Maureen Daly Goggin and Beth Fowkes Tobin, *Material Women 1750–1950: Consuming Desires and Collecting Practices* (Abingdon and New York: Routledge, 2016); Jennifer G. Germann and Heidi A. Strobel (eds.), *Materializing Gender in Eighteenth-Century Europe* (Abingdon and New York: Routledge, 2016).
19. Pearce, *On Collecting*, 198.
20. Pearce, *On Collecting*, 197–222.
21. We are using the term science, a contemporary category, broadly to encompass eighteenth-century disciplines of natural history and natural philosophy.
22. Patricia Phillips, *The Scientific Lady: A Social History of Women's Scientific Interests 1520–1918* (London: Palgrave Macmillan, 1990), states that during the seventeenth, eighteenth, and nineteenth centuries, women turned to science for edification, leisure, conversation, and/or personal solace; Ann Birmingham, *Learning to Draw: Studies in the Cultural History of a Polite and Useful Art* (New Haven: Yale UP, 2000), shows how women turned to artistic practices like drawing, music making, and collage work, considered accomplishments for learning and social identity. For more on the social spaces cultivated by women for the study of art, science, and collecting, see: Anna Catalani and Susan Pearce, 'Particular Thanks and Obligations: The Communications Made by Women to the society of Antiquaries Between 1776 and 1837, and Their Significance', *The Antiquaries Journal* 86 (2006): 254–278; Freya Gowrley, 'Craft(ing) Narratives: Specimens, Souvenirs, and Morsels in A la Ronde's Specimen Table', *Eighteenth-Century Fiction* 31, no. 1 (2018): 77–97; Kate Heard, 'The Print Room at Queen Charlotte's Cottage', *The British Art Journal* 13, no. 3 (Winter 2012–2013): 53–60; Meredith Martin, *Dairy Queens* (Cambridge: Harvard UP), 2011; Amanda Vickery, *The Gentleman's Daughter: Women's Lives in Georgian England* (New Haven: Yale UP, 2003). See also Annegret Pelz, 'The desk: excavation site and repository of memories' in Martin Myrone and Lucy Peltz (eds.) *Producing the Past: Aspects of Antiquarian Culture and practice 1700–1850* (Aldershot: Ashgate, 1999), pp. 135–147. Pelz draws interesting parallels between collections of objects found in desks and forms of the museum.
23. Charles Allen, *The Polite Lady: Or a Course of Female Education: In a Series of Letters, Form a Mother to a Daughter* (London, 1760), 207. Some conduct books warned against the negative effects that visiting private art collections could have on young ladies. The works of art on display in elegant salons (naked Venuses, Apollos and Cupids) were considered inappropriate for young women to see and 'should be industriously concealed from the eyes of young persons'.
24. See, for example, Adriana Craciun and Mary Terrall (eds.), *Curious Encounters: Voyaging, Collecting, and Making Knowledge in the Long Eighteenth Century* (Toronto: U of Toronto P, 2019), which examines the knowledge-making relationship of the history of discovery and collecting. See also Daniela Bleichmar and Peter Mancall, *Collecting Across Culture: Material Exchanges in the Early Modern Atlantic World* (Philadelphia: U of Pennsylvania P, 2011).
25. See Patricia Fara, *Pandora's Breeches: Women, Science, and Power* (London: Pimlico, 2004); Kate Heard, *Maria Merian's Butterflies* (London: Royal Collection Trust, 2016); Lynette Hunter and Sarah Hutton (eds.), *Women Science and Medicine 1500–1700*

(Stroud: Sutton, 1997); Mark Laird and Alicia Weisberg-Roberts, *Mrs. Delany and Her Circle* (New Haven: Yale Centre for British Art, 2009); Bernard Lightman and Ann B. Shteir (eds.), *Figuring It Out: Science, Gender, and Visual Culture* (Hanover and London: Dartmouth College Press, 2006); Steven Shapin, 'Invisible Technicians', in *A Social History of Truth: Civility and Science in Seventeenth-Century England* (Chicago: U of Chicago P, 1994), 355–408; Londa Schiebinger, *Plants and Empire: Colonial Bioprospecting in the Atlantic World* (Cambridge: Harvard UP, 2004); Irina Schmiedel, *Pompa E Intelletto: Formen Der Ordnung Und Inszenierung Botanischen Wissens Im Späten Großherzogtum Der Medici*, Phoenix Series (Berlin: de Gruyter, 2016); Carl Thompson, 'Women Travelers, Romantic-era Science and the Banksian Empire', *Notes and Records: The Royal Society Journal of the History of Science* (1 May 2019), https://doi.org/10.1098/renr.2018.0062; Jane Wildgoose, *Promiscuous Assemblage, Friendship and the Order of Things: and Installation by Jane Wildgoose in Celebration of the Friendship Between Mrs. Mary Delany and the Duchess Dowager of Portland*, exh. cat. (New Haven: Yale Center for British Art, 2009).

26. Ann B. Shteir, *Cultivating Women, Cultivating Science: Flora's Daughters and Botany in England, 1760–1860* (Baltimore and London: Johns Hopkins UP, 1996).

27. Bernadette Bensaude-Vincent and William R. Newman (eds.), *The Artificial and the Natural: An Evolving Polarity* (Cambridge, MA: MIT) 2007; Tobin, *The Duchess's Shells*.

28. Susan Sheets-Pyenson, 'The Role of Women in Eighteenth-Century French Scientific Culture: The Salon and the Latest Fashion', in Lewis Pyenson and Jean-François Gayuvin (eds.), *The Art of Teaching Physics: The Eighteenth-Century Demonstration Apparatus of Jean-Antoine Nollet* (Quebec: Septentrion, 2002); Geoffrey V. Sutton, *Science of a Polite Society: Gender, Culture, and the Demonstration of Enlightenment* (Boulder: Westview Press, 1995); Mary Terrall, 'Gendered Spaces, Gendered Audiences: Inside and Outside the Paris Academy of Sciences', *Configurations* 3 (1995): 207–232.

29. Jeremy Black, *Italy and the Grand Tour* (New Haven: Yale UP, 2003); Ilaria Bignamini and Andrew Wilton, *Grand Tour: The Lure of Italy in the Eighteenth Century*, exh. cat. (London: Tate Gallery, 1996); Brian Dolan, *Ladies of the Grand Tour: British Women in Pursuit of Enlightenment and Adventure in Eighteenth-Century Europe* (New York: Harper Collins, 2001); Rosemary Sweet, *Cities and the Grand Tour: The British in Italy c.1690–1820* (Cambridge: Cambridge UP, 2012).

30. Klaus Zernick, *Poland und Russland: Zwei Wege in der Europälschen Geschichle* (Berlin: Propyläen-Verlag, 1994).

Bibliography

Allen, Charles, *The Polite Lady: Or a Course of Female Education: In a Series of Letters, from a Mother to a Daughter*, London, 1760, 207.

Appadurai, Arjun, 'Introduction: Commodities and the Politics of Value', in *The Social Life of Thing: Commodities and Cultural Perspective*, Cambridge: Cambridge UP, 1986.

Attar, Karen, 'Ossified Collections: The Past Encapsulated in British Institutions Today', in T. Burrows and Cynthia Johnston (eds.), *Collecting the Past: British Collectors and Their Collections from the 18th to the 20th Centuries*, Abingdon and New York: Routledge, 2019, 113–138.

Aymonino, Adriano, 'The *Musaeum* of the First Duchess of Northumberland (1716–1776) at Northumberland House in London: An Introduction', in Susan Bracken, Andrea M. Gáldy and Adriana Turpin (eds.), *Women Patrons and Collectors*, Newcastle upon Tyne: Cambridge Scholars Publishing, 2012.

Belk, Russell W., 'Collectors and Collecting', in Christopher Tilley, et al. (eds.), *Handbook of Material Culture*, London: Sage, 2006, 534–545.

Bensaude-Vincent, Bernadette and William R. Newman (eds.), *The Artificial and the Natural: An Evolving Polarity*, Cambridge, MA: MIT, 2007.

Bernier, Oliver, *The Eighteenth-Century Woman*, New York: MET Publishing, 1982.

Birmingham, Ann, *Learning to Draw: Studies in the Cultural History of a Polite and Useful Art*, New Haven: Yale UP, 2000.

Black, Jeremy, *Italy and the Grand Tour*, New Haven: Yale UP, 2003.

Bleichmar, Daniela and Peter Mancall, *Collecting Across Culture: Material Exchanges in the Early Modern Atlantic World*, Philadelphia: U of Pennsylvania P, 2011.

Bracken, Susan, Andrea M. Gáldy and Adriana Turpin, *Women Patrons and Collectors*, Newcastle upon Tyne: Cambridge Scholars Publishing, 2012.

Brown, Bill, 'Thing Theory', *Critical Inquiry* 28 (2001): 1–22, 6–7.

Bubryák, Orsolya, 'The Treasure of Countess Erzsébet Rákóczi (1654–1707)', in *Women Patrons and Collectors*, Newcastle upon Tyne: Cambridge Scholars Publishing, 2012.

Burrow, Toby and Cynthia Johnston, *Collecting the Past: British Collectors and Their Collections from the 18th to the 20th Centuries*, Abingdon and New York: Routledge, 2019.

Catalani, Anna and Susan Pearce, 'Particular Thanks and Obligations: The Communications Made by Women to the Society of Antiquaries Between 1776 and 1837, and Their Significance', *The Antiquaries Journal* 86 (2006): 254–278.

Christie's catalogue, Wednesday, 17 May 1893.

Craciun, Adriana and Simon Schaffer (eds.), *The Material Cultures of Arts and Sciences*, London: Palgrave Macmillan, 2016.

Craciun, Adriana and Mary Terrall (eds.), *Curious Encounters: Voyaging, Collecting, and Making Knowledge in the Long Eighteenth Century*, Toronto: U of Toronto P, 2019.

Daly Goggin, Maureen and Beth Fowkes Tobin, *Material Women 1750–1950: Consuming Desires and Collecting Practices*, Abingdon and New York: Routledge, 2016.

Dolan, Brian, *Ladies of the Grand Tour: British Women in Pursuit of Enlightenment and Adventure in Eighteenth-Century Europe*, New York: Harper Collins, 2001.

Eagleton, Catherine, 'Collecting African Money in Georgian London: Sarah Sophia Banks and Her Collection of Coins', *Museum History Journal* 6, no. 1 (2013): 23–38.

Edgar, Elizabeth and Lucy Peltz, *Brilliant Women: 18th—Century Bluestockings*, New Haven: Yale University Press, 2008.

Elsner, John and Roger Cardinal, *The Cultures of Collecting*, London: Reaktion, 1994.

Fara, Patricia, *Pandora's Breeches: Women, Science, and Power*, London: Pimlico, 2004.

Findlen, Paula, *Possessing Nature: Museums, Collecting, and Scientific Culture in Early Modern Italy*, Berkeley, Los Angeles and London: U of California P, 1994, 88–92.

Fowles, John, *The Collector*, London: Vintage, 2004, 55.

Gere, Charlotte and Marina Vaizey, *Great Women Collectors*, London: Philip Wilson Publishers Ltd, 1999.

Germann, Jennifer, *Picturing Marie Leszczinska (1703–1768) Representing Queenship in Eighteenth-Century France*, Farnham and Burlington: Ashgate, 2015.

Gowrley, Freya, 'Craft(ing) Narratives: Specimens, Souvenirs, and Morsels in A la Ronde's Specimen Table', *Eighteenth-Century Fiction* 31, no. 1 (2018): 77–97.

Grant, Sarah, *Female Portraiture and Patronage in Marie Antoinette's Court: The Princess de Lamballe*, Abingdon and New York: Routledge, 2018.

Heard, Kate, *Maria Merian's Butterflies*, London: Royal Collection Trust, 2016.

Heard, Kate, 'The Print Room at Queen Charlotte's Cottage', *The British Art Journal* 13, no. 3 (Winter 2012–2013): 53–60.

Hunter, Lynette and Sarah Hutton (eds.), *Women Science and Medicine 1500–1700*, Stroud: Sutton, 1997.

Imscher, Christoph, *The Poetics of Natural History: From John Artram to William James*, New Brunswick and London: Rutgers University Press, 1999.

King, Catherine and Dianne Sachko Macleod, 'Women as Patrons and Collectors', *Grove Art* (2006), https://doi.org/10.1093/gao/9781884446054.article.T2022267.

Laird, Mark and Alicia Weisberg-Roberts, *Mrs. Delany and Her Circle*, New Haven: Yale Centre for British Art, 2009.

Leis, Arlene, 'Cutting, Arranging and Pasting: Sarah Sophia Banks as Collector', *Early Modern Women: An Interdisciplinary Journal* 9, no. 1 (2014): 127–140.

Leis, Arlene, 'Displaying Art and Fashion: Ladies Pocket-Book Imagery in the Paper Collections of Sarah Sophia Banks', *Kunsthistorisk tidskrift/Journal of Art History* 82, no. 3 (2013): 252–271.

Leis, Arlene, 'Ephemeral Histories: Social Commemorations of the Revolutionary and Napoleonic Wars in the Paper Collection of Sarah Sophia Banks', in Satish Padiyar, Philip Shaw and Philippa Simpson (eds.), *Visual Culture and the Revolutionary and Napoleonic Wars*, Abingdon and New York: Routledge, 2016, 183–199.

Leis, Arlene, ' "A Little Old China Mad": Lady Dorothea Banks and Her Dairy at Spring Grove', *The British Journal for Eighteenth-Century Studies* (Oxford: Wiley) 40, no. 2 (2017): 199–221.

Leis, Arlene, 'Sarah Sophia Banks: A "Truly Interesting Collection of Visitor Cards and Co." ', in Toby Burrows and Cynthia Johnston (eds.), *Collecting the Past: British Collectors and Their Collections form the 18th to the 20th Centuries*, Abingdon and New York: Routledge, 2019.

Lindeman, Christina K., *Representing Duchess Anna Amalia's Bildung: A Visual Metamorphosis in Portraiture, from Political to Personal, in Eighteenth-Century Germany*, Abingdon and New York: Routledge, 2017.

MacGregor, Arthur, *The Origins of Museums: The Cabinet of Curiosities in Sixteenth-and-Seventeenth-Century Europe*, Cambridge: Ashmolean Museum, 2017.

Marschner, Joanna, David Bindman and Lisa L. Ford, *Enlightened Princesses: Caroline, Augusta, Charlotte and the Shaping of the Modern World*, New Haven: Yale University Press, 2017.

Martin, Meredith, *Dairy Queens*, Cambridge: Harvard UP, 2011.

Miller Lawrence, Cynthia, *Women and Art in Early Modern Europe: Patrons, Collectors, ad Connoisseurs*, University Park: Penn State UP, 1997.

Neville, Kristoffer and Lisa Skogh (eds.), *Queen Hedwig Eleonora and the Arts: Court Culture in Seventeenth-Century Northern Europe*, Abingdon and New York: Routledge, 2017.

Newport, Emma, 'The Fictility of Porcelain: Making and Shaping Meaning in Lady Dorothea Banks's "Dairy Book" ', *Eighteenth-Century Fiction* (U of Toronto P) 31, no. 1 (2018): 117–142.

Pascoe, Judith, *The Hummingbird Cabinet*, Ithaca: Cornell UP, 2006.

Pearce, Susan M., *On Collecting: An Investigation into Collecting in the European Tradition*, Abingdon and New York: Routledge, 1995, 207.

Pelling, Madeleine, 'Collecting the World: Female Friendship and Domestic Craft at Bulstrode Park', *The British Journal for Eighteenth-Century Studies* 41, no. 1 (2018): 101–120.

Peltz, Lucy, *Facing the Text*, San Marino: Huntington Library, 2017.

Phillips, Patricia, *The Scientific Lady: A Social History of Women's Scientific Interests 1520–1918*, London: Palgrave Macmillan, 1990.

Pincott, Anthony, 'The Book Tickets of Miss Sarah Sophia Banks', *BookPlate Journal* 2 (2004): 3–130.

Rigby, Douglas and E. Rigby, *Lock, Stock and Barrel: The Story of Collecting*, Philadelphia: J. P. Lippincott, 1944.

Russell, Gillian, 'Sarah Sophia Bank's Private Theatricals: Ephemera, Sociability, and the Archiving of Fashionable Life', *Eighteenth-Century Fiction* 27, no. 3–4 (2015): 535–555.

Schiebinger, Londa, *Plants and Empire: Colonial Bioprospecting in the Atlantic World*, Cambridge: Harvard UP, 2004.

Schmiedel, Irina, *Pompa E Intelletto: Formen Der Ordnung Und Inszenierung Botanischen Wissens Im Späten Großherzogtum Der Medici*, Phoenix Series, Berlin: de Gruyter, 2016.

Shapin, Steven, *A Social History of Truth: Civility and Science in Seventeenth-Century England*, Chicago: U of Chicago P, 1994, 355–408.

Sheets-Pyenson, Susan, 'The Role of Women in Eighteenth-Century French Scientific Culture: The Salon and the Latest Fashion', in Lewis Pyenson and Jean-François Gayuvin (eds.), *The*

Art of Teaching Physics: The Eighteenth-Century Demonstration Apparatus of Jean Antoine Nollet, Quebec: Septentrion, 2002.

Shteir, Ann B., *Cultivating Women, Cultivating Science: Flora's Daughters and Botany in England, 1760–1860*, Baltimore and London: Johns Hopkins UP, 1996.

Shteir, Ann B. and Bernard Lightman (eds.), *Figuring It Out: Science, Gender, and Visual Culture*, Hanover and London: Dartmouth College Press, 2006.

Sloboda, Stacey, 'Material Displays: Porcelain and Natural History in the Duchess of Portland's Museum', *Eighteenth-Century Studies* 43 (2010): 455–472.

Stott, Rebecca, *Duchess of Curiosities: Margaret, Duchess of Portland*, Welbeck: Pineapple Press, 2006.

Strobel, Heidi A., *The Artistic Matronage of Queen Charlotte (1744–1818): How a Queen Promoted Both Art and Female Artists in English Society*, New York: Edwin Mellon Press, 2011.

Strobel, Heidi A. and Jennifer Germann (eds.), *Materializing Gender in Eighteenth-Century Europe*, Abingdon and New York: Routledge, 2016.

Sutton, Geoffry V., *Science of a Polite Society: Gender, Culture, and the Demonstration of Enlightenment*, Boulder: Westview Press, 1995.

Sweet, Rosemary, *Cities and the Grand Tour: The British in Italy c.1690–1820*, Cambridge: Cambridge UP, 2012.

Thompson, Carl, 'Women Travelers, Romantic-Era Science and the Banksian Empire', *Notes and Records: The Royal Society Journal of the History of Science*, 1 May 2019, https://doi.org/10.1098/renr.2018.0062; 'Invisible Technicians'.

Tobin, Beth, *The Duchess's Shells*, New Haven: Yale University Press, 2014.

Vickery, Amanda, *The Gentleman's Daughter: Women's Lives in Georgian England*, New Haven: Yale University Press, 2003.

Wildgoose, Jane, *Promiscuous Assemblage, Friendship and the Order of Things: and Installation by Jane Wildgoose in Celebration of the Friendship Between Mrs. Mary Delany and the Duchess Dowager of Portland*, exh. cat., New Haven: Yale Canter for British Art, 2009.

Wilton, Andrew and Ilaria Bignamini, *Grand Tour: The Lure of Italy in the Eighteenth Century*, exh. cat., London: Tate Gallery, 1996.

Yonan, Michael, *Empress Maria Theresa and the Politics of Habsburg Imperial Art*, University Park: Penn State UP, 2011.

Zernick, Klaus, *Poland und Russland: Zwei Wege in der Europälschen Geschichle*, Berlin: Propyläen-Verlag, 1994.

Part I

Artificialia and Naturalia

1 Science, Gender and Collecting

The Dutch Eighteenth-Century Ladies' Society for Physical Sciences of Middelburg

Anne Harbers and Andrea Gáldy

In 1785, the Ladies' Society for Physical Sciences (Natuurkundig Genootschap der Dames) was founded in Middelburg. The *Opening Address*, spoken in Dutch to the original circa forty women founders, stated:

> I am mentioning only these names, out of a countless number of a similar nature, in order not to deprive you too long of the study of the important Subjects to which your curiosity is longing for. I just wanted to draw your attention to them to show you how the most eminent & clever persons have appreciated our Science; *and to convince you that the Spirit of Wisdom and Science is not bound to any century, age, site or subject; and that, if the education is not neglected, and the means are not lost out of sight, your Gender, as much as Ours, can excel in the beautiful Literature and Sciences:* moreover, the same Spirit which inspires them, is also inspiring you; stemming from the same divine source.[1]

These motivating words recognised the rights of women in relation to scientific ambitions and, in particular, underlined the investment of the Middelburg women in forming their Ladies' Society to educate and instil in women an academic spirit connected to an Enlightenment ideal. We can further consider the ways that these Dutch women set themselves apart from the ways women in *ancien régime* countries interacted with science. As opposed to a reliance upon conspicuous fashion and luxury, as happened in fashionable circles in France, the women of the Ladies' Society took advantage of accepted Protestant practices and used their independent means in order to further their education in the sciences.

The wealthy and well-connected Middelburg women who formed the Ladies' Society for Physical Sciences were clear in their purpose to educate women when founding their group in 1785. In the *Opening Address*, given by the Chairman at the Society's first meeting,[2] reference was made to five women, among them Dutch female scholars, such as Anna Maria van Schurman (1607–1678) and painter and poet Margarita Godewijk (1627–1677), as well as to the German-born artist Maria Sibylla Merian (1647–1717). Caroline of Ansbach (1683–1737), the Princess of Wales and patron of the Newtonians, was also noted, as well as the French philosopher, mathematician and physicist Marquise de Chateler *(sic)* (1706–1749).[3] While the male role models mentioned date from classical antiquity to the days of the Society's foundation,[4] it is interesting to note that the women mentioned all lived and worked during the two centuries prior to the Ladies' Society's formation. This reflects the Society's interest in how women were becoming

more recognized in scientific work. The constitution of the Society united these role models and Dutch Protestant women by way of their Enlightenment motivations to increase their knowledge and form both public and personal collections as part of their contributions to the developments in the arts and sciences of their time. They eventually decided to hold their meetings at the Middelburg *Musaeum Medioburgense*, founded in 1787. In this space, the ladies undertook the intellectual pursuit of art and science, as well as the preservation and display of various collections.

This chapter will discuss the ways in which the Ladies' Society for the Physical Sciences of Middelburg reflected eighteenth-century Dutch Enlightenment ideals, collecting culture and the dissemination of scholarly learning to Dutch society.[5] Through examining the Society's first publication, which reveals the Society's composition, we see how the Ladies set themselves up as a complementary counterpoint to the male scientific societies of their time, while at the same time establishing their own identity. In the Society's goals and transactions, as far as they are available to us, we see the infusion of natural philosophy with Enlightenment ideals, such as economy, religion and education, specifically a dedication to ongoing female scientific education. This purpose was accompanied by the Society's collections of books and scientific instruments, as well as by the private collections amassed by individual members, which were composed of both scientific and artistic objects. We will, therefore, show how these women embodied the eighteenth-century ambition to create their own space for the study of science and art that reflected the well-established relationship of the study of nature and religion in Dutch Protestant Society.

Composition of the Society

The Ladies' Society for Physical Sciences held regular formal gatherings, and the proceedings of the first meeting in 1785 were published and are preserved as a printed booklet of around fifty pages (Figure 1.1). It provides the text of the *Opening Address*, and pages nine to twelve list the names of those present as founding members.[6] We are forced to speculate on several aspects of the Society's foundation, since apart from the first, no other meeting records of the Ladies' Society are preserved. In May 1940, a German bombing raid on Middelburg and the resulting fire storm caused the loss of significant numbers of archival documents and records of the Society. Only a few source documents survive and will be cited later, but for other information, this history of the Ladies' Society has to rely on the mention of their activities in the preserved records of the Men's Society.

The published surviving list includes forty-one names, one listed as deceased. Initially, the Society was limited to forty members. Thirty-nine handwritten invitations were sent to ladies for the founding meeting and, although membership was to be limited to forty, the Ladies' Society was oversubscribed by three aspiring members. The meetings were to commence on the second Wednesday in November 1785 and to be held every fortnight until the following April, from 6 pm to 8:30 pm. This indicates that the Society was to be active on a regular basis. In the case of the Ladies' Society, it seems that all members belonged to the top strata of society, since the fortnightly meetings may have reflected a responsibility to domestic duties for their households. The Ladies' meetings were held throughout the winter months, while in the summer meetings were suspended when many of the upper-class families resided in their country houses within the province of Zeeland.

There were three female directors: Anna Huijssen van Kattendijke-Hurgronje (1726–1791), Anna Maria Mathias Pous-Steengracht (1753–1828), and Jacoba van

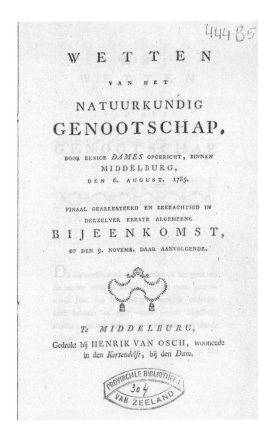

Figure 1.1 Title page of *Natuurkundig Genootschap der Dames*, 6 August 1785. Zeeland Archives, archief Natuurkundig Gezelschap Middelburg, nr. 66.

de Perre-van den Brande (1735–1794). Jacoba was married to the Ladies' Society's first elected chairman, Johan Adriaen van de Perre (1738–1790), who sent out the initial invitations to the prospective members of the Society.[7] Although the Society's chairman was male, the membership consisted of women only. Both Jacoba (Figure 1.2) and her husband were leading figures in Middelburg society; importantly, Jacoba was the wealthier by inheritance. The couple shared an interest in the physical sciences, and, together, they subsidised and founded the Ladies' Society.[8] It is from this shared interest that the Society was able to build a strong foundation and flourish.

Considering the respective roles of the leading couple, Jacoba van de Perre-van den Brande as Founding Director and Johan Adriaen van de Perre as first elected Chairman, it is possible that Jacoba felt that the women of Middelburg should have a society equivalent to that of the all-male *Natuurkundig Genootschap* (Men's Society for Physical Sciences), founded in 1780, of which her husband was a member.[9] Jacoba may have thus seen her husband as the linchpin between the two societies and/or as the representative to the outside world at a time when women did not usually assume public roles. As director, however, she held considerable status and was involved in the continued financial support of the *Musaeum Medioburgense* (to which we shall

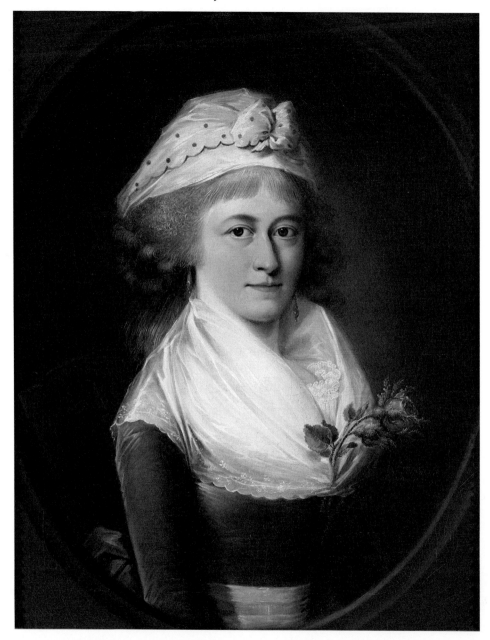

Figure 1.2 E. Uswald. *Jacoba van den Brande*, 1794. Oil on canvas, 63 × 41cm.

Source: Courtesy of Zeeuws Museum, Middelburg. Photograph by Ivo Wennekes.

return in more detail), established for meetings of the Ladies' Society and for housing physics collections donated to the Society. She also allowed continued access to the couple's private collections after the early death of her husband. Therefore, this chapter supports the position that she was as integral as her husband to the decisions leading to the formation and continued patronage of the Ladies' Society.

Detailed research by Margaret Jacob and Dorothée Sturkenboom additionally provides in-depth knowledge about the female founding members. Jacob and Sturkenboom were able to identify members' parents and husbands, as well as their occupations, and, in some cases, the capital they owned or left behind.[10] The ladies were aged between eighteen and fifty-nine; twenty-four were married, whilst five were widowed. Fifteen were yet to be married and only four remained unmarried.[11] This list shows that the founding members were a cross-section of women, not limited to a particular age group, but grounded in their own scholarly interests. The ladies were from the wealthy strata of Middelburg society, and a number had inherited their wealth through their mother, aunt or sister. This implies not only economic independence, but the considerable personal or intellectual freedom that wealth can offer.

The Society's Female Role Models

On the basis of the *Opening Address*, one can examine the gender dynamics as outlined by the presentation of role models for the composition and intentions of the Ladies' Society. As mentioned previously, the *Opening Address* names five women as exemplary, each coming from a different social background.[12] The inclusion of these women, among them notable scholars in languages, physics, mathematics and philosophy, artists and collectors, and a patron of the natural sciences, signalled the Society's respect for the formal learning of women.

Anna Maria van Schurman was the first woman to attend university in 1636 in Utrecht. Utrecht University cannot confirm if she graduated, since no exams were held for students in these early years.[13] She was proficient in fourteen languages and acted as an advocate for female students. Van Schurman was the first Dutch woman to seek publication of her correspondence, in which her letters to other scholars express her interests in a wide range of subjects, including philosophy, medicine, painting, sculpture and music. Among her numerous publications was her 1659 treatise on women's learning, which was translated into English under the title, *The Learned Maid, or Whether a Maid may be a Scholar?*[14] Anna Maria van Schurman embodied the wide-ranging and dedicated educational spirit that the Ladies' Society aspired to.

Alongside Van Schurman and the scholarly interests she represented, the Ladies' Society upheld a number of women who devoted their lives to creative and artistic endeavours. Margarita Godewijk was a highly regarded painter, glass engraver, draughtswoman, poet and musician.[15] She was included in the 1718 publication, *The Great Theatre of Dutch Painters*, by Dutch painter and art historian Arnold Houbraken.[16] Like the aforementioned Van Schurman, Godewijk was also multilingual; her father taught Greek, Latin, Italian, French and English, and she was a student of Cornelis Bisschop and the respected seventeenth-century painter, Nicolaes Maes. She painted mostly flowers, landscapes and marine genre pictures. Her chosen subject matter illustrates the overlap of art and science, which is also evident in the Society's collections, and which we will discuss later in this chapter.

Maria Sibylla Merian is championed for her artistic and scientific talents. Merian was a naturalist, entomologist and artist, specialising in artistic renderings of

closely-observed flora and fauna. She was recognised as advancing the understand-ing of entomology in the late seventeenth and early eighteenth centuries through her observations and drawings of the processes of insect metamorphosis. In 1699, at the age of 52, she accepted an invitation to join a five-year expedition to Surinam in the north of South America. A collector of plants and insects, she sold the contents of her study in Amsterdam before leaving for Surinam in 1699 in order to help fund her trip, but she continued collecting specimens while she travelled, and upon her return, she 'arranged her collections in her house, pressed and well-displayed in boxes where they can be seen by all'.[17] In 1705, she published her most significant work on insect metamorphosis, the *Metamorphosis Insectorum Surinamensium*. Her endeavours in collecting plants and animals for careful scientific observation and her detailed depic-tions highlighted the range of talents that the ladies of the Society were encouraged to emulate in their scientific enterprises and observations.

Amongst artists and writers was also a French woman philosopher, mathematician and physicist, Émilie du Châtelet. In 1740, she published her textbook on physics, *Institu-tions de physique*.[18] She died in 1749 at only 43 years of age, following complications arising from the birth of a daughter. From 1745 until her death, she worked on a French translation of Isaac Newton's *Principia Mathematica*, which was published posthumously by French philosopher Voltaire, in part in 1756 and in full in 1759. For many years, this translation would remain the main French translation of the English mathematician's work during the French Enlightenment. Émilie du Châtelet's influence can be seen in the Ladies' Society's dedication to collecting and utilizing specific scientific instruments.

Finally, Caroline of Ansbach, Princess of Wales, the future Queen Caroline, consort of George II of Great Britain, was lauded for her patronage of the arts and sciences. Tutored at the court of Dresden by the philosopher and mathematician Gottfried Leib-niz, Princess Caroline arrived to England in 1714 as a devotee of natural philoso-phy, mathematics, and collecting.[19] Once in Britain, she amassed a large collection of plants, animals, and art—in particular royal portraits in sculpture and painting—at Richmond gardens.[20] She championed Newtonian mathematics and invited the Royal Society member Sir Isaac Newton to St. James's Palace. Caroline was of the opinion that Newton 'shew'd the World was philosophically and mathematically made; and that it could be framed and held together by none but an infinitely Wise and Almighty architect'.[21] As a non-Dutch, devout Protestant, Caroline's inclusion among the role models listed in the *Opening Address* attests to the group's regard for and awareness of the strong tradition of intellectual interest in mathematics and scientific enquiry, as seen in the practice of princely collecting maintained by women at the English and Prussian courts. The affiliation between mathematics and God in her reference to the 'Wise and Almighty architect' was often discussed amongst theologians; it links sci-ence to the divine, uniting the rationality of science with religion.

This group of women reflect the interdisciplinary nature of the kind of learning to which the Ladies' Society aspired. These women role models represented the fields of art, science, mathematics, collecting, philosophy, natural history, and published scholarly learning. They provide a foundation from which we can now examine the purpose and practices of the Ladies' Society.

Purpose of the Ladies' Society: Education and Experimentation

A focus on the study of nature and the physical world (from insects to planets) and on collecting wonders and rarities of nature, as well as on their investigation through the

use of microscopes and telescopes, was underpinned by a close religious association in Dutch scientific studies during the Golden Age of the seventeenth century. Nature was regarded as a second Book of God, next to the Bible.[22] Thus, the study of nature and the physical world conducted by preachers and ministers was regarded as an extension of Dutch Reformed religious beliefs and convictions.

Both the Men's Society and the Ladies' Society invited lecturers. Often ministers were called to lecture in learned societies dedicated to natural and physical learning, since they tended to pursue such scholarly goals in their own writings. Their scientific and religious interests also reinforced the idea of God as creator of the universe and its workings. The Rev. Christophorus Ballot of the Dutch Reformed Church became the first appointed lecturer for the Ladies' Society.[23] His lectures covered topics from the characteristics of substances to movement, gravity, hydrostatics mechanics, optics, colour, light and electricity.[24] He also lectured to the Men's Society and, most likely, he gave the same lectures to both groups. His wife, Anna Ballot-Buys, was admitted as a member of the Ladies' Society and was exempt from paying an annual fee, possibly due to her lack of affluence and as a consequence of her husband's lecturing activities.[25] This could be seen as the Ladies' Society members exercising their sense of charity, suitable to their status as members of the gentility. The presence of Rev. Ballot as lecturer reflected that the members of the Ladies' Society were most likely adherents of either the Dutch Reformed or the Walloon Churches.[26] Ballot advocated and published on the Protestant ideals of compatibility between science and religion which, together with successful economic enterprise, formed the mainstays of Dutch society.[27] This view is supported by the Rev. Ballot's publication of a treatise defending the compatibility of science and religion in Middelburg, while he still acted as lecturer to the Ladies' Society in 1789.

In addition to the *Opening Address*, the surviving publication includes an introductory lecture given to the Ladies by the Rev. Ballot.[28] In his address to the members of the Ladies' Society at their first meeting, he stated that he understood that its members were not merely interested in the physical sciences for their amusement, and that he would, therefore, explain gravity, hydrostatics, mechanics and optics, and demonstrate air, water and fire in their nature and effects.[29] He also emphasised an interest in electricity, the experimentation with and demonstration of which were highly popular in the eighteenth century.[30] He outlined that the lectures for the Ladies' Society would ironically be based on the programme of the French Abbé Jean Antoine Nollet's (1700–1770) *Leçons de physique expérimentale* (1743), a work with an emphasis on mechanics and electricity, translated into Dutch and published in six volumes, between 1759 and 1772. Nollet's lessons were set out in the Ladies' Society regulations as the book on which lectures would be based, as they were for the Men's Society.

Nollet's lectures became fashionable throughout Europe, and they were well attended by both men and women. He had developed his scientific lecturing system in the scientific salons in Paris, after an earlier tour to visit the great lecturers of Holland and Britain.[31] In 1743, Nollet published his lectures in six octavo volumes of several hundred pages, each volume containing several dozen illustrative plates. In April 1736, the aforementioned female French mathematician and attendee of the salons of science, Émilie du Châtelet, commented in a letter to a friend that Nollet's lectures attracted 'the carriages of duchesses, peers, and lovely women. Voila, then, how pretty philosophy can make a fortune in Paris'.[32] This quote and the engraving of *Abbé Nollet Demonstrating his Electric Machine* (Figure 1.3), which highlights the

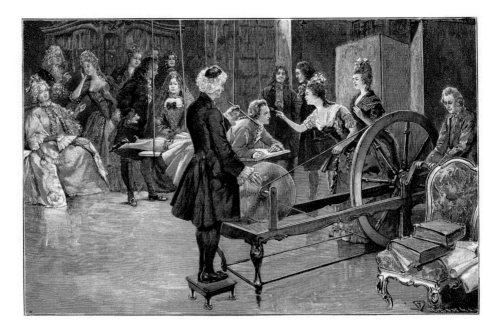

Figure 1.3 Hans Kraemer, *Jean-Antoine Nollet Demonstration, Circa 1740*, German engraving of the French clergyman and physicist Abbé Nollet demonstrating his electric machine in a Salon in France, from *Weltall & Menschheit* (universe and humanity), c. 1880, 31.8 × 20.1cm.

Source: Courtesy of CCI Archives/Science Photo Library.

spectacle of the display over its intellectual purpose, demonstrate women's precarious position in regard to scientific learning; although women were welcomed at Parisian scientific salons, they ran the risk of being appreciated more for their appearances and for their associations with commerce and luxury, rather than for their intellectual abilities.

The Ladies' Society in Middelburg strategically positioned itself in contrast to the fashionable scientific salons taking place in other parts of Europe. As we have seen, in his *Address* to the Ladies' Society, Johan van de Perre not only mentioned male and female role models, but stated that there were no gender boundaries to excel intellectually. Next, he listed the five women discussed in earlier sections of this chapter and then made the following statement: 'Why does your Sex, more than ours, remain deprived of it? *(ie intellectual excellence)*. Do we (as men) want to keep you blind and lower you to raise our sex and increase our worth?'[33] This is a strong statement in terms of gender designation and roles accepted in eighteenth-century Middelburg, and it definitely has a modern ring to it. Importantly, it also underlines the purpose and motivation behind the formation of the group to become more than a gathering of fashionable women meeting for lectures and entertaining demonstrations of electricity, as happened in other European centres.[34] The members of the Ladies' Society sought to create an institution, a formal society that met regularly and maintained an interest in cultivating knowledge and scholarship over time. Whereas salons discussing scientific topics and presenting

such ideas elsewhere in Europe may have been dependent on hosts temporarily convening such events, the Ladies' Society in Middelburg was an institution that continued to exist over an extended period of time, far beyond the lifetimes of its original members and founders. In fact, the Society would successfully sustain itself for over one hundred years. The Society's ability to support itself and to set itself apart from other ladies' societies in Europe at the time was, in large part, due to the unique interweaving of scientific and religious ideals and the simultaneous emphasis on female education as opposed to entertainment.

Female Education and the Society's Engagement with the Dutch Enlightenment

In the *Opening Address* to the members of the Ladies' Society, three main purposes are presented: an acknowledgment of the drive of curiosity and a thirst for understanding within the group, a plea that addressing such a curiosity is not bound 'to any century, age, site or subject, . . . or gender to excel', and the demand that the education of women should not be neglected. The intellectual curiosity of the Ladies' Society is evidenced by the topics of lectures that most interested its members. In addition to the electricity lessons of Abbé Nollet, astronomy remained a popular topic.[35] Access was given to the Ladies' Society to the Zeeuws Planetarium, a free-standing scientific instrument commissioned by Van de Perre and built in 1783–1786 for the purpose of studying astronomy.[36] A planetarium was then considered the epitome of academic luxury. In April 1794, the Society's second chairman, Daniel Radermacher (1722–1803), uncle to Johanna and Hillegonda Schorer, two active members of the Ladies' Society and collectors in their own rights, gave a lecture on the solar system, exactly the same lecture given to the Men's Society two weeks later.[37] On the occasion of this lecture to the Ladies' Society, Daniel Radermacher donated his own planetarium to them. One of the few original documents to survive in relation to the Ladies' Society is inscribed: 'This book is to remain with the Planetarium' in its location at the *Musaeum Medioburgense*; the document then gives a thirty-three page explanation of the planetarium, signed and dated by Daniel Radermacher.[38] In addition to reinforcing the ideal of God as the universal architect by looking to the cosmos, the access that the Ladies' Society had to planetariums shows the Society's engagement with the most valued scientific instruments of their day.

As mentioned earlier, from its foundation on 6 August 1785, the Ladies' Society met regularly until 1881 and then sporadically until 1887.[39] Clearly, there existed considerable interest in the physical sciences among the female membership over several generations. That the Ladies' Society of Middelburg lasted as long as it did is, however, quite surprising. Other groups of women living in Amsterdam and other regional centres also met for the purpose of learning about the physical sciences, but none lasted as long as the Middelburg group. For example, in 1765, the author and teacher of philosophy, geography, mathematics and physics, Benjamin Bosma (1724–1796), organised a weekly college for physics experimentation in Amsterdam, exclusively for women, that was also modelled on the lectures of the aforementioned Nollet.[40] In 1778, a minister of the Dutch Reformed Church, Johannes Florentius Martinet (1729–1795), organised weekly meetings in Zutphen with the intention of teaching 'young ladies of the first rank' to be 'philosophical Ladies, for brave Gentlemen, and to be experienced Mothers . . . for numerous children'.[41] As these attempts show, a

popular and philosophical belief in the dual role of mothers as both moral and intellectual teachers existed, and it was supposed that natural history could teach women how to fulfil this role. Jacob and Sturkenboom explore this avenue, advocating that the Middelburg Ladies' Society represented a unique confluence of science, commerce, cosmopolitanism, utilitarianism and reformist ideals that prompted the continuation of the Ladies' Society over its extended lifetime.[42] To this was added the emphasis on female education, specifically education in the sciences.

The importance of the education of women was stressed by Van de Perre in his *Opening Address*, with a particular focus on the personal benefits that women would gain from their studies of science: the advancement of the belief in God, respect for themselves and respect for their husbands. He also suggested that knowledge of physical sciences would assist the women in their pursuit of a well-recognised and respected Dutch theme: economy. This comment resonates with contemporary arguments caused by the political turmoil of the times; allegedly, the Dutch Republic was losing the leading role in Europe it had held during the Golden Age of the seventeenth century as a consequence of a diminishing of Dutch morals. Contemporary commentary argued that this reduction in morals was due to a regrettable imitation of French culture and fashions. What was needed was a return to the 'old' Dutch virtues of sobriety, frugality and economic initiative in a mostly Calvinist society.[43] The formation and participation of the women in their own Middelburg Society, set up for the purpose of studying the physical sciences, placed them securely within a transformational involvement of women in the pursuit of scientific knowledge during the eighteenth century.

The *Musaeum Medioburgense*

We know that in its early years the Ladies' Society was supported by both Jacoba and Johan in several ways, including the provision of a purpose-designed meeting place, the *Musaeum Medioburgense*. They also funded the employment of a Director for the *Musaeum*, salaried at the rate of 600–700 florins per annum, plus appropriate accommodation.[44] Their ambition was to create a centre of art and science and a place for amateurs to study 'for practical use of all citizens, for both the contributions to the Societies housed there and for the better education of the young people of both sexes'.[45] The vision for the *Musaeum Medioburgense* was maintained by Jacoba after her husband's death in April 1790. In 1791, Jacoba donated the property rights of the *Musaeum Medioburgense* to the Men's Society (Natuurkundig Gezelschap) to ensure that it remained the meeting venue for both the Ladies' and Men's Societies. The available information indicates that she did not offer it to the joint societies, since in 1791 the Ladies' Society was not of an appropriate legal status to own property; it gained this status only in 1800.[46] The Ladies' Society would continue to meet at the *Musaeum* until 1887, when the Society was dissolved.

The *Musaeum Medioburgense* was established following the Enlightenment ideal of housing encyclopaedic collections of art and science within one building.[47] Projected in 1787 and inaugurated by 1788, the *Musaeum Medioburgense* was shared by four Middelburg societies—the Ladies' Society for Physical Sciences, the fraternal Men's Society, the Middelburg Department of the Zeeland Society of Arts & Sciences (Zeeuwsch Genootschap der Wetenschappen) that continues today as the Royal Zeeland Society of Sciences, and the Middelburg Drawing Academy (Middelburgse

Teeken-Academie).[48] In spring 1788, the Pharmacy Guild established a medical garden or 'Hortus Medicus', together with the inclusion of a Library Cabinet and plans for a Theatre of Anatomy and Dissection.[49] The *Musaeum Medioburgense*'s meeting rooms were used by all societies, while adjacent space was reserved for the Cabinet of Natural History and Rarities, which was the property of the Middelburg Department of Zeeland Society of Arts & Sciences.[50] Over the years, the Zeeland Society formed a collection of paintings and historical objects, maps, drawings, prints, books and manuscripts, as well as of fossils, shells, minerals and ethnological objects from the overseas colonies.[51] Records show that the Ladies' Society contributed a number of significant items to the collections of books and scientific instruments used by both the Ladies' and Men's Societies.[52] The collected items were more than just exhibits; they were used for practical purposes, as well as study. Middelburg citizens were aware of the burgeoning of museums, which reflected this ideal, and they successfully established their own, supporting it through the shared effort of their scientific and artistic societies. Members of the respective societies actively gathered and contributed objects to help form collections displayed within the *Musaeum*.

Collections of the Ladies' Society for Physical Sciences

The intellectual curiosity that the Ladies' Society encouraged is reflected in the private collections of scientific items owned by its members and is further illustrated by later auction catalogues.[53] Through the records of the Men's Society, the donations made by individual women can be determined. On her death, one of the founding directors, Anna Huijssen van Kattendijke-Hurgronje (1726–1791), bequeathed a sum of money that the ladies used to purchase a special air-pump in November 1793. Earlier in 1785, they had purchased a pair of globes by the London maker George Adams, and, in 1789, a set of optical instruments.[54] Women thus supported the enlargement of the institutional collections by purchasing technical instruments with their own money, since they saw them as useful for their experiments and enquiries. The collections, therefore, were an essential part of their scholarly endeavours, rather than merely part of a display.

The collections of the Society also benefitted from the family connections of its members, since many of their family relations held important roles in the administrative councils and financial institutions of the country; their status was especially valuable during the latter half of the eighteenth and the early part of the nineteenth centuries.[55] Apart from their town houses, a number of the members' families owned country estates. Additionally, some of the husbands of the women involved were regents of the Dutch East India Company (Vereenigde Oostindische Compagnie; VOC), which was a source of great wealth to the Netherlands and helped propel the collecting craze through colonisation and the importation of exotic natural curiosities and man-made goods. Middelburg was an important VOC port, second only to Amsterdam. As Eric Jorink outlines in his study of Sir Hans Sloane of the Royal Society in London and his connections to Dutch collectors, the Dutch reputation for collecting had its roots in the foundation of Leiden University in the late sixteenth century and in the establishment of the VOC in 1602.[56] As a result of the arrival of exotic species and artefacts to Europe, collecting was seen not only as an ambitious display of wealth, but also considered an intellectual pursuit undertaken by the Ladies' Society.[57]

In addition to the Society's collection, the ladies had also gained access to the extensive private collection of Johan and Jacoba. As for the contents of this collection, the

auction catalogue provides insight. Following the death of Jacoba van den Brande in 1794, the collection was auctioned in 1798 by their heirs at W.A. Keel auction house in Middelburg.[58] The auction was held under the name of Mr J.A. van de Perre, and it was scheduled for a total of seven auction days, which may be understood as an indication of its massive size: 10–14 September for works on paper: books, drawings and prints; 26–27 September for Physics instruments, paintings, rarities and other items of interest (Figure 1.4). A small collection of drawings, prints and paintings had been previously sold through the art dealer and silversmith J.W. Gericke in Middelburg.[59] There was also a separate legacy of a bookcase containing books and papers bestowed to Jacoba's niece and Ladies' Society member Maria Petronella Versluys-van den Brande. The main heirs were three of Jacoba's nieces, including Maria Petronella.[60] The decision of the heirs to put the collection up for auction was most likely for financial reasons. Jacoba's niece, Maria, who, as mentioned, also received a separate legacy, chose not to donate the inheritance to the Ladies' Society but to retain it in the family, although she herself was a member of the Ladies' Society. Research on the works of art in the Van de Perre-van den Brande collection is ongoing.[61] The collection and its

Figure 1.4 Title page of the Auction Catalogue of Collection of Jacoba van den Brande & J. A. van de Perre, 1798.

Source: Courtesy of ZB, Image library Zeeland.

legacy represent the significant holdings and cultural contributions of the Middelburg Ladies' Society.

The sale catalogue lists numerous books and prints,[62] with an extensive group of scientific instruments under the title of 'Inventory of the Cabinet of Physics Instruments', numbering two hundred and forty-one items. These objects include objects such as astrolabes, theodolites, balances, two rings on feet and a copper ball for the expansion of metal. Listed under aerometric (meteorological) instruments are barometers, thermometers and hygrometers. There are fifteen hydraulic and hydrostatic instruments and over forty astrological and optical instruments. The inclusion of both microscopes and telescopes in the collections was significant to Middelburg. Middelburg was known in the sixteenth and seventeenth centuries as a centre of excellent lens making, reputedly the reason for the invention of the microscope by the Dutch in addition to the development and patenting of the telescope by a German lens maker working in Middelburg. These scientific instruments required active use—the microscope helped to observe minute natural items, whilst the telescope facilitated and enhanced astronomical investigations.

Among the tools for experimentation on electricity are five electric machines, an electric battery, a number of electrometers and a number of large and small Leiden flasks. Electric machines were regarded as important inclusions in eighteenth- and nineteenth-century scientific laboratories and collections because of the widespread popularity of electricity in scientific lectures and demonstrations. Several designs in the collection were introduced from the 1750s to the early decades of the 1800s.[63] The Leiden flask, a Dutch invention, would have been used in the demonstrations suggested by Abbé Nollet in his lecture programme followed by the Ladies' Society. Although used for demonstration and entertainment, scientific instruments could also serve medical or therapeutic purposes.

The list then goes on to include a number of magnetic instruments, and, finally, items of experimentation in chemistry, such as retorts, distilling kettles and seven green glass helmets.[64] The massive amount of objects auctioned from this collection speaks to the time dedicated to building a collection of this size and breadth. Even though the Society did not want to promote themselves in a way that flaunted wealth as did their European neighbours, the vastness and value of this collection illustrates the wealth of the Society's members and hints at Dutch global economic power.

Conclusion

On the dissolution of the Ladies' Society in 1887, their property was donated to the Zeeland Society of Sciences (previously the Zeeland Society of Arts & Sciences). During the World War II bombings of Middelburg on 17 May 1940, a large part of the holdings of the Society that were then held in the Provincial Library was lost, including the eighteenth-century documents of the Ladies' Society. Paintings, illuminated manuscripts, porcelain and many other objects burned, whilst books and manuscripts were water damaged.[65] Of the items from the Ladies' Society, only two were preserved, both made of Chinese porcelain: a milk jug and a cup and saucer.[66] Their provenance and material serves as a reminder that these women had strong connections to the Dutch East India Company (VOC), which was essential in introducing Chinese porcelain to Europe from early in the seventeenth century.[67] Chinese porcelain, in addition to spices, was one of the commodities traded by the VOC, and those connected to the

VOC often displayed their wealth by way of significant arrangements of porcelain in their homes' interiors. Not only do these objects allude to the importance of the domestic setting and women's role in the home as wife and mother to the moral and intellectual formation promoted by the Ladies' Society, but they also symbolize the underpinnings of the independent wealth that enabled the ladies to pursue their interests in self-education.

Notes

1. Zeeuws Archief, *Archief van het Natuurkundig Gezelschap, Aanhangsel la: Wetten van het Natuurkundig Genootschap* (Middelburg: Van Osch, 1785), with the attached 'Aanspraak' *(Opening Address)* by Van de Perre, 13–34 (own emphasis).
2. Unfortunately, only the minutes of the first meeting have been preserved, due to the loss of documents during bombing of the Middelburg provincial library during WWII in 1940.
3. Spelling error in the *Opening Address*—it should read 'Marquise du Châtelet'.
4. Van de Perre, *Opening Address*, 18–20.
5. Middelburg is the capital of the province of Zeeland, about two hundred kilometres south of Amsterdam in The Netherlands.
6. Archief, *Archief van het Natuurkundig Gezelschap, Aanhangsel la*, including the list of Founding Members, 9–12. Membership was limited to forty members in the first years. The published list includes forty-one names, of whom one is listed as deceased, one supernumerary name and two extra-ordinary names, totalling a membership of forty-four.
7. For a biography of Johan Adriaen van de Perre and a detailed account of his life and scientific interests, see Huibert Jan Zuidervaart, 'Mr. Johan Adriaen van de Perre (1738–1790): Portret van een Zeeuws regent, mecenas en liefhebber van nuttige wetenschappen (Mr. Johan Adriaen van de Perre (1738–1790), Portrait of a Zeeland Regent, Patron and Lover of Useful Sciences)', *Arch. Zeeuwsch Genootsch. Wet.* (1983): 1–169.
8. Zuidervaart, 'Mr. Johan Adriaen van de Perre (1738–1790)', 36.
9. See Margaret C. Jacob and Dorothée Sturkenboom, 'A Women's Scientific Society in the West: The Late Eighteenth-Century Assimilation of Science', *Isis* 94, no. 2 (2003): 217–252, for a consideration of the role of Jacoba van den Brande in the Ladies' Society, in particular 235.
10. For a detailed account of The Ladies' Society for Physical Sciences in English, as well as a prosopography including birthdates, parents, husbands, etc., see Jacob and Sturkenboom, 'A Women's Scientific Society in the West'.
11. Jacob and Sturkenboom, 'A Women's Scientific Society in the West', 223.
12. Van de Perre, *Opening Address*, 18–20.
13. See the website of Utrecht University, www.uu.nl/en/organisation/alumni/anna-maria-van-schurman.
14. See Bo Karen Lee and Anne Larsen, 'Anna Maria van Schurman', in Margaret King (ed.), *Oxford Bibliographies in Renaissance and Reformation* (Oxford: Oxford UP, 2018).
15. See the website of the Dutch National Institute for Art History Documentation RKD, https://rkd.nl/en/explore/artists/32252.
16. See www.dbnl.org/tekst/houb005groo01_01/houb005groo01_01_0150.php for a digital reproduction. See also: M. Russell, 'The Women Painters in Houbraken's Groote-Schouburge' *Women's Art Journal* 2, no. 1 (Spring–Summer 1981): 7–11.
17. Kate Heard, *Maria Merian's Butterflies* (London: Royal Collections Trust, 2016), 16, 22.
18. See Karen Detlefsen, 'Émilie du Châtelet', in Edward N. Zalta (ed.), *The Stanford Encyclopedia of Philosophy* (Stanford: Stanford UP, 2018).
19. See Emma Jay, 'Queen Caroline's Library and Its European Contexts', *Book History* 9 (2006): 31–55.
20. Joanna Marschner, David Bindman and Lisa L. Ford (eds.), *Enlightened Princesses: Caroline, Augusta, Charlotte, and the Shaping of the Modern World* (London and New Haven: Yale UP, 2017), see in particular, Robyn Asleson, 'Rediscovery, Collecting and Display', 177–183, and Kathryn Jones, 'Adorning the Cabinet', 185–201; Joanna Marschner, 'Michael Rysbrack's Sculpture Series for Queen Caroline's Library at St James's Palace',

in Diana Dethloff, Tessa Murdoch, Kim Sloan and Caroline Elam (eds.), *Burning Bright, Essays in Honour of David Bindman* (London: UCL Press, 2015), 27–35.

21. See the entry for a sculpture of Sir R. Isaac Newton, commissioned by Queen Caroline, Royal Collection Trust, www.rct.uk/collection/1392/sir-isaac-newton-1642-1727.

22. Eric Jorink, *Reading the Book of Nature in the Dutch Golden Age, 1575–1715* (Leiden, The Netherlands: Brill, 2010) on attitudes of the Dutch to science and nature.

23. His grandson, C.H.D. Buys Ballot (1817–1890) was inventor of the Buys Ballot law on atmospheric pressure, wind force and wind direction along with the Buys Ballot Table.

24. See Zuidervaart, 'Mr. Johan Adriaen van de Perre (1738–1790)', 42–43.

25. Zuidervaart, 'Mr. Johan Adriaen van de Perre (1738–1790)', 42–43.

26. The Walloon Church is a Protestant French-speaking congregation from the Southern Netherlands and France.

27. Jacob and Sturkenboom, 'A Women's Scientific Society in the West', 227.

28. See Rev. Christophorus Ballot, *Wetten van het Natuurkundig Genootschap* (Middelburg: Henrik Van Osch, 1785), 35–51.

29. See Zuidervaart, 'Mr. Johan Adriaen van de Perre (1738–1790)', 35–51 for his possibly more gendered consideration of the role of Jacoba van den Brande in the Ladies' Society.

30. Paola Bertucci, 'Sparks in the Dark: The Attraction of Electricity in the Eighteenth Century', *Endeavour* 31, no. 3 (2007): 88–93, discusses the popular interest in electricity during the eighteenth century. See also Simon Schaffer, 'Self Evidence', *Critical Inquiry* 18, no. 2 (1992): 327–362.

31. David M. Stewart Museum, Lewis Pyenson, and Jean-François Gauvin (eds.), *The Art of Teaching Physics: The Eighteenth Century Demonstration Apparatus* (Quebec: Septentrion, 2002).

32. Geoffrey V. Sutton, *Science of a Polite Society: Gender, Culture & the Demonstration of Enlightenment* (Boulder, CO: Westview Press, 1995), discusses the French interests in science during the Enlightenment.

33. Van de Perre, *Opening Address*, 29.

34. Margaret C. Jacob, *The First Knowledge Economy: Human Capital and the European Economy, 1750–1850* (Cambridge: Cambridge UP, 2014); this book argues for the importance of scientific knowledge gained through books and lectures as driving transformation and economic change in Europe.

35. Huibert Jan Zuidervaart and Rob H. Gent, *Between Rhetoric and Reality: Instrumental Practices at the Astronomical Observatory of the Amsterdam Society 'Felix Meritis', 1786–1889* (Hilversum: Uitgeverij Verloren, 2013).

36. See Huibert Jan Zuidervaart and H. Hoitsma, *Een Zeeuws planetarium uit de tweede helft van de 18e eeuw* (Middelburg: Koninklijk Zeeuwsch Genootschap van Wetenschappen, 1982). This planetarium is now (2020) housed in the current Zeeuws Archief and can be seen on request.

37. The Radermacher and Schorer family connection was important to the Ladies' Society. Daniel Radermacher became Second Chairman on the sudden death of Johan van der Perre. Johanna and Hillegonda Schorer were too young to be founding members of the Ladies' Society however their mother and elder sisters and nieces were members. In 1801, Johanna became the treasurer and secretary of the Ladies' Society, being handed the archive and banknotes from her uncle (see Jacob and Sturkenboom, 'A Women's Scientific Society in the West', 239). The auction catalogue of Johanna Schorer is very informative on the subject of her scientific collections and interests.

38. Documents about the lesson dated April 1794 and given by Daniel Radermacher to the Ladies' Society, and about the Planetarium that he donated to them, are held in the Zeeuws Archief.

39. See Jacob and Sturkenboom, 'A Women's Scientific Society in the West', 217.

40. See Zuidervaart, 'Mr. Johan Adriaen van de Perre (1738–1790)', 37, on the motivation for the education of Dutch women in the physical sciences.

41. Jacob and Sturkenboom, 'A Women's Scientific Society in the West', 242.

42. Jacob and Sturkenboom, 'A Women's Scientific Society in the West', 242.

43. W.R.E. Velama, 'The Dutch, the French and Napoleon: Historiographical Reflections on a Troubled Relationship', in A. de Francesco (ed.), *Da Brumaio ai cento giorni: cultura di governo e dissenso politico nell' Europa di Bonaparte*, Storiografica, no. 11 (Milan:

Guerini, 2007), 39–51, presents contemporary social arguments prevailing amongst political turmoil. On reformed Dutch Society and economic enterprise linked to religious affiliation and VOC endeavours worldwide, see Mary S. Sprunger, 'The Limits of Faith in a Maritime Empire: Mennonites, Trade and Politics in the Dutch Golden Age', in William Reger and Tonio Andrade (eds.), *The Limits of Empire: European Imperial Formations in Early Modern World History; Essays in Honor of Geoffrey Parker* (Farnham: Ashgate, 2012), 59–77.

44. See Zuidervaart, 'Mr. Johan Adriaen van de Perre (1738–1790)', 53.
45. Zuidervaart, 'Mr. Johan Adriaen van de Perre (1738–1790)', 53.
46. Jacob and Sturkenboom, 'A Women's Scientific Society in the West', 235, offer this reasoning.
47. Roughly contemporaneous to its establishment in Middelburg was the opening of a large building on the Keizersgracht in Amsterdam for the Felix Meritis Society in October 1788, the *Teylers' Museum* in Haarlem in 1783 and the *Diligentia* in The Hague in 1797. Many other European countries had established such buildings earlier in the eighteenth century, such as the *Sozietät der Wissenschaften* in Berlin, the *Istituto delle Scienze* in Bologna and the *Kunstkamera* in St Petersburg, all of which included an astronomical observatory, as did the *Felix Meritis* in Amsterdam. See Zuidervaart and Gent, *Between Rhetoric and Reality*.
48. See Zuidervaart, 'Mr. Johan Adriaen van de Perre (1738–1790)', 61, for an explanation of the evolution of these Zeeland societies.
49. Zuidervaart, 'Mr. Johan Adriaen van de Perre (1738–1790)', 62.
50. Zuidervaart, 'Mr. Johan Adriaen van de Perre (1738–1790)', 61.
51. See the website for the present Royal Zeeland Society of Sciences, https://kzgw.nl/kzgw/historie/ (in Dutch). These collections are now housed at several Zeeland and national institutions such as the Naturalis Biodiversity Centre in Leiden, the Zeeuws Museum, the Zeeland Maritime Museum, the Zeeuws Archief and the Zeeuwse Bibliotheek Planning Office and Library of Zeeland.
52. See Jacob and Sturkenboom, 'A Women's Scientific Society in the West', 237, for a discussion of items donated by the ladies.
53. Auction catalogues related to the Ladies' Society members are held in the Zeeuwse Bibliotheek. Of particular interest are those of E. Ph. Van Visvliet (1799/1800); D. Radermacher (1803); P. Changuion (1805); Jonkvrouwe H.C. Schorer (1821) and A. Drijfhout (1827).
54. Jacob and Sturkenboom, 'A Women's Scientific Society in the West', 237.
55. For example, the founding chairman, Johan van de Perre, was a representative of Prince Willem V as First Noble of Zeeland. Three of the ladies' husbands were listed as State Councillors of King Louis, whilst one husband held a position as governor of the province of Zeeland in the service of Dutch King Willem I.
56. See Eric Jorink, 'Hans Sloane and the Dutch Connection', in Alison Walker, Arthur MacGregor and Michael Hunter (eds.), *From Books to Bezoars: Sir Hans Sloane and His Collections* (London: British Library, 2012), 57–70, on the relationships between the English scientist & collector Sir Hans Sloane & the Dutch; for the cultural exchange between the Dutch Republic and its colonies, e.g. Batavia, through artistic commissions and collections, see Michael North, 'Collecting in the Dutch Colonial Empire, Seventeenth and Eighteenth Centuries', in Maia Wellington Gahtan and Eva-Maria Toelenberg (eds.), *Collecting and Empires, an Historical and Global Perspective* (London and Turnhout: Harvey Miller, Brepols, 2019), 183–195.
57. The Dutch Republic took over from Italy as the location in which to visit museums of note (well-reputed collections owned by private individuals) with the Florentine prince Cosimo de' Medici, the future Grand Duke Cosimo III and Tsar Peter the Great from Russia travelling to Amsterdam; see Jorink, 'Hans Sloane and the Dutch Connection', 59. During the eighteenth century, Swedish monarch Adolf Fredrik and his consort Lovisa Ulrika were known to spend a sizable fortune to acquire Dutch privately held collections to increase their own royal natural history collections. For a detailed account of Lovisa Ulrika of Sweden and her interests in natural history collecting, see Anne E. Harbers and Andrea M. Gáldy, 'Queen Lovisa Ulrika of Sweden (1720–1782): *Philosophe* & Collector', in Claire Jones and James Bainbridge (eds.), *The Palgrave Handbook of Women and Science: History, Cultures and Practice (Since 1660)* (London: Palgrave, 2020).

58. See Zuidervaart, 'Mr. Johan Adriaen van de Perre (1738–1790)', 99, Appendix 5.
59. Zuidervaart, 'Mr. Johan Adriaen van de Perre (1738–1790)', 99, Appendix 5.
60. See Jacob and Sturkenboom, 'A Women's Scientific Society in the West', 233.
61. Research into the art from the collections is an ongoing direction of enquiry by the author, A. Harbers.
62. The print collections are also part of ongoing research.
63. Explanation from Museo Galileo, a museum of historical scientific instruments in Florence, based on the collection of the Medici dynasty; see https://catalogue.museogalileo.it/indepth/ElectricalMachine.html.
64. See Zuidervaart, 'Mr. Johan Adriaen van de Perre (1738–1790)', List from Appendix 5, 119–126.
65. See the History section within the website of the present Royal Zeeland Society of Sciences, https://kzgw.nl/kzgw/historie/.
66. See Zuidervaart, 'Mr. Johan Adriaen van de Perre (1738–1790)', 40.
67. See Christine Ketel, *Early 17th Century Chinese Trade Ceramics for the Dutch Market: Distribution, Types & Consumption* (Hong Kong: University of Hong Kong, 2011).

Bibliography

Ballot, Christophorus, *Wetten van het Natuurkundig Genootschap*, Middelburg: Henrik Van Osch, 1785.

Bertucci, Paola, 'Sparks in the Dark: The Attraction of Electricity in the Eighteenth Century', *Endeavour* 31, no. 3 (2007): 88–93, https://doi.org/10.1016/j.endeavour.2007.06.002 (accessed 20 October 2019).

Detlefsen, Karen, 'Émilie du Châtelet', in Edward N. Zalta (ed.), *The Stanford Encyclopedia of Philosophy*, Stanford: Stanford UP, 2018, https://plato.stanford.edu/archives/win2018/entries/emilie-du-chatelet/ (accessed 12 January 2020).

Harbers, Anne and Andrea Gáldy, 'Queen Lovisa Ulrika of Sweden (1720–1782): *Philosophe* & *Collector*', in Claire Jones and James Bainbridge (eds.), *The Palgrave Handbook of Women and Science: History, Cultures and Practice (Since 1660)*, London: Palgrave, 2020.

Heard, Kate, *Maria Merian's Butterflies*, London: Royal Collections Trust, 2016.

Houbraken, Arnold, *De groote schouburgh der Nederlantsche konstschilders en schilderessen/The Great Theatre of Dutch Painters*, 3 vols., Amsterdam: gedrukt voor den auteur . . ., 1718–1721, digital reproduction (1976), www.dbnl.org/tekst/houb005groo01_01/houb005groo01_01_0150.php (accessed 12 January 2020).

Jacob, Margaret C., *The First Knowledge Economy: Human Capital and the European Economy, 1750–1850*, Cambridge: Cambridge University Press, 2014.

Jacob, Margaret C. and Dorothée Sturkenboom, 'A Women's Scientific Society in the West: The Late Eighteenth-Century Assimilation of Science', *Isis* 94, no. 2 (2003): 217–252, doi:10.1086/379385.

Jay, Emma, 'Queen Caroline's Library and its European Contexts', *Book History* 9 (2006): 31–55, www.jstor.org/stable/30227384 (accessed 20 October 2019).

Jorink, Eric, 'Hans Sloane and the Dutch Connection', in Alison Walker, Arthur MacGregor and Michael Hunter (eds.), *From Books to Bezoars: Sir Hans Sloane and His Collections*, London: British Library, 2012, 57–70, www.academia.edu/7695263/Hans_Sloane_and_the_Dutch_Connection (accessed 20 October 2019).

Jorink, Eric, *Reading the Book of Nature in the Dutch Golden Age, 1575–1715*, Leiden, The Netherlands: Brill, 2010, https://doi.org/10.1163/ej.9789004186712.i-472 (accessed 20 October 2019).

Ketel, Christine, *Early 17th Century Chinese Trade Ceramics for the Dutch Market: Distribution, Types & Consumption*, Proceedings of the International Symposium, City University of Hong Kong, Hong Kong: City University of Hong Kong, 2011.

Koninklijk Zeeuwsch Genootschap der Wetenschappen (Royal Zeeland Society of Sciences), History of the Collections, https://kzgw.nl/kzgw/historie/ (accessed 12 January 2020).

Lee, Bo Karen and Anne Larsen, 'Anna Maria van Schurman', in Margaret King (ed.), *Oxford Bibliographies in Renaissance and Reformation*, Oxford: Oxford UP, 2018, doi:10.1093/obo/9780195399301-0399 (accessed 19 October 2019).

Marschner, Joanna, 'Michael Rysbrack's Sculpture Series for Queen Caroline's Library at St James's Palace', in Diana Dethloff, Tessa Murdoch, Kim Sloan, and Caroline Elam (eds.), *Burning Bright, Essays in Honour of David Bindman*, London: UCL Press, 2015, 27–35.

Marschner, Joanna, David Bindman and Lisa L. Ford, eds., *Enlightened Princesses: Caroline, Augusta, Charlotte, and the Shaping of the Modern World*, London and New Haven: Yale UP, 2017.

Museum Galileo, 'Electrical Machines', https://catalogue.museogalileo.it/indepth/Electrical Machine.html (accessed 19 October 2019).

North, Michael, 'Collecting in the Dutch Colonial Empire, Seventeenth and Eighteenth Centuries', in Maia Wellington Gahtan and Eva-Maria Toelenberg (eds.), *Collecting and Empires, an Historical and Global Perspective*, London and Turnhout: Harvey Miller, Brepols, 2019, 183–195.

Sprunger, Mary S., 'The Limits of Faith in a Maritime Empire: Mennonites, Trade and Politics in the Dutch Golden Age', in William Reger and Tonio Andrade (eds.), *The Limits of Empire: European Imperial Formations in Early Modern World History; Essays in Honor of Geoffrey Parker*, Farnham: Ashgate, 2012, 59–77.

Sutton, Geoffrey V., *Science of a Polite Society: Gender, Culture & the Demonstration of Enlightenment*, Boulder, CO: Westview Press, 1995.

Velema, W.R.E. 'The Dutch, the French and Napoleon: Historiographical Reflections on a Troubled Relationship', in A. de Francesco (ed.), *Da Brumaio ai cento giorni: cultura di governo e dissenso politico nell' Europa di Bonaparte* (Storiografica, no. 11), Milan: Guerini, 2007, 39–51, https://pure.uva.nl/ws/files/1064490/61049_Velema_Wyger_Napoleon.pdf (accessed 19 October 2019).

Zeeuws Archief, Archief van het Natuurkundig Gezelschap, Aanhangsel 1a: *Wetten van het Natuurkundig Genootschap* (Middelburg: Van Osch, 1785).

Zeeuws Archief, Perre, Johan van de, no. 66, *Wetten van het Natuurkundig Genootschap der Dames*, Middelburg: Van Osch, 1785, including the "Aanspraak" (Opening Address).

Zeeuws Archief, Radermacher, Daniel, no. 68, *Stukken betre ende de lessen gegeven door D. Radermacher*.

Zeeuws Archief, *met het door hemzelf ontworpen planetarium, dat hij aan de Dames heeft geschonken*, 1794, 1797.

Zeeuwse Bibliotheek, Kluis 1113 F 16: Catalogus eener uitmuntende verzameling van extra fraaije medische, chirurgische, anatomische, botanische, natuurkundige, geographische, historische, reis, landbeschryvende, poëtische en tooneelkundige Boeken [. . .] door den Heer Mr. Egbert Philip van Visvliet [. . .] 16, 17, 18, 19, 20, 21 en 23 September, en [. . .] 3, 4 en 5 October 1799, Middelburg: W.A. Keel.

Zeeuwse Bibliotheek, Kluis 1113 G 56: Katalogus van eene fraaije verzameling boeken, in onderscheidene talen en wetenschappen [. . .] en eindelijk eenige bijzonderheden en rariteiten, nagelaten door wijlen Jonkvrouwe H. C. Schorer, Middelburg: Van Benthem, 1821.

Zeeuws Archief, Perre, Johan van de, no. 66, Wetten van het Natuurkundig Genootschap der Dames, Middelburg: Van Osch, 1785, including the "Aanspraak" (Opening Address).

Zuidervaart, Huibert Jan, 'Mr. Johan Adriaen van de Perre (1738–1790): Portret van een Zeeuws regent, mecenas en liefhebber van nuttige wetenschappen (Mr. Johan Adriaen van de Perre (1738–1790), Portrait of a Zeeland Regent, Patron and Lover of Useful Sciences)', *Arch. Zeeuwsch Genootsch. Wet.* (1983): 1–169.

Zuidervaart, Huibert Jan and Rob H. Gent, *Between Rhetoric and Reality: Instrumental Practices at the Astronomical Observatory of the Amsterdam Society 'Felix Meritis', 1786–1889*, Hilversum: Uitgeverij Verloren, 2013.

Zuidervaart, Huibert Jan and H. Hoitsma, *Een Zeeuws planetarium uit de tweede helft van de 18e eeuw*, Middelburg: Koninklijk Zeeuwsch Genootschap van Wetenschappen, 1982.

2 Between Art and Science

Portraits of Citrus Fruit for Anna Maria Luisa de' Medici

Irina Schmiedel

The last member of the Medici family, Anna Maria Luisa (1667–1743), is best known for the *Patto di famiglia*: the order that declared that after her death, the vast collections her family built were to remain in Florence. It is items from this collection that, today, form the basis of so many of the city's museums. This case study concentrates on the *Elettrice Palatina*'s personal collecting activities, specifically her commissioning of 'documentary' still life paintings and her interest in botany—a passion she had inherited from her father Cosimo III de' Medici (1642–1723).

One of the most curious items from Anna Maria Luisa's collection is a painting that shows two extraordinary specimens of citrus fruit (Figure 2.1). An atypically pepperoni-shaped specimen is placed next to an especially big and bulbous citron. The fruit differ in size and shape, and in the texture of their skin. One is entirely smooth and the other particularly rough; this contrast catches the beholder's eye and invites speculations and discussions about the portrayed specimens that are lying directly on the stony ground. The bumpy rind suggests that the fruit is a *Citrus limonimedica*, or *Florentine citron*, known for its pleasant fragrance and medicinal properties. Despite all their differences, the leaves, small bud, and delicate flower, positioned close to the large knobby fruit, suggest the specimens are from the *agrumi* family. Flowers and leaves not only facilitate the identification of the species, they allude to the plant itself and, thus, to the origin of the remarkable fruit developing from a neat little flower. An inserted *cartiglio* at the lower right of the canvas completes the composition and provides us with further details about one of the specimens: 'This citron, picked in the garden of [Andrea] Chiavistelli outside the Porta alla Croce, weighed forty-six ounces [1,325 kg]. It was given to Her Serene Highness Electress of the Palatinate in the year 1727'.

This kind of double documentation of plants that includes both a painted and written description is typical of the still life paintings of Bartolomeo Bimbi (1648–1729), who was a specialist in this genre.[1] The inscriptions state the weight and/or other particularities of the specimens, along with their place of origin and the name of the person who delivered the curiosity to the Medicean court. The aforementioned Andrea Chiavistelli was a gentleman gardener; his family owned an estate in the eastern outskirts of Florence. He must have carried out numerous horticultural experiments dedicated to improving plants, as he is also mentioned in another citrus painting Anna Maria Luisa owned.[2] The pictures bear testimony to a long tradition of citriculture fostered by the Medici from the fifteenth century onwards, and to the *Palle* on the Medicean coat of arms, which were often referred to as oranges (*Mala Medica*).[3] Cultivating produce for the Medici was an honour, especially if the specimens were memorialized in paintings collected by members of the Medici court.

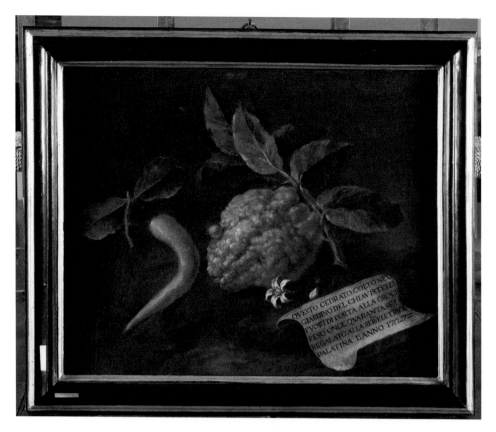

Figure 2.1 Bartolomeo Bimbi, *Portrait of Citrus Fruit*, 1727: oil on canvas. Florence, Museo di Storia Naturale, Sezione Botanica.

Source: Courtesy of Il Sistema Museale dell-Università degli Studi di Firenze.

The Medici villas were all famous for their extensive gardens. Travel notes, botanical treatises, and garden catalogues reveal that throughout the sixteenth and seventeenth centuries, natural scientists visited regularly. Yet, as it seems, it was not just the gardens outside, but it was also the painted natural world on display inside the villas, that attracted visitors—'amateurs and specialists, locals and foreigners'.[4] The Casino della Topaia, close to the bigger and more famous villas of Castello and La Petraia, housed Cosimo III's vast collection of botanical paintings. The Medici estates, the natural gardens and the painted plants complimented each other and represented Tuscany's botanical prosperity in all its splendour.

Commissioning citrus studies aligned Anna Maria Luisa with a family tradition that combined an interest in both art and science. This type of pictorial documentation of nature's curiosities can be traced back to the collections of the cardinal princes Leopoldo (1617–1675) and Giovan Carlo de' Medici (1611–1663), though no other painter seems to have created as many works as Bimbi did for Cosimo III and his descendants.[5] Anna Maria Luisa commissioned many similar paintings by Bimbi and by other artists.[6] She also figured prominently among the subscribers to a substantial

book on plant classification that was published in Florence in 1729 by Pier Antonio Micheli (1679–1737), a Florentine botanist who had been held in high esteem by the then-deceased Grand Duke, Cosimo III.[7] This reveals the *Elettrice Palatina*'s consistency in taste and interest with her forebears' collecting practices.

Through the Medici princess's marriage to the Elector Palatine Johann Wilhelm (1658–1716) in 1691, the *Palle* crossed the Alps, and began to appear on the façades of many buildings in that territory. Anna Maria Luisa brought select pieces from her collection of art with her, as she played an important role in promoting the visual arts, literature, and music at their residence in Düsseldorf and beyond.[8] In a letter from Düsseldorf to her uncle, Cardinal Francesco Maria, written in 1707, she asked him to send her the painting of a miraculous radish and cauliflower. In the letters she exchanged with the cardinal, the princess describes how the copy of the mentioned painting reminded her of a favourite painter, and how—along with some integrated information on 'life, death, and miracles' of the specimens—it would delight the locals and amaze her German gardener to see such large Mediterranean vegetables.[9] Pictures of fantastic produce represented the princess's native Tuscan land as flourishing. These images may have compensated for the fact that she had no offspring and that the Medici family were on the verge of extinction.

In Bimbi's painting of citrus fruit, botanical erudition aligns itself with curiosity and wonder, inviting close examination and discussion. It alludes to the miracle of nature and the cycles of life. The wondrous shapes and weights of the Florentine citrons and the information about who grew the produce was interesting. The picture promoted the gardeners who cared for plants, but it also celebrated the Catholic Medici court as rich and fertile, even though Anna Maria Luisa's death brought an end to the Medici house. Collecting this genre of scientific painting was in line with the *Elettrice Palatina*'s botanical interests and her self-imposed tasks to maintain the family's traditions and to preserve the Medici's *Memoria*.[10]

Notes

1. On Bartolomeo Bimbi, see Irina Schmiedel, *Pompa e intelletto. Formen der Ordnung und Inszenierung botanischen Willens im späten Großherzogtum der Medici* (Berlin/Boston: De Gruyter, 2016), and indicated literature. Much of this case study stems from research in my book, and I will only refer to it when stating single pages and notes.
2. 'Questo cedrato fù donato alla Serenissima Elettrice Palatina il di 19. Ottobre 1723. dal Signore Andrea Chiavistelli, crebbe nel suo giardino di Varlungo, e pesò [libbre] 4 e [once] 11. [1,675 kg]' Stefano Casciu and Chiara Nepi, eds., *Stravaganti e bizzarri. Ortaggi e frutti dipinti da Bartolomeo Bimbi per i Medici*, exh. Cat Poggio a Caino (Florence: Edifir, 2008), 126.
3. Giorgio Galletti, 'Agrumi in casa Medici', *Il giardino delle Esperidi. Gli agrumi nella storia, nella letteratura e nell'arte*, eds. Alessandro Tagliolini and Margherita Azzi Visentini (Florence: Edifir, 1996), 197–215; Giorgio Galletti, 'Le collezioni medicee di agrumi. Un patrimonio culturale vivente', *Giardini d'agrumi*, ed. Alberta Cazzani (Brescia: Grafo, 1999), 55–72; for the Medici coat of arms, see Schmiedel, *Pompa e intelletto*, 54f. (with reference to Julian Kliemann and Petrus Borgaeus, n. 114).
4. Francesco Saverio Baldinucci, *Vite di artisti dei secoli XVII—XVIII*, ed. Anna Matteoli (Rome: De Luca, 1975), 249f. The botanist Pier Antonio Micheli, for instance, turned to Bimbi's paintings as a source and reference.
5. On Leopoldo and Giovan Carlo de' Medici as collectors, see Marco Chiarini (ed.), *Il giardino del granduca. Natura morta nelle collezioni medicee* (Torino: Edizioni Seat, 1997), 104–136, 141–153 (see also the comprehensive chapters on the other members of

the family as collectors of still life painting, e.g. Cosimo III (205–237), Anna Maria Luisa (297–328)).

6. In 1723/24 Bimbi created two similar works depicting citrons for the *Elettrice Palatina*. See: Stefano Casciu (ed.), *La principessa saggia. L'eredità di Anna Maria Luisa de' Medici Elettrice Palatina*, exh. Cat. Florence (Livorno: Sillabe, 2006), 290f., cat. 159; Casciu and Nepi, *Stravaganti e bizzarri*, 126–131, cat. 28–30.
7. Pier Antonio Micheli, *Nova plantarum genera* (Florence: Bernardo Paperini, 1729). The 'Serenissima Anna Maria Aloysia Electrix Palatina Rheni &c. ac Magna Etruriae Princeps', opens the long list of subscribers at the beginning of the publication, and the name reappears on the very elaborate plate no. 32 (*Cyperoides*): 'Ausp.[iciis] Ser. Ann. M. Aloy'.
8. Ulrike Ilg, 'Anna Maria Luisa de' Medici e la corte di Düsseldorf', in Christina Strunck (ed.), *Medici Women as Cultural Mediators (1533–1743)* (Milan: Cinisello Balsamo, 2011), 315–339; Bettina Baumgärtel, 'Johann Wilhelm von der Pfalz und Anna Maria Luisa de' Medici. Sammelleidenschaften und Kulturtransfer zwischen Düsseldorf und Florenz', in Bettina Baumgärtel (ed.), *Himmlisch, herrlich, höfisch*, exh. Cat. Düsseldorf (Leipzig: Seemann, 2008), 12–57.
9. See Chiarini, *Giardino del Granduca*, 300–302.
10. I would like to thank Claire Neesham and Arlene Leis for their close readings and comments on my case study.

3 Anne Vallayer-Coster's *Still Life With Sea Shells and Coral*

Kelsey Brosnan

At the Salon of 1771, her first as an *académicienne*, the painter Anne Vallayer-Coster (1744–1818) exhibited two large paintings: *Still Life with Coral and Sea Shells* (Louvre, Paris) (Plate 1) and its now-lost pendant, *Still Life with a Porcelain Vase, Minerals, and Crystals*.[1] The surviving work is a vivid representation of twenty-four distinct plant and animal species, carefully arranged on a stone ledge. The bold, triumphant composition is dominated by the plumes of a stony white Venus sea fan (*Gorgonia)*, as well as red and purple coral (*Leptogorgia*). To the right, Vallayer-Coster positioned a large bivalve mollusk shell with a blood-orange belly (*Pinna nobilis*), buttressed by a pleated, buttercup-yellow sponge. The artist arranged smaller specimens in the foreground—including, from left to right, a mohawked, peach-colored *Chicoreus ramosus* (of an Indo-West Pacific sea snail); a fluted white clam (*Tridacna squamosa)*; a delicate sprig of lavender-colored coral; a large queen conch with its flesh-pink inner fold exposed (*Strombus giga*); and a marbled, reptilian green turban shell (*Turbo marmoratus*).[2] The painting is a complex formal exercise, juxtaposing colors (lacquered reds, chalky whites, delicate pinks, iridescent purples and blues, and vivid greens), shapes (from tall marine plants to small, tightly-wound shells), and textures (spiky, mossy, smooth, slick). The tight composition of objects serves to highlight those contrasts; yet, the shells also evince a kind of orgiastic intimacy, touching and overlapping.

Vallayer-Coster's attention to the formal qualities of shells and minerals paralleled an evolving attitude towards these specimens in the mid-eighteenth century. During this period, elite French collectors began to collect panoplies of shells and to display their collections in curiosity cabinets, where, they came to be viewed as objects of material and aesthetic value, as well as scientific inquiry. Though they had long been prized for their natural beauty and exotic origins, shells were now also subject to the Enlightenment impulse to label and classify living organisms. French *curieux* came to rely on a range of auction catalogues, illustrated guidebooks, and taxonomic texts to identify and organize the objects in their collections.

In this chapter, I situate Vallayer-Coster's shell paintings within the context of the conchological discourse in the eighteenth century. I analyze several visual and textual sources that espouse the twin systems of meaning that structured French curiosity cabinets and conchological texts: the aesthetic and the scientific, as well as the visual and the haptic. Though seemingly diametrically opposed, the aesthetic/scientific and visual/haptic understandings of shells are intricately connected in practice—that is, Vallayer-Coster's painting practice and the collecting practices of her patrons. In order to elucidate the relationships between these concepts, I place Vallayer-Coster's *nature mortes* in dialogue with contemporary ideas about the decorative and erudite value of

shells, as articulated by art dealer Edme-François Gersaint, shell connoisseur Antoine-Joseph d'Argenville, and Swedish naturalist Carl Linnaeus.

Shells also bore dual gendered inflections in the eighteenth century. Though associated with the primarily masculine space of the natural history cabinet, Vallayer-Coster's precise paintings of natural history specimens are enlivened by a throbbing, embodied sense of femininity—exemplified by the fleshy-pink conch shell in the foreground of Vallayer-Coster's *Still Life with Sea Shells and Coral*.

Vallayer-Coster and the Prince de Conti

Vallayer-Coster, the daughter of a Gobelins goldsmith, was twenty-six years old when she was admitted to the *Académie Royal de Peinture et Sculpture* (French Royal Academy of Painting and Sculpture) as a still-life painter in July 1770.[3] One of only fifteen women permitted to enter the Academy in its history, she was also among the first to be awarded her own studio and residence at the Louvre.[4] Throughout her career, Vallayer-Coster produced dozens of complex and sensual still lifes, and she exhibited regularly at the Parisian Salon until her death in 1818. There, her work elicited ample praise from contemporary critics; she soon earned the patronage of Marie Antoinette and several other prominent members of the French court.

Vallayer-Coster first exhibited *StillLife with Sea Shells and Coral* at her debut salon in 1771. There, the striking formal qualities of Vallayer-Coster's pendants earned significant critical praise.[5] A *Journal encyclopédique* critic complimented the young *académicienne*'s 'vigorous and transparent colour and strong sense of chiaroscuro'.[6] Similarly, the art critic and philosopher Denis Diderot declared the natural history pendants to be masterpieces of the genre—specifically praising the arrangement, as well as the varied color and form, of the 'polished shell bodies'.[7] He compared Vallayer-Coster to the French still-life and genre painter Jean-Baptiste-Siméon Chardin, concluding that her work 'excellent, vigorous, harmonious; it's not Chardin, however, but if it's less good than this master, it's far above what is to be expected of a woman'.[8] Diderot continued, 'It is certain that if all new members made a showing like Mademoiselle Vallayer's, and sustained the same high level of quality there, the Salon would look very different!'[9] Like many *philosophes* of the eighteenth century, Diderot was notoriously conflicted in his attitudes towards professional women artists, yet his criticism of their work—alternately venomous, patronizing, ambivalent, and encouraging—was always informed by his understanding of the inherent inferiority of women.

Despite their relative critical success, Vallayer-Coster's natural history pendants failed to attract an immediate buyer. In December 1775, Vallayer-Coster's paintings appeared in the catalogue of the sale of the collection of Madame du Barry, the last *maîtresse-en-titre* of Louis XV of France.[10] Madame du Barry had been exiled to the Abbey du Pont-aux-Dames after the king's death in 1774; when she left the convent in May 1775, she planned to sell her collection in order to reconcile her debts. Vallayer-Coster likely consigned her paintings to the sale through the prominent art dealer Pierre Rémy, who published the sale catalogue—a clever act of self-promotion, as the sale promised to be a high-profile event, given du Barry's notoriety.[11] The 1775 sale of du Barry's collection never came to fruition, for reasons unknown. Yet it may have been through Rémy that the paintings came to the attention of Louis-François de Bourbon, the sixth Prince de Conti, a cousin of Louis XV, who acquired the two works

for 960 *livres* a month after the cancelled sale.[12] A habitual and omnivorous collector of beautiful things, both natural and artificial, the Prince de Conti was undoubtedly Vallayer-Coster's ideal patron—precisely the sort of elite *curieux* that Vallayer-Coster sought to attract with her *Still life with Seashells and Coral*.

The Prince de Conti's display of Vallayer-Coster's paintings in his Palais du Temple in the Marais, endowed her paintings with additional meaning. It was there that, in the final twenty years of his life, the Prince built an enormous, high-profile collection of natural and exotic curiosities, as well as French, Italian, and Northern paintings.[13] Conti carefully organized his paintings by school and chronologically therein. For example, he displayed his collection of approximately 100 eighteenth-century French paintings in the *les pièces français*, three connected galleries in the Palais de Temple. Yet, Conti did not hang Vallayer-Coster's paintings in those galleries; instead, he chose to install her natural history pendants in his *l'appartement dit le Coquiller*, one of seven apartments dedicated to his botanical, mammalian, and maritime specimens.[14] Conti's decision to display Vallayer-Coster's pendants there was a fascinating juxtaposition of natural artifacts with artistic representation, and a significant departure from his own rigorous system of display, seen elsewhere in the Palais de Temple. This suggests that he viewed her paintings as closely linked with the practice of collecting natural history objects—so much so, that these still-life pendants, painted by a young female *acadèmicienne*, were displayed to their best advantage in dialogue with the very specimens that they represented, in the traditionally masculine space of a natural history cabinet.

The specificity with which Vallayer-Coster painted her subjects suggests that she herself had gained access to shell collections—most likely through a friend of the Vallayer family, artist Madeleine Françoise Basseporte.[15] While the facts of Vallayer-Coster's early training have proved difficult to ascertain, tradition holds that her first drawing teacher was Basseporte, who became the official *dessinatrice* (draftswoman) of the *Jardin des Plantes* in 1742 and godmother to Vallayer-Coster's youngest sister in 1751.[16] Given this intimate family connection to a professional female artist with access to the royal natural history collections, it seems reasonable to assume that Vallayer-Coster first learned to draw from Basseporte, and that her interest in the subject of *naturalia* was also encouraged or facilitated by Basseporte. As Conti's display suggests, Vallayer-Coster's paintings are best understood in the context of the Parisian vogue for collecting shells and minerals.

It may have been through Basseporte that Vallayer-Coster became aware of three major texts, each pivotal in cultivating the luxury market for shells, as well as the aesthetic and scientific discourses surrounding that market. Indeed, the composition of the *Still Life with Seashells and Coral* suggests the artist's fluency in the contemporary conchological discourse surrounding their collecting practices. To further understand the ways in which eighteenth-century practices of collecting shells overlapped with Vallayer-Coster's painting practice, we can turn to three important texts that linked collectors, artists, and natural philosophers across the century: a sale catalogue by the well-known Parisian dealer Edme-François Gersaint (1736), an illustrated collector's guide by connoisseur Antoine-Joseph Dezallier d'Argenville (*L'Histoire naturelle éclaircie dans deux de ses parties principales, la lithologie et la conchyliologie*, 1742), and a book on natural history taxonomy by the Swedish botanist Carl Linnaeus (the tenth edition of *Systema Naturae*, 1758). These innovative texts, accompanied by engraved frontispieces portraying shell specimens which served as important visual

references for the artist, each introduced a new understanding and appreciation of shells—the cultural current to which Vallayer-Coster's paintings directly appealed.

Gersaint's *Catalogue raisonné des coquilles et autres curiosités naturelles*

Vallayer-Coster and her patron, the Prince de Conti, were certainly familiar with the first and most famous sale catalogue dedicated to shells—*marchand-mercier* Edmé-François Gersaint's *Catalogue raisonné des coquilles et autres curiosités naturelles*. This 234-page catalogue accompanied Gersaint's first major sale of marine specimens on 30 January, 1736—considered the first of its kind in Paris.[17] The catalogue listed the shells for sale and concluded with an extensive, descriptive glossary—an early, if imprecise, attempt to taxonomize shells, which despite inaccuracies, continued to serve as an important resource for collectors for several decades.[18] Serious shell collectors, like the Prince de Conti, almost certainly owned a copy.

Importantly, this catalogue was also accompanied by an iconic frontispiece, designed by the academic painter François Boucher (Figure 3.1). This vertical, closely-cropped

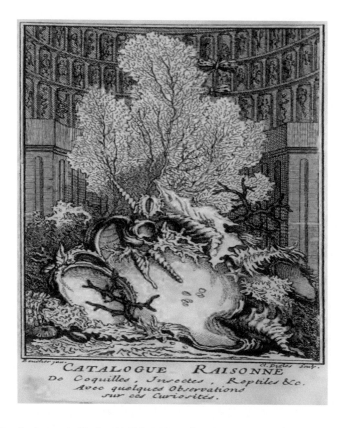

Figure 3.1 Claude-Augustin Duflos (1700–1786) after François Boucher (1703–1770), frontispiece for Edmé-François Gersaint (1694–1750), *Catalogue raisonné des coquilles et autres curiosités naturelles*, 1736.

Source: Getty Research Institute, Los Angeles. Getty Open Access Policy.

image of diverse marine specimens undoubtedly served as an important compositional model for Vallayer-Coster's own *Life with Seashells and Coral*. Boucher and Vallayer-Coster's images both represent similar specimens in an almost identical arrangement, highlighting the organic irregularity of the diversity of textures, sizes, and shapes—though Vallayer-Coster's painting benefits from the addition of dazzling color and painterly facture.

Vallayer-Coster's vivid, painterly interpretation of Boucher's design would have been instantly recognizable to erudite shell collectors; indeed, the engraved image had become critically linked to the market for rare and expensive natural curiosities in the intervening decades. After the sale of 1736, Gersaint would re-use Boucher's frontispiece for at least two subsequent auctions.[19] Even after Gersaint's death, Boucher's frontispiece was re-appropriated by other dealers' auction catalogues associated with prominent natural history collections.[20] Just as Boucher's design conferred legitimacy to shell auction catalogues long after its initial engraving in 1736, Vallayer-Coster deliberately evoked Boucher's frontispiece, and the flourishing shell economy heralded by his design, in order to engage with the same elite circle of connoisseurs who collected both art and shells, like the Prince de Conti.

Vallayer-Coster may have come into contact with Boucher's own extensive collection of over 2,500 shells, which undoubtedly served as a reference for his frontispiece design. As Jessica Priebe has shown, Boucher often experimented with creating sculptural *mélanges*—three-dimensional arrangements of diverse shells and coral specimens, mounted on a flat base, in compositions recalling his Gersaint frontispiece.[21] Boucher's notorious shell collection was placed on display in his studio-apartment at the Louvre during his lifetime, and sold with great fanfare in February 1771, soon after Vallayer-Coster's acceptance into the Academy in July 1770, and just before the debut of her *Morceaux d'Histoire Naturelle* at the Salon of 1771.

D'Argenville's *La Conchyliologie*

Vallayer-Coster's shell paintings were informed by another popular conchological text, which highlights the parallels between collecting and painting shells. Dezallier d'Argenville's *L'Histoire naturelle éclaircie dans deux de ses parties principales, la lithologie et la conchyliologie*, first published in 1742, with subsequent editions appearing in 1757, and 1780, was also accompanied by a frontispiece designed by Boucher (Figure 3.2).[22] For this publication, Boucher's whimsical frontispiece abandons commercial sobriety and scientific specificity in favor of visual pleasure, as merman and mermaid emerge from the sea with armfuls of shells and coral, mined from distant waters as indicated by the palm trees, elephant, and camel on shore.[23] Boucher's frontispiece lent artistic value to d'Argenville's text while emphasizing the erotic and exotic qualities of the shells described and illustrated therein.

In several ways, Vallayer-Coster's painting seems to be an articulation of d'Argenville's approach. In addition to identifying hundreds of different types of shells, d'Argenville text draws several explicit comparisons between techniques of painting and collecting shells, blurring the lines between artist and collector. First, d'Argenville advocated for the artistic reproduction of the shells as a means of understanding them, writing, 'What better way is there to understand the differences between shells than by drawing them from nature? The slightest fold, the fine details of the shape, the contour, the mouth: nothing escapes the draftsman, and nothing can better reveal

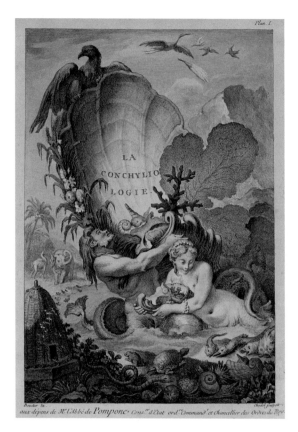

Figure 3.2 François Boucher (1703–1770), frontispiece for Antoine-Joseph d'Argenville (1680–1765), *La Conchyliologie*, second edition, 1757, American Museum of Natural History Research Library. Image no. 1001014254_1, AMNH Library.

their true nature'.[24] Vallayer-Coster seems to answer d'Argenville's call to '*dessiner d'après nature*', drawing and painting her own marine specimens with anatomical and textural precision.

D'Argenville also dedicated one chapter to the preparation of shells for display through a series of material interventions—for example, cleaning them with alcohol, and applying a coat of egg-white wash in order to enhance the natural shine and color of the shell.[25] This procedure clearly mimics the contemporary practice of varnishing oil paintings, in order to saturate and preserve oil paint pigment—a technique also employed by Vallayer-Coster in producing her shell paintings.

Vallayer-Coster's *Still Life with Sea Shells and Coral* also seems to embrace d'Argenville's hybrid strategy for displaying natural specimens in private collections. D'Argenville distinguishes between two different types of collectors, first identified by Gersaint in 1736: Naturalists and the Curious. In d'Argenville's words, 'Naturalists arrange shells according to classes and families . . . the Curious, by contrast, who value pleasing the eye above all else, sacrifice methodological order for the sake of varied arrangements, in respect of the form of shells as well as their colors'.[26] D'Argenville

advised his readers, however, to *combine* these strategies: to group shells by family, but to organize them within that group according to one's own personal taste, in order to achieve a pleasing juxtaposition of color, pattern, and texture.[27] Vallayer-Coster's painting embodies this advice, with specimens deliberately arranged to emphasize the contrasts between their surfaces.

Indeed, much like a still-life artist arranging the composition of a painting, d'Argenville's ideal collector employed several formal strategies in arranging his or her collection, pursuing symmetry, balance and order, as well as diversity in color and texture.[28] While collectors sought to better understand the origin and classification of the specimens in their collections, ultimately this ideal collector sought to integrate diverse curiosities into harmonious displays, creating visual pleasure and intellectual stimulation through the juxtaposition of various types of objects—and deriving sensual pleasure from the visual and textural contrasts between them.[29] Vallayer-Coster's painting seems to appeal directly to this modern sensibility, combining the aesthetic and scientific impulses of a shell collector in arranging her own composition.

Linnaeus's *Systema Naturae*

The exuberant composition and the rich juxtaposition of colors and textures of Vallayer-Coster's painting were generally informed by the texts and images produced by Gersaint and d'Argenville. However, her depiction of the fleshy pink conch shell in the foreground of her painting finds resonance in yet another text: Linnaeus's *Systema Naturae*, the first text to systematically employ a systematic, binomial nomenclature for the natural world. Vallayer-Coster most certainly encountered Linnaeus's work through her drawing teacher Basseporte—who first met Linnaeus during his visit to the *Jardin du Roi* in Paris in 1737 and thereafter maintained a regular correspondence with the Swedish naturalist.[30]

The tenth edition of Linnaeus's *Systema Naturae*, published in 1758, was the first version of Linnaeus's text to include shelled creatures, possibly a response to the enormous amateur interest in shells and the influx of available specimens on the European market.[31] Much like d'Argenville's *La Conchyliologie*, Linnaeus's system for identifying shells was a superficial one, based primarily on the shape, color, pattern, and texture of the shell—a formal methodology closely associated with the close observation required of a still-life artist. However, because *Systema Naturae* lacked extensive illustration, Linnaeus frequently cited d'Argenville's *Conchyliogie* throughout the text, applying his own Latin terminology to the specimens represented in d'Argenville's engravings. It must have been common, therefore, for shell collectors to own copies, and to make comparative use, of both authors' texts.

Linnaeus's binomial terminology gained acceptance among European collectors only gradually, due in part to the controversy surrounding his use of sexual metaphor. For example, Linnaeus described one bivalve shell, the *Venus Diones*, as reminiscent of female genitalia. He proceeded to label various parts of this shell with the Latin terms for the pubic mound, vulva, labia, hymen, and anus—despite the fact that those terms bear no connection to the true biological function of the shell.[32] This sexual lexicon was considered inappropriate by many European conchologists, namely Emanuel Da Costa, the author of *Elements of Conchology* (1776), who objected to what he called 'unjustifiable and very indecent terms' because he believed they were inappropriate for women to know and use.[33] In *Elements of Conchology*, Da Costa advocated

for more 'chaste' alternatives, in order to 'render descriptions proper, intelligible, and decent; by which the science may become useful, easy, and adapted to all capacities, and to both sexes'.[34] Da Costa seems to acknowledge the increasing numbers of female shell collectors while also revealing contemporary concerns about women gaining and employing scientific knowledge.

Despite Da Costa's insistence that women avoid using scientific terms for female genitalia when describing parts of shells, Vallayer-Coster's fleshy pink conch shell in *Still Life with Seashells and Coral* invokes this part of the female body, indicating that she was most likely familiar with Linnaeus's lexicon of conchology, and that she interpreted his theory with paint: slick splotches of yellow and peach-colored pigment on the outer contour of the conch shell, with a deeper pigment in the interior fold.

Vallayer-Coster's pink conch shell in the foreground of *Still Life with Seashells and Coral* underscores the morphological similarities between the conch and the vulva. Her formal association of shells with the female sex also resonated with a larger cultural system of meaning in which the shell is symbolic of female sexuality. This symbolism has ancient roots: the Ancient Greek word *kteis* referred to both the shell and the vagina, and it was from a shell that Venus, the Goddess of Love and Fertility (and the unofficial patron saint of the rococo), is thought to have emerged at birth.[35] Although most ancient Greek and Roman textual sources fail to mention a shell in their description of Venus's birth, the shell has long been a part of the visual iconography of the scene—the fresco in Pompeii's House of Venus (ca. first century AD), Sandro Botticelli's *Birth of Venus* (1486), and François Boucher's *Triumph of Venus* (1740) are among the most iconic examples. In these varied representations of the *Venus Anadyomene*, the shell is symbolically and morphologically genital, a kind of disembodied womb that cradles the goddess of love and fertility.[36] These associations of the shell with Venus, the patron saint of beauty, love, and fertility, persisted well into the eighteenth century, where it continued to function as a symbol and a conduit of sensual delight.

The Sensual Appeal of Vallayer-Coster's Shells

Even within the primarily masculine contexts of the eighteenth-century natural history text and the curiosity cabinet, the shell never shed its association with the erotic and the exotic. During this period, however, the shell also became the subject of a kind of epistemological vision—a means of understanding, and asserting dominance over nature, in addition to being a luxurious object of a French collector's lust. As Danielle Bleichermar has argued, the curiosity cabinet, sale catalogue, and natural history book functioned as overlapping 'spaces for learning to see in expert ways, and for articulating notions of order and taste'.[37] To this, I would add that these spaces also advocated, and satiated the desire for, a particular kind of touch—a way of manipulating shells in order to evaluate, clean, enhance, and arrange them. Chevalier Louis de Jaucourt articulated this dual compulsion in his entry on 'Painting' in the 1765 edition of *Encyclopédie*, in which he directly compares the sensual pleasures of both shells and *trompe l'oeil* painting: 'It is easy to see how the imitations of painting can move us when one stops to think how a shell . . . excites restless passions and arouses the desire to *see* them and to *possess* them. A grand passion ignited by a small object is an ordinary event [emphasis mine]'.[38]

Still Life with Sea Shells and Coral directly appeals to both the visual and the haptic desires described by Jaucourt. Vallayer-Coster seems to have luxuriated in the representation of a diversity of textures, describing natural surfaces with an almost fetishistic zeal. Vallayer-Coster achieved this vivid illusionism in part through the use of a textured ground: a warm gray layer of primer, mixed with some sort of gritty, ground pebble (perhaps ground shells?) applied to the canvas.[39] With this technique, the artist used the medium to *embody* the shells that she sought to represent. Vallayer-Coster also employed a unique combination of painting techniques in order to evoke a diversity of surfaces—for example, wet-on-wet paint for the soft, smooth, pink interior of the conch, and a thick dry impasto to articulate the veiny, craggy surface of the Venus sea fan coral.[40] This textural specificity suggests that Vallayer-Coster had direct access to shells—perhaps through her connection to the aforementioned Basseporte—and that the subjects were seen *and* felt by the artist herself.

Vallayer-Coster's critics responded directly to the haptic quality of her work; as one author wrote in *Lettres de M. Raphael le jeune* (1771):

> You honor the Salon with the perfection with which you have rendered the different subjects that you paint. . . . Your [*Still Life with Seashells and Coral*] and [*Attributes of Painting and Sculpture*] are surprising, for the magic that you have given your imitations; one can imagine touching the objects with a finger and with the eye, as if they were real and protruding [from the canvas].[41]

The surfaces embedded in Vallayer-Coster's painting seem to have seduced this author, inviting him to touch the painted specimens and to derive pleasure from those tactile sensations.[42]

The artist and critic's mutual emphasis on the tactility of shells in her paintings parallels a shift in the eighteenth-century discourse on the very nature of sensory experience. Condillac's *Treatise of Sensations* of 1754, for example, maintained that it was only through touching other objects that a subject could understand the boundaries of his or her own body, and comprehend the solidity of seen objects.[43] Similarly, for Diderot, suggests in *D'Alembert's Dream* (1769) that knowledge was obtained primarily through our tactile interactions with the material world, in collaboration with vision and the other senses.[44] Indeed, for artists and collectors, shells provided both sensual pleasure and intellectual stimulation, offering their beholders tangible evidence of the physical world beyond the walls of the collector's cabinet.

These *philosophes* purportedly address a 'universal' human condition of sensation; yet eighteenth-century understandings of sensory experience were undeniably gendered. Men and women were believed to experience sights, sounds, tastes, and smells differently, much as they were understood to think, write, and paint in different ways. Informing Diderot's *Sur les femmes* (1772), for example, is the belief that while men use their senses to support rational and moral thought, women are often overwhelmed or led astray by physical sensations—because they are 'less in control of their senses than we [men] are'.[45] Physician Pierre Roussel concurred, writing in his *Système physique et moral de la femme* (1775) of a woman's 'difficulty in shedding the tyranny of her sensations that constantly binds her to the immediate causes which produced them'[46]—that is, to the material stimuli that provoked various physical sensations. Given this understanding, it is perhaps unsurprising that the major theme that unites

the eighteenth-century criticism of Vallayer-Coster's paintings is that of their sensory appeal.

During her career, Vallayer-Coster would go on to depict shells for at least two other paintings.[47] Though painted at irregular intervals, her repetition of the subject attests to its richness, and its enduring appeal, and its enduring appeal to both the artist and her patrons. Indeed, there was much complexity embedded in the representation of the shell, which was associated with both the masculine *cabinet* and the female body. Vallayer-Coster's shells, in particular, evoked the collecting practices of the Prince de Conti, the material economy stimulated by dealers like Gersaint, and the conchological discourses advanced by D'Argenville and Linnaeus. While simultaneously inhabiting these related spheres of meaning, Vallayer-Coster's shells provoked both visual and haptic desires, connoting the erotic and the exotic—informed by the taste for sensual and material pleasure within these overlapping artistic and scientific spheres in the middle decades of the eighteenth century.

Notes

1. Marianne Roland Michael, *Anne Vallayer-Coster (1744–1818)* (Paris: Compotir International du Livre, 1970); Roland Michel, 'Vallayer in Her Time', in Eik Khang and Roland Michel (eds.), *Anne Vallayer-Coster* (Dallas: Dallas Museum of Art, 2002), 13–38.
2. These specimens were identified in Madeleine Pinault-Sørensen and Marie-Catherine Sahut, '*Panaches de mer, Lithophytes et Coquilles* (1769), un tableau d'histoire naturelle par Anne Vallayer-Coster', *Revue du Louvre: La Revue des Musées de France* XLVII (February 1998): 49–50. The Latin binomial descriptions used there and here are derived from Linnaeus's *Systema Naturae*, described next.
3. 'Anne Vallayer-Coster' is the artist's hyphenated married name, which she used to sign her paintings after 1781 (a practice also employed by married women artists like Adélaïde Labille-Guiard and Élisabeth Vigée Le Brun). Prior to 1781, she went by 'Anne Vallayer'. To avoid confusion, I use 'Vallayer-Coster' consistently throughout this chapter.
4. Christian Michel, *The Académie Royale de Peinture et de Sculpture: The Birth of the French School, 1648–1793* (Los Angeles: Getty Publications, 2018), xvi; Hannah Williams, *Académie Royale: A History in Portraits* (London: Ashgate, 2015).
5. These pendants were listed in the catalogue of the 1771 Salon under the joint title *Deux Tableaux représentans divers Morceaux d'Histoire Naturelle*. 'Salon de 1771', 27, no. 145; Roland Michel, *Vallayer-Coster*, 1970, no. 260, figure 181; Jacques Foucart et al., *Musée du Louvre, Nouvelles acquisitions du department des peintre, 1991–1995* (Paris: Réunion des musées nationaux, 1996), 147; Kahng and Roland Michel, *Vallayer-Coster*, 197–198, no. 11, pl. 4. The two paintings appeared once more together in a 1777 sale, after which *Still Life with a Porcelain Vase, Minerals, and Crystals* was lost. This second painting is known to us only through a loose sketch by Gabriel Saint-Aubin, who drew both paintings on the blank page of the 1777 auction catalogue. Rémy, *Catalogue d'une riche collection de tableaux des maîtres les plus celebres des trois écoles . . . qui composent le Cabinet de feu son Altesse Sérenissime Monseigneur le Prince de Conti, prince du sang et Grand Prieur de France* (Paris: Chez Muzier, 1777); Gabriel Saint-Aubin's illustration was published in Bailey, 'A Still-Life Painter and Her Patrons', 64, figure 4.
6. *Journal encyclopédique* 8, no. 1 (November 1771): 94–95. Translated from the original French.
7. Diderot, *Salon of 1771*, in *Oeuvres complètes de Diderot*, 512 no. 154.
8. Diderot, *Salon of 1771*, in *Oeuvres complètes de Diderot*, 512 no. 154. On the question of the authenticity of this text, see Else Marie Bukdahl, *Diderot, est-il l'auteur du 'Salon' de 1771?* (Copenhagen: Ejnar Muksgaard, 1966).
9. Denis Diderot, *Salon of 1771* in Jean Seznec and Jean Adhémar (eds.), *Denis Diderot: Les Salons*, 4 vols. (Paris: Hermann, 1957–1967), 4, 202.

10. Bailey, 'A Still-Life Painter and Her Patrons', 61.

11. *Catalogue de Tableaux Précieux . . . d'un Cabinet distingue* [Madame du Barry], Paris, 22 December 1775.

12. Foucart et al., *Musée du Louvre, Nouvelles acquisitions du department des peintre, 1991–1995*, 146.

13. Frédéric Chappey, *Les trésors des princes de Bourbon Conti* (L'Isle Adam: Musée d'Art et d'Histoire Louis Senlecq, 2000), 38.

14. Bailey, 'A Still-Life Painter and Her Patrons', 63; Chappey, *Les tresors des princes de Bourbon Conti*, 42, 163.

15. Londa Schiebinger, *The Mind Has No Sex? Women in the Origins of Modern Science* (Cambridge: Harvard UP 1991), 28.

16. Roland Michel, *Vallayer-Coster*, 1970, 15.

17. The bibliography on early eighteenth-century dealers includes Carolyn Sargentson, *Merchants and Luxury Markets: The Marchands Merciers of Eighteenth-Century Paris* (Oxford: Oxford UP, 1996); Andrew McClellan, 'Watteau's Dealer: Gersaint and the Marketing of Art in Eighteenth-Century Paris', *Art Bulletin* 78, no. 3 (1996): 439–453; Guillaume Glorieux, *À l'enseigne de Gersaint. Edme-François Gersaint, marchand d'art sur le pont Notre-Dame (1694–1750)* (Seyssel: Éditions Champ Vallon, 2002).

18. Krzysztof Pomian, *Collectors and Curiosities: Paris and Venice, 1500–1800*, trans. Elizabeth Wiles-Portier (Cambridge, MA: Polity Press, 1990), 122.

19. Edme-François Gersaint, *Catalogue d'une collection considérable de curiosites de différent genres* (Paris: Chez Prault Fils, 1737) and *Catalogue raisonné d'une collection considérable de diverses Curiosités en tous . . .* (Paris: J. Barois, 1744).

20. Notably, Pierre Rémy (who would organize the estate sales of Madame du Barry in 1775 and the Prince du Conti in 1777) used Boucher's frontispiece for the 1766 sales of Madame Dubois-Jourdain and Dezallier d'Argenville, whose *Conchyliologie* is discussed next. Pierre Rémy, *Catalogue raisonné des curiosités composoient le Cabinet de feu Mme. Dubois-Jourdain* (Paris: Chez Didot l'aîné, 1766); Pierre Rémy, *Catalogue raisonné . . . de feu Monsieur Dezallier d' Argenville* (Paris: Chez Didot l'aîné, 1766).

21. None of Boucher's three-dimensional *mélanges* survive, but at least twenty-nine of them were sold at his 1771 post-mortem sale. Boucher's collection and collecting practices are described at length in Jessica S. Priebe, 'Conchyliologie to Conchyliomanie: The Cabinet of François Boucher, 1703–1770' (Phd Diss., U of Sydney, 2011).

22. Antoine-Joseph d'Argenville, *L'Histoire naturelle éclaircie dans deux de ses parties principales, la Lithologie et la Conchyliologie* (Paris: Chez de Bure, 1742). Subsequent editions in 1757, and 1780 appeared under the slightly altered titles.

23. According to Priebe. D'Argenville was the first to use the term 'Conchyliologie' in 1742. Priebe, 'Conchyliologie to Conchyliomanie', 76.

24. D'Argenville, *L'Histoire naturelle éclaircie dans deux de ses parties principales, la Lithologie et la Conchyliologie*, 116–117. Translated from the original French.

25. Bettina Dietz, 'Mobile Objects: The Space of Shells in Eighteenth-Century France', *British Society for the History of Science* 39, no. 3 (2006): 373.

26. Dietz, 'Mobile Objects', 50. Translated from the original French.

27. Later editions of d'Argenville's text included several engravings that exemplify this approach: each plate represents a certain 'family', but shells are therein arranged in rhythmic geometric and floral patterns. The potential artistic value of these illustrations is demonstrated by the example of a 1757 edition, now in the collection of the American Museum of Natural History in New York. The eighteenth-century owner of the volume, Christien Guillaume de Lamoignon de Malesherbes (1721–1794), hired an artist to hand-paint Boucher's frontispiece and engravings of shells in the appendix of his 1757 edition, rendering the book a luxury collector's item and putting the author's ideas about color and display into practice. Kristel Smentek, *Rococo Exotic: French Mounted Porcelains and the Allure of the East* (New York: The Frick Collection 2007), 21.

28. Guichard, 'Taste Communities', 535.

29. Smentek, *Rococo Exotic*, 21.

30. Basseporte seems to have made a strong impression on the Swedish naturalist; in a 1749 letter to French naturalist Bernard de Jussieu, Linnaeus wrote, 'Send my thoughts of friendship to Mademoiselle Basseporte; I dream of her, and if I become widowed, she would be my second wife—whether she wanted to or not, willing or unwilling'. Translated from the original French. We, like Linnaeus, are unsure whether Basseporte reciprocated his affections. Linnaeus to Benard de Jussieu, 1749, published in Pierre Flourens, *Receuil des éloges historiques lus dans les séances publiques de l'Académie des Sciences* (Paris: Garnier, 1857), 78.

31. Carl Linnaeus, *Systema Naturae*, Tenth Edition (Stockholm: Laurentii Salvii, 1758). See Beth Fowkes Tobin, *The Duchess's Shells: Natural History Collecting in the Age of Cook's Voyages* (New Haven: Yale UP, 2014), 101–102.

32. Tobin, *The Duchess's Shells*, 104. See also Stephen Jay Gould, 'The Clam Stripped Bare by Her Naturalists, Even', in *Leonardo's Mountain of Clams and the Diet of Worms* (New York: Harmony Books, 1998), 77–98. Linnaeus employed sexual terms in order to describe relationships and anatomical parts of plants, as well. See Schiebinger, *Nature's Body*, 29.

33. Tobin, *The Duchess's Shells*, 104.

34. The British Duchess of Portland, Margaret Cavendish Bentinck (1715–1785) or the French Madame Blondel d'Azincourt, for example, were well-known for their natural history cabinets. Tobin, *The Duchess's Shells*, 104.

35. See Elizabeth G. Gitter, 'The Power of Women's Hair in the Victorian Imagination', *PMLA: Publications of the Modern Language Association of America* 99, no. 5 (October 1984): 934, for a discussion of the layers of meaning that connect the shell or comb and the female pudenda.

36. Imperial Roman IV fresco in the House of Venus at Pompeii, ca. 1st century AD, Museo Archeologico Nazionale di Napoli; Botticelli, *Birth of Venus,* 1486, Uffizi, Florence; Boucher, *Triumph of Venus,* 1740, Nationalmuseum, Stockholm. See also Odilon Redon's *Birth of Venus,* in which Venus is embedded, fetus-like, in a peach-colored conch shell. 1912, Museum of Modern Art, New York.

37. Danielle Bleichermar, 'Learning to Look: Visual Expertise Across Art and Science in Eighteenth-Century France', *Eighteenth-Century Studies* 46, no. 1 (2012): 85–111.

38. Chevalier de Jaucourt Louis, 'Painting', in Nelly S. Hoyt and Thomas Cassirer (trans.), *The Encyclopedia of Diderot & d'Alembert Collaborative Translation Project* (Ann Arbor: Michigan Publishing, U of Michigan Library, 2003).

39. The artist may have created this textured ground herself, although there is evidence that at least at the beginning of the nineteenth century, pre-prepared, textured canvases were available for purchase; these were employed, for example, by Jacques Louis David. See David's *Portrait of the Sisters Zenaide and Charlotte Bonaparte* of 1821, now at the J. Paul Getty Museum.

40. Barry, 'The Painting Technique of Anne Vallayer-Coster', 95–114.

41. *Lettres de M. Raphael le jeune, Eleve des Ecoles gratuites de Dessin, Neveu de feu M. Raphael, Peintre de l'Académie de St Luc, A un de ses Amis, Architecte à Rome: sur les Peintures, Sculptures & Gravures qui sont exposées cette année au Louvre*, 1771, 18. Translated from the original French.

42. 'Tu peins deux arts que tu cheris / Et la musique et la peinture / Bas-Relief, case, fruits, legumes et lapin /Sous tes magiques doigts tout a son train certain', M. Guichard, 'Académie royal de Peinture & Sculpture', *Mercure de France* (September 1770): 174; M. Guichard, 'Exposition des peintures, sculptures, gravures de MM. de l'Académie royale', *Mercure de France* (October 1771): 193 (Collection Deloynes, no. 138, 482–483), translated in Michel, 'Vallayer-Coster in Her Time', 17.

43. Condillac, *Treatise on Sensation*, 1754; see also John C. O'Neal, 'The Sensationist Aesthetics of the French Enlightenment', *L'Esprit créatur* 28, no. 4 (1988): 95–106.

44. Diderot, *D'Alembert's Dream*, 1769, circulated in *Correspondance Litteraire*, ed. Grimm, 1782 and published in *Mémoires, correspondance et ouvrages inédits de Diderot* (Paris: Paulin, 1831).

45. Diderot, 'Sur les femmes', *Correspondance littéraire* (1772), published in Diderot, *Ouevres*, ed. André Billy (Paris: Gallimard, 1951), 949–958. See the analysis of this essay

in Lieselotte Steinbrugge, *The Moral Sex: Woman's Nature in the French Enlightenment* (London: Oxford UP, 1995), especially 44–47.

46. Pierre Roussel, *Système physique et moral de la femme, ou Tableau Philosophique de la Condition, de l'État organique, de Tempérament, des Moeurs, & des Functions propres au Sexe* (Paris: Chez Vincent, 1775), 30: '*que la difficulté de se dérober à la tyrannie des sensations, l'attachant continuelemnt aux sauces immédiates qui les produisent*'. Discussed in Anne C. Vila, 'Sex and Sensibility: Pierre Roussel's *Système physique et moral de la femme*', *Representations* no. 52 (1995): 76–93; Steinbrugge, *The Moral Sex*, 37.

47. Five years after the debut of *Still Life with Seashells and Coral* at the Salon of 1771, Vallayer-Coster submitted *Still Life with Porcelain Vase, Marine Plants, Shells and Various Mineralogical Specimens* to the Salon of 1777, and *Still Life with Minerals* to the Salon of 1789 (both now in private collections).

Bibliography

Bailey, Colin B., 'Conventions of the Eighteenth-Century Cabinet de tableaux: Blondel d'Azincourt's La première idée de la curiosité', *The Art Bulletin* 69, no. 3 (September 1987): 436.

Bauchaumont, L.P. *Mémoires secrets pour server à l'histoire de la Republique des Lettres en France*, Londres: J. Adamson, 1780.

Bicart-See, Lise, 'Antoine-Joseph Dezallier d'Argenville: Supplement of Newly Identified Drawings from His Collection', *Master Drawings* 45, no. 1: French Collectors Before 1800 (Spring 2007): 55–66.

Bleichermar, Danielle, 'Learning to Look: Visual Expertise Across Art and Science in Eighteenth-Century France', *Eighteenth-Century Studies* 46, no. 1 (2012): 85–111.

Bukdahl, E.M., *Diderot, est-il l'auteur du 'Salon' de 1771?* Copenhagen: Ejnar Muksgaard, 1966.

Chappey, Frédéric. *Les trésors des princes de Bourbon Conti*, L'Isle Adam: Musée d'Art et d'Histoire Louis Senlecq, 2000, 38.

Chavignerie, Emile Bellier de la, *Dictionnaire général des artistes de l'école française depuis l'origine des arts du dessin jusqu'à nos jours: Architectes, peintres, sculpteurs, graveurs et lithographes*, Paris: Renouard, 1882–85; reprinted Paris, 1997.

Classen, Constance, 'Feminine Tactics: Crafting an Alternative Aesthetics in the Eighteenth and Nineteenth Centuries', in Constance Classen (ed.), *The Book of Touch*, Oxford: Berg Publishers, 2005, 228–239.

Condillac, Étienne Bonnot de, *Traité des sensations*, London and Paris: De Bure aîné, 1754.

Dezallier d'Argenville, Antoine-Joseph, *L'Histoire naturelle éclaircie dans deux de ses parties principales, la Lithologie et la Conchyliologie*, Paris, 1742.

Diderot, Denis, *Lettres sur les sourds et les muets: à l'usage de ceux qui entendent & qui parlent*, Paris: Jean-Baptiste-Claude II Bauche, 1751.

Diderot, Denis, *Mémoires, correspondance et ouvrages inédits de Diderot*, 4 vols., Paris: Paulin, 1831.

Diderot, Denis, *Ouevres*, ed. André Billy, Paris: Gallimard, 1951.

Diderot, Denis, *Oeuvres complètes de Diderot: rev. sur les éd. originales comprenant ce qui a été publié à diverses époques et les ms. inédits conservés à la Bibliothèque de l'Ermitage*, ed. J. Assézat, Krauss: Lichtenstein, 1875–1877.

Diderot, Denis, *Salons*, eds. Jean Seznec and Jean Adhémar, 4 vols., Oxford: Clarendon Press, 1957–1967.

Dietz, Bettina, 'Mobile Objects: The Space of Shells in Eighteenth-Century France', *British Society for the History of Science* 39, no. 3 (2006): 363–382.

Dietz, Bettina and Thomas Nutz, 'Collections Curieuses: The Aesthetics of Curiosity and Elite Lifestyle in Eighteenth-Century Paris', *Eighteenth-Century Life* 29, no. 3 (2005): 48.

Edwards, Jo Lynn, 'The Conti Sales of 1777 and 1779 and Their Impact on the Parisian Art Market', *Studies in the Eighteenth-Century Culture* 39 (2010): 77–110.

Encyclopédie ou Dictionnaire raisonné des sciences, des arts et des métiers, vol. 12, Paris, 1765.

Flourens, Pierre, *Receuil des éloges historiques lus dans les séances publiques de l'Académie des Sciences*, Paris: Garnier, 1857.

Foucart, Jacques et al., *Musée du Louvre, Nouvelles acquisitions du department des peintre, 1991–1995*, Paris: Réunion des musées nationaux, 1996.

The Detroit Institute of Art, *French Painting 1774–1830: The Age of Revolution*, Detroit: The Detroit Institute of Arts and New York: Metropolitan Museum of Art, 1975.

Gargam, Adeline, 'Savoirs mondains, saviors savants: les femmes et leurs cabinets de curiosités au siècle des Lumieres', *Genres & Histoire* (2009), http://genrehistoire.revues.org/899.

Gitter, Elizabeth G., 'The Power of Women's Hair in the Victorian Imagination', *PMLA: Publications of the Modern Language Association of America* 99, no. 5 (October 1984): 936–954.

Glorieux, Guillaume, *À l'enseigne de Gersaint. Edme-François Gersaint, marchand d'art sur le pont Notre-Dame (1694–1750)*, Seyssel: Éditions Champ Vallon, 2002.

Gould, Stephen Jay, 'The Clam Stripped Bare by Her Naturalists, Even', in *Leonardo's Mountain of Clams and the Diet of Worms*, New York: Harmony Books, 1998, 77–98.

Gruyer, Francois-Anatole, *Les portraits de Carmontelle*, Chantilly: Musée Conde, 1902.

Guichard, M., 'Académie royal de Peinture & Sculpture', *Mercure de France* (September 1770): 174–176.

Journal encyclopédique 8, no. 1 (November 1771).

Linnaeus, Carl, *Systema Naturae*, Tenth Edition, Stockholm: Laurentii Salvii, 1758.

MacGregor, Arthur, *Curiosity and Enlightenment: Collectors and Collections from the Sixteenth to the Nineteenth Century*, New Haven and London: Yale UP, 2007.

McClellan, Andrew, 'Watteau's Dealer: Gersaint and the Marketing of Art in Eighteenth-Century Paris', *Art Bulletin* 78, no. 3 (1996): 439–453.

Mercure de France (October 1771).

National Museum of Women in the Arts, *Royalists to Romantics: Women Artists from the Louvre, Versailles, and Other French National Collection*, Washington, DC: National Museum of Women in the Arts with Scala Arts Publishers Inc., 2012.

Oeuvres complètes de Diderot: rev. sur les éd. originales comprenant ce qui a été publié à diverses époques et les ms. inédits conservés à la Bibliothèque de l'Ermitage, ed. Jules Assézat, vol. 11, Lichtenstein: Nendeln, 1875–1877.

O'Neal, John C., 'The Sensationist Aesthetics of the French Enlightenment', *L'Esprit créatur* 28, no. 4 (1988): 95–106.

Pinault-Sørensen, Madeleine and Marie-Catherine Sahut, '*Panaches de mer, Lithophytes et Coquilles* (1769), un tableau d'histoire naturelle par Anne Vallayer-Coster', *Revue du Louvre: La Revue des Musées de France* XLVII (February 1998): 49–50.

Pomian, Krzysztof, *Collectors and Curiosities: Paris and Venice, 1500–1800*, trans. Elizabeth Wiles-Portier, Cambridge, MA: Polity Press, 1990, 122.

Priebe, Jessica S., 'Conchyliologie to Conchyliomanie: The Cabinet of François Boucher, 1703–1770', PhD Diss., U of Sydney, 2011.

Rémy, Pierre, *Catalogue de Tableaux Précieux . . . d'un Cabinet distingue* [Madame du Barry], Paris, 22 December 1775.

Rémy, Pierre, *Catalogue d'une riche collection de tableaux des maîtres les plus celebres des trois écoles . . . qui composent le cabinet de feu son Altesse Sérénissime Monseigneur le Prince de Conti, prince du sang et Grand Prieur de France*, Paris, 1777.

Rémy, Pierre, *Catalogue raisonné . . . de feu Monsieur Dezallier d' Argenville*, Paris, 1766.

Rémy, Pierre, *Catalogue raisonné des curiosités qui composoient le cabinet de feu Mme. Dubois-Jourdain*, Paris, 1766.

Rémy, Pierre, *Catalogue raisonné . . . le cabinet de feu M. Boucher, premier peintre du Roi*, Paris, 1771.

Roussel, Pierre, *Système physique et moral de la femme, ou Tableau Philosophique de la Condition, de l'État organique, de Tempérament, des Moeurs, & des Fonctions propres au Sexe*, Paris: Chez Vincent, 1775.

Sargentson, Carolyn, *Merchants and Luxury Markets: The Marchands Merciers of Eighteenth-Century Paris*, Oxford: Oxford UP, 1996.

Schiebinger, Londa, *The Mind Has No Sex? Women in the Origins of Modern Science*, Cambridge: Harvard UP, 1991.

Smentek, Kristel, *Rococo Exotic: French Mounted Porcelains and the Allure of the East*, New York: The Frick Collection, 2007.

Tobin, Beth Fowkes, *The Duchess's Shells: Natural History Collecting in the Age of Cook's Voyages*, New Haven: Yale UP, 2014.

Woodbridge, John D., *Revolt in Pre-Revolutionary France: The Prince de Conti's Conspiracy Against Louis XV, 1755–1757*, Baltimore and London: Johns Hopkins UP, 1995.

Part II
Travel, Borders, and Networks

4 Maria Sibylla Merian

A Woman's Pioneering Work in Entomology

Katharina Schmidt-Loske

Introduction

Maria Sibylla (1647–1717) grew up surrounded by painted flower bouquets; the magnificent displays of the beautiful and diverse flowers immersed in shadow or light inspired her to cultivate her own artistic talents. In the workshop of her stepfather, Jacob Marrel, art dealer and painter of flowers and still lifes, she learned how to draw, paint and engrave copper plates. During that time, she also met her future husband, the copper engraver and architectural painter, Johann Andreas Graff. Since Marrel travelled often to Utrecht and other workplaces, his apprentice Abraham Mignon took on the task of teaching Maria Sibylla to draw and paint. But even in his absence, Maria Sibylla referred to the art works Marrel produced in various mediums as templates for her own early works, such as flower drawings, pen on vellum illustrations of spring flowers (tulips, crocuses, etc.), watercolours and gouache colours. In his drawings, Marrel occasionally depicted colourful butterflies, bugs and dragonflies, but insects were usually an afterthought to his meticulous botanical renderings. In fact, he did not focus his attention on those details, and sometimes the specimens appear to be anatomically incorrect.[1] In contrast, Maria Sibylla's early works featured insects as a central motif. The little insects, such as larvae and caterpillars, that are at first coincidentally carried into the workshop alongside the freshly cut flowers, would become the focus of her art. Although seen by most people as vermin that destroy the beautiful flowers and leaves, Maria Sibylla was intrigued with learning their life cycles and patterns of metamorphosis. This would become the centre of Maria Sibylla's art production.

This chapter focuses on the career achievements and networks of the artist and copper plate engraver, Maria Sibylla Merian.[2] During her lifetime, she experienced some of her major achievements as an entrepreneur, and the impact of her endeavours on subsequent generations is far more profound than she could have imagined. More recently, researchers are examining Merian's printed works and drawings that illustrate different plant species and the development stages of insects, as well as her collection of Surinamese insects.[3] Therefore, this chapter will examine her life, work and contributions to the art and science of collecting and natural history. I will also introduce a recently found letter, dating 1724, that includes a list of thirty-seven painted works by Maria Sibylla listed for sale.[4] Ultimately, I suggest how this document will open up new avenues for research.

Maria Sibylla's Early Life and Work

Maria Sibylla was born in Frankfurt am Main, Germany towards the end of the Thirty Years' War. She was from a family of artists, and her older half-brother, Matthäus, most likely illustrated 'Schwedische Friedensmahl', an etching that was part of the sixth volume of the German history journal *Theatrum Europaeum*.[5] Her father, Matthäus Merian the elder, was a copper plate engraver and book publisher, as well as the joint founder of the aforementioned historical book series on the history of the German-speaking lands. Maria Sibylla's father died when she was three years old. As an upcoming artist and copper plate engraver, however, she took pride in and gained confidence from the fact that she was the daughter of Matthäus Merian the elder.[6]

From 1668, Maria Sibylla, her husband Johann Andreas Graff, and their daughter, Johanna Helena, lived in the inspiring and creative environment of the imperial town of Nuremberg. During this time, she taught female apprentices in drawing and painting. Nuremberg and the surrounding area provided a beautiful environment for her and her apprentices, as the over 400 gardens created a sensual experience of colours and scents. In Nuremberg, Graff owned a house below the Imperial castle at the Old Milk-market that he had inherited from his parents.[7] As a copperplate engraver and painter himself, Johann Andreas Graff supported his wife in many ways. He helped her with the work for her copper plate engraving and published her book projects.[8] While initially their collaborative relationship proved fruitful, Maria Sibylla eventually separated herself from her husband to work with her daughters.

Turning now to Maria Sibylla's early work, I will examine the relationship between accurate still lifes and artistic metaphor present in her early floral motifs, as well as the commitment to the German vernacular in the textual interpretations. Maria Sibylla's early work shows that she was interested in depicting minute details of natural history and combining these with metaphor. Maria Sibylla brought the exactness of botanical illustration a step further by combining visual representation with textual interpretation. This gives her work both a scientific and poetical character. For example, on one of her watercolour illustrations for Christoph Arnold, a scholar and poet from Nuremberg, she writes, 'Deß Menschen leben ist gleich einer Blum' [Human life is like a flower], the text and motif in the album *Amicorum* are chosen very carefully (Figure 4.1).[9] Arnold had an interest in natural history and was one of the first members of the Nürnberger Dichtervereinigung und Sprachgesellschaft Pegnesischer Blumenorden (Pegnitz Flower Society), and he also sought to promote the German language.[10] Arnold's invitation introduced Maria Sibylla to a literary and scientific community.

The floral symbol Arnold chose for the society was a wild rose. The flower that Maria Sibylla painted for him in 1675, however, is not a wild rose, but a cultivated rose breed, a so-called Batavian Rose (*Rosa* x. *centifolia*). The Batavian Rose is an ornamental and crop plant, bred in the late sixteenth century in the Netherlands as a complex hybrid; it was valued by gardeners for its full blossoms and strong scent.[11] Maria Sibylla's choice to depict the flower in its perfect form conveyed the excellence of Dutch botany. In the picture, the rose is illustrated as a bud, as well as in full bloom. The botanist and art historian Sam Segal claims, 'When accompanying the text, the rose is transformed into a type of *vanitas* motif, prompting the viewer to draw parallels between the passing of time, as seen in the plant kingdom and the youth (bud) and adulthood (bloom) of human life'.[12] Furthermore, the beauty of the idealised flower, in contrast to its sharp thorns, is a reminder of life's pleasures and pains. This illustration

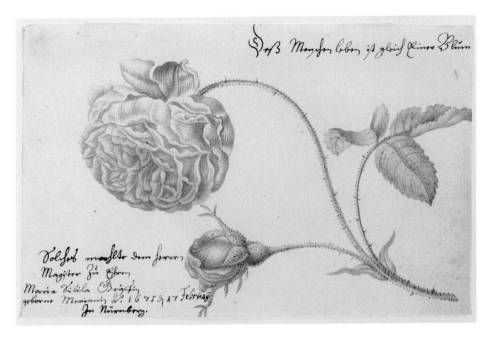

Figure 4.1 Maria Sibylla Merian. Album sheet with a Batavian rose. Bamberg, Staatsbibliothek, Inv. Nr. 1 R 90.

Source: Photograph by Gerald Raab.

thus exemplifies Maria Sibylla's decision to work both scientifically with the specimens available to her and to interpret those specimens in new and symbolic ways. Maria Sibylla would dedicate herself to producing images of flowers and insects for the rest of her life, and that same year she began producing copper engraved images for her first book.

Flower baskets and wreaths featuring a variety of flowers are among the popular motifs in Maria's first and now very rare book, *Blumenbuch (Book of Flowers)*. Over the span of five years, Maria Sibylla published three volumes of the book, each volume beautifully illustrated with twelve plates. The title of these volumes were written in Latin: *Florum Fasciculus Primus* (1675), *Florum Fasciculus Alter, Zweyter Blumen-Theil* (1677), and *Florum Fasciculus Tertius, Dritter Blumen Theil* (1680). The book was unbound, so the plates resembled a collection rather than a book, and they could have been viewed in a variety of ways, such as passed around at social gatherings or hung on walls. The work was well received, and a second edition, including all three volumes, was published in 1680 under the new title, *Neues Blumenbuch* (New Book of Flowers), also illustrated with plates by Maria Sibylla. Like the first, this edition was unbound, but it now included a preface and a newly-designed title page. For the second edition, she completely erased the Latin words in the aforementioned titles of each volume in exchange for German language titles, suggesting that, like Arnold, she too promoted her native language and wanted her work to be accessible to those unable to read Latin, including women.

The targeted audience of her *Neues Blumenbuch* were nature and art-loving read-ers, as she writes in her preface.[13] Among these readers were women artists. For exam-ple, in 1680, the engraver Susanna Maria von Sandrart framed a portrait of the French female philosophy student at Padua university, Gabrielle Charlotte Patin, with a flower wreath that clearly resembles the one that Maria Sibylla used for the front page of her *Neues Blumenbuch*.[14] Gabrielle Charlotte Patin was well educated, had learned Latin and hoped to achieve a doctorate at the University of Padua. The framed portrait was part of a congratulations poem from friends at Nuremberg.[15] Other women artists incorporated the same flower wreath depicting an imperial crown at the top and a Christmas rose at the bottom into their work, such as needlework artist Margaretha Wurfbain, who chose it for her silk art in an autograph book she made dating 1703, and the engraver and embroiderer Amalia Beer, born Pachelbel, who included it in a plate for her model book of knitting patterns, dated around 1720.[16] While Maria Sib-ylla's work appealed to both men and women, she shows herself to be an inspiration for other female artists, a pattern we see continue in her later work with her daughter.

A Collection of Natural History Specimens

The practice of collecting was central to Maria Sibylla's continued research. At this point, evidence reveals how Maria Sibylla's artistic practice continued to adopt sci-entific aspects through the practice of collecting. Collecting makes a difference in her artistic practice because she incorporates a kind of amateur scientific taxonomy, infused with aesthetic appreciation, in her recording of insects. In Frankfurt and Nuremberg—both workplaces of Maria Sibylla's younger years—wealthy patricians and merchants started forming exquisite private cabinets containing art, *naturalia* and/ or historical objects. Within these private cabinets were specialised *naturalia* cabinets, in which objects of animate or inanimate nature were gathered and preserved.[17] Boxes and crates containing dried butterflies and bugs were carefully organized and labelled. Yet, these collections completely overlooked the evidence of the metamorphosis of the insects because most life cycles were yet unknown, and caterpillars were generally dif-ficult to preserve. Maria Sibylla, however, dedicated her time to building a collection of caterpillars and to the procurement of adequate ecologically-related plants.

 With the help of her husband, Maria Sibylla eagerly and patiently garnered cater-pillars and appropriate plant fodder. Many of the caterpillars were difficult to breed. She notes, 'when they first hatch out of eggs, caterpillars are minute, and it is hard to see them, but they grow in size daily [. . .] and molt, sometimes molting three to four times [. . .] and some of them changing their colour in the process'.[18] Maria Sibylla illustrated the caterpillars she collected in an astonishingly precise manner. Often, she drew the pupae of the butterfly, or in the case of moths, the proper cocoon. She added to the illustrations many inconspicuous details, like small faecal excretions or parts of *exuvia*. She also illustrated flies and braconid wasps.

 Maria Sibylla's drawings precisely document her observations of her collected spe-cies. Located in St. Petersburg is a collection of watercolour drawings, often referred to by scholars as her 'studybook' or 'work journal'.[19] With this grouping, she includes small pieces of vellum that record information on the origins, the different stages of metamorphosis, the sustenance, appearance and sometimes the behaviour of the insects. Unlike botanical specimens, butterflies had few colloquial names in the sev-enteenth century. Because of the lack of precise identification, Maria Sibylla used a

somewhat poetical descriptive language to capture her wonder at the various insects she encountered. According to appearances, she calls the pupae 'Dattelkerne' (date kernels), the caterpillar 'Wurm' (worm), the butterfly 'Sommervögelein' (summer bird), and the moth 'Mottenvögelein' (moth bird). Another collection of watercolours by her at St. Petersburg contain works of bigger size.[20] Her compositions present the viewer with a suitable fodder plant in the centre of the page. The different developmental stages of the insects are arranged below and above the plant. Sometimes, she draws the fodder plants and flowers growing directly from the ground. Alternatively, at times only a flower stem is drawn on a plain background. In these illustrations, the artist zooms into the plant, highlighting the individual blossoms and leaves and thereby rendering the picture more suitable for study.

These studies form the foundation of Maria Sibylla's later published works,[21] especially her German book, *Der Raupen wunderbare Verwandelung und sonderbare Blumen-Nahrung* [The wondrous transformation of caterpillars and peculiar plant-nourishment], published in 1679.[22] For this publication, she produced 50 copperplate engravings, available in coloured or uncoloured copies. Importantly, Maria Sibylla also wrote the German-language text accompanying each plate of insect metamorphosis and description of its plant. The names of the plants are listed in a register in Latin, as well as in German. The written text is a mixture of technical terms and poetic descriptions that can be understood by Latin-speaking naturalists and German-speaking amateurs. Similar to the preface of her previous books, this book features a preface with a poem of praise written by the aforementioned Christoph Arnold. The quotation praises numerous men of science and Arnold also includes Maria Sibylla's name. It reads: 'It is surprising that women too dare to venture on topics that were reserved for a group of scholars. That what Gessner, Wotton, Penn and Mufet published; that, England, was repeated by my Germany with wise women's hands'.[23] Arnold's inclusion of Maria Sibylla into this international list of natural philosophers expresses the scientific recognition her work gained and her desires to promote both her culture and her gender. Not only does this quote reference the role of Germany and the German language in making this happen, but women, 'wise women', play a key role in this foray into the academic world of natural science. The small quarto work was published by her husband, J. A. Graff, in Nuremberg, and David Funken in Leipzig (Figure 4.2).

In *Der Raupen*, Maria Sibylla describes how she painted the caterpillars she observed at different stages of metamorphosis and with their appropriate fodder plant.:

> These specimens I have painted in many different stages, some half-changed, others wholly changed in skin and hair. And then I have painted them in their final stage. I have further planned to draw the fodder plants alongside the specimen. These, I have found and assigned to the correct species with the help of my dear husband.[24]

She also observes that all caterpillars come from eggs that have resulted from the mating of two butterflies and calls these eggs 'Hirsekörnlein' (millets). She describes the interesting metamorphosis of the caterpillars and takes note of their change in size and shape, as well as their moulting. One can clearly see that she is often surprised by the difference in appearance of the stages and the final form of the insect. Her practice of observation and documentation included both plants and insects, and further

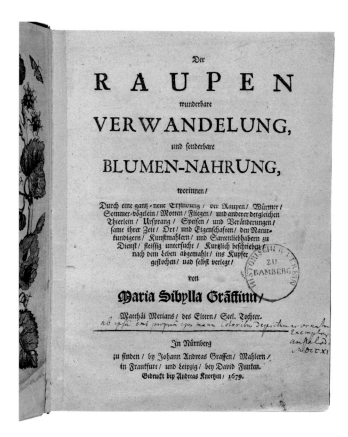

Figure 4.2 Title page of *Der Raupen wunderbare Verwandelung und sonderbare Blumennah-rung*, 1679. Bamberg, Staatsbibliothek, HV.Rar.103–1_TB.

Source: Photograph by Gerald Raab.

emphasizes the scientific methodology behind her illustrations. A second volume was published in 1683 in German.[25] Der Raupen introduced the viewer to an intricate microcosm of insect life that was unique for its time.

At the early stages of her research, however, Maria Sibylla seems unaware of the process of parasitism. While she documents the death of some of her caterpillars and pupae and draws the parasites, she does not make the connection that these parasites have led to the death of the insects she records. Only in one of her later works does she finally demonstrate that she is aware of that connection by illustrating the larvae of a wasp hatching from the body of a dead caterpillar. She notes, 'They were build-ing cocoons, from which—after a while—black wasps hatched'.[26] This work seems to refer back to Maria Sibylla's earlier metaphorical work, in which human life is compared to the life cycle of the flower, but this time, it is the insect that represents the cycle of life and death. Additionally, this sequence illustrates the development of her scientific knowledge, as it is represented in her drawings.

Maria Sibylla in Frisia and Amsterdam

In 1686, Maria Sibylla, as well as her two daughters and her mother, joined the pietistic Labadist Society in castle Waltha at Wieuwerd in Dutch Frisia. The castle belonged to the van Aerssen sisters, Maria, Lucia, and Anna, whose brother Cornelius van Aerrsen van Sommelsdijck served as first Governor of the Dutch colony of Surinam. This was the beginning of a series of radical changes in Maria Sibylla's life that would place her on the path to her work in Surinam. The Labadists were a pietist community, named after their founder Jean de Labadie. Johann Andreas Graff, Maria Sibylla's husband, was not allowed to join the society and returned to Nuremberg. Repeatedly, he tried to contact his wife and daughters, but he was turned away. The printed *Blumen-bücher*, as well as the *Raupenbücher* and the copper plates, were brought along into castle Waltha, so from that point on, they were inaccessible for him.[27] The Labadists taught the doctrine of the separation of the believer from the incredulous, and to this is attributed the communal mode of life they adopted. Therefore, Maria Sibylla separated from her husband by converting to the Labadists, and with this move, gained total control over her published works.

This period was also significant for Maria Sibylla, as it was at castle Waltha that she was exposed to a fantastic collection of specimens of natural history that came directly from the Dutch colony of Surinam, including a collection of 'large and brilliantly coloured butterflies'. The direct links being established between collecting and colonial expansion are of note here. Maria Sibylla's engagement with these collections illustrates a history of women artists' contributions to global exchange in the Dutch empire. Additionally, in the Frisian marshes she drew special butterfly species that can be seen around softwoods, like aspens or willows.[28] She illustrated water frogs spawning in drainage channels and studied their metamorphosis. At the Labadist community, Maria Sibylla learned about a daughter colony founded in Surinam by the aforementioned Cornelis von Sommelsdyk in 1683. Many years later, in April 1700, Maria Sibylla travelled to the plantation.[29] It is unclear whether she already had this in mind during her stay at castle Waltha, but the awareness gained during her stay there most likely began the process of her work's move toward Surinamese subjects.

When her mother died in 1690 in Frisia, Maria Sibylla and her daughters decided to settle in Amsterdam. Alongside the *Studienbuch*, there are only twelve letters, written by Maria Sibylla herself, that give some information about her personal life. Adding to that, there are six Dutch and French letters that she sent to other people. These six letters were written for her by other people capable of speaking French/Dutch.[30] The earliest of the letters written by her in Amsterdam is dated 1697 and is addressed to her acquaintance, Clara Regina Scheurl von Defersdorff, born Imhoff, in Nuremberg.[31] Maria Sibylla signed this letter with her maiden name, which she began using again after moving to Amsterdam. By writing to Scheurl von Defersdorff, she implied that she would like to re-establish some of her previous personal contacts.

Little is known about Maria Sibylla's first years in Amsterdam. Seemingly, her family absorbed her attention during that time. In her continued separation from her husband, the bonds with her daughters remained strong. Her oldest daughter, Johanna Helena, shared her mother's artistic inclinations and became a flower painter herself. In 1692, Johanna married the merchant Jacob Henrik Herolt in Amsterdam.[32] The two of them lived 'in de nieuwe Vyselstraet, aen de Oost-zyde van de Heere gragt, beneffens de Bakker die op de hoek woont' (in the new Vyselstreet on the east side of

the Heere Gracht next to the bakery on the corner).[33] Johanna Helena taught young women in drawing and painting, just like her mother.[34] Additionally, Jacob Hendrik seems to have sold coloured artworks painted by Maria Sibylla.[35] During this time, Maria Sibylla and her family began to strategically carve a new place for themselves in artistic and scientific circles around the city.

There are two joint pieces of art by Maria Sibylla and her daughter. They are both signed with 'Maria S. Merian' and 'Johanna Helena Herolt'.[36] Since both of these works are not dated, they must have been painted after 1692, since her daughter is already using the last name Herolt. Both mother and daughter had to earn their livings by painting as much as possible and selling their paintings. Maria Sibylla's act of teaching her daughter to paint and painting pieces alongside her indicates a working relationship between the two women. This relationship, when considered alongside the ways that Maria Sibylla's illustrations were constructed for study and discussion, continues to develop our understanding of Maria Sibylla as invested in the educational and potentially collaborative nature of art and collecting.

From Amsterdam to Surinam

When she moved to Amsterdam in 1691, Maria Sibylla regularly visited collections to continue carrying out her research, and she was especially interested in the beautiful dried insects that she found in the collections of the mayor of Amsterdam, the head of the east Indian society, Dr. Nicolas Witsen, and of Jonas Witsen, the secretary of the town, because they contained exotic insects unfamiliar to her.[37] These exotic collections that were garnered in foreign lands were testament to the spread of Dutch global power though colonization and to the removal of specimens and objects from their native lands for the purpose of bolstering European scientific and cultural prestige. However, for a researcher who was interested in the life and development of insects, these collections were incomplete, as they only included the final form of the insect, the *imago*.

The collections Maria Sibylla visited were of great inspiration to her and mark the beginning of a new phase of collecting and travel in her career. Today, scientific insect collections always have a label for the appropriate insect that features the provenance, collector, date, and scientific name. This practice differs from that of the beginning of the eighteenth century, when Maria Sibylla had access to the previously-mentioned insect collections. From the owners of these collections and other collectors (Levinus Vincent, Fredericus Ruysch), she was told that many of these butterflies and moths were from Surinam. However, she lacked information on their developmental stages and their fodder plants. Therefore, it is through these collections of insects that she planned and organized her own journey to Surinam to carry out the research herself and learn about the metamorphosis processes of the Surinamese insects.[38]

In a letter to Johann Georg Volkamer the younger, living in Nuremberg, Maria Sibylla writes about her journey to Surinam.[39] From 1699 to 1701, she spent time in the South American country observing the local insects, documenting their metamorphoses and, later on, publishing her research. Clear evidence for her journey can be found in a passenger list from a ship called *De Freede* that brought her back from Surinam to the Netherlands.[40] In past research on her journey, it was unclear which daughter travelled with her. Finally, however, Johann Le Fort, envoy at the Russian Tsar court

in St. Petersburg, confirmed that it was Dorothea Maria, the younger daughter, who travelled with her mother.[41] Thus, while her older daughter painted alongside Merian, her younger daughter travelled by her side to collect specimens for that artwork.

How Maria Sibylla managed to finance her expensive journey to Surinam is still unclear to scholars and is, therefore, an area ripe for research. It is clear that she took on some contract work, such as the colouration of the publication, *D'Amboinsche Rariteitkamer*, for Everhardus Rumphius, in order to finance the printing of the culmination of her studies, *Metamorphosis Insectorum Surinamensium*.[42] She also painted and sold many paintings of flowers and native butterflies and moths, many of which can now be found in different museums and research institutes (among them the British Museum, Windsor Castle, and the Academy of Science in St. Petersburg). Over the course of the last several years, a few of her works have famously been sold to the United States and Saudi Arabia.[43] As such, her work continues to thrive in both artistic and scientific collections at important institutions around the world.

During her years in Surinam, Maria Sibylla collected insects and plants and translated them onto a two-dimensional surface through her illustrations; today, these works are found in important private and institutional collections throughout the world. This demonstrates a unique trajectory of Maria Sibylla's work—its translation from nature, to personal collection, to artistic rendering, to, eventually, prominent public and private collections. Her works become the collectibles, rather than the natural objects she initially collected.

Provenance Research—Surinam

The art-historic discipline of provenance is especially interesting when researching the Merian family and the works of art they produced, as it reveals the breath of Maria Sibylla's work. In my recent archival research, I have discovered a previously unpublished, anonymous, hand-written list in German (Figure 4.3–4.3a). The list was attached to a French letter of the previously-mentioned Johann Le Fort, dated 14 October 1724 from St. Petersburg to his superior Elector Friedrich August I, who also reigned as August II, King of Poland. In this letter, it is mentioned that Dorothea Maria Gsell (younger daughter of Maria Sibylla) offered original works of her mother's, including thirty-seven pieces, as well as paintings by her husband Georg Gsell, painter and art consulter of Tsar Peter the Great. Sadly, no information is given on the prices of the paintings. Among the titles of the paintings are motifs of flowers and fruit arrangements, as well as drawings of animals that are connected to Maria Sibylla's journey to Surinam.

Some of Maria Sibylla's watercolour drawings listed in the letter correspond to those held today in public institutions. For example, *Capellen androstina, or Tutsan, eight snails and a beetle*, is a watercolour drawing depicting a St. John's wort plant surrounded by snails and a musk beetle. This drawing is signed 'M: Sybilla Merian', and is located in the Fitzwilliam Museum in Cambridge.[44] Other individual titles on this document, however, are not known from Maria Sibylla's works and can, therefore, be considered to be lost: for example, *A crocodile, high one Fuß two Zoll, broad one Fuß eight Zoll, all surrounded by a wreath of all kinds of flowers*, or the picture of a hedgehog. This list illustrates what Maria Sibylla produced and what people were interested in collecting.

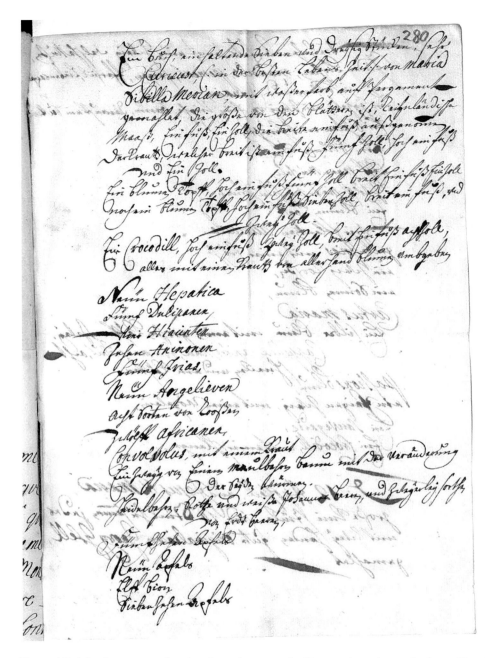

Figure 4.3–4.3a Anonymous hand-written document in German (recto), attached to a French
letter from Johann Le Fort, dated 14.10.1724 from St. Petersburg. Sächsi-
sches Staatsarchiv, Hauptstaatsarchiv Dresden, 10026 Geheimes Kabinett,
Loc. 3315/3, Bl. 278r., Bl. 278v.

Figure 4.3– 4.3a (Continued)

 Although both daughters were also artists, this document specifies that the works are all produced by Maria Sibylla herself; the authorship of even unsigned drawings, therefore, can now be determined. The critical information this document supplies leaves much room for research and could be central to future research projects focusing on Maria Sibylla Merian, including the movements of cultural property and how her work was positioned in international art markets after her death.

Cross-Pollination of Art and Science in Maria Sibylla's Floral Still Lifes

Taking on the role of natural scientist, documenting and analysing insects, Maria Sibylla illustrated caterpillars and butterflies for her books using copperplate engraving. However, during that time, she also continued to paint decorative floral still lifes— unfortunately, some of these are lost today. One of her earlier works, dated around 1675–1680, shows a 'Chinese vase', manufactured in Hanau, filled with beautiful flowers, standing on a table. With the help of UV scanning, researchers have found a signature on the side of the table, 'Mar: Sibi. Graeffin: geb: Merianin inv: fecit', that clearly belongs to Maria Sibylla.[45] In one of her latest floral still lifes, which shows a collection of flowers in a vase, standing on a marble cornice, a signature of hers can also be seen: 'Maria Sibilla Merian f. a Ams. D. 1714'.[46] These works are watercolour and body colour drawings on vellum, and they demonstrate her breadth of technical painting skill. Another very unique work is a signed still life featuring different types of crawling, jumping, and flying insects, including a moth, a spider, a cricket, and a fly that interact with different pieces of fresh fruits that have just been picked and placed on a stone table. This piece is unique because the background is black, which is atypical for her works, and to this day, no other example produced by her survives (plate 2).[47] She appears to have worked entirely as an engraver and watercolourist as there are no existing oil paintings known to have been painted by her.

Metamorphosis Insectorum Surinamensium and Maria Sibylla Merian's Influence Today

Biologists and artists around the world are interested in the illustrations (etchings and copper plate engravings) that Maria Sibylla published in her different works, as well as in her research on the metamorphosis of insects. Due to her stunningly beautiful illustrations, Maria Sibylla stands out from the other insect researchers of her time, who also published books on the topic. The idea of using the fodder plants as a motif for her illustrations alongside the insects was innovative when depicting natural history.

Maria Sibylla's main work, *Metamorphosis Insectorum Surinamensium*, was published in 1705 in Amsterdam by the artist herself, and it was available in both Dutch and Latin versions. The work consisted of 60 copper plate engravings that prominently feature almost 90 observations on the development of insects, especially that of butterflies.[48] After Maria Sibylla's death in 1717, Dorothea Maria published a third volume of her *Raupenbuch* in the Dutch language.[49] The substantial body of work Maria Sibylla created during her lifetime is testament to her dedication to the field of natural history and to her success as an artist.

Parts of Maria Sibylla's collection of insects from Surinam also remain intact today. Some of the specimens from that collection were used as a base for a natural history museum, the Landesmuseum Wiesbaden.[50] This historic material is of immense value, as some of these specimens were used for the original allocation of an individual to a taxon, the example for a certain species and the species name. As such, this collection is of special importance to taxonomists. Maria Sibylla's collection of insects was integrated into Johann Isaak von Gerning's collection of insects in Frankfurt. This collection is housed in the Landesmuseum Wiesbaden. In the eighteenth century, entomologist Eugen Johann Christoph Esper worked with the collection, as labels on the collection boxes show.

In 2013, artist Joos van de Plas published a very interesting research project on the *Metamorphosis Insectorum Surinamensium*.[51] On the front page of her book, Maria Sibylla mentions that she has documented the development of the insects 'as close to life and life size, drawn and written'.[52] Joos van de Plas came to the amazing conclusion of putting the dried specimen on the illustrations in the book. In order to show that the insects were drawn in life size, she took pictures of the dead specimen in Johann Isaak von Gerning's collection and used an image program to make accurate copies of the insects. She then went on to overlay the images of the specimen onto Maria Sibylla's works and, thereby, proved that the insects in Gerning's collection were most likely the actual models that Maria Sibylla used for her copper plate engravings. The biologist Michael Ohl recently found out that the eighteenth-century bee specialist, Johann Ludwig Christ, in his published *Naturgeschichte, Klassifikation und Nomenclatur der Insekten von Bienen, Wespen und Ameisengeschlecht* from 1791, described a South American sand wasp (*Vespa nasuta*) that was most likely the exact same specimen that Maria Sibylla Merian had collected in Surinam. Christ had visited Gerning's collection for his description of bees and wasps. The dried specimen of the sand wasp is relevant today as the reference specimen for the *Rubrica nasuta* species.[53] Maria Sibylla Merian's works have had a long-lasting impact on generations of not only biologists, but also artists and other professions.

Entomological research became the centre of Maria Sibylla's life. The collecting and observation of insects was the catalyst behind her art and placed her work in dialogue with larger movements of her time to promote northern European culture, the vernacular, and the global spread of Dutch power. Her works still inspire many research projects and will continue to do so, as many of the mysteries of her life have not yet been examined.

Notes

1. See Badische Landesbibliothek Karlsruhe, multivolume work—4 (1670) [Vol. 4]—GLA Karlsruhe Hfk-Hs Nr. 269, p. 20 (No 23), p. 27 (no 30), here, his artistic license is evident in the way he mixes up the patterns of butterflies; the designs on the upper part of the wings are portrayed on the lower side of the wing. Rijksmuseum Amsterdam, album with studies on tulips—Object number: RP-T-1950–266–41–1: The butterfly illustration shows a design of the lower side of the fore- and hindwing on the upper part of the wings. Object number: RP-T-1950-266-2-1, the designs of the upper side of the forewing is portrayed on the lower side of the forewing.
2. In my chapter, I frequently refer to Maria Sibylla Merian as Maria Sibylla. That is because she is married to Johann Andreas Graff, but since she is famous as Maria Sibylla Merian, it would be irritating to constantly refer to her as M. S. Graff. When I use her maiden name, I do so because she explicitly referred to herself as M. S. Merian and not Graff.
3. Kate Heard, *Maria Merian's Butterflies* (London: The Royal Collection Trust, 2016).
4. Sächsisches Staatsarchiv, Hauptstaatsarchiv Dresden, 10026 Geheimes Kabinett, Loc. 03315/03.
5. Matthaeus Merian d. J. (attributed): 'Schwedisches Friedensmahl 1649', etching and copper plate engraving, in: *Theatrum Europaeum*, Vol. 6, Frankfurt 1652, after p. 938.
6. M.S. Graff, *Der Raupen wunderbare Verwandelung und sonderbare Blumennahrung* (Nürnberg: Johann Andreas Graff; Frankfurt a. M. and Leipzig: David Funken, 1679), Titelseite.
7. Margot Lölhöffel, 'Johann Andreas Graff (1636–1701)—Annäherung an einen Vergessenen', in *Johann Andreas Graff, Pionier Nürnberger Stadtansichten*, hg. vom Förderverein Kunsthistorisches (Nürnberg: Museum Nürnberg, 2017), 43.

8. E.g. three engraving fascicles with Latin titles (1675, 1677, 1680), equipped with twelve copper plates, were published in 1680 as a new edition titled *Neues Blumenbuch*. The foreword to the nature- and art-loving reader that was anonymously published have recently been discovered as probably written by the German Christoph Arnold. It is a poem and describes the illustration of the flower-rich springtime as a competition, an artistic challenge with the clear goal to precisely illustrate the wonders of nature. The one who seeks and overcomes this challenge will benefit by being satisfied.

9. Album sheet with a Batavian rose. Watercolour of Maria Sibylla Merian. Bamberg, Staatsbibliothek, Inv. Nr. 1 R 90.

10. Doris Gerst (hrsg.), *Georg Philipp Harsdörfer und die Künste* (Nürnberg: Fachverlag Hans Carl GmbH, 2005), 132.

11. Heinz-Dieter Krausch, *Kaiserkron und Päonien rot . . . Von der Entdeckung und Einführung unserer Gartenblumen.* (München: DTV, 2007), 400 f.

12. Sam Segal died in June 2018. For further information on the album amicorum, see Werner Taegert, 'Des Menschen Leben ist gleich einer Blum' Stammbuch-Aquarell der Maria Sibylla Merian', in Kurt Wettengl (hrsg.), *Maria Sibylla Merian. Künstlerin und Naturforscherin (1647–1717)* (Ostfildern: Hatje, 1997), 88–93, translated from the German.

13. Maria Sibylla Graff, Neues Blumenbuch, Vorrede an den Natur- und Kunst-liebenden Leser, 1680.

14. This was researched and shown in 2017 in an exhibition in the town library of Nuremberg by Christine Sauer. She revealed this by presenting Wurfbain's silk art and Sandrart's etching; Grebe and Sauer catalogue Nürnberg, 54–55.

15. Grebe and Sauer catalogue, 55.

16. Grebe and Sauer catalogue, 14, 61. For Maria Sibylla's friendships with other women collectors, see: Joy Kearney, Agnes Block, a Collector of Plants and Curiosities in the Dutch Golden Age, and her Friendship with Maria Sibylla Merian, Natural History Illustrator, in Susan Bracken, Adriana Turpin and Andrea M. Gáldy, *Women Patrons and Collectors* (New Castel upon Tyne: Cambridge Publishers, 2012).

17. Kurt Wettengl, *Von der Naturgeschichte zur Naturwissenschaft. Maria Sibylla Merian und die Frankfurter Naturalienkabinette des 18. Jahrhunderts*, Kleine Senckenberg-Reihe 46 (Frankfurt a. M.: Taschenkatalog, 2003).

18. Maria Sibylla Graff, Raupenbuch (1679), Hoch-werther / Kunstliebender Leser, translated from the original German.

19. The drawings are located at the Manuscript Department of the Library of The Russian Academy of Sciences (RAS), St. Petersburg. Wolf-Dietrich Beer, *Maria Sibylla Merian: Schmetterlinge, Käfer und andere Insekten. Leningrader Studienbuch*, 2 Bde. (Leipzig, 1976). (facsimile).

20. The drawings are located at the Archive of The Russian Academy of Sciences (RAS), St. Petersburg. Ernst Ullmann, *Maria Sibylla Merian: Leningrader Aquarelle*, 2 Bde. (Leipzig und Luzern, 1974) (facsimile).

21. See Maria Sibylla Graff, Raupenbuch (1679), Lobgedicht; translated from the original German and Beer, *Maria Sibylla Merian*, 19.

22. From now on referred to as 'Raupenbuch'.

23. Maria Sibylla Graff, Raupenbuch (1679), Lobgedicht; translated from the original German.

24. Maria Sibylla Graff, Raupenbuch (1679), Vorrede; translated from the original German.

25. Maria Sibylla Graff, Raupenbuch (1683).

26. Maria Sibylla Merian, *Deerde en laatste Deel der Rupsen Begin, Voedzel en wonderbaare Verandering. [. . .]* (Amsterdam, 1717), 10, pl. XV, translated from the original Dutch.

27. Letter of Johann Andreas Graff to Dr. Johann Jakob Schütz from 14. April 1690 (Archivzentrum Universitätsbibliothek Frankfurt a.M., Sign. UBA Ffm, Na 31, Mappe 330), transcibed by Renate Ell, Hermann Neumann, Helge Weingärtner, Brigitte Wirth, Karl Kohn u. Ursula Timann, in Margot Lölhöffel, *Anhang 2*, Dokumente und übles Gerücht, *Johann Andreas Graff, Pionier Nürnberger Stadtansichten* (Nürnberg: Förderverein Kunsthistorisches Museum, 2017), 85.

28. Janice Neri, *The Insect and the Image: Visualizing Nature in Early Modern Europe 1500–1700* (Minnesota: University of Minnesota Press, 2011), 220.

29. Joos van de Plas, *Metamorphosis Insectorum Surinamensium* (Wiesbaden: Eine Entdeck-ungsreise neu erlebt, Museum Wiesbaden, 2013), XX.

30. Katharina Schmidt-Loske, Helga Prüßmann-Zemper, Brigitte Wirth, *Maria Sibylla Merians Briefe von 1682 bis 1712'*, Bd. 20 (Rangsdorf: Acta Biohistorica), Einleitung, in Press.

31. Letter from Maria Sibylla Merian to Clara Regina Scheurl von Defersdorff, dated Amster-dam, 29 August 1697, Stadtbibliothek Nürnberg, Autograph 167.

32. Amsterdam, Archief van de Burgerlijke Stand, DTB 697, 341. Herolt is from Bacharach, a small village located at the river Rhine, Germany.

33. Database Delpher, Amsterdamse Courant 1692/08/05; the newspaper copy is located at the Royal Library in the Hague.; "Advertentie". "Amsterdamse courant". Amsterdam, 1692/08/05 00:00:00, p. 2. Geraadpleegd op Delpher op 28 January 2020, http://resolver. kb.nl/resolve?urn=ddd:010707630:mpeg21:p002.

34. Database Delpher, Amsterdamse Courant, information is taken from a newspaper adver-tisement in the *Amsterdamse Courant,* placed by Maria Sibylla's son-in-law.

35. Database Delpher, Amsterdamse Courant, see endnote 33.

36. One watercolour shows three mice nibbling on fruits, an almond, an acorn and a wal-nut (sign. 'Johanna Helena Herolt') and an oak branch with a caterpillar (sign. 'Maria S. Merian'). See Sam Segal, 'Maria Sibylla Merian als Blumenmalerin', in Kurt Wettengl (ed.), *Maria Sibylla Merian. Künstlerin und Naturforscherin 1647–1717* (Frankfurt: His-torisches Museum, Verlag Gerd Hatje, 1997), 82. The second drawing shows six butterflies on blades (sign. "Maria S. Merian"), below two exotic butterflies (sign. 'J.H. Herolt'). See Gertrud Lendorff, *Maria Sibylla Merian 1647–1717 ihr Leben und ihr Werk* (Basel: Gute Schriften, 1955), [64], VII.

37. Maria Sibylla Merian, Metamorphosis Insectorum Surinamensium, Aan den Leezer, 1705.

38. Maria Sibylla Merian, Metamorphosis Insectorum Surinamensium.

39. Letter from Maria Sibylla Merian to Johann Georg Volkamer d. J., dated 8 October 1702, Universitätsbibliothek Erlangen-Nürnberg, Erlangen, the collection of letters by [Christoph Jacob] Trew.

40. The passenger list is located at the national archive in the Hague, and it features three entries related to Maria Sibylla: 'Maria Sibilla Merian', 'haer doegter' (her daughter) 'und einer Indianin' (and a native woman). NA, Den Haag, Sociëteit van Suriname, detail of "Lijste van de Passagiers" pictured by Ella Reitsma, *Maria Sibylla Merian & dochters. Vrouwenlevens tussen kunst en wetenschap* (Amsterdam: Museum Het Rembrandhuis; Los Angeles: J. Paul Getty Museum, Waanders Uitgevers Zwolle, 2008), 198.

41. Sächsisches Staatsarchiv, Hauptstaatsarchiv Dresden, 10026 Geheimes Kabinett, Loc. 03315/03.

42. Opinions differ about the extent of her contribution. See Jan van de Waals, 'Met boek en plaat—Het boeken- en atlassenbezit van verzamelaars', in Ellionoor Bergvelt and Renée Kis-temaker (hgs.), *De wereld binnen handbereik: Nederlandse kunst- en rariteitenverzamelin-gen, 1581–1735* (Amsterdam: Amsterdams Historisch Museum; Zwolle, 1992), 224. See Florence J. M. Pieters and Robert Moolenbeek, 'Rare schelpen en schaaldieren. Raadsels rond de illustraties bij D'Amboinsche rariteitkamer van Georgius Everhardus Rumphius', *Jaarboek van het Nederlands Genootschap van Bibliofielen XII* (2004 [publ. 2005]): 130.

43. For example: Maria Sibylla Merian, *A study of capers, gorse, and a beetle*, dated 1693, Metropolitan Museum of Arts, NY, Accession Number: 2012.83. Maria Sibylla Merian, *Heron Encircled by a Snake, with a Worm in His Bill*, The Morgan Library and Museum, NY, Accession Number: 1980.43. The latter library has more watercolours of mother and daughter. A watercolour of Maria Sibylla Merian with a mammal, an armadillo, has been sold by art dealer Silvano Lodi from Italy to a private collection in Saudi Arabia.

44. Fitzwilliam Museum Cambridge, Accession: Object number 1146C; see David Scrace und Thea Vignau-Wilberg (hgs.), *Das Goldene Jahrhundert* (Schirmer and Mosel: Katalog Staatliche Graphische Sammlung München, 1995), 70.

45. Michael Roth, Magdalena Bushart und Martin Sonnabend, *Maria Sibylla Merian und die Tradition des Blumenbildes von der Renaissance bis zur Romantik* (Berlin and Frankfurt a. M.: Ausstellungskatalog, 2017), 170.

46. Gertrud Lendorff, *Maria Sibylla Merian 1647–1717 ihr Leben und ihr Werk* (Basel: Gute Schriften, 1955), [64], VIII.

47. Signed M. S. Gräfin geb. Merian, Kupferstichkabinett, Staatliche Museen zu Berlin, KdZ 8834.
48. See endnote 38.
49. Maria Sibylla Merian, *Deerde en laatste Deel der Rupsen Begin, Voedzel en wonderbaare Verandering.*
50. Hannes Lerp and Fritz Geller-Grimm, *Die Sammlungen von Maria Sibylla Merian im Museum Wiesbaden* (Wiesbaden: Museum Wiesbaden, 2017).
51. Joos van de Plas, *Metamorphosis Insectorum Surinamensium. Eine Entdeckungsreise neu erlebt* (Wiesbaden: Museum Wiesbaden, 2013).
52. *Metamorphosis Insectorum Surinamensium*, title, translated from Dutch.
53. Michael Ohl, *Stachel und Staat* (München: Knaur, 2019), 76 ff.

Bibliography

Beer, Wolf-Dietrich, *Maria Sibylla Merian: Schmetterlinge, Käfer und andere Insekten. Leningrader Studienbuch*, 2 Bde., Leipzig, 1976.

Gerst, Doris (Hrsg.), *Georg Philipp Harsdörfer und die Künste*, Nürnberg: Fachverlag Hans Carl GmbH, 2005.

Gräffinn, Maria Sibylla [Merian, M. S.], Matthaei Merians/des Eltern/Seel. Tochter, *Der Raupen Wunderbare Verwandelung und sonderbare Blumen=nahrung*, Nürnberg zu finden/bey Johann Andreas Graffen/Mahlern/in Frankfurt/und Leipzig/bey David Funken. Gedruckt bey Andreas Knortzen, 1679.

Gräffin, Maria Sibylla [Merian, M. S.], Matthäi Merians/des Eltern/ Seel. Tochter, *Der Raupen Wunderbare Verwandlung/und sonderbare Blumen= nahrung/Anderer Theil*, Zu finden in Frankfurt am Mayn/bey Johann Andreas Graffen/Mahlern/zu Leipzig/und Nürnberg/bey David Funken. Gedruckt durch Joh. Michael Spörlin, 1683.

Gräffin, Maria Sibylla [Merian, M. S.], Matthäi Merians des Eltern Seel. Tochter, *Neues BlumenBuch* Allen Kunstverständigen Liebhabern zu Lust, Nutz und Dienst, mit Fleiß verfertiget. Zu finden bey Joh, Andrea Graffen, Mahlern in Nürnberg im Jahr, 1680.

Grebe, Anja und Christine Sauer, *Maria Sibylla Merian. Blumen, Raupen, Schmetterlinge*, Nürnberg: Ausstellungskatalog der Stadtbibliothek Nürnberg, Nr. 110, 2017.

Lendorff, Gertrud, *Maria Sibylla Merian 1647–1717 ihr Leben und ihr Werk*, Basel: Mit acht bisher unveröffentlichten Aquarellen, 1955.

Lerp, Hannes and Fritz Geller-Grimm, *Die Sammlungen von Maria Sibylla Merian im Museum*, Wiesbaden: Museum Wiesbaden, 2017.

Lölhöffel, Margot, 'Johann Andreas Graff (1636–1701)—Annäherung an einen Vergessenen', in *Johann Andreas Graff, Pionier Nürnberger Stadtansichten*, hg. vom Förderverein Kunsthistorisches, Nürnberg: Museum Nürnberg, 2017.

Merian, Maria Sibylla, *Deerde en laatste Deel der Rupsen Begin, Voedzel en wonderbaare Verandering. [. . .] Als mede een Appendix Behelfende eeinge Surinaamsche Insecten*, geobserveert door haar Dochter Johanna Helena Herolt, Tegenwoordig noch tot Surinaame woonagtig. Alles in Print gebracht, en in' t licht gegeven door haar Jongste Dochter Dorothea Maria Henricie. T'Amsterdam [. . .] [1717].

Merian, Maria Sibylla, *Metamorphosis Insectorum Surinamensium. Ofte Verandering der Surinaamsche insecten*. Waar in de Surinaamsche rupsen en wormen met alle des zelfs veranderingen na het leven afgebeeld en beschreeven worden [. . .]. Tot Amsterdam, Voor den Auteur, woonennde in de Kerk-straat, tussen de Leydse en Spiegel-straat, over de Vergulde Arent, alwaar de zelve ook gedrukt en afgezet te bekomen zyn; Als ook by Gerard Valck, op de waakende Hond [1705].

Merian, Maria Sibylla, *Metamorphosis Insectorum Surinamensium: In qua Erucae ac Vermes Surinamenses cum omnibus suis Transformationibus, ad vivum delineantur & describuntur [. . .]*. Amstelodami, Sumtibus Auctoris, habitantis in de kerk-straat, tussen de Leydse- en Spiegel-Straat, ubi impressa & colorata prostant. Venduntur & apud Gerardum Valk op den Dam, in de Waakende Hond; Anno MDCCV.

Merian, Matthaeus: Theatrum Europaeum. 21 Bde., Frankfurt a.M. 1633–1738.

Ohl, Michael, *Stachel und Staat. Eine leidenschaftliche Naturgeschichte von Bienen, Wespen und Ameisen*, München: Droemer Knaur Verlag, 2019.

Pierer's Universal-Lexikon, Band 14, Altenburg 1862.

Pieters, Florence J. M. and Robert Moolenbeek, 'Rare schelpen en schaaldieren. Raadsels rond de illustratics bij D'Amboinsche rariteitkamer van Georgius Everhardus Rumphius', in *Jaarboek van het Nederlands Genootschap van Bibliofielen XII*: 2004 [publ. 2005]

Plas, Joos van de, *Metamorphosis Insectorum Surinamensium*, Wiesbaden: Eine Entdeckungsreise neu erlebt, Museum Wiesbaden, 2013.

Reitsma, Ella (hg.), *Maria Sibylla Merian & dochters. Vrowenlevens tussen kunst en wetenschap*, Katalog Museum Het Rembrandthuis, Amsterdam: Zwolle, 2008.

Roth, Michael, Magdalena Bushart und Martin Sonnabend (hgs.), *Maria Sibylla Merian und die Tradition des Blumenbildes von der Renaissance bis zur Romantik*, Berlin und Städel Museum Frankfurt a. M.: Katalog Kupferstichkabinett—Staatliche Museen zu, 2017.

Scrace, David and Thea Vignau-Wilberg, *Das Goldene Jahrhundert*, Cambridge: Holländische Meisterzeichnungen aus dem Fitzwilliam Museum; München, Schirmer, Mosel: Katalog Staatliche Graphische Sammlung, 1995.

Ullmann, Ernst, *Maria Sibylla Merian: Leningrader Aquarelle*, 2 Bde., Leipzig und Luzern 1974.

Waals, Jan van de, 'Met boek en plaat—Het boeken- en atlassenbezit van verzamelaars', in Ellionoor Bergvelt and Renée Kistemaker (hgs.), *De wereld binnen handbereik: Nederlandse kunst- en rariteitenverzamelingen, 1581–1735*, 2 Bde., Zwolle: Katalog Amsterdams Historisch Museum, 1992, 205–231.

Wettengl, Kurt (hg.), *Maria Sibylla Merian, Künstlerin und Naturforscherin. 1647–1717*, Frankfurt a. M.: Katalog Historisches Museum, 1997.

Wettengl, Kurt (hg.), *Von der Naturgeschichte zur Naturwissenschaft. Maria Sibylla Merian und die Frankfurter Naturalienkabinette des 18. Jahrhunderts*, Kleine Senckenberg-Reihe 46, Frankfurt a. M.: Taschenkatalog, 2003.

Archives

Archivzentrum Universitätsbibliothek Frankfurt a.M
Nationaal Archief, Den Haag, Sociëteit van Suriname
Sächsisches Staatsarchiv, Hauptstaatsarchiv Dresden
Stadsarchief Amsterdam, Archief van de Notarissen
Stadtbibliothek Nürnberg

5 Sarah Sophia Banks's Coin Collection
Female Networks of Exchange

Erica Y. Hayes and Kacie L. Wills

Introduction

According to R.J. Eaglen, 'Since its foundation in 1903, only eight percent of the British Numismatic Society's collectors have been female and most of them have been a husband and wife team'.[1] Sarah Sophia Banks, sister to Joseph Banks, famed botanist on the first Cook voyage and later President of the Royal Society, is considered by scholars and collectors today as one of the very few and noteworthy female collectors of coins, medals, and tokens in the late eighteenth and early nineteenth centuries (Figure 5.1).[2] Sarah Sophia Banks's collection of coins consists of more than 9,000 numismatic objects, diverse in their historical and geographical range. Scholars like Catherine Eagleton have examined the organizational strategies employed by Sarah Sophia in the cataloguing of her numismatic collection, and Katy Barrett has explored the ways that Sarah Sophia strategically 'organized the world in a drawer' with her coins.[3] Importantly, Eagleton also draws connections between Joseph Banks's interest in the reform of British coinage as a member of the Privy Council Committee on Coins and the collecting interests and patterns of Sarah Sophia Banks.[4] Through collaborative efforts, it appears that both brother and sister had a strong interest in promoting British coinage within their various spheres. Sarah Sophia's efforts, however, seem to be part of a larger interest in numismatic collecting and in the exchange of coins with a variety of individuals.

From 1791 onwards, Sarah Sophia kept a detailed list of the coins she collected.[5] This list includes the provenance of more than 8,500 coins, tokens, and medals in her collection, acquired from 523 individuals, along with a separate list of coins she gave away or exchanged with 480 other collectors. In her coin acquisition and exchange lists, she identified some of these individuals, making it easier to trace the contacts she collaborated with when compiling her collection. During the last few years of her life, she reorganized these lists into eight volumes of coin catalogues.[6] The volume numbers of the coin catalogues are arranged geographically, beginning with coins from England, before moving on to Europe, Africa, the Middle East, Asia, and the Americas. Her arrangement of her coin catalogues positions England, and its growing empire, at the center of the world. Within each country, she listed her coins, tokens, and medals first by the authority behind the coin, rather than according to its place of issue and use.[7] The networks of power represented in her taxonomical and organizational structures, connecting the monarchy to its imperial reach, to the actual place of where the coin, token, or medal was used, reflect not only the interests of Sarah Sophia in coinage struck for use throughout the growing British empire, but also her own approach to

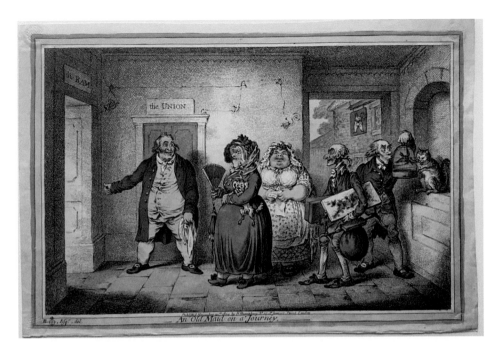

Figure 5.1 James Gillray, *An Old Maid on a Journey*, 1804. Hand-colored etching, 255 ×
383mm. Private collection. This print is commonly thought to depict Sarah Sophia
Banks in one of her riding habits.

visualizing cultural constructions of political power and global space throughout her
collection as a whole.

 While we have written elsewhere about her numismatic catalogue and collection of
African coins and its illustration of colonial power,[8] in this chapter, we will specifi-
cally focus on the ways Sarah Sophia's coin collection served to establish collecting
networks among and between women in England during this period, and how the
exchanges of coins within these networks reflects a larger investment in the coinage
and authority of the growing British empire.[9] Held in the Department of Coins and
Medals at the British Museum, two of Sarah Sophia's manuscripts, 'List of coins etc.,
Presents to me and of Duplicates that I have bought', and 'coins &c which I have
given away', include detailed lists of the coins she acquired and gave away to indi-
viduals.[10] Through examining these lists, we have chosen to highlight a number of
Sarah Sophia's unique exchanges of coins with other women. Though it is difficult to
trace the specific identities of the women listed in Sarah Sophia's manuscripts due to a
lack of first names listed, we can read the potential identities and stories behind these
exchanges within a larger network of women collectors of coins in the eighteenth
century and consider the ways collecting networks like those created by Sarah Sophia
could be acknowledged and better visualized today, using digital humanities methods,
such as social network analysis.

Maria Josepha Holroyd

One woman who stands out among the lists of individuals with whom Sarah Sophia exchanged coins with is a 'Miss Holroyd'. The coins given to Miss Holroyd are diverse and number second only to coins given to prominent men of science like Mr. Dryander, the curator of her brother's collections, and Mr. Forster, naturalist on Cook's second voyage.[11] Unlike the other women with whom Sarah Sophia exchanged coins, most of whom were married or part of a network of exchange that included their family members, Miss Holroyd was, at least at the times of the exchanges with Sarah Sophia, a single woman unconnected by name to other men or women in either list. Throughout her lists of coin acquisitions and exchanges, Sarah Sophia only refers to her as 'Miss Holroyd'.

John Baker Holroyd, the 1st Earl of Sheffield, had two daughters around the time Sarah Sophia was collecting coins: Maria Josepha Holroyd (1771–1863) and Louisa Dorothea Holroyd (1776–1854) (Figure 5.2).[12] In 1783, John Baker Holroyd was elected as a Fellow of the Royal Society and was a 'man of cultivated literary taste, an authority on questions of Finance, Commerce, and Agriculture, and an industrious Member of Parliament'.[13] Due to his authority on matters of agriculture and his aristocratic position as Lord Sheffield and as a Fellow of the Royal Society, it is not

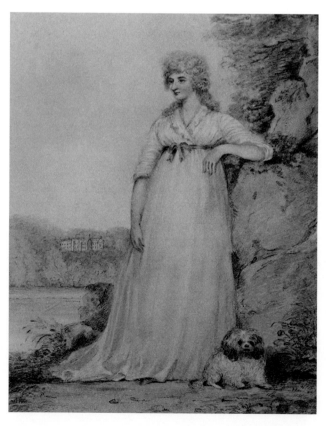

Figure 5.2 Edridge, *Maria Josepha Holroyd*, 1795. Walker & Boutall, Ph.Sc.

surprising that his family was associated with the Banks family and other elite members of society. According to Jane H. Adeane, editor of Maria Josepha Holroyd's memoir and letters, John Baker Holroyd 'entertained the leading spirits of his day. Men of mark in politics, science, literature, and art met at his home' where they dined with his family on Downing Street in Sussex.[14] One of John Baker Holroyd's closest friends was Edward Gibbon, an English historian, writer, and Member of Parliament. When Maria Josepha turned twelve in 1783, Edward Gibbon declared his wish to educate John Baker Holroyd's daughter. He admired Maria Josepha's talent for writing and saw in her 'the mixture of just observation and lively imagery, the strong sense of a man expressed with the easy elegance of a female'.[15] Fascinatingly, it is believed that Maria Josepha even aided her father in the editing and publication of Gibbon's groundbreaking memoirs.[16] This was no small feat, as the renowned historian died, leaving the work in fragments.

In a letter dated 10 November 1792, Gibbon advised Maria Josepha, 'You must not, you shall not, think yourself unworthy to write to any man: there is none whom your correspondence would not amuse and satisfy'. In his letter, Gibbon encourages Maria Josepha in correspondence with men like Joseph Banks, whom she greatly admired. This reflects not only the talent and scientific interests that Gibbon wanted to foster in Maria Josepha, but also his encouragement of her pursuit of activities that were unusual for women. While most girls were working to acquire more feminine accomplishments, Maria Josepha was corresponding about botany with the leading scientific minds of her day. Adeane notes Maria Josepha 'delighted in gardening and country pursuits' and gained a strong appreciation for plants from Sir Joseph Banks who visited the Holroyd family home on more than one occasion.[17] This additionally suggests that since botany and gardening were closely connected to recipes and certain domestic activities that women engaged in, the tendency to create strong divisions between masculine and feminine activities is incorrect. In fact, Joseph Banks acquired much of his love for botany from his mother.

On 24 August, 1788, Maria Josepha wrote to her Aunt Serena, with whom she kept an extensive correspondence:

> How I wish it had been possible to have had you this summer! I would have made a Botanist of you. Sir Joseph Banks' Company was the greatest Treat that I could possibly have in that way, and with his assistance I have made a tolerable proficiency in the Study. My collection is a pretty considerable one; I have above 250 plants all gathered by my own hands; within five miles of this place. I have another collection on hand, viz., Seals, which I must beg your assistance in; I shall be obliged if you will save for me all the seals that come to you, and if they are Arms, to write the name of the owner on the back.[18]

Although there is no specific mention of an exchange of coins between Sarah Sophia and Maria Josepha during the Banks family visits, this letter documents how Maria Josepha had already begun to show an interest in collecting through her collections of plants and seals from documents and letters. Sarah Sophia's collection of ephemera shows a similar interest in collecting letters and invitations with the seals intact. In addition to these shared interests, several dates mentioned in Maria Josepha's letters to her Aunt Serena correspond with dates of exchange recorded by Sarah Sophia in her

aforementioned list of coins exchanged. For example, on 11 May 1795, Maria Josepha wrote to her Aunt Serena that she would be 'dining at Sir Joseph Banks's and visiting the Opera House, Lady Galloway's, and Almack's assembly rooms'.[19] In Sarah Sophia's list, she notes an exchange with a Miss Holroyd on Monday, 11 May 1795, in which Miss Holroyd was given '33 tokens'.[20] The correspondence in dates suggests that Miss Holroyd was given the coins by Sarah Sophia on the day that she dined at the Banks's home. Giving and receiving coins, then, was part of the other social activities Sarah Sophia engaged in both within and outside of the home.

In another letter from Maria Josepha to her Aunt Serena, Maria Josepha notes another visit with the Banks family on a date that corresponds with an exchange listed in Sarah Sophia's manuscript. Maria Josepha writes on 2 August, 1795:

> The Banks family came on Sunday. The Ladies, as usual, visited Mrs. Newton, and Sir Joseph and Papa the wool Fair at Lewes on Monday. The Red Ribbon has made no alteration in Sir Jo. in any other respect than that there is a red ribbon across his waistcoat. He sprawls upon the Grass, kisses Toads, and is just as good humoured or an Otaheitan as ever.[21]

This entry is notable for a number of reasons. First, we see a glimpse of Sir Joseph Banks after he has been awarded the Red Ribbon of the Order of Bath, a mark of distinction that, still in Maria Josepha's eyes, changes him little. She suggests in her description of the President of the Royal Society, that, much like James Gillray's famous satirical print, at heart Sir Joseph Banks is very much the same scoundrel of the South Seas he was when he was young. Maria Josepha highlights this by referring to him as an 'Otaheitan,' the term given to the indigenous people of Tahiti on the Cook voyages.[22] In doing this, she is also referencing, if obliquely, the name Joseph had made for himself as a collector while on his voyage with Cook. Importantly, she also refers to 'The Ladies' in this letter, referring Sarah Sophia and Lady Banks; this is the term of endearment by which Sir Joseph would refer to his wife and sister. While, again, no mention is made in Maria Josepha's letter of an exchange with Sarah Sophia, Sarah Sophia's list of coins given away, reveals that she gifted '41 tokens' under Miss Holroyd's name on 27 July 1795. In addition to this connection, it is significant that this is the last recorded gift of coins to Miss Holroyd in Sarah Sophia's manuscript. The following year, on 11 October 1796, Maria Josepha married John Stanley, the first Baron Stanley of Alderley, one of the first English explorers of Iceland in 1789.[23] Iceland is a place both Joseph Banks and Maria Josepha's husband explored; in fact, correspondence exists between Sir Joseph and John Stanley on the subject, and upon Lord Stanley's return to England, he presented seeds and plants gathered from his expedition to Joseph Banks.[24] There is no mention in Sarah Sophia's manuscripts of an exchange with a Mrs. Stanley, but John Stanley's close relationship with Joseph Banks emphasizes the strength of Sarah Sophia and Maria Josepha's social connections. Like their husband and brother, respectively, Maria Josepha and Sarah Sophia seem to be invested in exploration, though their investment can be seen through the collection and exchange of coinage.

In addition to the coins Sarah Sophia gave to Miss Holroyd, Miss Holroyd is listed as giving Sarah Sophia a number of coins, including mostly European coins from Germany, Austria, the Netherlands, and Switzerland. In fact, it appears that it was Miss Holroyd who initiated their exchanges, on 16 March 1792, with a gift to Sarah

Sophia of a handful of coins dated as minted around that same time; as modern coins, most of these specimens were not likely rare or costly. The coin from Switzerland, however, is dated 1622.[25] The date of exchange signals Miss Holroyd's collecting of numismatic objects, even prior to the gifts Sarah Sophia gave her. Foreign coins would be valued as both physical embodiments and representations of the foreign countries from which they came. Coins represented the spirit of travel, and while women like Maria Josepha and Sarah Sophia may not have been able to travel, abroad as freely as their husband or brother did, they could learn of distant places virtually through the study of their coins. While the list of coins Miss Holroyd gave to Sarah Sophia is short and far less comprehensive than the list of coins that Sarah Sophia gave to her, the act of exchange between these two women remains significant.

Miss Holroyd's Coins

The individual coins given to Miss Holroyd by Sarah Sophia are from numerous places throughout Europe and from the distant reaches of the growing British Empire (Plate 3). Sarah Sophia gifts Miss Holroyd coins from England, Scotland, and Ireland, as well as coins from Holland, Germany, Sweden, Denmark, Italy, France, Spain, and the Netherlands, an exchange of coins that reflects Sir Joseph's foreign networks in his correspondence.[26] The exchange includes upwards of 30 coins from England, bearing the figures of King Edward I, King James I, King Charles I, King Charles II, King William and Queen Mary, King William III, Queen Anne, King George I, King George II, and King George III. These coins are followed by English coins from places such as Leeds, Southampton, Warwickshire, and Scottish coins from Edinburgh, dating from 1791 and 1790, respectively. The organization of these coins not only reflects the larger taxonomical structure of Sarah Sophia's coin catalogue, as she begins the list with the monarch, the authority behind the coin, but it also places England first, as she does in the volumes of her *Catalogue of Coins*.

When Sarah Sophia begins to list English coins again later in the entry, she follows the same pattern. Additionally, she includes a specific coin from Edinburgh under England, while she begins the section of Scottish coins next. This reflects the perception of Scotland and Scottish money as existing within and without England. As we can see in the following section detailing the Scottish coins she exchanges, the coins bear the figures of the English monarchy. In the case of the coins given to Miss Holroyd, the Scottish coins are engraved with the figures of King Charles II, King William, and Queen Mary.

In this same gift from 17 March 1792, Sarah Sophia not only shares with Miss Holroyd a significant number of coins from the British Isles, but she also gifts coins from continental Europe, establishing a collection of coins with this gift that reflects a sort of Grand Tour through coinage, geographically. Following Ireland, Sarah Sophia lists nine coins from Holland, listing not a monarch, but the locations of various mints, such as Utrecht. She then moves on to Germany, where she lists the monarchs associated with half a dozen coins, after listing the locations of the mints, including Cologne, Bavaria, and others. Next, she lists a coin from Sweden, where her organizational structure returns to listing the monarch: King Gustavus III. This organizational structure continues with coins from Denmark and Italy, the latter of which she specifically lists the authority behind the coinage as 'the Pope', followed by the

minting locations of Pisa, Venice, Tuscany, Sardinia, and Ferrara. She then returns to her earlier organizational structure with the coins from France and Spain, listing first the monarch associated with the coins, then the type of coins gifted to Miss Holroyd. These gifts include about 40 coins from France alone, making the number of coins Miss Holroyd received from England and France greater than from any other country represented in their exchanges she documents in her catalogue. This also properly reflects the two nations that were most central to Sarah Sophia's social circles and to her own collections, which include a number of scrapbooks focused on events like hot air ballooning that took center stage in both England and France and during the Napoleonic Wars.[27]

The coins gifted to Miss Holroyd on subsequent exchanges, on the 4 and 8 of May 1793 and on 6 August 1793, extend well beyond European borders into South America and Africa, with coins from Brazil and Sierra Leone. While the list of these exchanges begins again with roughly a dozen English coins, she follows them with more coins from Ireland, Holland, Denmark, and Sweden, and also includes coins from Switzerland, attributed to the mints at Unterwalden and Zurich. Importantly, the Portuguese coins Sarah Sophia gifts to Miss Holroyd are designated for its colonial outgrowth of Brazil. Sarah Sophia first lists Portugal, then Brazil, and next the Portuguese monarch, King Joannes V. She emphasizes in this entry, as she does in her *Catalogue of Coins*, the political power of the European nation and its monarchy through the numismatic objects connected with its developing empire.

The British Empire and Women's Numismatic Collections

Following the coins from Brazil, Sarah Sophia gifts Miss Holroyd a '50 cent' or '1/2 dollar' piece from Sierra Leone in an exchange on 6 August 1793. The coins from Sierra Leone are from the Sierra Leone Company. Established at the height of British participation in the slave trade, the Sierra Leone Company was part of an attempt 'to reform trading practices and to transfer British value systems to the West African Coast'.[28] It 'constituted one of the first tangible manifestations of abolitionism in Africa' and also participated in the European imperial interest in Africa through its implementation of 'commerce, civilization, and Christianity'.[29] As Sophie Mew notes, Sierra Leone is an interesting case in terms of currency, for it had no centralized currency system before the presence of colonizers, and therefore offers an opportunity to analyze the role of money and its use in the region's development.[30] This exchange, thus, illustrates the connection between currency and the expansion of the colonial empire of Britain, at the same time that it shows Sarah Sophia's investment in promoting the British empire through numismatic exchanges with other women.

Sarah Sophia's lists indicate that she exchanged a substantial number of coins with another woman, 'Mrs. Hay'. Unlike the coins gifted to Miss Holroyd, however, Mrs. Hay's entry focuses less on continental Europe and its shifting geopolitical landscape. Mrs. Hay's gifts begin in 1795 and end in 1797. Sarah Sophia gifts Mrs. Hay a variety of coins (upwards of two dozen), with the majority of them being from England. She lists English coins from Bungay, Newgate, Hereford, and Norwich—with the striking exception of a Sierra Leone Dollar. In her list of coins given away, she notes:

1795 Mrs. W. Hay.
March 31. Sierra Leone Dollar. ½ dollar. 20 cent. 10 cent.[31]

Mrs. Hay and Miss Holroyd are the only women listed in the manuscripts to have received Sierra Leone coins. If we compare the gift of coins given to Miss Holroyd to that given to Mrs. Hay, we can see that the types and variety of the coins given to Miss Holroyd span continental Europe and its colonial outgrowths into Africa and the Americas. The coins gifted to Mrs. Hay and Miss Holroyd are simultaneously linked to and valued for both their place of use in Africa and their connections to Britain and the Sierra Leone Company. As products of the Sierra Leone Company, the Sierra Leon Coins are both an English and African entity, and they exemplify a geographical location validated by a foreign authoritative body of power. Rather than serving as a reflection of the authority of the African continent and its domestic currencies, the circulated Sierra Leone coins in Sarah Sophia's collection are objects of her own (and also her brother's) investment in the British Empire in Africa.[32]

The colonial engagement of the coins Sarah Sophia gifts to Miss Holroyd continues in an exchange on 5 May 1794. Sarah Sophia lists coins and tokens given to Miss Holroyd that include a 'Sir Isaac Newton' ½, 1793, a Manchester ½, 1793, 'Success to Navigation,' and a Bengal ½ *Anna*. The Bengal *Anna*, launched from Calcutta, was a ship of the British East India Company. These coins, in order, exemplify Sarah Sophia's interests in science, navigation, and trade that drove the imperial effort. They reveal the role currency can play in symbolically representing scientific progress as a means of promoting empire, a cause championed, of course, by Joseph Banks.

Sarah Sophia's Exchanges: Women and Social Class

With England as its center, Sarah Sophia gifts the women listed in these manuscripts a series of coins that engage with English social and cultural connections to Europe and with the ways Britain's and Europe's understanding of the globe were changing. Sarah Sophia's exchanges of coins reflect not only her perspectives on authority, as it was connected to money in the developing colonial world, but also her own interest in expanding and developing the numismatic collections of women in the late eighteenth century.

Sarah Sophia's 'List of coins &c. Presents to me & of Do. that I have bought' and her list, of 'coins &c which I have given away' indicate that roughly a quarter of the individuals with whom Sarah Sophia exchanged coins with were women, an unprecedented number, considering that coin collecting, as cited by Eaglen earlier, was and still is considered to be a male-dominated field.[33] These women include not only Miss Holroyd and Mrs. Hay, but also members of the royal family, like Princess Elizabeth, and a woman she refers to as 'Mrs. Harding Housekeeper'.[34] In this section, we will examine the variance in social class among these women within the pages of these manuscripts.

Sarah Sophia's lists show she was very generous when exchanging coins with other collectors. To Princess Elizabeth, Sarah Sophia gave a number of tokens and medals in 1811 and 1817.[35] These included a 'God Save the King' token, two silver bank tokens, and a 'half crown in a new die'. On 22 June 1817, she lists a silver medal with an image of His Royal Highness the Prince Regent and the standard of England on the reverse. These medals and tokens bearing symbols of the monarchy suggest not only Sarah Sophia's loyalty to the monarchy, but also her efforts to encourage that loyalty in others through these acts of exchange. These are coins that would hold a

personal significance to the princess in a way they wouldn't for the other women with whom Sarah Sophia exchanged coins. In 1810, Sarah Sophia lists that she gave the princess several gold ducats and silver coins from Germany and copper and bronze pieces of the Prince of Wales's Island. Sarah Sophia also includes a note in Volume 6 of her *Catalogue of Coins* that indicates she gave a number of 1804 Ireland Dollars minted by Mr. Boulton to Princess Augusta, Princess Elizabeth, Princess Mary, Princess Sophia, and Princess Amelia. These coins, however, are not listed in her 'coins &c which I have given away' manuscript.[36] These coins are significant because they were struck by Boulton at the Soho Mint and were made from old Spanish pillar-dollars.[37] Representing the failing state of Irish currency and the minting powers of private institutions like that of the Soho Mint, the gift of these coins speaks to the key role that currency played in the expanding British empire. These gifts can be connected to the culture of coinage Sarah Sophia was trying to promote at this time when the Royal Mint was being established, alongside Mr. Boulton's privately-owned Soho Mint. This was a project her brother Joseph was deeply invested in, so Sarah Sophia's distribution of coins was likely connected to a shared interest between brother and sister.

The other manuscript, 'List of coins &c. Presents to me & of Do. that I have bought', reveals that Sarah Sophia was gifted coins by Princess Elizabeth.[38] These include twenty francs of the Emperor Napoleon from 1808, gifted in 1810, and a coin engraved with a map of France, gifted in 1796. These coins stand out as gifts from English royalty that represent two different periods in Britain's history with France. The gift in 1796 of the map occurs prior to the rise of Napoleon during the wars that followed the French Revolution, while the coin gifted in 1810 reflects the period at the height of the Napoleonic Wars. If we compare this gift from the princess to the gift of French coins given by Sarah Sophia to Miss Holroyd, we see a totally different period in French history, with Sarah Sophia's coins engraved with images of the French monarchy. Princess Elizabeth also gifts Sarah Sophia in 1805 a medal of the Pretender. These exchanges give us a glimpse into the ways that these women's coin collections served as reminders of historical change and the shifting nature of authority. This is especially interesting, as the coins embody the fall and rise of those in power and were gifts from a member of the royal family. The gift of the Pretender medal in 1805, however, far removed from the historical moment of the Jacobite uprising, shows how the exchange of numismatic objects can serve as both reminder of more tumultuous periods in history, but also as a signal that those times are in the past, and are confined to the objects collected and circulated in their memory.

In what seems like a drastic shift from her exchanges with Princess Elizabeth, roughly a decade prior, Sarah Sophia lists coins given to her by the household staff of a Mr. and Mrs. Harding.[39] While Sarah Sophia lists a gift of coins from Mrs. Harding in 1794 and to Mr. Harding in 1799, this gift of coins from 'Mrs. Harding Housekeeper' stands out as the first in 1791 and 1792, with more coins received in 1799.[40] These coins include a Hull ½, a coin from Portugal engraved with King Johannes V, a Virginia ½, and a coin from Germany. The range of individual women Sarah Sophia exchanged coins with is highlighted by these gifts from Mrs. Harding's Housekeeper. These gifts also illustrate the possibility of networks of female collectors of numismatic objects beyond the elite and fashionable classes of women. Sarah Sophia is collecting with women of all social levels, illustrating how the practice of collecting has the potential to break class boundaries.

Sarah Sophia was an unmarried member of the Banks family, and, as such, she was able to move among social classes more easily. This enabled her to promote the values associated with the coins she distributed across diverse groups of women. Her coin collection was a living thing, made up of objects and networks of individuals with whom she exchanged coins, and her collection reveals a broader interest in the circulation of numismatic objects among women in the eighteenth century. Each exchange listed in Sarah Sophia's manuscripts gives us a glimpse into how she structured her collection and its purpose. Whether she was distributing 'God Save the King' medals to a number of women in a family, or she was exchanging coins to a housekeeper, Sarah Sophia demonstrates that numismatic collecting was not about just keeping the objects in a drawer. Sarah Sophia's circulation of coins, particularly among women, served the purpose of promoting the pro-monarchy, imperial agenda shared by the interests of both her and her brother. By looking at Sarah Sophia's acquisitions lists as a whole and her exchanges with individual women, we can expand our understanding of numismatic collections and the role female collectors played in supporting the growth of Britain's economic and social power.

Digital Humanities and the Afterlife of Sarah Sophia's Collecting Networks

Through these acts of exchange with other women, Sarah Sophia not only promotes aspects of British coinage, but helps to establish globally-situated collections for other women. Miss Holroyd, as a single woman, is one outstanding example of this, but Sarah Sophia's list also draw into question how much more widespread women's numismatic collections were during this time period. It is possible that the British Numismatic Society's numbers do not fully capture the reality of the ways that numismatic objects were collected and circulated among women of varying social classes throughout England in the eighteenth century. We now want to turn to the question of how to best trace and illustrate Sarah Sophia's collecting networks today, especially when dealing with the challenges surrounding the extensive size of her collections and the lack of identifying information for many of the individuals she exchanged coins with throughout her lifetime. While we have been able to identify some of the women with whom she exchanged coins in this chapter, the possibilities for telling a broader story of women's numismatic collecting in Sarah Sophia's manuscripts can be further examined with future research. Instead of studying collections like those of Sarah Sophia Banks through a lens shaped by the dominant establishments of her day, we would like to consider how digital humanities methods, such as social network analysis, might assist us with examining her collections and acts of exchange in new ways.

In *Social Network Analysis in the Long Eighteenth Century*, Ileana Baird notes how social interactions and associations in the eighteenth century can be approached through innovative methodological lenses, such as social network analysis and digital humanities scholarship.[41] By mapping out Sarah Sophia's collecting networks, perhaps the insularity of 'British clubability' can be challenged and reveal gender gaps, as well as the complex and nuanced networks of women numismatic collectors.[42] While Sarah Sophia's coin manuscripts document women's numismatic exchanges, these accounts have not been formally recorded or acknowledged by groups like the British Numismatic Society. Current work in the digital humanities on social network analysis has

revealed significant gender gaps in the records of formal institutions within seventeenth- and eighteenth-century social networks.

Six Degrees of Francis Bacon, a digital humanities project at Carnegie Mellon University and Georgetown University, has traced the relationships among figures like Bacon, Shakespeare, Isaac Newton, and others.[43] From the Oxford Dictionary of National Biography (ODNB), they gathered biographies of individuals who lived between 1500–1700, creating a dataset of 13,309 actor nodes. While their network analysis provided insight into the extensive connections among individuals and groups within early modern studies, the project team found there to be more connections between men than women. Within their dataset, they found that only '5.4 % of early modern entries in the *Oxford Dictionary of National Biography* (ODNB)' represent biographies of women.[44] They also noted how their 'algorithm mining the ODNB for historical names' biases men because women were 'often named in relation to the men around them', or changed their last name upon marriage.[45] While there is gender bias in the underlying data, the team has made efforts since then to expand their social network analysis to ensure 'the richness of connections between individuals of all genders are well-represented' and to provide avenues for users to correct existing data that may be wrong or submit additional data to their project.[46]

As these gender gaps have been identified in early modern studies and digital humanities projects, we must return to Sarah Sophia's collections and consider how her acquisition lists might be able to address some of these gender biases and how social network analysis and digitization of Sarah Sophia's collections may be able to make her collecting activities more accessible to the public at large. Split between the British Museum and the Royal Mint, Sarah Sophia's coin collection is challenging to assess and to access from a distance. Through further digitization and computational analysis of her collections, we may be able to piece together missing information pertaining to the identities of the individual women with whom she exchanged coins and continue to fill in the gender gaps that have been indicated by our analysis of Sarah Sophia's manuscripts and the aforementioned digital humanities project.

The interdisciplinary nature of digital humanities scholarship and social network analysis is particularly applicable to the study of women's collections in the eighteenth century.[47] Application of social network analysis methods to historical research can be applied to a variety of aspects surrounding women's collections, including interactions between individuals, friendship analysis, object exchange, correspondence, and cataloguing.[48] Starting with Sarah Sophia's detailed acquisition lists, we can draw connections between Sarah Sophia and the various women with whom she shared coins, along with information about the particular coins that were acquired and gave away. As we piece together the various women's names listed in Sarah Sophia's manuscripts of coins given away and coins acquired,[49] we hope to trace the edges that may connect the various women listed in her acquisition lists, considering attributes like their connections to the Royal Society, their relationships to other prominent female collectors, and their links to any other scientific or social organizations that valued collecting and intellectual exchange during this period.[50] As we work to illustrate these social networks, we can analyze the dynamic collecting processes communicated by Sarah Sophia's manuscripts. As Graham, Milligan, and Weingart have discussed regarding social network analysis, 'Many networks one encounters appear to be static snapshots of a moment in time: one large visualization of nodes connected by edges, whether it

be about people or books or ideas. In reality, the underlying networks often represent a dynamic process that evolves and changes over time'.[51] Sarah Sophia's manuscripts illustrates such a dynamic collecting practice that can offer us new insights into the range of women's collecting interests and intellectual exchanges, not just within elite circles, but throughout diverse social classes during the long eighteenth century.[52]

Notes

1. R.J. Eaglen, 'Sarah Sophia Banks and Her English Hammered Coins', *British Numismatic Society* 79 (2008): 200–215, 204. Russell W. Belk, on the other hand, when referring the diminishing gender differences in collecting, claims that '41% of American coin collectors are women', but this claim clearly does not account for gender bias towards coin collectors over the centuries. See Belk, 'Collectors and Collecting', in Christopher Tilley, et al. (eds.), *Handbook of Material Culture* (London: Sage, 2006), 539, and Diane Crispell, 'Collecting Memories', *American Demographics*, 60 (Nov. 1988), 38–41.
2. For more on Sarah Sophia's collections, beyond her coin collection, see Arlene Leis, 'Cutting, Arranging, and Pasting: Sarah Sophia Banks as Collector', *Early Modern Women* 9, no. 1 (2014): 127–140; Arlene Leis, 'Displaying Art and Fashion: Ladies' Pocket-Book Imagery in the Paper Collections of Sarah Sophia Banks', *Journal of Art History* 82, no. 3 (2013): 252–271; Arlene Leis, 'Ephemeral Histories: Social Commemoration of the Revolutionary and Napoleonic Wars in the Paper Collections of Sarah Sophia Banks', in Satish Padiyar, Philip Shaw and Pilippa Simpson (eds.), *Visual Culture and the Revolutionary and Napoleonic Wars* (London: Routledge, 2017), 183–199; Arlene Leis, 'Sarah Sophia Banks: Femininity, Sociability and the Practice of Collecting in Late Georgian England', PhD Thesis, U of York, 2013, http://etheses.whiterose.ac.uk/5794/. Anthony Pincott , 'The Book Tickets of Miss Sarah Sophia Banks,' *BookPlate Journal* 2 (2004): 3–30; Gillian Russell, 'Sarah Sophia Bank's Private Theatricals: Ephemera, Sociability, and the Archiving of Fashionable Life', *Eighteenth-Century Fiction* 27, no. 3–4 (2015): 535–555.
3. Katy Barrett, 'Writing On, Around, and About Coins: From Eighteenth-Century Cabinet to Twenty-First Century Database', *Journal of Museum Ethnography*, no. 25, Ojects and Words: Writing On, around, and About Things Papers from the Annual Conference of the Museum of Ethnographers Group Held at the Pitt Rivers Museum, U of Oxford, 14–15 April 2011 (2012): 70.
4. Catherine Eagleton, 'Collecting African Money in Georgian London: Sarah Sophia Banks and Her Collection of Coins', *Museum History Journal* 6, no. 1 (2013): 23–38, 26.
5. Sarah Sophia Banks, *Catalogue of Coins*, vol, 1–8, The British Museum Department of Coins and Medals.
6. Sarah Sophia Banks, *Catalogue of Coins*, vol. 1–8, The British Museum Department of Coins and Medals.
7. Eagleton discusses this at length with Sarah Sophia's African coins in 'Collecting African Money', 29–30.
8. Erica Y. Hayes, Kacie L. Wills, 'Visualizing Sarah Sophia Banks' African Coins', *Interdisciplinary Digital Engagement & Humanities*, vol. 1, issue, 1 (2020). https://doi.org/10.21428/f1f23564.1d32a4b3
9. See our digital project: sarahsophiabanks.com. See also Erica Hayes and Kacie L. Wills, 'Visualizing Sarah Sophia Banks's African Coins', *EBR* (forthcoming).
10. SSB I.21 MS, Sarah Sophia Banks, 'List of coins etc Presents to me and of Duplicates that I have bought'; SSB I.22 MS, 'coins &c which I have given away', 1796, British Museum, Department of Coins and Medals.
11. Sarah Sophia Banks, 'Coins &c Which I Have Given Away', 9, 14.
12. Stanley, M. Josepha Holroyd Stanley and J.H. Adeane, *The Girlhood of Maria Josepha Holroyd (Lady Stanley of Alderly): Recorded in Letters of a Hundred Years Ago: From 1776 to 1796*, 2nd editon (London: Longmans, Green, 1897), 234. For more on Maria Josepha Holroyd, see Barbara Bremner, 'The Life, Times and Correspondence of Maria Josepha Holroyd (later Lady stanley of Alderley)', PhD Thesis, School of History, Philosophy, Religion and Classics, The U of Queensland, 2004.

13. Baroness Maria Josepha Holroyd Stanley, *The Girlhood of Maria Josepha Holroyd Stanley, Recorded in Letters of a Hundred Years Ago, From 1776–1796*, ed. Jane Henrietta Adeane (London: Longmans, Green, and Co, 1896), 23.
14. Maria Josepha Holroyd Stanley, *The Girlhood of Maria Josepha Holroyd Stanley*, 23.
15. Marvin Stern, 'Stanley [née Holroyd], Lady Maria Josepha (1771–1863), Letter Writer and Liberal Advocate', *Oxford Dictionary of National Biography*, 23 September 2004, www.oxforddnb.com/view/10.1093/ref:odnb/9780198614128.001.0001/odnb-9780198614128-e-74489.
16. Edward Gibbons, *Memoirs of My Life and Writings*, ed. John Baker Holroyd, 1st Earl of Sheffield (1796), is known for its candid and entertaining depictions of events.
17. Maria Josepha Holroyd Stanley, *The Girlhood of Maria Josepha Holroyd Stanley*, xvii.
18. Maria Josepha Holroyd Stanley, 'Maria Josepha to Serena' Sheffield Place, 24 August 1788, 23.
19. Maria Josepha Holroyd Stanley, 'Maria Josepha to Serena', 320.
20. Sarah Sophia Banks, 'Coins &c Which I Have Given Away', 18.
21. Maria Josepha Holroyd Stanley, 'Maria Josepha to Serena', 329.
22. James Gillray, *The Great South Sea Caterpillar, Transform'd into a Bath Butterfly*, The British Museum Department of Prints and Drawings, 1795.
23. See Andrew Wawn, 'John Thomas Stanley and Iceland: The Sense and Sensibility of an Eighteenth-Century Explorer', *Scandinavian Studies* 53, no. 1 (1981): 52–76.
24. Joseph Banks, 'Correspondence Concerning Iceland: Written to Sir Joseph Banks', 1771–1818, http://digital.library.wisc.edu/1711.dl/HistSciTech.BanksJ.
25. Sarah Sophia Banks, 'List of Coins &c. Presents to Me & of Do. That I Have Bought', 42.
26. Joseph Banks, *The Letters of Sir Joseph Banks, A Selection 1768–1820*, ed. Neil Chambers (London: Natural History Museum, 2000).
27. Sarah Sophia's scrapbooks are housed at the British Library, LR 301.h3–11.
28. Suzanne Schwarz, 'Commerce, Civilization and Christianity: The Development of the Sierra Leone Company', in D. Richardson, S. Schwarz and A. Tibbles (eds.), *Liverpool and Transatlantic Slavery* (Liverpool: Liverpool UP, 2007), 253.
29. Schwarz, 'Commerce, Civilization and Christianity', 253.
30. Sophie Mew, 'Trials, Blunders, and Profits: The Changing Contexts of Currencies in Sierra Leone', *The Journal of Imperial and Commonwealth History* 44, no. 2 (2016): 199.
31. Sarah Sophia Banks, 'Coins &c Which I Have Given Away', 17.
32. Sarah Sophia Banks, Adam Afzelius and a Coin from Sierra Leone,' in Adriana Craciun and Simon Scaffer (eds.), *The Material Cultures of Enlightenment Arts and Sciences*, (London: Palgrave, 2016, 203–205.
33. Eagleton discusses this briefly in 'Collecting African Money', 26.
34. Sarah Sophia Banks, 'Coins &c Which I Have Given Away', 17.
35. Sarah Sophia Banks, 'Coins &c Which I Have Given Away', 11.
36. Sarah Sophia Banks, *Catalogue of Coins*, vol. 6, The British Museum Department of Coins and Medals.
37. Herbert Appold Greuber, The British Museum Department of Coins and Medals, *The Handbook of the Coins of Great Britain and Ireland in the British Museum* (London: William Clowes and Sons, 1899).
38. Sarah Sophia Banks, 'List of Coins &c. Presents to Me & of Do. That I Have Bought', 26.
39. Sarah Sophia Banks, 'List of Coins &c. Presents to Me & of Do. That I Have Bought', 39.
40. Sarah Sophia Banks, 'List of Coins &c. Presents to Me & of Do. That I Have Bought', 39.
41. Ileana Baird (ed.), *Social Networks in the Long Eighteenth-Century: Clubs, Literary Salons, Textual Coteries* (Newcastle upon Tyne: Cambridge Scholars, 2014), 4.
42. Baird, *Social Networks in the Long Eighteenth-Century*, 4–5.
43. Shilo Rea, 'Six Degrees of Francis Bacon: Carnegie Mellon Mines Early Modern Social Network', 12 June 2013, www.cmu.edu/news/stories/archives/2013/june/june12_francisbacon.html.
44. Scott Weingart and Jessica Otis, 'Gender Inclusivity in Six Degrees', *Six Degrees of Francis Bacon: Reassembling the Early Modern Social Network*, 5 January 2016, https://6dfb.tumblr.com/post/136678327006/gender-inclusivity-in-six-degrees.

45. Weingart and Otis, 'Gender Inclusivity in Six Degrees'.
46. Weingart and Otis, 'Gender Inclusivity in Six Degrees'; 'Founder Members of the Royal Society Network [1500–1700]', *Six Degrees of Francis Bacon*, www.sixdegreesoffrancis bacon.com/?ids=36&min_confidence=60&type=network (accessed 26 February 2020).
47. Baird, *Social Networks in the Long Eighteenth-Century*, 5, 16.
48. Shawn Graham, Ian Milligan and Scott Weingart, *The Historian's Macroscope—Working Title*, Under contract with Imperial College Press, Open Draft Version, Autumn 2013, http://themacroscope.org; 'Network Analysis', par. 15.
49. Shawn Graham, Ian Milligan and Scott Weingart, 'Network Analysis Fundamentals', par. 3.
50. Shawn Graham, Ian Milligan and Scott Weingart, 'Network Analysis Fundamentals', par. 3.
51. Shawn Graham, Ian Milligan and Scott Weingart, 'Network Analysis Fundamentals', par. 13.
52. We are grateful to the Keats-Shelley Association of America who, through the Pforzheimer Research Grant, enabled much of this research to be completed. A special thanks, as well, to the staff and curators at the Royal support of our research. We would like to thank Arlene Leis for her helpful comments. Finally, thank you to Katie Eagleton for all of her helpful advice and direction as we undertook this project.

Bibliography

Baird, I. (ed.), *Social Networks in the Long Eighteenth Century: Clubs, Literary Salons, Textual Coteries*, Newcastle: Cambridge Scholars Publishing, 2014.

Banks, Joseph, *Correspondence Concerning Iceland: Written to Sir Joseph Banks*, 1771–1818, http://digital.library.wisc.edu/1711.dl/HistSciTech.BanksJ.

Banks, Joseph, *The Letters of Sir Joseph Banks, a Selection 1768–1820*, ed. Neil Chambers, London: Natural History Museum, 2000.

Banks, Sarah Sophia, *Catalogue of Coins*, Vol. 1–8, The British Museum Department of Coins and Medals.

Barrett, Katy, 'Writing On, Around, and About Coins: From Eighteenth-Century Cabinet to Twenty-First Century Database', *Journal of Museum Ethnography*, no. 25, Objects and Words: Writing On, Around, and About Things Papers from the Annual Conference of the Museum of Ethnographers Group Held at the Pitt Rivers Museum, U of Oxford, 14–15 April 2011 (2012): 84–80.

Belk, Russell W., 'Collectors and Collecting', in Christopher Tilley, et al. (eds.), *Handbook of Material Culture*, London: Sage, 2006, 534–545.

Bremner, Barbara, 'The Life, Times and Correspondence of Maria Josepha Holroyd (later Lady Stanley of Alderley)', PhD Thesis, School of History, Philosophy, Religion and Classics, The U of Queensland, 2004.

Crispell, Diane, 'Collecting Memories', *American Demographics*, 60 (Nov. 1988): 38–41.

Eaglen, R.J., 'Sarah Sophia Banks and Her English Hammered Coins', *British Numismatic Society* 79 (2008): 200–215.

Eagleton, Catherine, 'Collecting African Money in Georgian London: Sarah Sophia Banks and Her Collection of Coins', *Museum History Journal* 6, no. 1 (2013): 23–38.

Eagleton, Catherine. "Sarah Sophia Banks, Adam Afzelius and a Coin from Sierra Leone,' in Adriana Craciun and Simon Schaffer (eds.), *The Material Cultures of Enlightenment Arts and Sciences*, (London: Palgrave, 2016, 203–205.

Gibbons, Edward, *Memoirs of My Life and Writings*, ed. John Baker Holroyd, 1st Earl of Sheffield, 1796.

Gillray, James, *The Great South Sea Caterpillar, Transform'd into a Bath Butterfly*, The British Museum Department of Prints and Drawings, 1795.

Graham, Shawn, Ian Milligan and Scott Weingart, *The Historian's Macroscope—Working Title*, Under contract with Imperial College Press, Open Draft Version, Autumn 2013, http://themacroscope.org; 'Network Analysis.'

Greuber, Herbert Appold, *The Handbook of the Coins of Great Britain and Ireland in the British Museum*, The British Museum Department of Coins and Medals, London: William Clowes and Sons, 1899.

Hayes, Erica Y. and Kacie L. Wills, 'Visualizing Sarah Sophia Banks' African Coins', Interdisciplinary Digital Engagement & Humanities, vol. 1, issue, 1 (2020). https://doi.org/10.21428/f1f23564.1d32a4b3

Leis, Arlene, 'Cutting, Arranging, and Pasting: Sarah Sophia Banks as Collector', *Early Modern Women 9*, no. 1 (2014): 127–140.

Leis, Arlene, 'Displaying Art and Fashion: Ladies' Pocket-Book Imagery in the Paper Collections of Sarah Sophia Banks', *Journal of Art History 82*, no. 3 (2013): 252–271.

Leis, Arlene, 'Ephemeral Histories: Social Commemoration of the Revolutionary and Napoleonic Wars in the Paper Collections of Sarah Sophia Banks', in Satish Padiyar, Philip Shaw and Pilippa Simpson (eds.), *Visual Culture and the Revolutionary and Napoleonic Wars*, London: Routledge, 2017, 183–199.

Leis, Arlene, 'Sarah Sophia Banks: Femininity, Sociability and the Practice of Collecting in Late Georgian England', PhD Thesis, U of York, 2013, http://etheses.whiterose.ac.uk/5794/.

Pincott, Anthony , 'The Book Tickets of Miss Sarah Sophia Banks,' *BookPlate Journal 2* (2004): 3–30

Mew, Sophie, 'Trials, Blunders, and Profits: The Changing Contexts of Currencies in Sierra Leone', *The Journal of Imperial and Commonwealth History 44*, no. 2 (2016): 195–213.

Rea, Shilo, 'Six Degrees of Francis Bacon: Carnegie Mellon Mines Early Modern Social Network', 12 June 2013, www.cmu.edu/news/stories/archives/2013/june/june12_francisbacon.html.

Russell, Gillian, 'Sarah Sophia Bank's Private Theatricals: Ephemera, Sociability, and the Archiving of Fashionable Life', *Eighteenth-Century Fiction 27*, no. 3–4 (2015): 535–555.

Schwarz, Suzanne, 'Commerce, Civilization and Christianity: The Development of the Sierra Leone Company', in D. Richardson, S. Schwarz and A. Tibbles (eds.), *Liverpool and Transatlantic Slavery*, Liverpool: Liverpool UP, 2007, 252–276.

SSB I.21 MS, 'List of Coins etc Presents to Me and of Duplicates That I Have Bought', British Museum, Department of Coins and Medals.

SSB I.22 MS, 'Coins &c Which I Have Given Away', British Museum, Department of Coins and Medals.

Stanley, Baroness Maria Josepha Holroyd, *The Girlhood of Maria Josepha Holroyd Stanley, Recorded in Letters of a Hundred Years Ago, from 1776–1796*, ed. Jane Henrietta Adeane, London: Longmans, Green, and Co, 1896.

Stern, Marvin, 'Stanley [née Holroyd], Lady Maria Josepha (1771–1863), Letter Writer and Liberal Advocate', *Oxford Dictionary of National Biography*, 23 September 2004, www.oxforddnb.com/view/10.1093/ref:odnb/9780198614128.001.0001/odnb-9780198614128-e-74489.

Wawn, Andrew, 'John Thomas Stanley and Iceland: The Sense and Sensibility of an Eighteenth-Century Explorer', *Scandinavian Studies 53*, no. 1 (1981): 52–76.

Weingart, Scott and Jessica Otis, 'Gender Inclusivity in Six Degrees', *Six Degrees of Francis Bacon: Reassembling the Early Modern Social Network*, 5 January 2016, https://6dfb.tumblr.com/post/136678327006/gender-inclusivity-in-six-degrees.

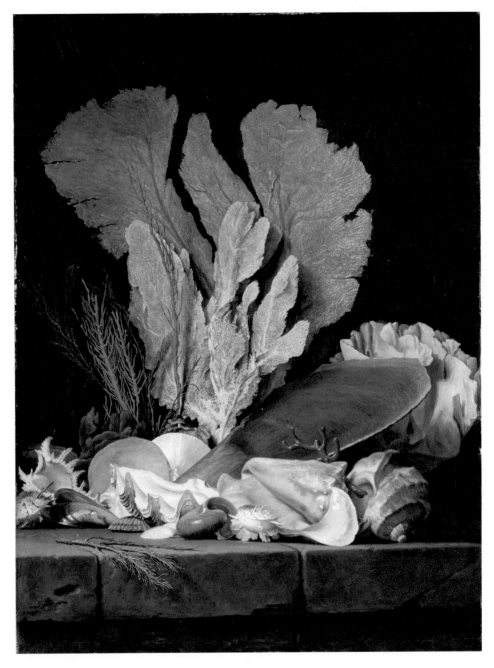

Plate 1 Anne Vallayer-Coster (1744–1818), *Still Life with Seashells and Coral*, 1769. Oil on canvas, 130 × 97cm. Musée du Louvre, Paris.

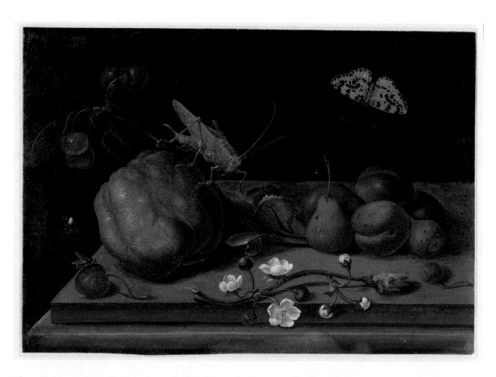

Plate 2 Maria Sibylla Merian, *Still Life with Fruits, Cherry Blossom Twig, a Bush Cricket and Magpie Moth, on a Table*. Watercolour on vellum. bpk Berlin/Kupferstichkabinett, SMB.

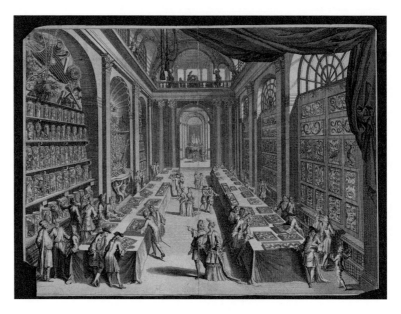

Plate 4 Illustration from Levinus Vincent's catalogue of his collection *Wondertooneel der Nature*, c.1706. Engraving by Andries van Buysen.

Plate 5 Anonymous, *Maria Thérèse Charlotte de France*, 1796. Oil on canvas, 138 × 98cm. Palazzo delle Aquile, Palermo, Sicily.

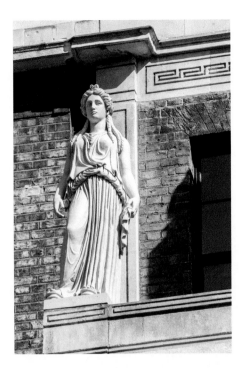

Plate 6 Eleanor Coade, Caryatid figure after those supporting the porch of the Erechtheion, on the Acropolis in Athens. © Sir John Soane's Museums, London. Photograph by Gareth Gardner.

Plate 7 'Painting and verses by Margaret Casson, July 8th, 1796', Anne Wagner's Album, Carl H. Pforzheimer Collection of Shelley and His Circle, The New York Public Library, *The New York Public Library Digital Collections*.

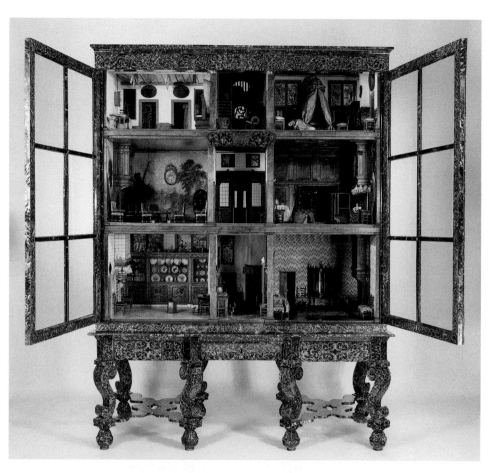

Plate 8 The Dollhouse of Petronella Oortman, 1686–1711. Wooden case, various materials, 255 × 190 × 78cm. Amsterdam, Rijksmuseum.

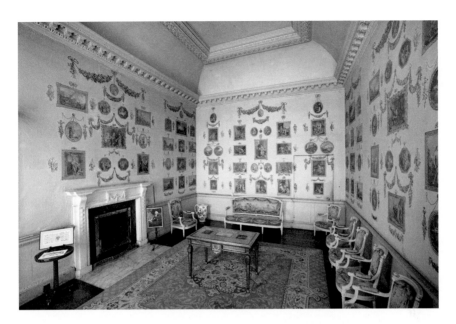

Plate 9 The print room at Castletown House. © Office of Public Works, Castletown House.

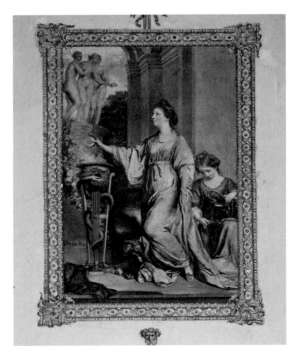

Plate 10 Edward Fisher after Joshua Reynolds, *Lady Sarah Bunbury Sacrificing to the Graces*, 1766. Mezzotint. © Office of Public Works, Castletown House. Photograph taken in November 2010.

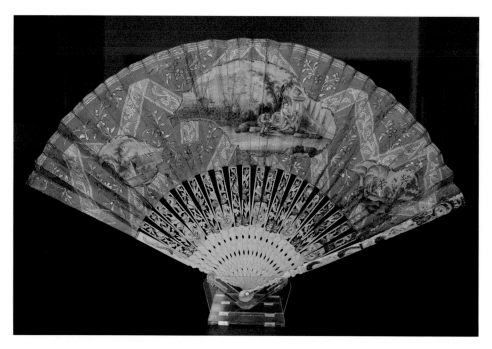

Plate 11 Eighteenth-century, French folding fan. Tomasi Di Lapadusa Museum, Palazzo Butero 28, Palermo, Sicily.

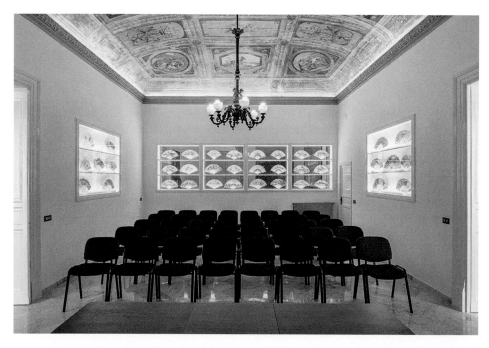

Plate 12 View of the conference suit at the Tomasi Di Lampadusa Museum, Palazzo Butero 28, Palermo, Sicily.

6 Conversing With Collecting the World

Elite Female Sociability and Learning Through Objects in the Age of Enlightenment

Lizzie Rogers

Introduction[1]

In Levinus Vincent's catalogue of his collection *Wondertoonel der Nature*, dated 1706, we are presented with a wonderful image of the collector's gallery in Amsterdam (Plate 4). Open cabinets burst with an abundance of curios; trays of objects on long tables are marvelled at and inspected closely in conjunction with the consultation of books from the bottom shelves. The gallery is a hive of activity, an environment of conversation and knowledge exchange as visitors move around the collection, pointing things out and seeking to understand each object on display. This chapter begins with this brilliantly detailed image not just as a representation of an early eighteenth-century collection, but because of the presence of both sexes in the gallery. Both women and men are experiencing an intellectual journey within the collection, equally engaging with objects and discussions, literally experiencing becoming enlightened through practising curiosity and exchanging knowledge with others. The image visually frames the crux of this chapter: that the social and material were crucial to the elite female experience of the Enlightenment.

This chapter will explore the two avenues of sociability and materiality through the letters exchanged between Henrietta Fermor, Countess of Pomfret (1698–1761), and Frances Seymour, Countess of Hertford (1699–1754), published in three volumes in 1805.[2] Framed by the themes of discovery, learning and collecting, the letters begin following the completion of Lady Hertford and Lady Pomfret's roles as Ladies of the Bedchamber to Queen Caroline. They cover a three-year period from September 1738, when Lady Pomfret departed for a tour of continental Europe with her husband, Thomas Fermor, Earl of Pomfret, and their two eldest daughters. Lady Hertford remained at home in England, but, as this chapter will demonstrate, held a serious stake in her close friend's travels: she learned and gained as much both socially and materially as Lady Pomfret did whilst physically travelling. Not only do these letters offer an insight into the myriad ways women could engage with collecting the material object, but also the processes by which women could collect knowledge within the eighteenth century. The letters demonstrate engagement with the educative experience[3] of becoming enlightened and enlightenment as experienced in different geographical and cultural locations. They also portray a shared experience, fully realised through social interaction and object exchange.

Collecting Social Experiences and Cataloguing Conversations

On 23 October 1740, Lady Hertford wrote to Lady Pomfret full of praise for the type of travel her friend had embarked upon: a Grand Tour that had her meeting several interesting characters and visiting a variety of sites and collections. Everything was communicated back to Lady Hertford with intense detail. Lady Hertford eulogised:

> since, besides a variety of objects and knowledge which it furnishes to people of any curiosity, I think it useful in enlarging the mind, and aspiring it with a more universal benevolence to its fellow-creatures.[4]

Furthermore, she added:

> those persons who live only within the circle of a few friends and acquaintance, are apt to entertain narrow opinions, and unjust prejudices against whatever is out of the sphere of their knowledge. I have always thought that truth, good-sense, and reason, are much the same in all places.[5]

Here, Lady Hertford pinpointed the importance of collecting other knowledge and experiences than those immediately available, making it clear she believed sociability and social opportunities to be inherently linked to the act of collecting such things. The opportunity to discuss and reframe knowledge according to contact with new places, experiences, and things had an indelible effect on personal understanding and private aspirations to learning. Arguably, in the way Lady Hertford framed it, it also impacted on an individual's compassion for other people, cultures and places, as well as the way they conducted themselves with care in relation to this—intimately linking enlightenment cultures of discussion to the wider development of politeness during the eighteenth century. Lawrence E. Klein has asserted that the Enlightenment should be seen as a moment in the history of human conversation.[6] Enlightenment intellectual culture was intimately bound to codes of conversation, sociability, and politeness through the active engagement and participation of many people in the quest to shed light and break free from the chains of old, outdated knowledge.[7]

Lady Hertford's recognition of the potential of sociability to provide knowledge exchange is unsurprising due to the centrality of women to social politics: Elaine Chalus has summarised that eighteenth-century women were social beings, and that the management of people and social situations for political ends were often a fact of life for women.[8] Women were socially intuitive, and the Pomfret and Hertford letters act as a site of conversation between not only the two women, but others whom Lady Pomfret met on her tour and the intellectual spaces they had the opportunity to enter. For example, Lady Pomfret wrote to Lady Hertford in June 1741 from Bolsano, Italy, that she had been invited by the Venetian *procuratessa* Foscarini, her niece, and three gentlemen to attend a meeting of the Academy of Sciences that she unfortunately could not attend.[9] Letters were a social practice central to women participating in the intellectual culture of the late seventeenth and early eighteenth centuries; thus, the materiality of the letter shaped the life of the mind.[10] Conversations begun in the physical world in one circle were furthered in the written world, acquaintances and experiences shared and examined in further detail (Figure 6.1). In April 1740, Lady Pomfret discussed a meeting she had with a local historian working in Florence. He had shared with her manuscripts

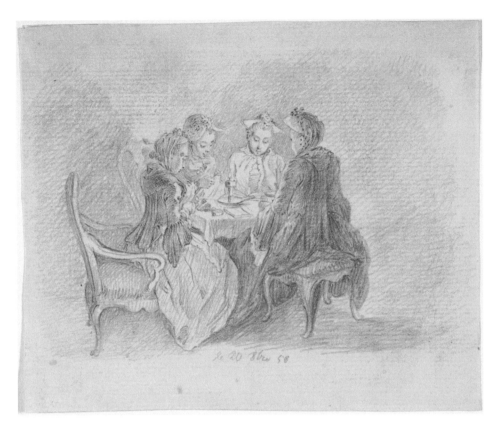

Figure 6.1 Daniel Nikolaus Chodowiecki, *Four Ladies Sitting Around a Table Occupied with Needlework, Reading, and Writing*, 1758. Drawing.

Source: Courtesy of the Metropolitan Museum of Art. CC0 1.0.

relating to the affairs of the Medici family, which she shared with Lady Hertford, adding: 'If it will give you any pleasure to have such imperfect accounts as I can find there, I will not fail to send them to you, in as plain English as I can'.[11] For Lady Pomfret, learning did not stop with encountering the local historian: she was dedicated to passing these ideas on to satiate the intellectual curiosity of her friend, and this was an important part of the encounter itself.

Snippets of these encounters made it into the letters, and the act of sharing meant that knowledge exchanged moved even further along the networks of these women, with these letters effectively forming a co-created catalogue of knowledge collected throughout the three-year period. Letters created the intimacy crucial to an intellectual friendship.[12] Such friendships offered women a kind of solution to their exclusion from privileged spaces of learning, with the relationships cultivated through correspondence representing the receipt of mentoring and the giving of guidance which was invaluable to female participation in scholarly cultures. This fuelled female intellectual curiosity and the creation of their own ever-evolving collections of knowledge outside

of the institution to support their interests.[13] Friendships could be built on the basis of shared intellectual interests and created fertile spaces for learning that mimicked institutional modes of discussion.

The act of conversing with each other enabled both Lady Hertford and Lady Pomfret to validate their own intellectual curiosities and for both to benefit from the active physical engagement of Lady Pomfret with various circles of scholarly activity on the continent. This was done both as a result of their friendship and as a stimulant to it: by shedding light on subjects, reading widely and sharing with each other, and the focus on material objects both encountered and collected, their relationship became one of kindred spirits, working to a common goal of collecting further knowledge. Conversation's importance to the processes of friendship and enlightenment was celebrated by Hannah More in her 1786 text *The Bas Bleu: or, Conversation*, which praised the intellectual curiosity, discovery and discussion of the Bluestocking Circle. More wrote:

> Enlighten'd spirits! you, who know
> What charms from polish'd converse flow
> Speak, for you can, the pure delight
> When kindred sympathies unite;
> When correspondent tastes impart
> Communion sweet from heart to heart:[14]

The process of validation of women pursuing intellectual activity is one Lady Pomfret and Lady Hertford discussed in depth. Both clearly supported women as collectors and as learners—it cannot be forgotten that Lady Hertford married into the Percy dynasty, and her daughter was the formidable Elizabeth Percy, First Duchess of Northumberland, who created her own museum within Northumberland House in London.[15] In their letters, they lauded intellectual women, with Lady Hertford commenting of the Bluestocking Elizabeth Carter, who translated *Epictetus*,

> I am well informed that she is an admirable Greek and Latin scholar; and writes both these languages, as well as French and Italian, with great elegance. But, what adds to the wonder she excites is, that all this learning has not made her the less reasonable woman, the less dutiful daughter, or the less agreeable and faithful friend.[16]

In response, Lady Pomfret penned the very reverential:

> I thank you for transmitting to me what the wit or dulness of our countrymen produces; and am very proud of the genius that honours our sex in the person of the young woman you mention.[17]

For Lady Pomfret and Lady Hertford, fulfilling the moral and traditional duties of womanhood was not mutually exclusive with being learned. This was a judgement often linked to women who wished to pursue learning, with the 'woman question' frequently occupying enlightenment thinkers.

Women were subject to a double-edged sword during the Enlightenment: they were now accepted to study, but simultaneously became objects of study themselves. Early Enlightenment ideas, such as those of philosopher John Locke, opened up further

discussions about the educability of women and their participation within public intellectual culture. Locke's theorisation of the mind as a *tabula rasa*, or blank slate, upon which experiences of the outside world imprinted themselves, constituting the first ideas that the mind could then proceed to actively build upon more complex ideas, rendered learning as a process which required observation and discipline.[18] More importantly, it was a concept that did not exclude women. The new epistemological methods of philosophers such as Francis Bacon and René Descartes made the systematic investigation of woman possible, which was crucial to the establishment of gender discourse, and resulted in the huge market of conduct literature published for women.[19] These were both eulogising and admonishing of women, but ultimately, these disagreements between scholars and writers left gaps for women to carve a role for themselves. Using connections, shared interests, and curated friendships was something advocated by enlightenment writers, with philosophers such as Defoe, Voltaire, and Condorcet calling for more social opportunities for women to use and acquire skills and learning.[20]

Despite such encouragement, women who collected as a hobby faced scrutiny as insatiable consumers, switching their role from being emblematic of progress to being symbolic of shopping and luxury.[21] Whether collecting knowledge or objects, or working the two into a tandem process in order to shed light on the wider world, women had a multitude of criticisms to consider when negotiating their roles as collectors and learners. Connecting with others who had successfully evinced these occupations, and heralding them as role models, ensured the continuation of these activities and conversations, pushing women further in their quest for some kind of enlightenment. Lady Pomfret and Lady Hertford had found kindred spirits within each other as two people who saw the stimulant social networking was to knowledge exchange, both in person and via the written word, and their friendship throughout the three-year period of letters seemed to become increasingly reoriented with this as their main focus. The experiences shared with each other became a collection of social encounters that transformed their own knowledge and understanding, with both women collecting role models and ideas from various actors in Lady Pomfret's Grand Tour that were catalogued within their letters.

Perhaps the most significant social encounter in these letters is that of Laura Bassi, the first woman to hold a science professorship and the second woman ever recorded to have a PhD, after Elena Cornaro in the seventeenth century.[22] Bassi's presence in a male-dominated university at Bologna was revered by Lady Pomfret and Lady Hertford: though put on a pedestal, Bassi's teaching position gave her a firm foot inside the dignity and respect of the academy and university. The universal appraisal of the learned woman was tricky territory to navigate. Whilst being celebrated, she also ran the risk of being aestheticized in a way that inherently diminished her intellectual achievements and lauded her as a muse. This parallel can perhaps be detected in Richard Samuel's famous group portrait *The Nine Living Muses of Great Britain*.[23] On one hand, it celebrated their achievement, yet Samuel did not paint any of the women from life, so it lacked a direct connection with those it represented. As Lisa Jardine has explained in her work on women as 'muse' in the Renaissance, learned women became connected in the imagination of men, metamorphosing from individual talented learners to a representative type of female worth.[24] The admiration of learned women could tread a fine line between engagement with their intellectual talents and the ornamentalisation of these in the same manner as beauty or virtue.

This was why making connections through travel and letter-writing was so crucial to the inherent learning and collecting agenda of Lady Pomfret and Lady Hertford's friendship. The chance to converse with such a woman humanised her and recognised her for her individual talent, as well as elevated their own understanding; records of this made tangible the 'superior knowledge and capacity' that Bassi had which they so admired.[25] The dialogue with Bassi made active Lady Pomfret's, and by extension Lady Hertford's, engagement with cultures of knowledge, as explored in Klein's framework of understanding enlightenment through conversation.[26] The collection of these experiences by Lady Pomfret and their sharing with Lady Hertford really informed their attitudes about the heights intellectual women could climb to, and what was deemed acceptable for women to do in the name of the collection of knowledge. Lady Pomfret wrote of the encounter on 29 May 1741:

> [we] went to the house of the famous doctress signora Laura Bassi, where all but the signora Gozzadini, and the English, left us. She is not yet thirty, and did not begin to study till she was sixteen, when, having a tedious illness, and being attended by a physician who was a man of great learning, he perceived her genius, and began to instruct her with that success that she is now able to dispute with any person whatever on the most sublime points. This she does with so much unaffected modesty, and such strength of reason, as must please all hearers, of which number we were; for the signora Gozzadini, who is herself very clever and prodigiously obliging, had got two doctors to meet us here. . . . I wish I was capable of translating the dialogue; for I flatter myself that our tastes are so much alike that you would be no more tired of reading, than I was of hearing, it. With many thanks, and not without reluctance, I left this house, to conclude the evening at the Casino.[27]

Lady Hertford responded: 'It would have made me very happy, could I have attended you to visit the signor Laura Bassi. Her attainments do honour our sex'.[28] This idea that a learned woman could honour the rest of her sex pinpointed the active way Lady Hertford and Lady Pomfret believed women should participate in cultures of knowledge creation, collection, and circulation. Understanding this meant that they had the expectation for themselves and others that women were meant to learn and exercise their own curiosity about the world, and it was something to be admired. Having this at the forefront of their minds when discussing these social encounters, the things they had read, and the places Lady Pomfret visited informed the way they connected with new knowledge. What is especially significant about the collection of new knowledge within the friendship of Lady Pomfret and Lady Hertford was that besides being associated with instances of important conversation, it often worked in tandem with the discussion of material objects that represented new ideas in a tangible, visible, and thought-provoking way.

Collecting and Curating Tangible Knowledge

Objects acted as a significant part of many of the social encounters discussed by Lady Pomfret in her correspondence with Lady Hertford. Not only this, but they became illustrative of people and of concepts, and were key to experiencing new knowledge and developing new understandings. Visiting continental collections gave Lady Pomfret much to write about to Lady Hertford, and for Lady Hertford to offer comment on.

These undoubtedly informed their own material practices, acquainting them with different types of display, objects, and, of course, the collectors themselves. Just as enlightened and intellectually active women offered examples for elite women to follow, so did collectors of all different backgrounds and interests. Opening up their collections for these women to view—much like Vincent in the catalogue frontispiece that began this chapter—meant engagement with individual objects and of meanings of collections as a whole. It had women pondering the questions that collections raised about the world beyond their experience and about the role of the collector in both assembling the objects and the knowledge the objects made tangible. By recording their responses for each other, Lady Pomfret and Lady Hertford were effectively co-creating a catalogue of knowledge, objects, and experiences upon which their friendship thrived.

Examining how particular collectors engaged with their own objects could illuminate the potential of collecting as a way to learn about the world. The collector could be a curious figure, completely incongruous to how women collectors during this period viewed themselves and their agenda. Perhaps this made the activity of collecting more interesting and enlightening. Lady Pomfret's July 1740 visit to a Florentine collector named Cosimo Riccardi revealed a collection that was

> full of the best pictures, statues, and furniture, that are to be seen in Florence; and containing a noble collection of books, medals, intaglios, cameos, and so vast a quantity of plate (both useful and ornamental) that it appears rather the treasure of a sovereign prince than that of a private person.[29]

Yet this princelike collection, though created by 'one of the richest men in this country', saw its owner in 'dress and person greatly resemble those of an old broken shop-keeper'.[30] She was clearly puzzled by Riccardi's demeanour, but finished her description with a key observation that, in being surrounded by all of these objects and being visited by many people, he was crazed by the pursuit of knowledge, employing staff specifically to fill 'hundreds of volumes with his observations, or rather his collections'.[31] Riccardi's collection did not stop with the material objects presented in his home: it was intimately connected to his understanding of the objects and the world beyond. His knowledge as written down had become a collection in itself, recorded diligently 'in order to retain what he learns'.[32] This practice is not dissimilar to reading the letters between Lady Hertford and Lady Pomfret as a catalogue of the collection of knowledge. Objects were integral, and the physical act of acquiring objects crucial to their learning progress, whether that be books or other artefacts,[33] but the knowledge acquired in cultivating their minds as a by-product of engaging with the material became a collection of sorts too.

Thus, Lady Pomfret became shrewd in the way she appraised collections, taking special note of how the collector was represented or recalled in a collection and how they came to amass their collections. It became as much a part of her reportage as the collections themselves, and sometimes took precedence when she felt anxiety for doing justice to the objects she had seen. In October 1740, she visited the Ducal collection in Florence with Lady Mary Wortley Montagu, explaining to Lady Hertford that in seven rooms, the collection held 'more treasure than I can either pretend to describe, or even to have examined as it deserves'.[34] Yet she did run through the cabinets in the different rooms, the mathematical instruments, the art and the statues. In particular, she became interested in a statue which commanded the third room of the collection.

It represented the man who had designed the room it stood in: Cardinal Leopoldo, the son of Cosimo[35] II de' Medici, and was erected by the Cardinal's nephew, Cosimo III. She noted his commemoration:

> At the feet is an inscription, signifying who he was; and that it was he who collected and placed there the *ritratti* of all the eminent painters of every country, done by themselves.[36]

Similarly, when visiting the Villa Borghese in Rome (Figure 6.2) with the Contessa Bolognetti a few months later, Lady Pomfret declared the collection was 'the richest in antiquities that I ever saw'.[37] Like her fascination with the Cardinal in Florence, her next preoccupation was 'So vast a treasure, in a private family, gave me curiosity to inquire how it came there', and discovered that Cardinal Scipio Borghese constructed both the palace and the collection when his uncle was in power as Pope Paul V.[38] Understanding the collectors behind these spaces and how the objects found their way into the collections, particularly when staged in private homes, must have been intriguing for women who themselves were interested in the same activity. Collecting is symptomatic of an individual's desire to understand the wider world and reconcile themselves to their place in it,[39] and female visitors to these collections in

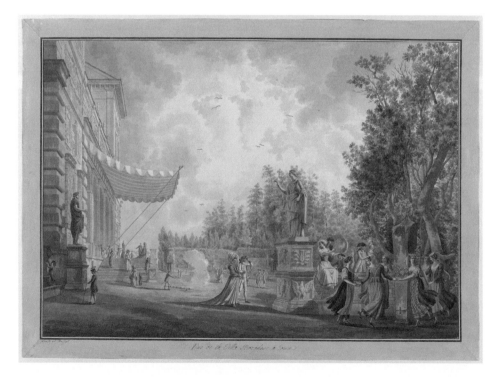

Figure 6.2 Giovanni Volpato, Villa *Borghese*, ca. 1780. Etching.
Source: Courtesy of the Metropolitan Museum of Art. CC0 1.0.

the eighteenth century clearly had these ideas at the forefront of their minds. When entering into conversations that convened around the objects before them, they were looking to comprehend how the collector had tried to create a microcosm of the world as they understood it.

Part of this was appraising the way the collections were presented: whether they allowed the objects to take full presence and reach their potential in raising questions and explaining new concepts, or whether they fell short. This would have been invaluable in enabling women to understand the importance of presentation and curation: how they could create their own microcosms of the worlds of knowledge they were attempting to understand. Lady Pomfret was quite indignant when she felt collections were neglected in this respect, rendering them useless. Upon visiting the Barberini Palace in Rome in 1741, (Figure 6.3) she listed the wide variety of objects on show, including paintings, busts, tapestries, and silver, but her ultimate verdict on the objects was that:

> they are so crowded and ill kept, that they appear a heap of fine things going to ruin as fast as possible: and of the many apartments I passed through, I could not see one comfortable room, nor a piece of furniture that seemed to have been of any use since the death of the first owner.[40]

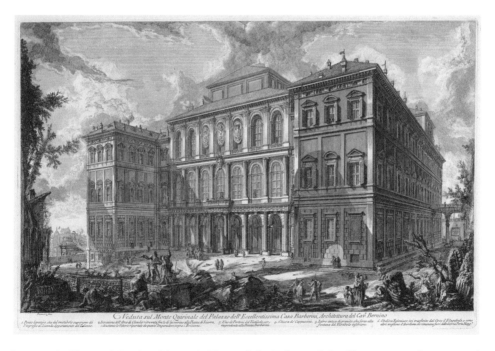

Figure 6.3 Giovanni Battista Piranesi, *View of the Palace of the Illustrious Barberini Family on the Quirinal Hill, Designed by Cavaliere Bernini, from Vedute di Roma (Roman Views)*, ca. 1750–1759. Etching.

Source: Courtesy of the Metropolitan Museum of Art. CC0 1.0.

That was not all. A longer description is devoted to a similar experience she had a few days later when she entered the palace of Prince Giustiniani:

> In my life I never saw a worse: the rooms (I mean those of state, where the family never live) were small dark, dirty and without any furniture, except old leather chairs, bad statues, and very indifferent pictures, without frames. You will wonder, and indeed I did, why I was taken thither; but at last I arrived at a gallery, once painted by Zucchero, but now covered with mould, arising from damps, which emitted no very agreeable smell. Here, on both sides, stood as thick as possible three or four rows of statues and busts, but so confusedly, that it was hardly possible to distinguish them as one ought. The place much more resembled a sculptor's shop, than the collection of a nobleman.[41]

The visiting of collections developed women's knowledge of how they should be presented, what uses should be made of them, and helped them reflect upon their own use of objects and what traditions, ideas, and interests these would reflect.

The travels Lady Pomfret pursued helped both her and Lady Hertford experience different kinds of intellectual traditions, allowing them to exercise knowledge as a form of social currency and add to it with each new encounter. This happened immediately for Lady Pomfret as physically present, but for Lady Hertford, who travelled 'on the wings of the imagination',[42] the letters recorded each item for her to bank in her own collection of imagined experiences, further exploring them through additional reading and objects she had available to her. Through this process of sharing, both women could virtually enter various spaces of enlightenment cultures of learning. One in particular which was particularly rousing for both of them was a visit Lady Pomfret made to Ambras Castle[43] whilst staying at Innsbruck. Here, she viewed the collection of the sixteenth-century Archduke Ferdinand. Lady Pomfret was highly impressed with the 'great and magnificent collection of various kinds of curiosities, which has been since much augmented by his successors'.[44] She went on to outline the entrance hall and eighteen rooms which contain a variety of objects, including armour, cabinets, natural history specimens, ivories, clocks, miniatures, minerals, and antiquities, ending with the summary that:

> I stood for some hours (without knowing it) looking on these treasures; for when I left Italy, I did not imagine in the Alps to find anything of this sort, or that the German princes were greater *virtuosi* than the Italians; but by experience I find that virtue and knowledge are the growth of every climate, as well as vice and ignorance, and travelling convinces one of this truth.[45]

Entering into conversation with new spaces of scholarly practice meant that both women could experience a different kind of enlightenment and collecting tradition, adding further to their knowledge in understanding their own relationship to and uses of the material world. An insight is provided into Lady Pomfret's understanding of the geographical specificity of intellectual traditions: she noted the differences from the Italian collections, growing out of the Renaissance *studiolo*, when confronted with an assemblage undoubtedly in the tradition of the German *Wunderkammer*, or Cabinet of Curiosity. Musing upon this and realising there were several paths to follow in collecting must have been an educational experience. Sharing with Lady Hertford meant both

women were engaged with the cultural experiences that travel offered, and were able to discuss and understand what they meant, particularly within the context of what they knew. Dana Arnold has suggested that travel meant acquaintances with different natures which encouraged a kind of pan-European consciousness,[46] further encouraging links between different intellectual pockets around Europe and further away in an Enlightenment fashion; she quoted Laurence Sterne: 'It is an age so full of light, that there is scarce a country or corner of Europe whose beams are not crossed and interchanged with others'.[47]

Yet it was not just the written word and the opportunity for reflection that Lady Pomfret sent to Lady Hertford from the continent. Whilst these conversations locked Lady Hertford into the social networks Lady Pomfret was creating as she travelled across continental Europe, it was the present of a set of earthenware from Florence that made tangible the world she imagined beyond her physical reach. Lady Pomfret had these commissioned in February 1740 and had very high standards for the gift she was to send back. She desired it to be perfect for her friend and gave many options to Lady Hertford:

> I can supply you from hence with alabaster vases, small brass statues, or marble and paste tables extremely fine and beautiful . . . for I must have a representative in your grotto, where, retired from better company, I would sometimes steal on your remembrance.[48]

These objects were a means of cementing the friendship between the two women, not only evoking the bond they shared but also celebrating their common goal of the collection of knowledge and understanding by a physical means. They were the 'kindred spirits' in conversation as described by Hannah More in *The Bas-Bleu*.[49] Their letters catalogued this goal and the conversations they had had with each other, with collections of objects and with other people, but these objects made it visible to others. The deliberation over the gift also saw the two women exercising their discernment and taste and what they had learned through other objects and collections. The two women had built an intellectual world through their epistolary relationship, as well as an emotional connection that offered a significant outlet for both of them. Lady Hertford's response to Lady Pomfret showed her happiness at the way her friend honoured their relationship:

> You confound me, dear madam, by requesting me to choose you a representative in my grotto: you will never want one in my heart; where your image is immoveably fixed, with every amiable quality to adorn and secure its seat. But, if I am to have yet another proof of your generosity, I must prefer the alabaster vases, which may serve as a monument of the happiness I enjoy in your friendship; and I shall take care to place them so as that an inscription can be put under them, that may perpetuate the memory of what I am so justly proud of.[50]

The vases arrived in September of the same year, and Lady Hertford not only adored them for the beauty and skill in their craftmanship, but moreover because of 'there being a mark of your friendship enhances their value to me even beyond their own merit'.[51] Having a physical souvenir from her friend's life on the continent meant that Lady Hertford now had with her a piece of the imagined world of European curiosities and collections that had been described to her so many times, a world she had traversed every

day in her mind and that had made an indelible mark on her understanding and self-directed learning. Their value was indescribable:

> I have not a room in my house worthy of them; no furniture good enough to suit with them: in short, I found a thousand wants that never entered my head before. I am grown ambitious all at once: and want to change my *bergerie* for a palace; and to ransack all the cabinets in Europe for paintings, sculptures and other curiosities, to place with them.[52]

These vases presented an overpowering desire to have more of a material grasp of the world out of reach, to create a microcosm of the Europe experienced by her friend within her own home. They were a further stimulus for her to engage with her friend's activities and utilise the letters sent to her in an effective way that secured her space within wider conversations that reached far beyond the country house she stayed in. Coupled with the letters, material representations of a world of discovery for oneself offered Lady Hertford agency: she, too, could achieve what her friend had done physically by her pen and her imagination.

Conclusion

The letters between Lady Pomfret and Lady Hertford offer a three-year snapshot of an intellectual friendship that thrived upon the social and material. They highlight collecting and the use of collections as activities experienced in numerous interesting ways that acted to enlighten elite women and give them agency over their own education and learning. The letters acted as a catalogue of knowledge gained as well as a site of conversation: they were physical objects inscribed with social and educative experiences, constantly exchanging, curating and challenging knowledge and contemporary ideas. They were a space of enlightenment, demonstrating further the fluidity of Enlightenment spaces for women and the centrality of conversation to engaging with intellectual culture and improvement. Lady Pomfret and Lady Hertford's experiences—or rather, shared experiences—show the collaborative nature of the process of searching for knowledge: their friendship was fashioned and sustained by a shared love of collecting both knowledge and things, focussed on a common goal of becoming enlightened.

Notes

1. I would like to thank my three supervisors, Dr Amanda Capern, Professor Jessica Malay, and Dr Briony McDonagh, for previously giving me feedback on much of the material in this chapter which has shaped the ideas framing my research. As well as this, I would like to thank the BSECS Presidents' Prize Committee 2019 for their interest in this research, and the delegates to the panel in which I presented my paper for their questions and discussion, from which grew this chapter. Most of all, I'd like to thank Edward Mair and Gill Rogers for reading drafts of this chapter and offering feedback and enthusiasm, as well as the editors of this volume for their insightful and encouraging comments.
2. See *Correspondence Between Frances, Countess of Hartford and Henrietta Louisa, countess of Pomfret* (London: Printed by I. Gold, Shoe Lane, for Richard Phillips, No. 6, Bridge-Street, Blackfriars, 1805), published in three volumes.
3. Geraint Perry, 'Education and the Reproduction of the Enlightenment', in Martin Fitzpatrick et al. (eds.), *The Enlightenment World* (Abingdon: Routledge, 2007), 217.
4. *Correspondence Between Frances and Henrietta*, vol. II, 172–173.

5. *Correspondence Between Frances and Henrietta*, vol. II, 173.
6. Lawrence E. Klein, 'Enlightenment as Conversation', in Keith Michael Baker and Peter Hanns Reill (eds.), *What's Left of Enlightenment? A Postmodern Question* (Stanford: Stanford UP, 2001), 150.
7. See Roy Porter, *Enlightenment: Britain and the Creation of the Modern World* (London: Allen Lane, 2000) for further discussion of the idea of being freed from the chains of old knowledge, in particular within the Introduction and Chapter 1.
8. Elaine Chalus, *Elite Women in English Political Life c.1754–1790* (Oxford: Oxford UP, 2005), 77–78.
9. *Correspondence Between Frances and Henrietta Louisa*, vol. III, 243.
10. Leonie Hannan, 'Women's Letters: Eighteenth Century Letter-Writing and the Life of the Mind', in Hannah Greig, Jane Hamlett and Leonie Hannan (eds.), *Gender and Material Culture in Britain Since 1600* (London: Palgrave Macmillan, 2016), 32.
11. *Correspondence Between Frances and Henrietta Louisa*, vol. I, 207.
12. Hannan, 'Women's Letters', 42.
13. For discussion of this in the seventeenth-century Republic of Letters, see Carol Pal, *Republic of Women: Rethinking the Republic of Letters in the Seventeenth Century* (Cambridge: Cambridge UP, 2012), 18–19.
14. Hannah More, *Florio: A Tale, for Fine Gentlemen and Fine Ladies: And, the Bas Bleu; or, Conversation: Two Poems* (London: Printed for T. Cadell, in the Strand, 1786), 84–85.
15. See Adriano Aymonino, 'The *Musaeum* of the 1st Duchess of Northumberland (1716–1776) at Northumberland House in London: An Introduction', in Susan Bracken, Andrea M. Gáldy and Adriana Turpin (eds.), *Women Patrons and Collectors* (Newcastle upon Tyne: Cambridge Scholars Publishing, 2012), 102–120.
16. *Correspondence Between Frances and Henrietta Louisa*, vol. I, 93.
17. *Correspondence Between Frances and Henrietta Louisa*, vol. I, 109.
18. Perry, 'Education and the Reproduction of the Enlightenment', 218.
19. Anthony Fletcher, *Gender, Sex and Subordination in England 1500–1800* (New Haven: Yale UP, 1995), 383.
20. Katherine B. Clinton, 'Femme et Philosophe: Enlightenment Origins of Feminism', *Eighteenth-Century Studies* 8, no. 3 (1975): 289–290, 295.
21. In fact, Scottish Enlightenment writers, such as David Hume, praised the polite fashion for mixed assemblies due to the refining effect of female behaviour, and in general women were often enshrined within public imagination as the initiators of social and cultural change. See Porter, *Enlightenment*, 325; and Arianne Chernock, 'Cultivating Woman: Men's Pursuit of Intellectual Equality in the Late British Enlightenment', *Journal of British Studies* 45, no. 3 (2006): 516–517.
22. Elena Cornaro obtained her doctorate in philosophy at Padua on 25 June 1678, in which she combined the study of Aristotelian philosophy with the humanities. See Paul Oskar Kristeller, 'Learned Women of Early Modern Italy: Humanists and University Scholars', in Patricia H. Labalme (ed.), *Beyond Their Sex: Learned Women of the European Past* (New York and London: New York UP, 1980), 103.
23. The muses represented were Elizabeth Montagu, Elizabeth Griffith, Elizabeth Carter, Charlotte Lennox, Elizabeth Linley, Angelica Kauffman, Catharine Macaulay, Anna Barbauld, and Hannah More. Interestingly, all but one of the women earned a living from the talents alluded to in Samuel's portrait. See Elizabeth Eger, *Bluestockings: Women of Reason from Enlightenment to Romanticism* (Basingstoke: Palgrave Macmillan, 2012), 1.
24. Lisa Jardine, ' "O Decus Italiae Virgo", or the Myth of the Learned Lady in the Renaissance', *The Historical Journal* 28, no. 4 (1985): 809.
25. *Correspondence Between Frances and Henrietta Louisa*, vol. I, 110.
26. See Klein, 'Enlightenment as Conversation', 148–166.
27. *Correspondence Between Frances and Henrietta Louisa*, vol. III, 179–180.
28. *Correspondence Between Frances and Henrietta Louisa*, vol. III, 317–318.
29. *Correspondence Between Frances and Henrietta Louisa*, vol. II, 9–10.
30. *Correspondence Between Frances and Henrietta Louisa*, vol. II, 9–10.
31. *Correspondence Between Frances and Henrietta Louisa*, vol. II, 10.
32. *Correspondence Between Frances and Henrietta Louisa*, vol. II, 10.

33. Both women enjoyed sending book recommendations, or indeed procuring books, for each other. Lady Hertford mentioned reading the letters of Madame de Sevigné [Vol. I, 24], histories and other accounts of travel [Vol. I, 69–70] as well as offering to put Lady Pomfret's name down on a list to subscribe to the papers of Thurloe, secretary to Oliver Cromwell [Vol. I, 194–195]. For her part, Lady Pomfret offered opinions on many of Lady Hertford's readings and books and relished the moments during which she was 'in silent conversation with my books and writing-table'. [Vol. I, 54.]
34. *Correspondence Between Frances and Henrietta Louisa*, vol. II, 119.
35. In the letters, Lady Pomfret spells the name of Cosimo II de' Medici and Cosimo III de' Medici as 'Cosmo'.
36. *Correspondence Between Frances and Henrietta Louisa*, vol. II, 120.
37. *Correspondence Between Frances and Henrietta Louisa*, vol. II, 308–309.
38. *Correspondence Between Frances and Henrietta Louisa*, vol. II, 309.
39. Susan Pearce, *On Collecting* (London: Routledge, 1995), 25.
40. *Correspondence Between Frances and Henrietta Louisa*, vol. III, 76.
41. *Correspondence Between Frances and Henrietta Louisa*, vol. III, 85.
42. *Correspondence Between Frances and Henrietta Louisa*, vol. I, 160.
43. *Correspondence Between Frances and Henrietta Louisa*, vol. III, 256. Recorded in her letter as Castle Amras.
44. *Correspondence Between Frances and Henrietta Louisa*, vol. III, 256.
45. *Correspondence Between Frances and Henrietta Louisa*, vol. III, 261–262.
46. Dana Arnold, 'The Illusion of Grandeur? Antiquity, Grand Tourism and the Country House', in Dana Arnold (ed.), *The Georgian Country House: Architecture, Landscape and Society* (Stroud: The History Press, 2013), 105.
47. Laurence Sterne, *A Sentimental Journey Through France and Italy*, vol. I, 2nd edition (London: Printed for T. Becket and P. A. De Hondt, in the Strand, 1768), n.p., quoted in Arnold, 'The Illusion of Grandeur?' 105.
48. *Correspondence Between Frances and Henrietta Louisa*, vol. I, 186–187.
49. More, *The Bas Bleu*, 85.
50. *Correspondence Between Frances and Henrietta Louisa*, vol. I, 196.
51. *Correspondence Between Frances and Henrietta Louisa*, vol. II, 135.
52. *Correspondence Between Frances and Henrietta Louisa*, vol. II, 135–136.

Bibliography

Arnold, Dana, 'The Illusion of Grandeur? Antiquity, Grand Tourism and the Country House', in Dana Arnold (ed.), *The Georgian Country House: Architecture, Landscape and Society*, Stroud: The History Press, 2013, 100–116.

Aymonino, Adriano, 'The *Musaeum* of the 1st Duchess of Northumberland (1716–1776) at Northumberland House in London: An Introduction', in Susan Bracken, Andrea M. Gáldy and Adriana Turpin (eds.), *Women Patrons and Collectors*, Newcastle upon Tyne: Cambridge Scholars Publishing, 2012, 102–120.

Chalus, Elaine, *Elite Women in English Political Life c.1754–1790*, Oxford: Oxford UP, 2005.

Chernock, Arianne, 'Cultivating Woman: Men's Pursuit of Intellectual Equality in the Late British Enlightenment', *Journal of British Studies* 45, no. 3 (2006): 511–531.

Clinton, Katherine B. 'Femme et Philosophe: Enlightenment Origins of Feminism', *Eighteenth-Century Studies* 8, no. 3 (1975): 283–299.

Correspondence Between Frances, Countess of Hartford and Henrietta Louisa, Countess of Pomfret, London: Printed by I. Gold, Shoe Lane, for Richard Phillips, No. 6, Bridge-Street, Blackfriars, 1805, Volumes I, II and III.

Eger, Elizabeth, *Bluestockings: Women of Reason from Enlightenment to Romanticism*, Basingstoke: Palgrave Macmillan, 2012.

Fletcher, Anthony, *Gender, Sex and Subordination in England 1500–1800*, New Haven: Yale UP, 1995.

Hannan, Leonie, 'Women's Letters: Eighteenth Century Letter-Writing and the Life of the Mind', in Hannah Greig, Jane Hamlett and Leonie Hannan (eds.), *Gender and Material Culture in Britain Since 1600*, London: Palgrave Macmillan, 2016, 32–48.

Jardine, Lisa, ' "O Decus Italiae Virgo", or the Myth of the Learned Lady in the Renaissance', *The Historical Journal* 28, no. 4 (1985): 799–819.

Klein, Lawrence E., 'Enlightenment as Conversation', in Keith Michael Baker and Peter Hanns Reill (eds.), *What's Left of Enlightenment? A Postmodern Question*, Stanford: Stanford UP, 2001, 148–166.

Kristeller, Paul Oskar, 'Learned Women of Early Modern Italy: Humanists and University Scholars', in Patricia H. Labalme (ed.), *Beyond Their Sex: Learned Women of the European Past*, New York and London: New York UP, 1980, 91–116.

More, Hannah, *Florio: A Tale, for Fine Gentlemen and Fine Ladies: And, the Bas Bleu; or, Conversation: Two Poems*, London: Printed for T. Cadell, in the Strand, 1786.

Pal, Carol, *Republic of Women: Rethinking the Republic of Letters in the Seventeenth Century*, Cambridge: Cambridge UP, 2012.

Pearce, Susan, *On Collecting*, London: Routledge, 1995.

Perry, Geraint, 'Education and the Reproduction of the Enlightenment', in Martin Fitzpatrick, Peter Jones, Christa Knellwolf and Ian McCalman (eds.), *The Enlightenment World*, Abingdon: Routledge, 2007, 217–233.

Porter, Roy, *Enlightenment: Britain and the Creation of the Modern World*, London: Allen Lane, 2000.

7 Portrait of Charlotte de France

From Naples to Sicily, a Collection in Transit

Maria Antonietta Spadaro

In the prestigious Palazzo delle Aquile, Palermo's Town Hall, is preserved the beautiful portrait of Marie Therese Charlotte, daughter of Marie Antoinette and Louis XVI (Plate 5).[1] The princess Charlotte was born in the golden court of Versailles in 1778 and died in 1815 at Frohsdorf Castle, near Vienna. She was the firstborn, and the only one of the royal family's children to survive illness and the revolution. As a child, Charlotte was often painted at Versailles by Elizabeth Vigee Le Brun, official court painter to Marie Antoinette.[2] Throughout her life, she continued to collaborate with numerous court painters, as a means for disseminating notions of status, politics, and mood.

Several portraits of Marie Therese Charlotte, painted immediately after she left the court of Versailles, are preserved, and this case study is the genesis of research being carried out on the study of their provenance and the artists who created them.[3] During the French Revolution, Charlotte was confined in the Temple Tower from 1792 until 1795, and she witnessed the death of her family. After Robespierre was executed in 1794, Charlotte was exchanged for six French prisoners who had been captured by the Austrian troops, and she was sent to Vienna, the birthplace of her mother.[4] She arrived in Vienna feeling hostile towards Francesco I of Austria, enough so to refuse the hand of his brother, the Archduke Carlo d'Asburgo-Teschen, a brave Lieutenant Field Marshall and reformer of the Austrian army, but for her an unbelievable 'enemy of France'; instead, she married his cousin, Luigi Antonio, duke of Angouleem.[5] They were married on 10 June 1799 at Jelgava, but the marriage turned out to be an unhappy one and they had no children of their own.

As an adult, distinguished artists always portrayed Charlotte in official poses and finery to convey her royal standing. In contrast, the painting in Palermo, which was painted during the period after she left France and before she met her future husband, is more intimate: she is stripped of her finery, her dress is simple, and she wears no jewellery. Her black dress conveys her grief. This is clearly a portrait that expresses Charlotte's mourning for the loss of her family, as well as the loss of the monarchy. The eighteen-year-old princess presents herself as the rightful heir presumptive to the French throne. She is shown at a particular moment of her life, remembering her parents, who are both portrayed on the two urns next to her in the painting. Their presence makes known her direct descent to the French crown, which is further reinforced by the fact that she holds her father's testament with her right hand, while she holds a white cloth with her left one. This cloth, used to wipe her tears, also symbolizes Charlotte's sad surrender of the throne and of both her parents to death. In the

background, a blue drape with the fleur-de-lis motif opens, presenting the viewer with a cypress landscape, the kind reminiscent of ancient cemeteries. This tree was associated with death and the underworld in the classical tradition because of its inability to regenerate when cut back. The drapery serves as a threshold between the dead monarchy and the living Charlotte, whose fate is now in the hands of her uncle Louis XVIII.

The portrait was produced in 1796, while Charlotte was in Vienna, shortly after she arrived in the city and before she travelled to Mitau in present day Latvia to meet her uncle and future husband. She appears to have gifted the portrait to her aunt Maria Carolina di Bourbon, Queen of the Kingdom of the Two Sicilies, for the important art collection the queen was building in Naples. The picture would have had a sentimental value for the Queen, as it was her surviving niece's portrait, daughter of her beloved sister, Marie Antoinette of France, who died under the guillotine three years earlier. In addition, it was a strong political statement. When the riots started in Naples on the wave of the French Revolution, the monarchy was threatened, and Ferdinand IV and Maria Carolina of Bourbon moved to Palermo, the second capital of their reign.[6] Maria Carolina insisted that she bring select pieces from her collections of art and other objects with her, and it took several days to board the amount of property belonging to the Bourbon court onto the English vessels captained by admiral Horatio Nelson.[7] The ships contained the Bourbon art collection, tapestries, crown jewels, precious furnishings, and a royal cash deposit of more than ten and a half million Ducati.[8] On 21 December 1798, Ferdinando and Carolina boarded the English vessel *The Vanguard*, sailing towards Palermo, reaching the city two days later after violent storms.[9] On 26 December, Boxing Day, the vessels arrived in Palermo. Charlotte's painting, titled *Madame Royal*, was most likely on one of those boats.

At the Royal Palace of Caserta in Naples, there is an exact copy of the portrait from Palermo with the same dimensions, signed by Francesco Pascucci and dated 1796.[10] It is presumed that Queen Carolina asked him to paint a copy of it for her palace. Compared to the original, the copy lacks emotional impact. Recent conservation work carried out on the Palermo picture in 2019 by the conservator Ambra Lauriano reveals Charlotte's dramatic expression, conveying her humiliation at the violent death of her parents and the determination she harboured for the rest of her life to try and restore the French monarchy.[11] As such, not only did these portraits convey her mourning, but the copies would have played a fundamental role in disseminating Charlotte's political message and goals.

The fate of the artefacts belonging to Queen Carolina's collection from their departure from Naples to their arrival to Palermo and later dispersal, is a subject that is recently gaining more scholarly interest. In the Palazzo delle Aquile, there is another confirmed work that was originally in Queen Carolina's collections in Naples and later travelled with her to Palermo, an exquisite tapestry by Pietro Duranti, titled, 'Banchetto di Isacco e Rebecca' 1777, executed by the Borbon tapestry manufacturer, that belonged to a series, 'Abraham's stories', made especially for Villa Reale di Resina (Ercolano). Queen Carolina's impact while living in Palermo is significant. She is remembered with several place names: La Porta Carolina, il Teatro Carolino (known today as the Teatro Bellini), la Serra Carolina at the Orto Botanico, and the small neogothic chapel Carolina at the Royal Palace. As this case study demonstrates, Queen Carolina's collecting practices in Naples and Palermo is an understudied area that is ripe for future research.

Notes

1. Camillo Filangeri, Pietro Gulotta, Maria Antonietta Spadaro, *Palermo. Palazzo delle Aquile*, Palermo 2004/2012, 109–110.
2. Elizabeth Vigee Le Brun (1755–1842) was in Vienna from 1792 till summer 1795. She never met Charlotte in Vienna because the princess arrived in December 1795.
3. There are three paintings: the one discussed here as well as a painting, now at the Hermitage, by Heinrich Freidrich Füger, painted in Vienna in 1798. It portrays Charlotte in a similar way to this one in a black dress and in a hat. It, too, makes a family reference with the cameo painted on her chest with the double portraits of her parents. This portrait has a more official character. The inscription of the Vienna painting says: 'Marie Therese Charlotte France . . . born 1779 pe int a Vienne par . . . Füger'. Finally, there is also a copy of the portrait of Palermo in Caserta.
4. Philippe Delorme, *Madame Royale, survivante de l'Histoire* (Paris: Édition Perrin, 2008); Hélène Becquet, *Marie-Thérèse de France. L'orpheline du temple* (Paris: Plon, 2012).
5. L'atto di matrimonio di Charlotte, conservato presso gli Archivi nazionali di Francia, è digitalizzato e consultabile on-line, http://www2.culture.gouv.fr/Wave/image/archim/Pages/03151.htm. Acte de mariage de Louis Antoine d'Artois de Bourbon, duc d'Angoulême, fils mineur de Charles-Philippe de France, comte d'Artois, frère du Roi avec Marie Thérèse-Charlotte de France, fille mineure de feu Louis XVI, donné en Russie le 9 juin 1799.
6. Denis Mack Smith, *Storia della Sicilia medievale e moderna* (Bari: Laterza, 1998); Salvo Di Matteo, *Storia della Sicilia* (Palermo: Edizioni Arbor, 2006).
7. Mack Smith, *Storia della Sicilia medievale e moderna*.
8. Vincenzo Cuoco, *Saggio storico sulla rivoluzione napoletana del 1799* (Firenze: con note di N. Cortese, 1926).
9. Cuoco, *Saggio storico sulla rivoluzione napoletana del 1799*.
10. Francesco Pascucci (Rome, 1748—after 1803) made a name for himself in Rome and worked as a neoclassic artist. He left his artwork in several places such as Livorno, Pisa, Naples, Caserta, and Scicli (Sicily). Arabella Cifan and Franco Monetti, *Contributo per il pittore Francesco Pascucci*, in Paragone Arte, anno 43/1992, nuova serie 505/507, 32/33, 47–50.
11. Throughout her life, Charlotte opposed Napoleon and even tried to rally an opposition against him. Napoleon said of Charlotte that she was the only man in her family, due to her courage. Philippe Delorme, *Madame Royale, survivante de l'Histoire* (v. il dipinto di Antoine-Jean Gros, *L'eroina di Bordeaux*, 1819, Musée des Beaux-Arts de Bordeaux).

8 The Collecting Activity of Catherine II in Eighteenth-Century Russia

Pioneering Action or Sheer Demonstration of Power?

Charis Ch. Avlonitou

To the memory of my mother, an example herself of an extremely active, inventive and assiduous woman, and a fighter who generously dedicated the creativity and warmth of her life to her family.

In an era when women ruling in Europe was a taboo matter, Catherine II, who was not even Russian, came to power via coup d'état, amongst widespread rumors of her involvement in the sudden death of the legal heir of the throne and her second cousin, Peter III. At the same time, Russia remained a political and cultural backwater compared with the great European countries, and the distant Saint Petersburg was, for the Europeans, nothing more than a muddy capital on the frozen Neva, whose 'Scythian' citizens were unable to appreciate high culture.[1] This situation changed thanks to Catherine II, who ruled the Russian Empire for thirty-four consecutive years (1762–1796) and established herself during that time as 'Great', earning a title that no other female leader has managed to obtain.

Catherine the Great managed to legalize her right to power and profoundly revitalized the image of the country she represented institutionally (Figure 8.1). Through diplomatic alliances and longstanding wars, she took control of south Ukraine, north Caucasus, and Crimea, gaining access to the Black Sea. Thus, she maximized the extent and population of Russia and transformed it into a global naval force, a commercial power, and one of the richest empires in the world. Her cultural input, through the proliferation of arts and sciences in Russia, played a critical role in her politics, and this chapter explores how the massive collections she garnered during her reign were meant to radically change her political image in both Russia and Europe.

The Making of an Enlightened Despot

Catherine II was deeply inspired by the progressive ideas of her era, and she embraced the ethical values of the French Enlightenment at least until the period of the French Revolution.[2] As empress she cultivated close relations with the French enlightened *Republic of Letters*, especially with her idol Voltaire, with whom she corresponded until the end of his life.[3] Her royal patronage to him, as well as to Diderot, granted her the privilege to be overtly praised and supported by the greatest European thinkers of her time, all the while inserting her cultural activity into the sphere of politics.

Consistent with Voltaire's belief that absolute monarchs should be 'enlightened' and their power tempered by wisdom, tolerance, and law,[4] the active and assiduous

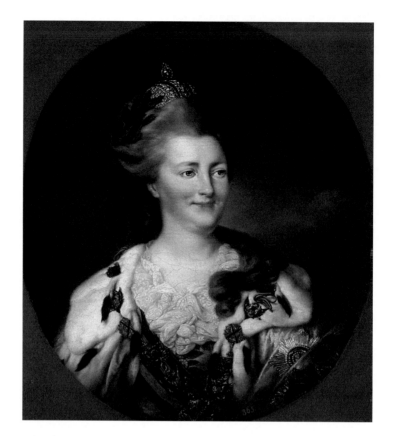

Figure 8.1 Richard Brompton, *Catherine II*, 1782. Oil on canvas, 83 × 69cm, Great Britain, 1782. The State Hermitage Museum, St. Petersburg (Romanov Gallery, the Small Hermitage, 1918).

Source: Photograph © the State Hermitage Museum. Photo by Vladimir Terebenin.

czarina, who voraciously read works of literature and treatises on history, political philosophy, and art, had an interest in 'everything'.[5] She was glad to adopt the concept of 'enlightened despotism', which matched her forward-looking nature. In this sense, and apart from the political and military reform of Russia, she constantly pursued its cultural revival on the basis of Westernization introduced by Peter the Great, since she considered herself his spiritual child and successor. As a result of frantic building activity, she reconstructed the city of Saint Petersburg, which during the 1770s was already described as 'the most beautiful city in the world'.[6] Similarly, the empress amassed her enormous art collection, establishing her image as enlightened and introducing Russia into the European scene as a global cultural center.

Indeed, in the name of her vision for revitalization, Catherine II implemented the calculated politics of acquiring abundant representative objects of European culture in an 'ark of a kind',[7] where the noble ideas of the Enlightenment would be exhibited along with the Old Continent's cultural past. Courtesy of the at-will use of Russia's high-powered public fund, as well as of the extensive network of her apt envoys,

which included renowned *Encyclopédistes*, she created a vast art collection that could compete with those of generations of royal houses in Vienna, Berlin, or Dresden. Catherine II's cultural input, dictated by the ideological principles of her governance, should be seen as a strategic act of high symbolic meaning, as it served her political goals in the best possible way.

Particularly when seen from a political point of view and examined under the light of *game theory*,[8] Catherine's ambitious collecting activity seems to be part of a dynamic and evolving network of relationships between the participants, mainly herself and the leading European leaders of her time. Integrated into such a framework of examination, Catherine's 'ark', that contained a vast thesaurus of European artifacts and valuable works of art adequate to re-write Russia's cultural history, summarized her endeavor to change Russia's political status within Europe and overthrow the existing status quo.

In this political game, Catherine the Great often used the strategy of provocation with the aim of maximizing her benefits and minimizing her losses, as the weaker side in such games usually does.[9] Trying to overturn the current power balance in Europe's politics, where she was initially looked down on as an illegal female leader with no future, she made effective alliances with the intellectual elite of her time. She exchanged a large amount of state funds with the collaboration of the recipients of her patronage, Voltaire or Diderot, as well as other members of the European nobility who visited her much-coveted court and art collection. In this way, she gradually succeeded in qualitatively modifying the magnitudes of the forces in the European cultural and political scene. This chapter will employ a model of critical examination and assessment of collections and collectors of art, which has already been implemented for the conduct of similar studies, in order to analyze the qualities of Catherine II and her collection.[10] This analysis will support the unique collecting practices of Catherine the Great.

The Collecting Environment, Practices, and Content

As an armchair traveler, Catherine II neither visited art exhibitions in Europe nor managed to see any artwork before buying it. This obstacle could not prevent her, however, from massively buying works of art in a great variety spanning from antique to contemporary pieces. In the Age of Tolerance, a wide range of trends and styles made up the dominant taste, including the movement and dynamics of Baroque styles, the delicate princely Rococo, and the exotic Chinese style, as well as Neoclassicism, the aesthetic expression of the Enlightenment. Being aligned with the spirit of her time, Catherine II let herself be guided by the new trends and was one of the first to appreciate the early stages of Neoclassicism, while at the same time she revived all the past trends of art collecting.

Within the context of the prevailing styles in art collecting of her time in Europe, the once highly-valued Venetian artists like Titian were now less popular than Raphael or Correggio. Similarly, the demand for Rococo artists was such that Watteau or Lancret waned in popularity to the Dutch and the Flemish schools that were becoming more and more highly appreciated.[11] On the contrary, for the empress of Russia, they were all equally sought after, provided that her agents assured her of their quality or that they had once belonged to a famous art collection. Treating her collecting activity as a serious state matter within the spirit of her enlightened despotism, Catherine II

immediately found the right tools in order to act efficiently and quickly in the crea-tion of her collection. In an attempt to rival the great European monarchs and their valuable art collections, she used her privilege, which permitted lavish spending on art without any hesitation, in order to make up for lost time. In this regard, she adopted and frequently implemented the practice of purchasing collections *en bloc*. Thus, col-lections of great importance, patiently amassed by important personalities of the era, such as the Graf von Cobenzl, Maria Theresa's plenipotentiary minister in Brussels, the Count Heinrich von Brühl, the most powerful man in the Electorate of Saxony, or the famous banker Louis-Antoine Crozat, baron de Thiers, were targeted and brought into Catherine's possession.

Like the other monarchs of the time, the collector built her collection with the help of her agents, her shrewd and knowledgeable ambassadors, dealers, or scouts, who, scattered around the significant cultural centers of Europe and mostly in Paris, informed her of important upcoming auctions or of the dispersal of a famous collec-tion that was about to follow. In this way, she managed to obtain entire collections by making secret deals with the collectors' heirs, even before the works of art were put up for auction.[12] In filling her 'ark' with cultural samples of the European world, Catherine II was assisted in particular by Russian ambassadors, such as Prince Andre Belosselsky in Dresden or Alexey Musin-Pushkin in the court of St. James. Of crucial importance to the creation of her collection was Dmitry Golitsyn, a cosmopolitan Rus-sian diplomat who bargained for many purchases on her behalf in Paris and Brussels,[13] the German baron Melchior Grimm, her devoted friend and trustworthy agent in Paris, with whom she exchanged over 1,500 letters on various topics,[14] and the famous critic of the Parisian 'Salon', Denis Diderot, who often directed the empress towards the purchase of contemporary works of art.[15] With the support of this particular net-work of great assistants, whom the empress brilliantly chose herself, as well as their valuable cultural and social contacts, Catherine II's vast art collection was realized.

The art collection, which could be easily characterized as a *megacollection*, was particularly wide-ranging both quantitatively and stylistically. Through it, Catherine II became acquainted not only with the art of the dominant European aesthetic, within which the love for Eastern and mostly Chinese art was included, but also with almost every other kind of Western art.[16] Both the older trends and the new rising aesthetic values of the era found their place in the collection of the Empress of All Russia, who conquered the art of the past while also amply offering her patronage to contemporary European artists and to a small number of local ones.

In its final phase, in 1796, the collection comprised an enormous amount of works of art, which consisted of approximately 4,000 paintings by Old Masters, mostly Flemish and Dutch, as well as Italian and French artists, nearly 10,000 drawings, 10,000 cam-eos and intaglios — constituting one of the greatest such collections in the world[17] — art from Ancient Greece and Rome, 16,000 coins and medals, sculptures dating from Renaissance to the eighteenth century, and thousands of decorative objects, such as tapestries, porcelain, glass, furniture, mosaics, and various silver and gold artifacts, varying from royal emblems and snuffboxes dotted with diamonds to valuable stones for clothing decoration. Together with the samples of natural history and the 38,000 books of the collector, Catherine's collection, which included both original objects and replicas, was housed at the specially-designed Hermitage.[18] The grandeur of the build-ing went hand in hand with that of her collection, evidently manifesting the glory of the empress's power and the sophistication of her enlightened vision.

Amongst the collections bought *en bloc*, a landmark in the history of Catherine II's collecting activity was the acquisition between 1768–1769 of both the famous collections Cobenzl[19] and Brühl,[20] which contained numerous master paintings. Through these purchases she also amassed a massive collection of works on paper, dating from the fifteenth to the eighteenth century.[21] Thanks to these *en bloc* acquisitions, Catherine II entered the circle of great collectors, however, the one that helped her gain dominance in the field was the *en bloc* purchase in 1771–1772 of the most important private collection in France, deriving from the banker Louis-Antoine Crozat. The collection was comprised of a great number of art pieces from European masters and works on paper made by artists of the past, such as Raphael and Michelangelo.[22] At that time, since all of the works belonged by then to Russia and were added to her other acquisitions, Catherine the Great could be proud of having fulfilled her dream of having one of the largest and most significant art collections of her time.

However, the crowning achievement of the czarina's collecting activity came in 1779, with the acquisition of 240 of the best paintings of Robert Walpole's collection.[23] With its important works by Titian, Rubens, Van Dyck, Murillo, Veronese, Holbein, Rembrandt, Velazquez, and Raphael, the collection of the Prime Minister of England was regarded as one of the greatest in his country. Having obtained it, further boosted Catherine's cultural and political status.

In addition to the aforementioned mass purchases, the empress obtained individual works of art. Among these were a wide range of Old Masters (from Michelangelo to Rembrandt and Poussin) and contemporary artists, such as the precursor of Neoclassicism, Anton Raphael Mengs, the skillful British painter, Joseph Wright of Derby, the French painter of architectural landscapes, Hubert Robert, and court artists, such as the Danish Vigilius Eriksen, the Swedish portrait painter Alexander Roslin, and the Russians Fyodor Rokotov and Vladimir Borovikovsky.

Having analyzed the collecting environment, practices, and content of Catherine the Great's collection, I can turn now to the aforementioned model of critical examination to more closely study the profile of both collector and her collection.

The Collection Profile: Physical-Material Properties

Catherine II and her collection can be better understood through breaking down and analyzing methodologically the various components and data surrounding the person and the collection. This process involves rating measurements on specific criteria. These criteria, which can be presented in three diagrammatic tables regarding both the collection and the collector, resulted from a systematic and thorough study of the material of hundreds of collections and collectors with the ultimate aim of focusing on their most basic structural features. According to this methodological tool, it is accepted that the features are both evolving and altering qualitatively over time.

Focusing firstly on Catherine II's art collection, we can formulate value judgments about criteria concerning both the *physical-material* (Table 8.1) and the *spiritual-immaterial* properties of the collection (Table 8.2) during its final phase in Russia of 1796. The 'profile' of the collection, which consists of all its particular characteristics, arises from these judgments formulated per criterion and quantified into a bipolar —according to the needs of our mental system—assessment scale, which ranges from 1 to 5.[24] What arises is not an overall evaluation of the collection, either positive or negative, but rather a critical classification of it in space and time.

Table 8.1 The Diagrammatic Profile of Catherine II's Art Collection: Physical-Material Properties.

Object of Judgement: Physical-Material Properties of the Collection							
	POLE A						POLE B
1 SIZE	large	1	2	3	4	5	small
2 DURATION	of long duration	1	2	3	4	5	of short duration
3 OLDNESS	old	1	2	3	4	5	contemporary
4 MARKET VALUE	expensive	1	2	3	4	5	cheap
5 ACCESSIBILITY	accessible to the public	1	2	3	4	5	non-accessible to the public
6 SPECIALIZATION	specialized	1	2	3	4	5	non-specialized, indiscriminate
7 COMPLETENESS	completed	1	2	3	4	5	incomplete
8 AUTHENTICITY	authentic	1	2	3	4	5	forged

More specifically, Catherine II's art collection, examined in the context of the environment of the European collections of the era and known in 1790 as 'without doubt the largest in Europe',[25] can be considered as an *exceptionally strong collection*, both in *size* and variety (Table 8.1, 1). Therefore, it can be rated at Level 1. In 1764 it was already obvious that the newly formed collection flirted with monumental scale. The first bulk purchase of artworks spurred the creation of a special area next to the Winter Palace, the so-called *Little Hermitage*, while the constant increase of the collection was soon linked with new structural additions that led in the 1780s to the *Big Hermitage*.

Besides, considering the fact that the collection was formed within a period of a little more than thirty years, essentially during the reign of Catherine II and even during the period of the long wars she conducted, it is judged as *long in duration* (Table 8.1, 2).[26] Regarding *the oldness* of its works of art, we assess that in the czarina's collection, works of the glorious European past prevailed, although it also contained a large number of artifacts from the eighteenth century, often commissions from living artists of the era (Table 8.1, 3).

At the same time, the collection —even though its market value is impossible to be precisely measured— can be characterized as *particularly expensive* for its era, especially when considering the fact that some paintings, as well as whole sub-collections it included, were considered extremely highly valued by European collectors (Table 8.1, 4). In some cases, such as the famous Jean de Jullienne sale in 1767, the amounts spent for their acquisition were so elevated that collectors such as Frederick the Great or Horace Walpole, son of the British Prime Minister, could simply not afford them.[27] Thus, Russia's empress exchanged a part of her financial predominance for her fame as a highly reputable art collector.

Purchases or commissions on a large scale, which in some cases were associated with excessive or even enormous prices —for instance, the *Roettiers Silver Pottery* and especially the celebrated *Sèvres Cameo Service*[28]— affirmed the economic superiority of Russia. During the golden century of the Russian gentry, even though the prevailing class actually lived beyond its means and the state economy was not as mighty as it appeared to be, the unwavering investment in expensive works of art constituted the necessary prerequisite for the proper promotion of the country as a wealthy and civilized state.[29]

The *admission of the public* to visit the collection was undeniably extremely limited (Table 8.1, 5). Only princesses and counts, such as the French ambassador Louis Philippe, Comte de Ségur, the Habsburg Monarchy's plenipotentiary minister Johann Karl Philipp, Graf von Cobenzl, the general Charles-Joseph Lamoral, Seventh Prince de Ligne, the Russian diplomat Prince Dmitry Alexeevich Golitsyn, the Russian counts Ivan Ivanovich Shuvalov and Alexander Sergeyevich Stroganov, and the director of the St. Petersburg Academy of Sciences, Princess Yekaterina Romanovna Vorontsova-Dashkova had the unique opportunity to admire the artworks of the empress's collection, along with the wealth of the czarist court. These viewings often took place in a particular atmosphere, under the lights of candles and amid the sounds of live music. Visitors enjoyed a luxurious and relaxed environment that favored sensual and aesthetic pleasure as well as conversations about art.[30] The exclusivity of her audience was, however, in contrast to the mode of this time when, under the principles of the Encyclopaedists, the national museums started opening their doors to the public—with the British Museum being the first one in 1759.

Regarding its content, the collection, which included objects from almost every period of Western art and numerous categories of art objects, can be classified as *non-specialized* (Table 8.1, 6). The empress's preference for objects, such as her enormous and specialized collection of cameos, could only slightly hone the level of its specialization. This non-specialized collection, on the other hand, consisted of a plethora of sub-collections. Naturally, each of them was probably far from being complete in representing all the types of its group (every possible style, every stage in the evolution of an artistic production, every significant work of art, etc.).[31] However, the collection is considered fair for its *level of completion*, as measured in regard to the collecting goals of its founder (Table 8.1, 7). The latter, who decided to stop purchasing art in bulk around the middle of the 1780s, redirected her action and the wealth of the state fund.[32] In fact, upon acquiring the Walpole collection in 1779, Catherine II felt that her main goal of making Russia a collecting superpower was indeed accomplished.

Finally, the *degree of authenticity* of the artworks, which can only be approximately evaluated within the framework of this chapter, did not differ from that of the average princely courts in Europe (Table 8.1, 7). The purchase of distinguished and highly-valued collections garnered by experts and connoisseurs partially limited the danger of frauds or forgeries.

Here I have covered the physical-material properties of Catherine II's collection: the collection's size, level of completion, duration, age, specialization, market value, accessibility, and authenticity. Next, I will turn to the analysis of the *spiritual-immaterial* properties in order to give the fullest possible picture of the makeup and further attributes of the collection.

The Collection Profile: Spiritual-Immaterial Properties

In regard to the immaterial properties of the collection (Table 8.2), there was a constant and rapid increase of its *reputation* that promptly reached the most famous degree (Table 8.2, 1).[33] The *reception* of the collection's much-coveted artworks in the art market of the era was, likewise, the most favorable possible (Table 8.2, 2). In the eyes of her cultivated guests, Catherine II appeared to finally embody the figure of 'Queen of the World'.[34] Furthermore, Catherine II's rapidly recognized authority within the circle of European rulers appears to be linked with the absolute *legality* of the objects she possessed (Table 8.2, 3).

Table 8.2 The Diagrammatic Profile of Catherine II's Art Collection: Spiritual-Immaterial Properties.

Object of Judgement: Spiritual-Immaterial Properties of the Collection

CRITERION	POLE A	EVALUA-TION SCALE	POLE B
1 REPUTATION	famous	1 2 3 4 5	non-famous, obscure
2 RECOGNITION/RECEPTION	accepted	1 2 3 4 5	not accepted, rejected
3 LEGALITY	legal	1 2 3 4 5	illegal, subversive
4 RARITY	rare, original	1 2 3 4 5	common, conventional
5 SYMBOLISM	of high symbolism	1 2 3 4 5	of low symbolism

Taking into consideration, however, the largely homogeneous character of the famous collections of the eighteenth century, we observe that most of these objects were the type preferred by both the European nobility and art experts, or even the wealthy bourgeois.[35] Hence, with an exception of a few mainly contemporary pieces or works rejected by other monarchs, the collection remains far from being characterized as *rare* (Table 8.2, 4). On the contrary, it entails a *high symbolic meaning* (Table 8.2, 5). The 'conspicuous consumption'[36] of the glorious European past that the empress so voraciously purchased resulted in a collection that constituted a social sign of status and a guarantee for Russia's entrance into the elite of the civilized Western states. The possession of works of Old Masters, which in Catherine II's mind linked her with the European gentry that maintained or produced them in the past, aligned perfectly with her image as an 'enlightened despot' —which she consistently promoted in the spiritual circles of the era— as it implied not only wealth, but also culture, education, and graciousness of spirit.

The Collector Profile

Having examined the material and immaterial properties of the collection, I have demonstrated that Catherine II garnered a collection of size, range, and value in representation of her *enlightened despotism*. Her collection, in its various properties, was formed out of a desire to promote the aesthetic, political, and cultural greatness to which she aspired, both personally and for her country. Focusing now on Catherine II as *a collector* (Table 8.3), we will examine her economic status and collecting behavior, practices, and motives, in order to understand the political and psychological drive behind her quest.

The economically mighty czarina, who lavishly spent the state resources of her empire aiming at the creation of an emblematic collection, is effortlessly valued as *wealthy with no limitations* (Table 8.3, 1). Her economic power, though decreasing toward the end of her collecting activity, still enabled her to create a collection that was colossal in both size and market value.

Studying Catherine II's collecting practice reveals that she acted both *rationally and emotionally* (Table 8.3, 2–6). As a shrewd strategist, she built an art collection in a politically charged manner and chose art according to the artist's name or other significant

Table 8.3 The Diagrammatic Profile of Catherine II's Art Collection: The Collector.

Object of Judgement: the Collector

	CRITERION	POLE A	EVALUATION SCALE					POLE B
1	ECONOMIC STATUS	wealthy	1	2	3	4	5	not wealthy
2	COLLECTING	emotional	1	2	3	4	5	rational
3	BEHAVIOR/	independent	1	2	3	4	5	guided
4	COLLECTING	extrovert	1	2	3	4	5	introvert
5	PRACTICES	innovative	1	2	3	4	5	non-innovative
6		idealist	1	2	3	4	5	non-idealist
7	COLLECTING MOTIVES	social (political) motives	1	2	3	4	5	non-social (political) motives
8		economic motives	1	2	3	4	5	non-economic motives
9		psychological motives	1	2	3	4	5	non-psychological motives
10		aesthetic motives	1	2	3	4	5	non-aesthetic motives

information. Moreover, an advocate of the scientific method, she included in her collection's management a provision for the restoration or archiving of artworks.[37] The element of passion, however —a structural element of her personality made apparent in her lavish spending on artworks for her spectacular court— often carried the empress away in excesses that resulted in the bankruptcy of the public fund.[38] Retreating from her decision to stop buying art, she continued to practice her collecting activity until her death.

Her passion made Catherine II even more *dependent* on her agents, who largely directed her in art matters. Over time, however, and by training her eye and mind, she became more selective (Table 8.3, 2–6). Intimately active in the process of putting together her collection, she used to scrutinize the sale catalogues sent to her by her envoys in order to make a decision or choice, while at the same time she was the final supervisor and coordinator of the whole collecting procedure.[39] Even though the empress purchased artworks without seeing them first, she did not hesitate to gift to others the pieces she did not like.[40]

A further typical feature of the collector's profile was her *extroversion*, primarily as it occurred within the confines of Russian and European gentry and in accordance with her propagandistic role as an enlightened leader (Table 8.3, 2–6). Highly valued was Catherine II's *degree of leadership* as a collector, not thanks to her aesthetic choices, but on account of the fact that she established collecting as a dominant aspect of her ruling in order to relocate Russia on the global cultural map. In fact, this view, the political vision of 'enlightened despotism' that she shared with political thinkers like Voltaire, decisively reveals *the ideology* that fueled the collector's movements. Even though it proved to be consistently decreasing through time, this principle shaped Catherine II's public image and constituted a defining *motive* for her collecting activity (Table 8.3, 7–10).

Additionally, the formation of her collection was perceived as a political game in opposition to monarchs like Frederic the Great or Augustus III of Saxony. Within this

game, she loved to reward her alliances and challenge or humiliate her opponents.[41] By means of constant pursuit and devious tactics, biblical patience and unexpected attacks, the czarina indeed frequently outwitted her rivals, leaving them 'green with envy'.[42] As the Russian ships were carrying the art and the culture of the shocked and anxious Europe to Saint Petersburg, the collector enjoyed her victories with pleasure. The vociferous grievances from critics, artists, and collectors in France and Great Britain upon the sale and exportation of the Crozat, Baudouin, Jullienne, or Walpole collections, was the best advertisement of her achievements.[43]

Amongst the other motives that define Catherine II's activity, the *economic* ones seem to be less significant (Table 8.3, 8), while the *psychological* factors played a decisive role (Table 8.3, 9). Specifically, the tendency of collectors to identify their creations with their own self-image aligns with the empress's stated need to maximize her knowledge and her advancement on every level.[44] Finally, the motive of *aesthetic* pleasure should be regarded as increasing over time (Table 8.3, 10). The aesthetic stimulus is indicated by her own writing,[45] her indulgence in art books, and her every-day strolls through her galleries.[46]

In conclusion, we come to realize that the profile of both the collection and the collector examined appear to be *vivid or extreme*, since most of their characteristics touch or come close to one of the two value poles of our evaluation system. This fact is in accordance with the great social and cultural impact of the czarina's collecting activity, which proved to be her longest legacy.

Catherine II as a Russian and Global Collecting Icon

Under the example of Catherine II, the collection of Western art in Russia turned from a simple imperial or aristocratic hobby, during the time of Peter the Great, into an organized and systematic activity. Her innovative action established a long and rich collecting tradition in Russia. As such, collecting art slowly became a reliable indicator of cultural education.

The influence of the empress's cultural practices on the members of the Russian gentry —often even on those of the European[47]— was deep and absolute. The Russian nobles during the eighteenth century and beyond followed her example of collecting according to the Western aesthetic standards and continued gathering invariably numerous *objets d'art*, European painting or brass and marble sculptures, in order to decorate their impressive neoclassical mansions. Appearing to be 'as passionate as no one else',[48] the Russians continued to connect their national collecting identity with large and pluralistic collections, even in their remote and recycled Soviet society, if not up until today.[49]

A self-styled 'Minerva' and 'enlightened despot', Catherine II fostered the arts and the sciences and promoted new cultural and educational institutions. The reorganization in 1754 of the Imperial Academy of Arts in Saint Petersburg according to the French standards, along with the enormous cultural inheritance the czarina left to her country, nurtured new generations of artists and decisively influenced the shaping of the national aesthetic standards, at least until the 1870s.

On an international level, the activity of Catherine II paved the way for the collecting practices of many famous male collectors. More than a century later, in the Gilded Age of the United States, American collectors such as H.C. Frick or J.P. Morgan —the so-called collector of collections— and a large number of other industrial tycoons,

who pretentiously ignored art but not its economic value, insatiably amassed the cultural capital of Europe, acquiring the supremacy they were lacking. Similarly, today, West Asian collectors, such as Farah Pahlavi from Iran or Sheikha Al-Mayassa, member of the royal family of Qatar, who may have at their disposal the resources of a whole state, build outstanding collections by profusely paying for the undisputed signs of European civilization. Thus, they try to elevate their country's cultural status, forming in parallel a strong national identity for their people.

Nevertheless, the collecting model of Catherine II remains unsurpassed and unique in history, even today, both for her acquisition of art on such a monumental scale and for the faith in the political value of art collecting she inspired. The archetypal power this model conveys justifies her social impact and elucidates the reason why her mass-collecting activity as a serious political act proves still to be innovative and deeply influential.

Notes

1. According to Niels von Holst, *Creators, Collectors and Connoisseurs: The Anatomy of Artistic Taste from Antiquity to the Present Day*, trans. Brian Battershaw (New York: G.P. Putnam's Sons Group,1967), 189, at the *Jean de Jullienne sale* in Paris, as early as 1767, people were complaining about purchases made by Russian agents: 'How sad it is to see such lovely things going to the Scythians. In Russia there can hardly be ten people who will appreciate them, whereas, when they were here, the whole of Europe came to see them. Everyone can hope for the pleasure of seeing the Seine, but very few are curious enough to visit the frozen Neva'. For the city as a 'confused mass of palaces and cottages', according to Diderot, see Susan Jaques, *The Empress of Art: Catherine the Great and the Transformation of Russia* (New York and London: Pegasus Books, 2016), 136. For the radical transformation of its image, from a swampy capital into a sophisticated cultural center, by Catherine II, see Jacques, 33, 158–159, 215–220, and Robert K. Massie, *Catherine the Great: Portrait of a Woman* (London: Head of Zeus, 2012), 523–524. About 'the Scythians' who, according to Voltaire, recompensed in Paris 'the virtue, science and philosophy' thanks to Catherine II, see Henri Troyat, *Catherine the Great*, trans. Joan Pinkham (New York: E.P. Dutton, 1980), 203.
2. Catherine II's adjustment to reality, especially after the fall of the Bastille, lessened her initial enthusiasm for progressive ideas such as the abolishment of slavery. Her enthusiasm was finally replaced by strict censorship for books by Voltaire and Shakespeare as well as for her own laws (Jaques, *The Empress of Art*, 328–329).
3. She also supported the efforts of the '*philosophes*' by printing the thirty-two volumes of Denis Diderot's *Encyclopédie*, which had been banned in France, gaining, in return, both his and Voltaire's embrace. They even supported her invasions against Poland and Turkey, while Voltaire used to call her 'the brightest star of the north' (Jaques, *The Empress of Art*, 10–14, 177; Catherine II, *The Memoirs of Catherine the Great*, trans. Mark Cruse and Hilde Hoogenboom (New York: Modern Library, 2006), xix; Troyat, *Catherine the Great*, 183). Voltaire wrote to her: 'there are three of us, Diderot, D' Alembert and myself, who raise altars to you' (Stuart Andrews (ed.), *Enlightened Despotism* (London, 1967), 141).
4. David Williams (ed.), *Voltaire: Political Writings* (Cambridge: Cambridge UP, 1994), xiv–xv. Although the term 'enlightened absolutism' is regarded to have been coined by the physiocrats and specifically by Mercier de la Riviere —who actually did not advocate a particular political system but rather an economic doctrine (Betty Behrens, 'Enlightened Despotism', *The Historical Journal* 18, no. 2 (1975): 401)— Voltaire has been strongly connected with the endeavor to implement it in reality, as he believed in the ideal monarch who would enlighten his people. For Voltaire's vision of a supreme monarch or a philosopher-king in Zadig, see also Voltaire, *Zadig, and Other Tales*, trans. Robert Bruce Boswell (London: G. Bell and Sons, Ltd, 1910), 69–73.
5. The sphere of activities of Catherine II, who even wrote plays for the theater or made her own architectural designs, included, according to Frederick the Great, 'everything'

(Jaques, *The Empress of Art*, 29, 286, Cynthia Whittaker, 'Catherine the Great and the Art of Collecting: Acquiring the Paintings That Founded the Hermitage', in Maria Di Salvo, Daniel H. Kaiser and Valerie Kivelson (eds.), *Word and Image in Russian History: Essays in Honor of Gary Marker* (Brighton, MA: Academic Studies Press, 2015), 151; Troyat, *Catherine the Great*, 269, 294–295).

6. By the cosmopolitan Charles-Joseph Lamoral, Seventh Prince de Ligne (Jaques, *The Empress of Art*, 215).

7. Katia Dianina, 'Art and Authority: The Hermitage of Catherine the Great', *The Russian Review* 63, no. 4 (2004): 631.

8. See Constantina Cottaridi and Grigoris Siourounis (eds.), *Αφιέρωμα στον John Nash: Θεωρία Παιγνίων* [*Tribute to John Nash: Game Theory*] (Athens, Greece: Eurasia, 2002), 85–89.

9. Paris Varvaroussis, *Στρατηγική των παιγνίων: Συνεργασία και σύγκρουση στις διεθνείς σχέσεις* [*Game Strategy: Cooperation and Conflict in International Relations*] (Athens: Papazisis, 1998), 88–90.

10. This model is used for the protection against the risk of arbitrary or accidental judgments. From the variety of criteria on which one can evaluate each object of judgment, those considered to be the most critical and fruitful in conclusions have been selected. See Zacharoula Avlonitou, 'Συλλέκτης και συλλογή, μια αδιαίρετη ενότητα: η περίπτωση του συλλέκτη και της συλλογής Γιώργου Κωστάκη' [Collector and Collection, an Indivisible Unit: The Case of the Collector and Collection of George Costakis], (PhD diss., U of Ioannina, School of Fine Arts, 2018), 455–459.

11. Holst, *Creators, Collectors and Connoisseurs*, 183, 190, 193. Strangely enough, however, paintings by minor artists who were in style, such as Metsu, Dou, Teniers, or the popular Dutch Philips Wouwerman, often cost more than a classic Rembrandt or Rubens. Thus, in 1770, two battle scenes by the Flemish Van der Meulen were sold as the most expensive items of an auction, topping those by Rubens and Rembrandt (Jaques, *The Empress of Art*, 66, 115).

12. That happened, for example, in the cases of von Brühl and Walpole collections (Jaques, *The Empress of Art*, 71–72, 193).

13. It seems that Prince Dmitry Alexeevich Golitsyn (1734–1803) was indeed the first to conceive the strategic of purchasing collection *en bloc* (Jaques, *The Empress of Art*, 67). He managed to get artworks from the famous Jean de Jullienne's collection, while Rembrandt's *The Return of the Prodigal Son* was one of his finds (Jaques, *The Empress of Art*, 68).

14. Publisher of the *Correspondance littéraire, philosophique et critique,* a complete history of the cultural life in Paris during that time, Friedrich Melchior, Baron von Grimm (1723–1807) kept a regular correspondence with the czarina, who used to say: 'I never write to you, I chat with you', Catherine II, *The Memoirs of Catherine the Great*, xxi; Catherine II, *Selected Letters*, trans. Andrew Kahn and Kelsey Rubin-Detlev (New York: Oxford UP, 2018), passim. Melchior Grimm was in 1777 a full-time agent and art buyer with an annual salary of 2,000 rubles, and also had a Swiss assistant (Jaques, *The Empress of Art*, 167; Troyat, *Catherine the Great*, 231).

15. Denis Diderot (1713 —1784), whose library had Catherine bought for an enormous sum of money, was one of her cleverest art scouts, who 'combed Paris's salons, studios, and picture galleries on Catherine's behalf' (Jaques, *The Empress of Art*, 7), constantly informed her about impending auctions, like the Gaignat's one, or even convinced collectors like Tronchin or Lalive de Jully to sell to Catherine. He made the secret negotiations for Crozat's collection, while thanks to him, the commission of a monument to Peter the Great was awarded to Falconet. He used to write and advise the empress about works of art like the ones by van der Meulen (Jaques, *The Empress of Art*, 49, 69, 115).

16. Following the trend of the time as well as her taste, Catherine the Great had her Chinese Palace built at Oranienbaum in 1768, while at the same time Frederick the Great's Chinese Teahouse at Sanssouci and George III's chinoiserie garden were also completed. For the fact that Europeans had been smitten with the East since the sixteenth century, as well as for a more specific bibliography, see Jaques, *The Empress of Art*, 19–25.

17. Jaques, *The Empress of Art*, 289–292.

18. The annex to Winter Palace, which contained Catherine the Great's collection of paintings, became known as 'Hermitage' after the French word '*ermitage*' with Greek origin, which

implies a quiet hermit's dwelling. That was probably conceived as a sort of contrast with *Sans-souci* ('free of care'), the famous gallery formed by Frederick the Great in Potsdam in 1755 (Jaques, *The Empress of Art*, 36; Dianina, 'Art and Authority', 633; Holst, *Creators, Collectors and Connoisseurs*, 189).

19. The collection of Johann Karl Philipp, Graf von Cobenzl (1712–1770), contained forty-six paintings (*Roman Charity, Statue of Ceres* and *Portrait of Charles de Longueval* by Rubens, *La Devideuse* by Dou, *Polish Nobleman* by Rembrandt etc.) and exceptional designs (approximately 4,030). Among them was the greatest collection of French pastel portraits outside of France (Jaques, *The Empress of Art*, 68–69).

20. The collection of the powerful and controversial Count Heinrich von Brühl (1700–1763), also known as *Richelieu of Saxony*, which was considered to be by far better and greater than the one by King Augustus II, comprised 600 paintings and many designs, approximately 1,020 sheets. It was acquired for 90,000 rubles. The collection included Rembrandt's *Portrait of an Old Man in Red*, Rubens's *Perseus and Andromeda*, *The rape of Europe* by Francesco Albani, *Receiving the Letter* by Ter Borch, Poussins's *Descent from the Cross*, and Watteau's *An Embarrassing Proposal*, along with some twenty pictures by Philips Wouwerman. See Jaques, *The Empress of Art*, 71–81; Pierre Cabanne, *The Great Collectors* (New York: Farrar Straus, 1963), 4; Holst, *Creators, Collectors and Connoisseurs*, 72–79.

21. Among these were works by artists like Dürer, Hans Holbein the Younger or Piero di Cosimo, Titian or Veronese, Rembrandt, Rubens, Van Dyck or Jordaens, as well as Poussin, Lorrain and Watteau.

22. The highly coveted collection of 500 paintings was created by Pierre Crozat (1665–1740) and expanded by his heirs, in particular Louis Antoine, Baron de Thiers (1700–1770). It was considered the most important collection in France, right after the king's and the regent's. Two-thirds of the collection was Italian, including Titian's *Danaë*, as well as *the Portrait of Cardinal Pallavicini, Saint George and the Dragon* and *Holy Family* by Raphael, Giorgione's *Judith*, and *Dead Christ with the Virgin Mary and an Angel* by Veronese. It also contained Rubens's *Bacchus* and *Portrait of a Lady-in Waiting to the Infanta Isabella*, portraits by Anthony van Dyck, as well as works by Poussin, Watteau or Chardin *(The Laundress)*. It was acquired for 440,000 livres. See Jaques, *The Empress of Art*, 119; Beverly Whitney Kean, *French Painters, Russian Collectors: The Merchant Patrons of Modern Art in Pre-Revolutionary Russia* (London: Hodder & Stoughton, 1994), 10; Francis Henry Taylor, *The Taste of Angels: A History of Art Collecting from Rameses to Napoleon* (Boston: Little, Brown and Company, 1948), 530–531; Whittaker, 'Catherine the Great and the Art of Collecting', 163.

23. Described as 'the greatest coup of all', the great Walpole collection, of the person known as Sir Robert Walpole (1676–1745), included works by Italians, Flemish, Netherlandish, French, as well as Spanish and English artists. It was originally housed at Houghton Hall (Jaques, *The Empress of Art*, 185–196; Holst, *Creators, Collectors and Connoisseurs*, 194; Taylor, *The Taste of Angels*, 531; Whittaker, 'Catherine the Great and the Art of Collecting', 165).

24. Avlonitou, 'Συλλέκτης και συλλογή, μια αδιαίρετη ενότητα', 458.

25. According to the French art-lover Fortia de Piles (Holst, *Creators, Collectors and Connoisseurs*, 189). The collection, made up by some of the largest and most important collections of France, England, Saxony and Brussels, is also renowned today for its variety, while its quality should be considered as typical for collections of the aristocracy of the era (Holst, *Creators, Collectors and Connoisseurs*, 189; Massie, *Catherine the Great*, 523). In any case, regarding its size and according to the model of critical examination used here, the collection is classified at Level 1, since it exceeds 10,000 art objects (Avlonitou, 'Συλλέκτης και συλλογή, μια αδιαίρετη ενότητα', 461).

26. A collection formed within a period of thirty years or more is defined as 'long in duration', while 'particularly long in duration' is one that is formed within a period of fifty years or more (Avlonitou, 'Συλλέκτης και συλλογή, μια αδιαίρετη ενότητα', 464).

27. Jean de Jullienne (1686–1766) was one of the leading French collectors of the eighteenth century, *director* of the *Gobelin* textile factories, and Antoine Watteau's patron and friend. For the sale of his collection in 1767 see Jaques, *The Empress of Art*, 67–68; Holst, *Creators, Collectors and Connoisseurs*, 189–190.

28. The value of the commission of the latter, which most of the craftsmen of the factory, thirty-seven painters and five gilders, worked on, is valued today approximately at forty million dollars (Jaques, *The Empress of Art*, 99, 169).

29. Despite the fact that Russia's state income was spectacularly increased during the eighteenth century, the increase of the public expenses proved to be even more rapid. Of the public expenses, 9% concerned the maintenance of the czaric court, while it was the first time that a significant public debt appeared (4.5% of the state expenses in 1794). According to Riasanovsky: 'Although a poor, backward, overwhelmingly agricultural, and illiterate country, Russia had a large and glorious army, a complex bureaucracy, and one of the most splendid courts in Europe. With the coming of Westernization, the tragic, and as it turned out fatal, gulf between the small enlightened and privileged segment at the top and the masses at the bottom became wider than ever', Nicholas V. Riasanovsky, *A History of Russia* (New York: Oxford UP, 1984), 284.

30. The visits were already inaugurated in February 1769 at the so-called 'Thursday's dinners', where the use of Russian instead of the official French language was allowed (Dianina, 'Art and Authority', 645–654; Jaques, *The Empress of Art*, 37–38).

31. Due to its fragmentariness, the collection has been described as a 'bricolage of national schools and personal opinions' (Dianina, 'Art and Authority', 634).

32. Jaques, *The Empress of Art*, 252, 214.

33. The reputation of the czarina's collection was further enhanced after each large acquisition, each time she outwitted her rivals. When Catherine II reached her throne in 1762, there was no art collection in the empire, while her numerous significant trophies, especially the ones she obtained between 1767 and 1771, surprised the intellectual circles in Europe. By 1779, her reputation had reached its highest peak (Cabanne, *The Great Collectors*, 11, and Massie, *Catherine the Great*, 519–523).

34. Jaques, *The Empress of Art*, 349.

35. There was a similarity indeed between the nobility's collecting taste in Paris, London, Dresden, or Saint Petersburg, and the one of the merchants in Antwerp or Amsterdam (Holst, *Creators, Collectors and Connoisseurs*, 1967, 183). Evidence of this is that Catherine also purchased parts of collections created by self-made men, such as Antoine Crozat in France or the timber merchant Gerrit Braamkamp in Amsterdam, that were as much coveted as the ones belonged to the nobility. For the pieces of Braamkamp's 'Temple of Art' collection that were lost at sea, see Jaques, *The Empress of Art*, 88–90, and Troyat, *Catherine the Great*, 215.

36. Thornstein H. Veblen, *Θεωρία της αργόσχολης τάξης*, [The Theory of the Leisure Class] (Athens: Κάλβος, 1982), 84.

37. Jaques, *The Empress of Art*, 72, 336.

38. There are plenty of examples showing her extravagance in spending, which was surely not within the confines of reason and providence, although it created a sophisticated image for her court (Jaques, *The Empress of Art*, 38, 93–102, 111, 173, 208, 289, 351). For the attributes of her personality see also Troyat, *Catherine the Great*, 208.

39. Catherine studied constantly catalogues of the paintings she purchased and even asked for them to be compiled, when they did not exist, as in von Brühls' case. There, for example, she marked the pictures she wanted and then asked if the heirs would sell wholesale (Troyat, *Catherine the Great*, 71). She also used to learn everything she could about the art market (Troyat, *Catherine the Great*, 31). In other cases, she dared to prefer unknown artists (Troyat, *Catherine the Great*, 274) or artists who may have fallen in disfavor in other courts (Holst, *Creators, Collectors and Connoisseurs*, 179). She also liked to give advice to her agents and reach the final decisions herself (Jaques, *The Empress of Art*, 82–83).

40. She gave away, for instance, *Minerva* by Joseph-Marie Vien as well as the works by Charles van Loo from the L.M. van Loo collection, while, on the contrary, she kept the work *Still Life with Attributes of the Arts* by Chardin instead of giving it to St. Petersburg's Academy as planned (Jaques, *The Empress of Art*, 70, 83).

41. Thus, the big commission of the czarina for the *Green Frog Service* can be received as an action of courtesy towards the British monarch George III for his facilitation in the sneak attack of Russia against the Turks in Cesme in 1770. On the contrary, the purchase of works owned by the famous for his anti-Russian politics Étienne François, duc de Choiseul (which was comprised mostly of Flemish and Dutch painters and works by Wouwerman, Murillo, David Teniers, Jan Steen, Rembrandt, Dou or Van Dyck), can be seen as one of vengeful character (Cabanne, *The Great Collectors*, 10; Jaques, *The Empress of Art*, 150, 125–131).

42. Whittaker, 'Catherine the Great and the Art of Collecting', 160.
43. As Diderot wrote to Falconet in 1772: 'The sciences, the arts, good taste and wisdom go north and barbarianism with all its train comes south' (Cabanne, *The Great Collectors*, 10–11).
44. She described her collecting impulse as 'not for the love of art, but for voracity' and herself as a 'glutton'. As she put it: 'Je ne suis pas amatrice, je suis gloutonne'; see Nathalie Bondil (ed.), *Catherine the Great: Art for Empire. Masterpieces from the State Hermitage Museum, Russia* (Montreal: Montreal Museum of Fine Arts; Ghent: Snoeck Publishers, 2005), 169; Francis Henry Taylor, *The Taste of Angels: A History of Art Collecting from Rameses to Napoleon* (Boston: Little, Brown and Company, 1948), 531.
45. According to her: 'Like the [Byzantine] Empress Theodora I do love icons; but I like them to be well painted' (Jaques, *The Empress of Art*, 118). She used to describe herself as 'a great art lover' (Jaques, *The Empress of Art*, 347) and was enthusiastic about specific works of art (Jaques, *The Empress of Art*, 197), while the epitaph she wrote for herself upon Potemkin's death ended with the words 'She loved the arts' (Massie, *Catherine the Great*, 573).
46. Jaques, *The Empress of Art*, 83, 342.
47. As it is observed, the fashion launched by Catherine II also influenced Paris, which, according to Melchior Grimm, resulted in a 'fashion for all things Russian' (Jaques, *The Empress of Art*, 106).
48. Holst, *Creators, Collectors and Connoisseurs*, 203.
49. Avlonitou, 'Συλλέκτης και συλλογή, μια αδιαίρετη ενότητα', 230–231.

Bibliography

Andrews, Stuart (ed.), *Enlightened Despotism*, London: Longmans, 1967.

Avlonitou, Zacharoula, *Συλλέκτης και συλλογή, μια αδιαίρετη ενότητα: η περίπτωση του συλλέκτη και της συλλογής Γιώργου Κωστάκη* [Collector and Collection, an Indivisible Unit: The Case of the Collector and Collection of George Costakis]', PhD diss., U of Ioannina, School of Fine Arts, 2018.

Behrens, Betty, 'Enlightened Despotism', *The Historical Journal* 18, no. 2 (1975): 401–408, www.jstor.org/stable/2638495.

Bondil, Nathalie (ed.), *Catherine the Great: Art for Empire. Masterpieces from the State Hermitage Museum, Russia*, Montreal: Montreal Museum of Fine Arts; Ghent: Snoeck Publishers, 2005.

Cabanne, Pierre, *The Great Collectors*, New York: Farrar Straus, 1963.

Catherine II, Empress of Russia, *The Memoirs of Catherine the Great*, trans. Mark Cruse and Hilde Hoogenboom, New York: Modern Library, 2006.

Catherine II, Empress of Russia, *Selected Letters*, trans. Andrew Kahn and Kelsey Rubin-Detlev, New York: Oxford UP, 2018.

Cottaridi, Constantina and Grigoris Siourounis (ed.), *Αφιέρωμα στον John Nash: Θεωρία Παιγνίων* [*Tribute to John Nash: Game Theory*], Athens, Greece: Eurasia, 2002.

Dianina, Katia, 'Art and Authority: The Hermitage of Catherine the Great', *The Russian Review* 63, no. 4 (2004): 630–654, http://www.jstor.org/stable/3663984.

Holst, Niels Von, *Creators, Collectors and Connoisseurs: The Anatomy of Artistic Taste from Antiquity to the Present Day*, trans. Brian Battershaw, New York: G.P. Putnam's Sons Group, 1967.

Jaques, Susan, *The Empress of Art: Catherine the Great and the Transformation of Russia*. New York and London: Pegasus Books, 2016.

Kean, Beverly Whitney, *French Painters, Russian Collectors: The Merchant Patrons of Modern Art in Pre-Revolutionary Russia*, London: Hodder & Stoughton, 1994.

Massie, Robert K., *Catherine the Great: Portrait of a Woman*, London: Head of Zeus, 2012.

Riasanovsky, Nicholas V., *A History of Russia*, New York: Oxford UP, 1984.

Taylor, Francis Henry, *The Taste of Angels: A History of Art Collecting from Rameses to Napoleon*, Boston: Little, Brown and Company, 1948.

Troyat, Henri, *Catherine the Great*, trans. Joan Pinkham, New York: E.P. Dutton, 1980.

Varvaroussis, Paris, *Στρατηγική των παιγνίων: Συνεργασία και σύγκρουση στις διεθνείς σχέσεις* [*Game Strategy: Cooperation and Conflict in International Relations*], Athens: Papazisis, 1998.

Veblen, Thornstein, *Η Θεωρία της αργόσχολης τάξης* [*The Theory of the Leisure Class*], Athens: Κάλβος, 1982.

Voltaire, *Zadig, and Other Tales*, trans. Robert Bruce Boswell, London: G. Bell and Sons, Ltd, 1910.

Whittaker, Cynthia Hyla, 'Catherine the Great and the Art of Collecting: Acquiring the Paintings That Founded the Hermitage', in Maria Di Salvo, Daniel H. Kaiser and Valerie A. Kivelson (eds.), *Word and Image in Russian History: Essays in Honor of Gary Marker*, Brighton, MA: Academic Studies Press, 2015, 147–171, www.jstor.org/stable/j.ctt1zxsht1.16.

Williams, David (ed.), *Voltaire: Political Writings*, Cambridge: Cambridge UP, 1994.

Part III
Displaying, Recording, and Cataloguing

9 'I Made Memorandums'

Mary Hamilton, Sociability, and Antiquarianism in the Eighteenth-Century Collection

Madeleine Pelling

In a letter to her friend Charlotte Gunning in June 1783, the courtier, diarist and Bluestocking Lady Mary Hamilton (1756–1816) reported on an invitation from the antiquarian and writer Horace Walpole to visit his house and collection at Strawberry Hill. According to Walpole's instructions, she was to arrive 'two hours before dinner that he might shew me his Pictures'.[1] Narrating the same visit, Hamilton would afterwards write in her diary:

> I was summoned to accompany Mrs W[alsingham] and Miss B[oyle] to Straw-berry Hill at half-past one [. . .] Mr Walpole was so obliging as to show us the pictures, busts, drawings of Lady D. Beauclerc, not to forget the house, which is all Gothic. [. . .] It is impossible to make memorandums of the things I saw, from the great variety, besides too, we could only take a transient view. There were many cabinets filled with rare and curious things some of which had belonged to famous people, others executed by famous artists. [. . .] After tea Miss Boyle and myself went to look at pictures in the Gallery and Drawing-Room adjoining: I made memorandums of some.[2]

Conveying the rich interior at Strawberry Hill and the variety and scale of the collection it housed, Hamilton's account is equally inscribed with the complex social manoeuvrings that accompanied visits to eighteenth-century private collections, not least the performative practices of the host in delighting guests with personal access as well as the visitor's reciprocal work to record the impressive display. Her declaration, 'I made memorandums', affirms a compulsion to record the collection, to memorialise and chronicle her experiences within it. Shifting focus from quotidian articles, most prominent amongst them the drawings of Lady Diana Beauclerk who, like Hamilton herself, benefitted greatly from Walpole's patronage, to descriptions of the broader sensory and emotional effect of the whole, her account provides a rich and detailed record of the social, cultural, and material meanings of the collection. She concludes: 'I left Strawberry Hill with regret as my curiosity was not half satisfied, but as Mr Walpole told me at parting he hoped that I should frequently visit his villa I do not regret so much that I did not recollect all yt pleased me.[3]

This chapter explores Hamilton's important writing on two collections, one formed by Walpole and the other gathered by his contemporary, the actor and

collector David Garrick. It engages social network analysis as a methodological framework to explore the deeply sociable and performative nature of object encounters within collections assembled by those in Hamilton's circle, and examines how her letters and diaries reflect and quantify both the collections themselves and the social networks that were built around and sustained them. For Hamilton, writing accounts of her visits to collections served as a key component in the performative maintenance of her place within a wider group. Writing usually took place in private, as described by Hamilton in 1784 when she 'went to my B[ed] Room[,] scribbled in my diary', before being shared with friends and acquaintances.[4] She was an active, though still largely overlooked, member of the Bluestocking circle that included in its ranks several prolific collectors. Connections within this network were numerous and multifaceted, and delineated friendship and familial ties, as well as professional literary and artistic collaborations. Recording collections and conducting antiquarian work represent, I argue, an important part of Hamilton's previously overlooked contribution to the group, and proved central activities in enacting elite sociability.[5] That women did not enjoy the intellectual or social benefits of membership in all-male groups, including the Societies of Antiquaries and Dilettanti, led them to build their antiquarian and connoisseurial knowledge through privately negotiated access to objects and, often, more imaginative and flexible modes of engagement.[6] Here, I position Hamilton's accounts of collections as a form of antiquarian praxis, one that allowed for the performance of historical knowledge outside of the paternal metropolitan institutions traditionally closed off to women, the dissemination of the moral and rational values attached to such assemblages and the navigation and location of the author within the complex social structures that surrounded them.

In her accounts of Walpole's collection, Hamilton's descriptions are peppered with references to the vast scope, visual and emotional effect of the assemblage, and her own lived experience within strict models of polite sociability. In her writing centred on Garrick's collection of Shakespeareana, Hamilton turns toward quotidian artefacts to expose the opportunities held in collections for historical encounter and embodied experience. I posit the collections visited by Hamilton as physical and conceptual locations akin to the Bluestocking salons, and as deriving from this particular model of eighteenth-century sociability in which conversation and the advancement of morality and learning were key. Although the sociability of the Bluestockings has received sustained study, most often through their prolific correspondence, the role of material culture and, in particular, of collecting within the group has only recently begun to occupy scholars and warrants further attention.[7] In expanding our definition of the Bluestocking project to include the works and conversations generated in collections assembled by its members, it is possible to identify many of the otherwise-obscured avenues women in the circle took in generating material and historical knowledge. Here, I argue for Hamilton's letters and diaries as sociably imbued works, read and shared among select audiences, that served as the record of specific rituals, ambitions and behaviours enacted within collections, and that expanded the parameters of her network, disseminating its values and delineating objects spatially, emotionally, and temporally.

Social Networks, Collecting, and Antiquarianism

Though still overlooked, Hamilton was an active member of the Bluestocking group, which Anni Sairio has described as a 'clearly defined social network, or a dynamic web of people who are connected to each other in various capacities'.[8] 'It was a closed network', she notes, 'in that new members were invited to join by the established members, but simultaneously widely connected to other social worlds'.[9] Elizabeth Montagu, Elizabeth Vesey, and Frances Boscawen headed the main salons, which were frequented by regulars including Mary Delany and Margaret Cavendish Bentinck, Duchess of Portland (both of whom hosted their own smaller gatherings), as well as more peripheral figures including Horace Walpole, David Garrick and occasionally Samuel Johnson.[10] The group can be characterised by their shared ambition for rational friendship and intellectual betterment; connections were shaped and interactions driven by the performance and materialisation of these values at specifically designated sites. Sairio has traced the various local and textual geographies of the group, noting how 'the London salons of Montagu, Vesey and Boscawen were the most visible Bluestocking venues, but their geographical mobility required the friendships to be maintained also in extensive correspondence and via visits in the countryside and spa towns'.[11] Though still neglected by scholars, sites of collecting and assemblies of objects represented powerful epicentres of learning within this social and geographical framework, around which connoisseurial, antiquarian, and authorial praxes could be developed as part of a programme of learning and performed sociability. If, as Sairio outlines, 'social network analysis considers the structure and contents of a network, particularly by investigating the density and multiplexity of network ties', then we might consider the collection within this methodological framing as an important location in wider Bluestocking culture, and the high density of social interactions and textual commentary taking place within and around it as clear evidence of its significance in providing order and materiality to the group.[12]

Along with her voluminous correspondence, sixteen of Hamilton's diaries survive, with the majority dating from a period of intense social interaction from the early 1780s until her marriage in 1785.[13] In 1782, Hamilton resigned from her post in the royal nursery at the court of George III and Queen Charlotte, and moved to a house in Clarges Street, London with her friend Anna Maria Clarke. Hamilton, who had travelled in France and Belgium before joining the Georgian court in 1776, had quickly became a favourite of the royal children, by whom she was affectionately called 'Hammy'. After leaving her position at court, she began what would prove a busy and creative period.[14] Natalia Voloshkova has noted that, during this time, Hamilton's social engagements ranged 'from the Bas Bleu parties and crowded assemblies to intimate get-togethers at breakfast, tea or, more often, the dinner table organised by her Bluestocking friends in their London and country houses'.[15] Among her developing circle of writers, artists, antiquarians, and collectors was Elizabeth Vesey, whose salon was situated across the street from Hamilton's Clarges Street address. Although it is not clear when Hamilton and Walpole first met, Voloshkova has identified a diary entry from January 1783 detailing a visit to Vesey's salon as the earliest record of them together.[16] From then, they met regularly. In April 1784,

she described in her diary how she 'went to M^rs Delany to whom I was engaged[.] met there M Horace Walpole[,] ye D[owager] D[uchess] of Portland & Lady Weymouth. Paintings—Vertú & Beauty were the chief topics of discourse—the conversation was agreeable'.[17] Among the Bluestocking circle, discussion of art and history became central to their ideas of societal advancement and British moral development. Hamilton's writing chronicles the significance of collections, and the conversations they prompted, in formulating narratives of national history and collective identities based on shared lineages and cultivated threads of material, moral, and intellectual inheritance. Her letters and diaries reveal the importance of Strawberry Hill and David and Eve Garrick's nearby Hampton house at Twickenham as Bluestocking where guests including Elizabeth Vesey and Hamilton herself moved between Walpole's fantastical medieval reimaginings and Garrick's assemblage of Shakespearean literary and material artefacts to witness and disseminate ideas of an English past.

In writing lived experience, Clifford Geertz claims, the writer transforms 'a passing event, which exists only in its own moment of occurrence, into an account, which exists in its inscriptions and can be reconsulted'.[18] Here, I read Hamilton's letter and diary accounts of collections not only as important records of historic objects, many of which are now lost to us, but as the textual evidence of a performative and sociable antiquarianism that, although born in the wider context of eighteenth-century collecting cultures, allowed the writer to harness and advance specifically Bluestocking values and, in doing so, legitimize her place within the group. Expanding on her relatively modest claim 'I made memorandums', I take her writing as an ambitious methodology that sought to capture not only brief and immediate experience, but to signal and transmit the values and ambitions of those around her.

Horace Walpole's Strawberry Hill

In late June 1783, Hamilton spent the day visiting the Garricks at Hampton house. Among her company were the salon hostess Elizabeth Vesey, Mrs Walsingham, Charlotte Boyle, and Horace Walpole. In the aforementioned letter to her friend Charlotte Gunning, Hamilton describes how the conclusion of one excursion led to the invitation to another: 'before we parted Mr Walpole politely invited me to his Villa, & invited y^e Company to meet me on that day week'.[19] Describing the subsequent visit to Walpole's home at Strawberry Hill (Figure 9.1), Hamilton writes to her friend:

> At ½ past 1 o'clock' we set out for Mr Walpoles and got to Twickenham at ½ past 2. We had lost half an hour of the two we spent in looking over the Pictures. I shall not pretend to tell you all I saw—for that is impossible. Have you ever been at this Villa? What a collection. Such Pictures—Miniatures—Antiques—relicks—China &c. &c. What w^d I not give to spend a Month in this House to examine y^e various & valuable curiosities it contains—I hope however to have opportunities of seeing them as Mr W has politely invited me to come as often as I chose [sic], for I had only time to take a transient view.[20]

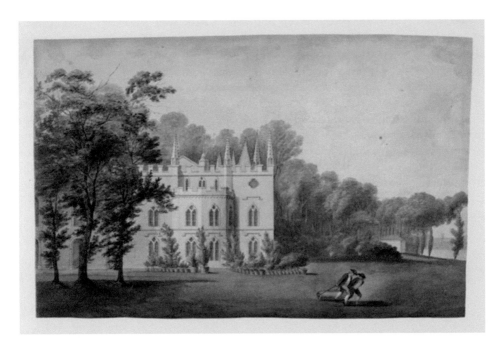

Figure 9.1 Unknown artist, *A View of Horace Walpole's Home in Twickenham, Strawberry Hill from the South*, c. 1756. Watercolour on laid paper, 30.6 × 45.1cm.

Source: Courtesy of the Lewis Walpole Library, Yale University.

Hamilton's question, 'Have you ever been to this Villa?' works to confirm her own status as a key figure in the circle associated with Strawberry Hill, centring it as an important site within a wider social world occupied by both writer and reader and, in an act that makes oblique reference to the form and function of the letter itself, provides temporary relief from Gunning's geographical and social exclusion. Her account reflects not only her abilities as a descriptive writer and chronicler of historical objects, but also her investment in Walpole's wider project at the house and the opportunities for visitors to participate in his historical and aesthetic reimaginings. She promises Gunning that she will 'not pretend to tell [her] all [she] saw', and, instead, the '&c., &c.' that comes at the end of her list of object types becomes shorthand for those objects not listed and not made visible, inviting Gunning and anyone else reading her letter to fill in the omissions with their own fabrication. Ideas of temporality also abound as Hamilton's precise documenting of the time she spends at Strawberry Hill, from her arrival 'at ½ past 1 o'clock' to the 'half an hour' she spends looking at pictures with Walpole, soon gives way to imaginative forecasting as she predicts she must 'spend a Month in this House' in order to know the true scope of its contents. Her vocabulary here, that she 'lost' time looking at pictures and must 'spend' a month further examining the collection, underscores ideas of Hamilton's personal investment in the

site and the performative expenditure of her creative and cognitive energies in unpacking it. That she closes her account with reference to the future opportunities she will have to visit, thanks to Walpole's extended invitation, foregrounds temporality as a key framework in her reading and writing of the site, one that unites retrospection and antiquarian pursuits anchored in the material fabric of the past with a kind of futurism expressed within the collection and its promise of further creative work.

Hamilton became a regular visitor to Strawberry Hill, and, in 1785, Walpole gifted her a copy of his *Description of the Villa*, a privately printed text circulated amongst a select group of friends (Figure 9.2).[21] In the autumn of 1784, she brought her uncle Sir William Hamilton to the house. Sir William returned to Britain in 1783, travelling from Naples following the death of his wife Catherine.[22] Hamilton, who was then at the height of her Bluestocking activity, took up the responsibility of introducing her uncle back into London society and, that winter, was instrumental in negotiating the

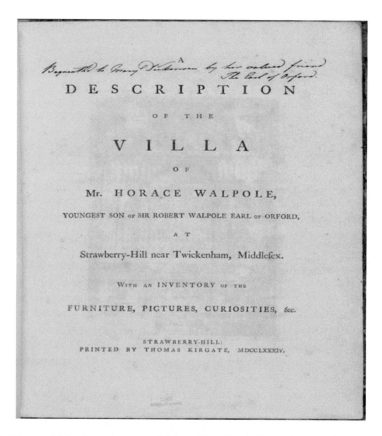

Figure 9.2 Horace Walpole, title page of Mary Hamilton's [later Mrs Dickenson] copy of *A Description of the Villa*, 1784. LWL Quarto 33 30 Copy 7.

Source: Courtesy of the Lewis Walpole Library, Yale University.

sale of the Barberini (later Portland) vase between Sir William and the Duchess of Portland.[23] In September 1784 she travelled with him to Strawberry Hill, afterwards writing in her diary:

> A little before 3 we got to Mr. Walpole's his Chaise was at y^e door to carry him to Mrs Garricks—but we would go in—he was pleased to see us but he had been so disappointed in not seeing my Uncle at Strawberry Hill this summer that he said he did not think he w^d let him in if he had not heard my name. We spent ab^t 20 minutes very agreeably—Mr. W. carry'd us through some of y^e Rooms to show my Uncle some things w^ch he had not seen.[24]

Here, the geographical proximity and social interconnectedness of Strawberry Hill with Hampton house is apparent, with Walpole setting out to visit the Garricks when Hamilton and her uncle arrive. Although Walpole's quip about admitting Sir William only because of her presence is no doubt meant in friendly flattery to Hamilton, a point she emphasises by underscoring her words on the page of her diary, it confirms the important social dynamic that governed the etiquette of visiting elite homes and their contents—a familiarity between visitor and host that meant Walpole himself showed them round, opening drawers and cabinets and providing an oral commentary to the objects which, although likely rehearsed and repeated elsewhere, was not necessarily recorded textually and readily available to other guests. In reiterating the same narrative of exclusivity created by Walpole in his collection, Hamilton becomes a participant in his project of self-invention, positioning herself as an important commentator associated with the site and taking up its themes of luxury, exclusivity, scale, texture, and imagination.

David Garrick's Shakespearean Collection

From her earliest arrival in London, Hamilton developed a close acquaintance with Eve Garrick and, along with their mutual friend and fellow Bluestocking Hannah More, regularly attended the theatre as her guest. On 17 March 1784, Hamilton wrote in her diary that she 'rec^d a note from Miss H More with Mrs Garricks Ticket w^ch allows me y^e use of her whole Box without paying any thing at Drury Lane Theatre for one night—this is for next Thursday when Mrs Siddons is to act'.[25] In the same month, Hamilton described a growing bond between the three women, reporting: 'Mrs Garrick & Miss H More came & staid ½ an hour[.] Mrs G is a most unaffected—elegant, pleasing & friendly woman'.[26] Her social connection to the Garricks also gained Hamilton regular invitations to their home in Twickenham where she encountered the couple's collection of Shakespeare-associated objects, many of which were displayed in a temple dedicated to the playwright and erected in the grounds (Figure 9.3).[27] Hamilton's interest in Shakespeare during the 1780s is clear. In February 1784, she read *Macbeth*, and in spring 1785 reported in her diary seeing Sarah Siddons in the role of Lady Macbeth at the actress's Drury Lane benefit.[28] Shakespearean texts were a regular topic in her correspondence. In October 1788, Hamilton's cousin Jane Holman wrote to her:

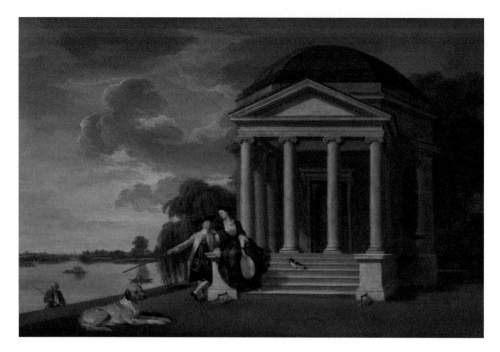

Figure 9.3 Johan Joseph Zoffany, *David Garrick and his Wife by his Temple to Shakespeare, Hampton*, c. 1762. Oil on canvas, 43 ¼ × 53inches.

Source: Yale Centre for British Art, Paul Mellon Collection.

> I admire Shakespeare more than ever; I am going to give you a detailed descrip-
> tion of the parts which I am most struck by [in] those which I have read, and
> perhaps you will tell me if you are of my opinion. "The Tempest. The Mer-
> chant of Venice. The Winters' Tale. King John. and some parts of Measure for
> Measure". You will apparently find me very bold, to give my opinion of your
> immortal Shakespeare, but since it is to speak well of him I suppose you will
> excuse it.[29]

Holman's deference to Hamilton's authority on the playwright, whom she describes
as 'your immortal Shakespeare', signals her awareness of Hamilton's knowledge of
the subject, as well as the broader endurance and cultural ubiquity of this literary
figure.

Certainly, Shakespeare represented an important staple in the education and crea-
tive work of elite and middling women. Fiona Ritchie has noted that 'just as male
figures like Johnson and Garrick linked themselves with Shakespeare's burgeoning
status as a way to consolidate their own reputations, so eighteenth-century women
critics and performers also used Shakespeare's growing significance to legitimise their
careers and to establish their own positions in society'.[30] As early as 1736, the Coun-
tess of Shaftsbury headed a committee, known as The Shakespeare Ladies' Club, that

petitioned theatres in London to produce his plays.[31] Elizabeth Eger has noted how Shakespeare was a subject of intense interest for the Bluestockings and was most famously vindicated in Elizabeth Montagu's *An Essay on the Writings and Genius of Shakespear* (1769).[32] Elizabeth Child similarly suggests that 'Shakespeare clearly represented cultural capital for Montagu, her *Essay* the currency with which she might trade in the marketplace of ideas on an equal basis with such literary luminaries as Voltaire and Samuel Johnson'.[33] Beyond reading and writing about Shakespeare's plays, which held key opportunities for embodied engagement with the playwright as well as participation in wider sociable and intellectual behaviours, consultation with objects associated with the man opened channels for transhistorical and corporeal encounters.

Statuary depictions of Shakespeare appeared in the homes and gardens of the elite, most notable among these the Shakespearean bust in the Temple of Worthies at Stowe as well as a statue in Garrick's temple. In 1773, Hannah More visited Garrick's shrine to the bard and later gave a rare diary account of its contents:

> [The house] is on the banks of the Thames; the temple about thirty or forty yards from it. Here is the famous chair, curiously wrought out of a cherry-tree which really grew in the garden of Shakespeare at Stratford. I sat in it, but caught no ray of inspiration. But what drew, and deserved, my attention was a most noble statue of this most original man, in an attitude strikingly pensive—his limbs strongly muscular, his countenance expressive of some vast conception, and his whole for seeming the bigger from some immense idea with which you suppose his great imagination pregnant.[34]

That she was not visited by authorial inspiration whilst sitting in Shakespeare's chair was for More, as a playwright and poet herself, a disappointment. Her description does, however, expose something of the expectations that surrounded such collected objects and their potential uses in connecting corporeally and intellectually with figures of the past. If Shakespeare's impregnated imagination remained inaccessible to More, locked away behind the surprisingly engaging yet ultimately unknowable statue of the man himself, the same objects compellingly aroused in Hamilton a keen interest in antiquarian work.

In June 1783, Hamilton travelled to Hampton with a party that included Horace Walpole and fellow Strawberry Hill visitors Mrs Walsingham and Charlotte Boyle:

> 'join'd ye gentlemen at tea time in Shakespeares Temple—this temple is an Octagon—a simple elegant Building with a very fine statue in a Niche opposite ye door of Shakespeare—by Roubilliac—there is likewise in this Temple—a high Chair with a footstall the decorations design'd by Hogarth—wch consist of ye emblems of Tragedy & Comedy—carv'd & going round ye back of ye Chair wch is high of a fine dark Oak—in ye Centre of ye back in the back is a medallion of Shakespeare's head carv'd by Hogarth of ye Oak of ye Tree under which Shakespeare shot ye Deer.[35]

Hamilton's 'thick description', to use Geertz's term, is rich in its detail of the space, its shape and contents, as well as the various social networks attached to the material landscape. From the statue sculpted by Louis-François Roubiliac, commissioned by Garrick in 1758, to the carvings designed by William Hogarth, Hamilton signals the artistic collaborations and commissions that are represented in the collection, taking care to simultaneously signpost her own privileged access to this knowledge. Beyond this performative signalling, however, there is very little of Hamilton herself in the account. Approaching it as an antiquarian, she focuses in on the objects, diligently noting the geometric shape of the temple, the 'fine dark Oak' of the chair and the narrative attached to the tree under which the playwright was believed to have poached a deer, an act that supposedly led to his temporary incarceration as a young man.

A year later, in September 1784, Hamilton warranted a dinner invitation to Hampton during which Garrick exhibited more of his collection, this time bringing out objects displayed in the house. She recorded in her diary:

> Whilst the dinner was serving Mr Garrick shew'd us some things wch had been Shakespeares—Gloves wch he had worn—wrought at ye tops such as one sees in old Pictures with gold, silver & color'd embroidery, a Small Knife of this Shape ye handle silver & ebony wch some of his descendants had given Mr. Garrick, a Cup made of ye mulberry tree he had plant'd, lin'd with Silver gilt—his hand writing (upon a lease) & a very elegant square box ye size & shape of a middle size Tea Chest carved in Ash of ye Tree under wch Shakespeare shot ye Deer for wch he was taken up &c. the Carving was done at Birmingham & is really well done—ye 4 sides are different subjects, ye back represents Garrick in King Lear—it is lined wth Crimson Velvet—& ye Handle & feet on Silver—ye feet are very pretty. They are 4 birds—the box has a black shagreen Case to preserve it—it was given by ye People of Stratford upon Avon after ye great Jubilee wch Garrick made in honour of this great disciple of Nature.[36]

Once again, the text is informed by typical Hamiltonian attention to specific materiality, from the 'gold, silver & colord embroidery' of the gloves to the 'silver & ebony' handle of a knife. In her notation, 'Mr Garrick shew'd us some things', Hamilton signposts the sociable, even theatrical, performance of her host, akin to that of Walpole at Strawberry Hill, as he presents and narrates objects to the group. We can imagine, perhaps, Garrick pulling back the 'black shagreen Case' that covered the carved box, turning the item in his hands as he explained its provenance and histories. Hamilton's description does more than represent this moment of object encounter. In including in her account details of the objects' history, and in particular the actions and exchanges that linked Shakespeare and Garrick, she is recording and conjuring a rich procession of historical moments from Shakespeare planting the mulberry bush to Garrick's 1769 jubilee celebrations in Stratford.

Michael Dobson has noted Garrick's literary and material endeavours to fashion himself as the definitive embodiment of Shakespeare.[37] Here, Hamilton endorses this ambitious alignment, describing how Garrick is combined with the playwright in a decorative motif carved into the malleable yet enduring material of the wooden box. Similarly, in recording how Shakespeare's descendants gifted the silver

knife to Garrick, she reiterates his established genealogical narrative of a traceable, albeit indirect, line from man to man via the object itself, a connection underscored by the reference to the jubilee and to Garrick's vindication by the people of Stratford. For Hamilton and Garrick, the collected objects are not only possessable, but useable as devices through which to access Shakespeare's corporeal ghost. In specifying how the gloves had been worn by the playwright, Hamilton provides the faintest outlines of a ghostly hand, the tool of his genius, as well as a rich description of the embroidered fabric itself. Unlike More's uninspiring encounter with the chair in Garrick's temple, Hamilton finds opportunity for proximity to Shakespeare in the sample of his writing as well as in the transformation of materials associated with him into usable objects, including the mulberry cup and the tea chest. Significantly, both items are crafted to hold comestible goods, offering ritualistic connections between the historical world of Shakespeare's England and the polite sociability of her own. Supposedly made from the wood of a mulberry tree planted by Shakespeare in his garden, the cup was presented to Garrick by the mayor of Stratford at the 1769 jubilee (Figure 9.4). The ritualistic, even eucharistic, potential of the cup to unite Shakespeare and its user was eloquently expressed in a poem performed by Garrick at the presentation he drank from it:

> Behold this fair Goblet, t'was carved from the Tree
> Which, Oh! My sweet Shakespeare was planted by thee
> As a relic I kiss it, and bow at thy shrine

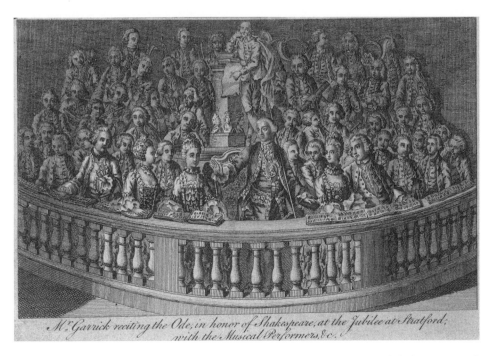

Figure 9.4 Unknown Artist, *David Garrick Reciting the Ode in Honour of Shakespeare at the Jubilee at Stratford*, c. 1769. Engraving.

Source: Royal Collection Trust/© Her Majesty Queen Elizabeth II 2019.

What comes from thy hand must be ever divine
All shall yield to the Mulberry Tree
Bend to thee, blessed Mulberry
Matchless was he who planted thee
And thou, like him, immortal shalt be[38]

Hamilton's writing becomes part of Garrick's campaign for a historiography that, in its methods, could be characterised by what Nietzsche termed the 'conservatism and reverence' of antiquarianism, but that equally endeavours to position its subject, Shakespeare, as vital to and powerfully transformative of eighteenth-century culture.[39] For Hamilton and Garrick, antiquarianism becomes what Stephen Bann defines as a 'specific, lived relationship to the past', something dynamic that also reflects on the contemporary lives of the wider social circle in which they live and create, as much reflective on their own identities as it is of individuals of the past.[40] Hamilton's accounts chronicle a kind of transhistorical sociability in which Shakespeare becomes not only an emblem of literary and artistic achievement, but also of the careful recovery of a national past, one that positions its reclaimants as the rightful inheritors of a rich legacy, accessible through direct empirical and literary encounter with the materials of the past.

Conclusion

Hamilton's letters and diaries were produced in the context of, and deeply implicated in, collections and the social routines surrounding them. Her writings survive as documentary evidence not only of her commitment to textually recording the collected objects she encountered, but also the socio-political balances of her friendships and associations and, crucially, how these played out at sites of collecting where the collections themselves were used to mediate and perform social nuance. This chapter has argued for the centrality of material culture to Bluestocking sociability, focusing on Strawberry Hill and Hampton house where collections formed by Walpole and Garrick became important sites useful in driving the values of the group, acting as the material manifestations of connection and meaning within a wider network. At both sites, chronicled by Hamilton across her letters and diaries, assemblages and single objects were positioned as holding opportunity for interpersonal, sometimes transhistorical, encounters. Within this context, Hamilton is an important writer of object and collecting histories who, through her written accounts, sought to reflect the activities and ambitions of those in her circle as well as to confirm her status within it. In making these 'memorandums', Hamilton took on a key role in recording and disseminating conversations and narratives cultivated within collections, reporting on the complex relationship between collector and visitor, as well as wider Bluestocking ideas about historiography, literary and artistic creativity.

Notes

1. Mary Hamilton to Charlotte Gunning, June 1783. HAM/1/15/2/26, U of Manchester.
2. Hamilton's diary, 5 July 1783, HAM/2/3.
3. Hamilton's diary, 5 July 1783, HAM/2/3.
4. Hamilton's diary, 27 March 1784, HAM/2/9.

5. For an overview of Hamilton's life and surviving archive, see Lisa Crawley, 'Mary Hamilton: A Life Recovered', *Bulletin of the John Rylands Library* 90, no. 2 (Autumn 2014): 27–46.

6. Ileana Baird and Laura C. Mayer have both argued for the significance of sociability as a central tenant in eighteenth-century cultures of collecting and antiquarianism. Across private collections in Britain and Europe, layers of meaning relating to social transactions, networks of exchange, and notions of connoisseurship were encoded into and represented within its objectscapes, and later relayed in textual and oral commentary. Baird notes that the Society of Dilettanti, which counted among its members David Garrick and Hamilton's paternal uncle and antiquarian Sir William Hamilton, started as 'a dining club whose members had enjoyed the excitement of the Grand Tour'. See Ileana Baird (ed.), *Social Networks in the Long Eighteenth Century: Clubs, Literary Salons, Textual Coteries* (Newcastle: Cambridge Scholars Publishing, 2014), 18; Laura Mayer, 'The Society of Dilettanti: Bacchanalians & Aesthetes', in Ileana Baird (ed.), *Social Networks in the Long Eighteenth Century: Clubs, Literary Salons, Textual Coteries* (Newcastle: Cambridge Scholars Publishing, 2014), 199.

7. See Elizabeth Eger, 'Paper Trails and Eloquent Objects: Bluestocking Friendship and Material Culture', *Parergon* 26, no. 2 (2009): 109–138; Nicole Pohl, 'Knitting Needles, Knotting Shuttles, & Totums & Cards & Counters: The Bluestockings and the Material Culture of Fibre Arts', *Textile History* (2019); Madeleine Pelling, 'Collecting the World: Female Friendship and Domestic Craft at Bulstrode Park', *Journal for Eighteenth-Century Studies* 41, no. 1 (March 2018): 101–120.

8. Anni Sairio, 'Methodological and Practical Aspects of Historical Network Analysis: A Case Study of the Bluestocking Letters', in Arja Nurmi, Minna Nevala and Minna Palander-Collin (eds.), *The Language of Daily Life in England, 1400–1800* (Amsterdam: John Benjamins Publishing, 2009), 108.

9. Sairio, 'Methodological and Practical Aspects of Historical Network Analysis', 116.

10. See S.H. Myers, *The Bluestocking Circle: Women, Friendship, and the Life of the Mind in Eighteenth Century England* (Oxford: Clarendon Press, 1990); Nicole Pohl and Betty Schellenberg (eds.), *Reconsidering the Bluestockings* (San Marino: Huntington Library, 2003); Elizabeth Eger, *Bluestockings: Women of Reason from Enlightenment to Romanticism* (London: Palgrave Macmillan, 2010); Eger and Lucy Peltz (eds.), *Brilliant Women: 18th-Century Bluestockings* (New Haven: Yale UP, 2008).

11. Sairio, 'Methodological and Practical Aspects of Historical Network Analysis', 108.

12. Sairio, 'Methodological and Practical Aspects of Historical Network Analysis', 116.

13. The diaries are now held at the University of Manchester.

14. One of Hamilton's most significant contributions to the Bluestockings during this period was in her role as an editor of Hannah More's poem 'The Bas Bleu'. See Moyra Haslett, 'Becoming Bluestockings: Contextualising Hannah More's "The Bas Bleu"', *Journal for Eighteenth-Century Studies* 33, no. 1 (March 2010): 89–114.

15. Natalia Voloshkova, '"My Friend Mr. H. Walpole": Mary Hamilton, Horace Walpole and the Art of Conversation', *Image & Narrative* 18, no. 3 (2017): 96.

16. Voloshkova, '"My Friend Mr. H. Walpole"', 97. See also Mary Hamilton's Diary, 11 January 1783. HAM/2/2.

17. Hamilton's diary, April 1784. HAM/2/9. Jon Mee has argued that from the early eighteenth century until the Romantic period, 'the uses of conversation became [. . .] a key issue for inquiries into the unity of the new society and the means of its further development'. Mee, '"The Use of Conversation": William Godwin's Conversable World and Romantic Sociability', *Studies in Romanticism* 50, no. 4 (Winter 2011): 567.

18. C. Geertz, 'Thick Description: Towards an Interpretive Theory of Culture', in *The Interpretation of Cultures* (New York: Basic Books Inc., 1973), 19. Gowrley similarly engages Geertz's 'thick description' in her study of study of the diarist, and contemporary of Hamilton's, Caroline Lybbe Powys to reveal how such writing not only functions to describe the material landscapes and object encounters of the writer's life but the social processes that led to their formulation. See Gowrley, *Domestic Space in Britain, 1750–1840: Materiality, Sociability and Emotion* (Bloomsbury, forthcoming).

19. Hamilton to Charlotte Gunning, 6 June 1783. HAM/1/15/2/26.

20. Hamilton to Charlotte Gunning, 6 June 1783. HAM/1/15/2/26.
21. Hamilton's copy of *A Description of the Villa* (1784 edition). LWL Quarto 33 30 Copy 7, Lewis Walpole Library, Yale University. For more on Walpole's Description and visitor experience, see Stephen Clarke, ' "Lord God! Jesus! What a House!": Describing and Visiting Strawberry Hill', *Journal for Eighteenth-Century Studies* 33, no. 2 (2010): 357–380.
22. See Ian Jenkins and Kim Sloan, *Vases and Volcanoes: Sir William and His Collection* (London: British Museum Press, 1996).
23. See Milo Keynes, 'The Portland Vase: Sir William Hamilton, Josiah Wedgwood and the Darwins', *Notes and Records of the Royal Society of London* 52, no. 2 (July 1998): 237–259.
24. Hamilton's diary, 5 September 1784, HAM/2/14, emphasis Hamilton's own.
25. Hamilton's diary, 27 March 1784. HAM/2/9.
26. Hamilton's diary, 12 March 1784. HAM/2/8. For more on Hamilton's friendship with Hannah More, and in particular her central role in editing More's poem 'The Bas Bleu', see Moyra Haslett, 'Becoming Bluestockings: Contextualising Hannah More's "The Bas Bleu" ', *Journal for Eighteenth-Century Studies* 33, no. 1 (March 2010): 99.
27. Eve Garrick also gifted Hamilton a copy of a catalogue to David Garrick's library following her husband's death, and bid her read anything she chose from it. See Hamilton's diary, August to December 1784. HAM/2/14.
28. Hamilton's diary, December 1784–May 1785. HAM/2/15.
29. Jane Holman, née Hamilton, to Mary Hamilton, 5 October 1788. HAM/1/4/3/12. Translated from the original French.
30. Fiona Ritchie, *Women and Shakespeare in the Eighteenth Century* (Cambridge: Cambridge UP, 2014), 176.
31. Susan Brock, 'Shakespeare Ladies' Club', in *The Oxford Companion to Shakespeare* (Oxford UP, 2004), https://www-oxfordreference (accessed 2 September 2019); See also Andrew S. Brown, 'Marina and the Market for Shakespeare in Eighteenth-Century Performance', *Eighteenth-Century Studies* 51, no. 2 (2018): 163–178.
32. E. Eger, ' "Out Rushed a Female to Protect the Bard": The Bluestocking Defense of Shakespeare', *Huntington Library Quarterly* 65, no. 1–2, Reconsidering the Bluestockings (2002): 127–151.
33. Elizabeth Child, 'Elizabeth Montagu, Bluestocking Businesswoman', *Huntington Library Quarterly* 65, no. 1–2, Reconsidering the Bluestockings (2002): 166.
34. William Roberts, *Memoirs of the Life and Correspondence of Mrs. Hannah More*, vol. I (New York: Harper & Brothers, 1834), 36. For more on More's visit to Hampton house, see Peter Holland, 'David Garrick: Saints, Temples and Jubilees', in Clara Calvo and Coppélia Kahn (eds.), *Celebrating Shakespeare: Commemoration and Cultural Memory* (Cambridge: Cambridge UP, 2015), 15–37.
35. Hamilton's diary, 28 June 1783. HAM/2/3.
36. Hamilton diary, 5 September 1784. HAM/2/14, f.58–59.
37. Michael Dobson, *The Making of the National Poet: Shakespeare, Adaptation and Authorship, 1660–1769* (Oxford: Oxford UP, 2004).
38. David Garrick, 'Shakespeare's Mulberry Tree, Sung with a Cup in His Hand Made of the Tree, by Mr. Vernon and Others', in *The Poetical Works of David Garrick, Esq. Now First Collected into Two Volumes*, vol. II (London, 1785), 431–434.
39. Friedrich Nietzsche, *The Use and Abuse of History*, trans. Adrian Collins (Indianapolis: Bobbs-Merrill Co., 1978), 12.
40. Stephen Bann, 'Clio in Part: On Antiquarianism and the Historical Fragment', *Perspecta* 23 (1987): 27.

Bibliography

Baird, I. (ed.), *Social Networks in the Long Eighteenth Century: Clubs, Literary Salons, Textual Coteries*, Newcastle: Cambridge Scholars Publishing, 2014.

Bann, S., 'Clio in Part: On Antiquarianism and the Historical Fragment', *Perspecta* 23 (1987): 24–37.

Bock, S., 'Shakespeare Ladies' Club', in *The Oxford Companion to Shakespeare*, Oxford: Oxford UP, 2004.

Brown, A.S., 'Marina and the Market for Shakespeare in Eighteenth-Century Performance', *Eighteenth-Century Studies* 51, no. 2 (2018): 163–178.

Child, E., 'Elizabeth Montagu, Bluestocking Businesswoman', *Huntington Library Quarterly* 65, no. 1–2, Reconsidering the Bluestockings (2002): 153–173.

Clarke, S., ' "Lord God! Jesus! What a House!": Describing and Visiting Strawberry Hill', *Journal for Eighteenth-Century Studies* 33, no. 2 (2010): 357–380.

Crawley, L., 'Mary Hamilton: A Life Recovered', *Bulletin of the John Rylands Library* 90, no. 2 (Autumn 2014): 27–46.

Dobson, M., *The Making of the National Poet: Shakespeare, Adaptation and Authorship, 1660–1769*, Oxford: Oxford UP, 2004.

Eger, E., *Bluestockings: Women of Reason from Enlightenment to Romanticism*, London: Palgrave Macmillan, 2010.

Eger, E., ' "Out Rushed a Female to Protect the Bard": The Bluestocking Defense of Shakespeare', *Huntington Library Quarterly* 65, no. 1–2, Reconsidering the Bluestockings (2002): 127–151.

Eger, E., 'Paper Trails and Eloquent Objects: Bluestocking Friendship and Material Culture', *Parergon* 26, no. 2 (2009): 109–138.

Ellis, M., 'Reading Practices in Elizabeth Montagu's Epistolary Network of the 1750s', in Elizabeth Eger (ed.), *Bluestockings Displayed: Portraiture, Performance and Patronage, 1730–1830*, Cambridge: Cambridge UP, 2013, 213–232.

Garrick, D., 'Shakespeare's Mulberry Tree, Sung with a Cup in His Hand Made of the Tree, by Mr. Vernon and Others', in *The Poetical Works of David Garrick, Esq. Now First Collected into Two Volumes*, Vol, II, London, 1785.

Geertz, C., 'Thick Description: Towards an Interpretive Theory of Culture', in *The Interpretation of Cultures*, New York: Basic Books Inc., 1973.

Gowrley, F., *Domestic Space in Britain, 1750–1840: Materiality, Sociability and Emotion*, Bloomsbury, forthcoming.

Haslett, M., 'Becoming Bluestockings: Contextualising Hannah More's "The Bas Bleu" ', *Journal for Eighteenth-Century Studies* 33, no. 1 (March 2010): 89–114.

Holland, P., 'David Garrick: Saints, Temples and Jubilees', in Clara Calvo and Coppélia Kahn (eds.), *Celebrating Shakespeare: Commemoration and Cultural Memory*, Cambridge: Cambridge UP, 2015.

Jenkins, I. and K. Sloan, *Vases and Volcanoes: Sir William and His Collection*, London: British Museum Press, 1996.

Keynes, M., 'The Portland Vase: Sir William Hamilton, Josiah Wedgwood and the Darwins', *Notes and Records of the Royal Society of London* 52, no. 2 (July 1998): 237–259.

Llandover, A. (ed.), *The Autobiography and Correspondence of Mary Granville, Mrs. Delany: With Interesting Reminiscences of King George the Third and Queen Charlotte*, 6 vols. in 2 series, London: Richard Bentley, 1861–1862.

Mayer, L., 'The Society of Dilettanti: Bacchanalians & Aesthetes', in Ileana Baird (ed.), *Social Networks in the Long Eighteenth Century: Clubs, Literary Salons, Textual Coteries*, Newcastle: Cambridge Scholars Publishing, 2014, 199–220.

Mee, J., ' "The Use of Conversation": William Godwin's Conversable World and Romantic Sociability', *Studies in Romanticism* 50, no. 4 (Winter 2011): 567–590.

Mee, J., *Conversable Worlds: Literature, Contention, and Community 1762–1830*, Oxford: Oxford UP, 2011.

Myers, S.H., *The Bluestocking Circle: Women, Friendship, and the Life of the Mind in Eighteenth Century England*, Oxford: Clarendon Press, 1990.

Nietzsche, F., *The Use and Abuse of History*, trans. Adrian Collins, Indianapolis: Bobbs-Merrill Co., 1978.

Pelling, M., 'Bluestocking Collecting, Craft and Conversation in the Duchess of Portland's Museum, c. 1770–1786', PhD Thesis, U of York, 2018.

Pelling, M., 'Collecting the World: Female Friendship and Domestic Craft at Bulstrode Park', *Journal for Eighteenth-Century Studies* 41, no. 1 (March 2018): 101–120.

Pohl, N., '"Perfect Reciprocity": Salon Culture and Epistolary Conversations', *Women's Writing* 13, no. 1 (2006): 139–159.

Pohl, N. and B. Schellenberg (eds.), *Reconsidering the Bluestockings*, San Marino: Huntington Library, 2003.

Ritchie, F., *Women and Shakespeare in the Eighteenth Century*, Cambridge: Cambridge UP, 2014.

Roberts, W., *Memoirs of the Life and Correspondence of Mrs. Hannah More*, vol. I, New York: Harper & Brothers, 1834.

Sairio, A., 'Methodological and Practical Aspects of Historical Network Analysis: A Case Study of the Bluestocking Letters', in Arja Nurmi, Minna Nevala and Minna Palander-Collin (eds.), *The Language of Daily Life in England, 1400–1800*, Amsterdam: John Benjamins Publishing, 2009.

Tobin, B.F., *The Duchess's Shells: Natural History Collecting in the Age of Cook's Voyages*, New Haven: Yale UP, 2014.

Voloshkova, N., '"My Friend Mr. H. Walpole": Mary Hamilton, Horace Walpole and the Art of Conversation', *Image & Narrative* 18, no. 3 (2017): 94–106.

10 Eleanor Coade, John Soane, and the Coade Caryatid

Nicole Cochrane

For much of the late eighteenth and early nineteenth centuries, one of the most used sculpture manufacturers in Britain was Coade Stone. This material was produced by a business that was effectively and expertly run by a woman, Eleanor Coade (1733–1821), for over fifty years. Coade Stone, which was in fact not stone but rather a type of ceramic fired within a kiln, was particularly attractive to architects and designers for its durability and weatherproofing. Little is known of Coade's life outside of her Baptist beliefs, and she never married, despite being known professionally as 'Mrs Coade'.[1] Though there is a lack of archival material relating to Coade's involvement in the firm, it is clear she was an effective manager and businesswoman, proudly working with some of Britain's most influential architects, including Robert Adam and John Nash. In her 1799 catalogue of works titled *Coade's Gallery*, Coade listed civic and domestic architecture that included Coade pieces.[2] This case study will focus on one sculptural figure featured in that catalogue: the Coade Caryatid, exploring the figure of the Caryatid as a piece of classical reception, as well as a collectable product produced by the firm and displayed by Sir John Soane at his London home and architectural studio.

One of Coade's most common collaborators was the architect and collector Sir John Soane (1753–1837). The most ubiquitous example of their relationship comes in the form of the Coade Caryatid (Plate 6). The figure was clearly an important architectural feature for Soane, being used in one of the most important commissions of his career, as architect and surveyor of the Bank of England from 1788 until 1833.[3] The Caryatids were also used for exterior decoration of his home Pitzhanger Manor in Ealing, where he resided with his family from 1800 to 1810, and his London townhouse in Lincoln's Inn Fields. This house, which spans numbers 12, 13, and 14, was a space purpose-built by Soane to act as his home and architectural workshop, and as a museum for his growing collection of books, art, antiquities, and architectural fragments.[4] It was within his home that Soane engaged in constant rearrangement of his collection, where antiques, casts, and contemporary sculpture acted in dialogue with one another, and where Coade stone remained an important figure.

The Coade Caryatid, a life-sized figure of a woman with long, braided hair wearing a peplos, was produced both as an architectural feature with a supporting capital (as was the case for the Caryatids encircling the lantern of the Bank of England Rotunda) and as a singular, freestanding figure, as seen on the exteriors of Soane's homes.[5] They have been traditionally understood as copies after the figures of the Caryatid porch of the Erechtheion, located on the Acropolis of Athens, Greece. The earliest use of the Coade Caryatid by Soane dates to the early 1790s, where they were integrated

within an oval lantern at Buckingham House.[6] This date suggests that Coade and her modellers had no three-dimensional references to the Erechtheion figures; it was not until 1801 that Thomas Bruce, Earl of Elgin removed and transported one of the Erechtheion figures from Athens to England. Therefore, it is most likely that Coade made use of James Stuart and Nicholas Revett's *Antiquities of Athens and other Monuments of Greece*, published in 1762, which included a description and illustration of the Erechtheion. Coade's Caryatid was, therefore, based on a two-dimensional representation of sculpture.[7] Stuart and Revett's publication can also be found in Soane's collection of books at Lincoln's Inn Fields. *Antiquities of Athens* provided the first published representations of the sculpture and architecture of the Acropolis, and, as such, both Soane and Coade likely used the same material for reference and inspiration.

Additionally, the Coade Caryatid's looser hair and heavier drapery bears resemblance to the Caryatids of the Canopus at Hadrian's Villa in Tivoli.[8] Hadrian's Villa was a major site for eighteenth-century British tourism and was actively excavated by British expatriate dealers Thomas Jenkins and Gavin Hamilton, who sold antiquities to tourist and buyers abroad.[9] Soane also undertook a tour as a student, and as he did not have the means to purchase items while travelling, he later sought to emulate these practices and went on to garner a significant collection of antiquities.[10] The Coade Caryatid was, therefore, an object produced to best appeal to British buyers and collectors. It was cleverly crafted by the Coade Manufactory to recall British collectors' experiences on the Grand Tour, as well as to capitalise on their interest in the Antique designs of Stuart and Revett's text, combining both a textual and a spatial engagement with antiquity through the lens of a newly-created object.

For Soane, the role of the Coade Caryatid as collectable and Eleanor Coade's ability to produce a desirable product as a classically-alluding work of art are illustrated in a unique manuscript held in the Sir John Soane's Museum archives. Titled, 'Crude Hints Toward An History of My House', the document, composed between August and September 1812, was an account of Soane's residence of Lincoln's Inn Fields, imagined as a ruin.[11] The imaginative text, written by Soane, follows 'An Antiquary' as he surveys the building and its contents, with suggestions for various interpretations of its former use or functions. When the Antiquary encounters the Caryatids, they are described as most likely ancient works, possibly indicating origins in a Greek temple or that they 'might have been brought from Greece to this Country and here placed for Ornament'.[12] In this passage, the Antiquary acknowledges the traditional Grand Tour pursuit of purchasing ancient sculpture and bringing pieces back to Britain with the intention of building important collections that were displayed within the homes of the British elite, whilst adding humour to the text for those readers who would have been aware of Soane's frequent use of the Coade Caryatid in his architectural designs.[13]

In his 'Crude Hints', Soane describes many of the features of the Coade Caryatids that made them attractive collectable objects, especially to an architect. The hard-wearing material made them able to withstand the test of time; comparing its durability as being like that of an ancient marble and just like the ancient works she emulates, Coade's Caryatids stand to be appreciated and interpreted by interested parties in the future. Furthermore, the passage celebrates Coade's artistic merit, suggesting that although the Caryatids were modern, aesthetically and technically, they were indistinguishable from those produced by the ancients. Soane's home displayed ancient, medieval, and modern works together in dialogue with one another to present a pedagogical and

aesthetically-enriching collection; in the Coade Caryatid, this dialogue between past and present, artist and architect, was proudly displayed on the façade, complimenting the works inside.[14]

As collector and business strategist, both Soane and Coade positioned the Caryatids as being in line with the spirit of the ancients, but fused with the technology of the modern world. Coade reinterpreted antique models and designs to fit the modern cosmopolitan demand. For Soane, the Caryatids placed on the façade of his home served as an ideal emblem of the past, and through their collection and display, he was able to engage with this artistic heritage, positioning his architectural style as being simultaneously ancient, yet modern. The Coade Caryatids served as a constituent to the larger collection housed inside and stood as testament to Coade and Soane's shared interest in reinventing the past.

Notes

1. A. Kelly, *Mrs Coade's Stone* (Upton-upon-Severn: Self-Publishing Association in Conjunction with the Georgian Group, 1990), 23–24.
2. E. Coade, *Coade's Gallery, or Exhibitions in Artificial Stone, Westminster-Bridge Road* (Lambeth: S. Dibson, 1799).
3. E. Schumann-Bacia, *John Soane and the Bank of England* (London: Longman, 1991).
4. Soane purchased 12 Lincoln's Inn Fields in 1792, number 13 in 1806, and finally acquired number 14 in 1823. For a survey of Soane's use of Coade stone in his architectural commissions, see A. Kelly, 'Sir John Soane and Mrs Eleanor Coade: A Long Lasting Business Relationship', *Apollo* (April 1989): 247–253; Kelly, *Mrs Coade's Stone*.
5. A version of the Coade Caryatid with supporting capital survives freestanding at Anglesey Abbey; the date of its purchase and display in the Abbey's gardens is unknown.
6. G. Darley, *John Soane: An Accidental Romantic* (New Haven and London: Yale UP, 1999), 106.
7. J. Stuart and N. Revett, *Antiquities of Athens and Other Monuments of Greece* (London, 1762). Plate XXXVIII. See S. Weber Soros, *James 'Athenian' Stuart: The Rediscovery of Antiquity* (New Haven and London: Yale UP, 2007).
8. C. Vout, 'The Error of Roman Aesthetics', in B. Dufallo (ed.), *Roman Error: Classical Reception and the Problem of Rome's Flaws* (Oxford: Oxford UP, 2017).
9. See W. Macdonald, *Hadrian's Villa and its Legacy* (New Haven and London: Yale UP, 1995), 268; I. Bignamini and C. Hornsby, *Digging and Dealing in Eighteenth-Century Rome*, 2 vols. (New Haven and London: Yale UP, 2010).
10. H. Dorey, 'The Union of Architecture, Sculpture and Painting: Sir John Soane (1753–1837) as a Collector of Sculpture', *Sculpture Journal* 12 (2004): 57–70.
11. J. Soane, 'Crude Hints Towards an History of My House', unpublished MS. SM Soane Case 31. For a full account, see Helen Dorey's transcription in *Visions of Ruin: Architectural Fantasies and Designs for Garden Follies* (London: Sir John Soane's House Museum, 1999).
12. Soane, 'Crude Hints'; Dorey, *Visions of Ruin*, 65.
13. N. Cochrane, 'Ancient Sculpture and the Narratives of Collecting: Legacy and Identity in Museum Display 1770–1900', PhD Thesis, U of Hull, 2019.
14. For a discussion of the display of Soane's collection, see H. Furjan, *Glorious Visions: John Soane's Spectacular Theatre* (London and New York: Routledge, 2011); J. Elsner, 'A Collector's Model of Desire: The House and Museum of John Soane', in J. Elsner and R. Cardinal (eds.), *The Cultures of Collecting* (London: Reaktion Books, 1994); S. Feinberg, 'The Genesis of Sir John Soane's Museum Idea: 1801–1810', *Journal of Society of Architectural Historians* 43, no. 3 (1984): 225–237.

11 Anne Wagner's Album (1795–1805)

Collecting Feminine Friendship

Ryna Ordynat

Eighteenth-century women's albums were multi-faceted, multifunctional visual tools, often collected, assembled, and exchanged by and for women and their families. Albums would have an author—a compiler or collector who would curate it—with many of the items selected being contributed by the author's family, friends, and social connections. Gathered within their pages are numerous wide-ranging objects— sketches, watercolour drawings, poetry, letters, and personal keepsakes. Such albums became a gendered space of collected visual and material items that reflected feminine identity.[1] As such, the album container oscillates between friendship token and histori- cal archive.

The album studied here belonged to Anne Wagner, the daughter of a wine merchant from Liverpool, England, who was born in 1771 to a family of three daughters and at least two sons.[2] We know very little about Anne and her family; no other documents related to her aside from her album survive today. It is likely that she never married, and her album is illustrative of her acquaintances and family connections, and of her extensive travel abroad. The most frequent contributors to the albums are at the core of a small, intimate female circle, with Anne at the centre: her sister Elizabeth, who also remained unmarried; her second sister Felicity Browne, who married and settled in Wales; her niece Felicia Browne (later the famous poet Felicia Hemans); and several evidently close female friends.

The album itself contains 164 leaves, none of which were left blank. It is quite small in size, measuring at 12.5 cm in width and 8 cm in length, which would have made the album very portable. The front page is inscribed with Anne's initials, and a title 'Anne Wagner, 1795, Memorials of Friendship'. This album would have been displayed to others frequently and would have been made with this in mind. It is not chronologi- cal and does not appear to be structured in any specific way. Rather, it seems that the process was spontaneous.

Contributions to Anne's album are usually in the form of short poems about friend- ship, but they can also be coloured sketches or even small paintings. For example, in 1796 Margaret Casson gifted a small watercolour picture she produced to Anne's album (Plate 7). It is a pastoral scene showing a woman playing the harp; a small child, playing with a floral garland, is seated next to her on the grass. It is possible that the picture is of Casson and her daughter. During that time, playing music and arranging flowers were considered admirable female accomplishments, and the picture might also convey the friend's mutual love for music. The picture is also accompanied by a mes- sage of friendship to Anne written in Casson's hand, which makes the gift even more

personal. Casson begins her address with 'But where the pen or pencil shall I find; with power to paint the beauties of her mind; These are reflected lovely Ann, in thee, and in thy other sisters Grace's three under one roof!', referring to Anne's sisters Elizabeth and Felicity.[3] She concludes, 'Oh happiness divine to call such charming women, friends of mine!', acknowledging the album's main purpose of celebrating and sharing 'Memorials of Friendship' of Anne and her close friends. Like many of Anne's friends and contributors, Casson pays tribute to Anne's intellect and praises her appearance, talents, and taste. Anne, in turn, consistently arranges these contributions into an artfully organised, displayed, illustrated collection of friendships and memories.

Another particularly fascinating friendship item Anne collected was locks of hair accompanied by personal messages from friends who gifted her the lock. The cut locks reveal different aspects of the women's friendship that the donors valued most. For example, a braided lock of hair tied with a ribbon was given 'To Miss Anne Wagner' from another female friend, Elizabeth Venables. It is pasted into the album next to the verse 'Tho' time shall change my tress's hue . . . I, still unchanged shall think of you',[4] thus affirming her never-ending devotion to Anne. Another similar lock Anne collected was accompanied by verses from another friend, Eliza Crooke: 'Close as this lock of hair the ribbon binds, may friendship's sacred bonds unite our minds'.[5] This message conveys the women's friendship as intellectual, a meeting of the minds.

Locks of hair were often enclosed in albums, as well as lockets, rings, broaches, and miniature portraits, and were seen as highly valuable sentimental pieces.[6] Exchanging locks of hair with family and friends was part of an established iconography of friendship and mourning in the eighteenth and early nineteenth century, used not only for remembering the dead, but also those who are absent, separated, or gone.[7] But while locks associated with death and mourning were very common for both men and women, exchanging locks of hair to commemorate friendships was a very feminine activity, and was part of a shared feminine visual culture within the close female circle, such as Anne inhabited. Collecting such friendship tokens as hair locks can be directly related to the feminine collecting aim of 'achievement of sentiment' which has been frequently discussed by historians.[8] Anne's collected locks of hair are clearly part of, and cannot be separated from, her emotional life, and embody and reflect the private, public, and subconscious parts of her social life, her shared connections, and memories.[9] Such ties were especially evident in Anne's close female circle, and her album visually illustrates the keeping up of friendships and emotional ties with her sisters, niece, and close female friends being the core 'underlying structure upon which groups of friends and their network of female relatives clustered'.[10]

Anne Wagner's friendship album was collected from the visual and material culture that was available to her, and was mainly obtained from her female friends and relatives. The album sheds light on the importance of female friendship in women's lives, on their values, and the social roles they took on in their daily relationships. As this study shows, women like Anne expressed their own identity and the close connections to other women they valued and relied on in their day-to-day lives visually, through objects they collected and pasted in their albums. Analysing sources such as women's albums can help scholars gain a better understanding of eighteenth- and early nineteenth-century middle-class women's collecting practices, and the material culture which held sentimental and emotional—not monetary—value.

Notes

1. Katherine D. Harris, 'Borrowing, Altering and Perfecting the Literary Form—or What It Is Not: Emblems, Almanacs, Pocketbooks, Albums, Scrapbooks and Gift Books', *Poetess Archive Journal* 1 (2007): 1–30, 19.
2. Elizabeth C. Denlinger, '"L'intention fait valoir les bagatelles": Circles of Friendship in the Anne Wagner Album, 1795–1809', paper presented at the Pride & Prejudices: Women Writing of the Long Eighteenth Century Conference, Chawton House Library, Chawton, Hampshire, 4–6 July, 2013; Anne Wagner's Album, Carl H. Pforzheimer Collection of Shelley and His Circle, The New York Public Library Digital Collections, http://digitalcollections.nypl.org/items/510d47db-b633-a3d9-e040-e00a18064a99 (accessed 29 August 2019).
3. 'Thus with my pencil I delight to trace . . . ', Anne Wagner's Album, Carl H. Pforzheimer Collection of Shelley and His Circle, The New York Public Library Digital Collections.
4. Lock of hair and inscription by Elizabeth Venables, 29 July 1803, Anne Wagner's Album, Carl H. Pforzheimer Collection of Shelley and His Circle, The New York Public Library Digital Collections.
5. 'Close as this lock of hair the ribband binds . . .', Anne Wagner's Album, Carl H. Pforzheimer Collection of Shelley and His Circle, The New York Public Library Digital Collections.
6. Jane Wildgoose, 'Ways of Making with Human Hair and Knowing How to "Listen" to the Dead', *West 86th: A Journal of Decorative Arts, Design History, and Material Culture* 23, no. 1 (2016): 79–101, 82.
7. Christiane Holm, 'Sentimental Cuts: Eighteenth-Century Mourning Jewelry with Hair', *Eighteenth-Century Studies* 38, no. 1 (2004): 139–143, 140.
8. Russell W. Bel and Melanie Wallemdorf, 'Of Mice and Men: Gender Identity and Collecting', in Katherine Martinez and Kenneth L. Ames (eds.), *The Material Culture of Gender, the Gender of Material Culture* (London: UP of New England, 1997), 7–26, 23.
9. Helen Sheumaker, '"This Lock You See": Nineteenth-Century Hair Work as the Commodified Self', *Fashion Theory: The Journal of Dress, Body & Culture* 1, no. 4 (1997): 421–445, 436; Helen Sheumaker, *Love Entwined: The Curious History of Hairwork in America* (Philadelphia: U of Pennsylvania P, 2007), 119–121.
10. Carroll Smith-Rosenberg, 'The Female World of Love and Ritual: Relations Between Women in Nineteenth-Century America', *Signs* 1, no. 1 (1975): 1–29, 11.

12 An Art Cabinet in Miniature

The Dollhouse of Petronella Oortman

Hanneke Grootenboer

In the Summer of 1718, the German scholar Zacharias von Uffenbach paid a visit to Amsterdam as part of a pleasure journey.[1] The Frankfurt collector was keen to see the dollhouse of Petronella Oortman, which was, if not a fairly accurate copy, at least a version of Oortman's impressive residence in the Warmoessstraat. Oortman (1656–1716) had started this life-long building project shortly after her second marriage to silk merchant Johannes Brandt in 1684, as her first husband (as well as a daughter) had died in the years before.[2] The keeping of this small-scale house was clearly not a mere hobby project undertaken by a dynamic and imaginative housewife, but a serious means to assemble an art collection, albeit in miniature. As the largest and most extensive of surviving Dutch dollhouses, Oortman's collection stands out for the refinement of its furniture, the quality of its painting work (all done by genuine masters), its state-of-the-art technology (it had a working fountain!), and the amazing level of detail in the miniature household goods. For instance, a sewing box not even half an inch in length reveals inside tiny compartments filled with even smaller tools, while a miniscule mirror had been mounted inside the lid (Plate 8).

Unlike most European dollhouses largely containing items produced locally, Oortman commissioned objects to be made overseas, including a set of blue-and-white plates ordered from the East Indies to decorate the *pronk*-kitchen, where we also find Chinese-style painted silk window-covers. The presence of such foreign luxuries testifies to Oortman's wealth, contacts, and organizational skills, as well as to Amsterdam's reputation as the entrepot of exoticism. While most paintings of seventeenth- and eighteenth-century Dutch interiors are largely devoid of exotica, Oortman's dollhouse presents a more accurate—if not excessively luxuriant—example of an elite residence.[3] According to Von Uffenbach, Oortman's project had cost between twenty to thirty thousand guilders, approximately the value of the ornate town house that contained it.

Contemporary texts refer to Oortman's dollhouse as a doll *cabinet*. It obviously carries a strong resemblance to early modern curiosity cabinets, standing on legs which, once opened, reveal numerous compartments and sets of drawers. Unlike other European examples, Oortman's dollhouse does not have a removable façade, but, instead, sports a set of glass doors that were covered by curtains to protect the contents from light. Opening the curtains and subsequently unlocking the doors would have been a performative gesture that was staged so as to heighten the expectation of eager visitors, like Von Uffenbach, to behold the treasures inside. In addition, the miniaturization of the house and its contents works like a magnifying glass, further intensifying the act of seeing as such. By the time von Uffenbach came to admire this

miniature art cabinet, it had been attracting the same kind of cultured tourists who would visit celebrated collections of curiosities of Simon Schijnvoet (1653–1727) or Albert Seba (1665–1736). Kept in lavishly decorated cabinets, these collections were usually owned by men and curated by their wives. For instance, Johanna van Breda, the wife of the famous collector Levinus Vincent (1658–1727), received high praise for her sophisticated shell patterns that were eventually published in Vincent's illustrated volume on *Nature's Theatre of Wonder* (*De Wondertoneel der Nature*, Amsterdam, 1706).[4] In contrast to art cabinets, dollhouses were owned exclusively by women. Apparently, miniaturization and domestication of exotica were a way for women to assemble an art collection—and to evoke serious interest in their work: prominent members of society flocked to see Oortman's dollhouse, and it was said that Peter the Great had wanted to buy it.

In many ways, Oortman's dollhouse is a monument to the home as such. Dutch middle-class burghers, male and female, were particularly proud of their homes. As the country lacked a ruling aristocracy, good housekeeping had become a metaphor for good government, and the family house was seen as the place where children—as the country's future governors—were to be raised in preparation for their lives as ruling citizens. The home, therefore, was effectively understood as the nursery for the young Republic as it looked toward its maturity and future prosperity, as well as a showcase for the burghers' individual economic success.[5] Oortman's monetary investment in her dollhouse was extraordinary—but so was her emotional attachment. She may even have commissioned Amsterdam painter Jacob Appel (1680–1751) to make a portrait of her life's work, which doubled as a visual inventory. The highly-detailed painting perfectly mirrors the dollhouse—with one great exception. In the picture, the house is inhabited. Twenty-five figures, among them twelve children, occupy the rooms. Whereas early inventories confirm that up to the present day, not a single item has vanished from the house's contents, it is somewhat uncanny to realize that the only thing to have gone missing over the centuries are these waxen dolls, leaving the house essentially vacant. By sheer chance, the only surviving doll is a new-born baby. That precisely this figure should survive is all the more uncanny when we realize that the nine rooms of the dollhouse are not mere display cases for curious objects, but they are also scenes in an unfolding narrative around the birth and death of a child. Appel has numbered the rooms from one to nine, starting from the top left, suggesting a reading direction. The first three rooms in the attic serve as a prologue—we see maids busying themselves with the laundry and taking care of children, while we proceed to the meat of the story taking place on the *belle etage*: A new born child is presented to visitors while the doctor plays a game of tric-trac with the new father and host. On the ground floor, we see servants working in the kitchen, while in the last room, the story comes to an dramatic and sad end in a scene in which the body of a child is laid out in a coffin, surrounded by other children.

This narrative sequence remaining visible in Appel's painting has also been described in full by Von Uffenbach. This poignant story of birth, life, and death within a family home indicates that Oortman's dollhouse had an additional function beside a female art cabinet. The Dutch were notoriously bad diarists, but family patriarchs usually kept large albums or scrapbooks containing miscellanies, from political events and cut-outs, to dates of birth and death, occasionally including intimate expressions of grief over the loss of a beloved. Oortman's dollhouse is an alternative to such a scrap album. Without having taken up the quill, she has reflected on what she possessed as

much as on what she had lost, in material rather than verbal terms, finding the precious balance between the intellectual pleasures of collecting and the personal pain of loss.

Notes

1. Excerpts of Zacharias von Uffenbach's diary in English have been published as: Zacharias Konrad von Uffenbach, *An Eighteenth-Century German Bibliophile in Holland* (Amsterdam: Avalon Press-Woubrugge & Gezelschap Nonpareil, 1997). An annotated version in Dutch is: J.R. ter. Molen, *Een plezierreis in de zomer van 1718: De familie Von Uffenbach in de Nederlanden* (Zwolle: Waanders Uitgevers, 2017); Molen J.R. ter., 'Een bezichtiging van het poppenhuis an Petronella Brandt-Oortman in de zomer van 1718', *Bulletin van het Rijksmuseum* 42 (1994): 120–136. The excellent classic source on Dutch dollhouses is: J. Pijzel-Dommisse, *Het Hollandse pronkpoppenhuis: Interieur en huishouden in de 17e en 18e eeuw* (Amsterdam and Zwolle: Rijksmuseum en Waanders, 2000). An extensive discussion of Oortman's collection and the narrative of the dollhouse is: Hanneke Grootenboer, 'Thinking with Things in the Dollhouse of Petronella Oortman', in Marisa Bass, Anne Goldgar, Hanneke Grootenboer and Claudia Swan (eds.), *Conchophilia: Shells, Art and Curiosity in Early Modern Europe* (U of Princeton P, forthcoming); Hanneke Grootenboer, *The Pensive Image: Art as a Form of Thinking* (Chicago: U of Chicago P, 2020).
2. A short biography of Petronella Oortman (in Dutch) has been included in Els Kloek (ed.), *1001 Vrouwen uit de Nederlandse Geschiedenis* (Nijmegen: Van Tilt, 2013), 514–515.
3. This point is made by Claudia Swan, 'Lost in Translation: Exoticism in Early Modern Holland', in A. Langer (ed.), *Art in Iran and Europe in the 17th Century: Exchange and Reception* (Zurich: Museum Rietberg, 2013), 100–116.
4. Jet Pijzel-Dommisse, *Het Hollands pronkpoppenhuis: Interieur en huishouden in de 17e en 18e eeuw* (Zwolle: Waanders, 2000). See ook, Bert van de Roemer, 'Redressing the Balance: Levinus Vincent's Wonder Theatre of Nature, Public Domain Review', http://publicdomain review.org/2014/08/20/redressing-the-balance-levinus-vincents-wonder-theatre-of-nature.
5. On the position of the home in Dutch culture, see Mariët Westermann, *Art & Home: Dutch Interiors in the Age of Rembrandt* (Zwolle: Waanders, 2001).

Part IV
Beyond the Eighteenth Century

13 Collection, Display, and Conservation
The Print Room at Castletown House

Anna Frances O'Regan

On 14 February 1768, Lady Louisa Conolly (née Lennox) wrote to her sister, Sarah: 'At any time that you chance to go into a print shop, I should be obliged to you if you will buy me five or six large prints. There are some of Teniers, engraved by Le Bas, which I am told are larger than the common size. If you meet with any, pray send a few'.[1] From 1762, it was well known by those close to her that Lady Louisa (1743–1821) was collecting prints. The collection that she lovingly assembled can be seen today at Castletown House in the form of an eighteenth-century print room: the only surviving example of its kind in Ireland, and one of the finest examples remaining in the British Isles (Plate 9). This meticulously planned print room was the work of a discerning mind, and a skilled hand created its harmonious and symmetrical design. This elaborate scheme has been impressive enough to withstand changes in ownership of the house, as well as changing tastes in interior decoration. This print room tells a story about Lady Louisa's commitment, values, and interests, and it also gives insight into her personality. Print rooms were a place for social and intellectual exchange that carry still today a cultural value and legacy. With proper conservation, the Castletown House print room can remain an awe-inspiring space for visitors in the years to come.

Castletown House, Lady Louisa's Formative Years, and Her Passion for Design

Castletown House in Celbridge, County Kildare, is situated twelve miles inland from Dublin and was built for William Conolly, Speaker of the Irish House of Commons. The floor plan and the façade of the main block were designed by Italian architect, Alessandro Galilei. However, it was Irish architect, Edward Lovett Pierce, in consultation with Galilei, who added wings with Palladian colonnades and pavilions during its construction. The construction of Castletown began in 1722 and was completed by 1725, but the interior decoration had barely begun by the time of Conolly's death. Conolly's widow, Katherine (née Conyngham), lived in the house until her death in 1752, after which the estate was inherited by their nephew William James Conolly. After some years, during which Castletown had been left unoccupied, William James Conolly's son, Thomas (1738–1803), and his English-born wife, Lady Louisa, took up residence of Castletown in 1759. It was from hereafter that the extensive redecoration of the finest Palladian country house in Ireland began.

Lady Louisa (Figure 13.1) was the third daughter of Charles Lennox, the second Duke of Richmond, and Sarah Cadogan. Lady Louisa and her sisters Caroline, Emily, Sarah, and Cecilia also had two brothers, Charles, the third Duke of Richmond and

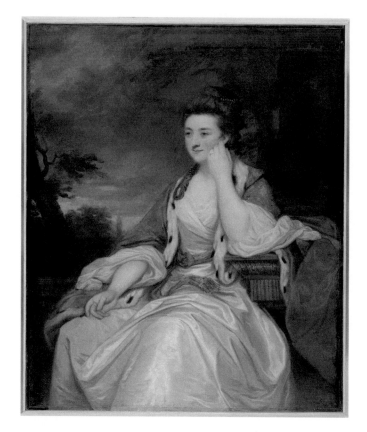

Figure 13.1 Sir Joshua Reynolds, *Portrait of Lady Louisa Conolly*, 1775. Oil on canvas, 136.53 × 99.7cm. Harvard Art Museums/Fogg Museum, Bequest of Elizabeth Sears Warren.

Source: © President and Fellows of Harvard College. Accession number: 1970.112.

Lord George. After their parents passed away in 1750 and 1751, respectively, Louisa, Sarah, and Cecilia were sent to live in Ireland at Carton House near Maynooth, a neighbouring estate five miles northwest of Castletown. Here, they were cared for by their sister, Emily, Countess of Kildare. It was during Lady Louisa's time at Carton House that she met Thomas Conolly, whom she married on 30 December 1758, when she was just fifteen years old.[2]

Lady Louisa devoted her life to the interior decoration of Castletown and the upkeep of the estate. From 1759 to 1776, she set upon the redecoration of Castletown, supervising much of the work herself, as there was no single architect involved. The entrance hall, with its black and white marble floor, dates to the 1720s and was unaltered by Lady Louisa. She did, however, have the two-story cantilevered staircase installed in 1759, and a year later, the solid brass banisters were added, three of which have the inscription, 'A. King Dublin 1760'. From 1764–1768, the red and green drawing rooms and the dining room were remodelled and 'mahogany doors, carved architraves, overdoors and doorcases were put in place. There were new skirting

boards, dados, chair rails, cornices, friezes, shutters and window sashes,' amounting to an impressively long list of improvements.[3] The long gallery also underwent significant transformation: doors and columns were removed, and the room was decorated in Pompeian style with elegant glass chandeliers, classical busts, and statues. A portrait of Thomas Conolly hangs at one end of the gallery, faced by one of Lady Louisa at the other. Lady Louisa also changed the position of many of the fireplaces within the house, which, alongside all the alterations already mentioned, gives testament to the extraordinary scale of work that went into the redecoration of Castletown House.

These large-scale changes to the fabric of the building were not the only type of changes Lady Louisa made to Castletown. She also spent much of her time decorating many of the eighteen small rooms or closets (dressing rooms, sitting rooms, washrooms) around the house.[4] Because of the smaller size of these rooms, Lady Louisa was able to experiment with different designs, bringing to life a number of ideas, while getting to use a variety of materials. Today, these closet rooms still bear the essence of Lady Louisa's creativity and style of design, and highlight the depth of her love for interior as well as exterior decoration.

Lady Louisa gained pleasure from her creative endeavours through the planning involved, as well as the order and balance required in executing her designs.[5] As described by Stella Tillyard, 'Louisa never committed any of Tom Conolly's money to a scheme until she was absolutely sure she wanted it. Then she went about building and decorating in a steady and concentrated way, enjoying the process because she was utterly certain of its purpose'.[6] By taking her time when committing to decorative schemes and alterations to the house, Lady Louisa chose to only commit to projects she knew she enjoyed and that were worthy her time and effort.

Some of the passion for design Lady Louisa possessed likely stems from her time at Carton House. She watched her sister Emily alter the house and estate, helping her choose some of the furnishings, and assisted Emily when Lord Kildare was away.[7] Being exposed to the beautifully exciting alterations that occurred at Carton House during her formative years likely inspired some of the ways in which Lady Louisa redecorated Castletown and the estate, as well as taught her about the power of decorating.

One of the most elaborate alterations Lady Louisa made was that of creating a print room. The print room is located in what was originally an anteroom to the state bedroom and is situated along an enfilade of rooms.[8] It was transformed into an informal, more intimate sitting room from its previous ceremonial function in which capacity it was rarely used, and it became a space where Lady Louisa entertained her sisters and friends.[9] The shift to informality was prevalent in society during the mid-eighteenth century. Informality blossomed through a return to nature with changes in attitude toward the countryside.[10] Gatherings were less rigid and structured, allowing for more freedom and mingling between guests with the advent of assemblies.[11] This informality was also reflected in changes to the layout of houses. Main rooms were expanded and moved closer to ground level so they could be open to the landscape, and, in general, the social rooms became more of a focus over the private spaces.[12]

During Lady Louisa's time, Castletown was considered to be too formal and old-fashioned, which is why she went to great lengths to alter so many of the rooms. The informal nature of her print room embodies this shift through its use as a room for entertainment and educated discussions in place of a ceremonial room that had become obsolete. The move to a more informal society suited Lady Louisa well, for

she preferred to keep to herself and avoid social engagements as much as possible, unless her position demanded them of her. In a letter to the Duchess of Leinster dated 8 January 1775, Lady Louisa wrote: 'I sometimes fear that I am an unsociable sort of animal, I do enjoy so prodigiously the living alone'.[13] Lady Louisa would receive visitors, but she rarely visited them in return, which, according to her sister, Lady Sarah, was because she had more acquaintances than she could keep up with.[14] Her print room was the ideal place for entertaining visitors, for it was a space she loved and it inspired intellectual discussions. Her print room, thus, became a place where her visitors could gather and exchange socially in a manner that drew the attention away from Lady Louisa and toward the room itself, highlighting the design and display of her collection.

A Short History of Print Rooms in the British Isles

Print rooms were a popular form of interior decoration in historic properties in the British Isles, particularly from the 1750s to the 1820s. Surrounded by paper borders and other decorative elements, collections of prints showcased the owner's personal taste. Chosen prints often included popular themes of the day and were affixed directly to walls using adhesives, such as flour pastes or animal glues that were available at the time. This short-lived trend was an innovative way of displaying print collections, which were more often pasted into albums, portfolios or scrapbooks, onto screens or displayed in drawers and cabinets. Britain has twelve surviving examples[15]; they feature either the original prints or later replacements, following extensive deterioration, and only one such room remains in Ireland. Print rooms were spaces both men and women enjoyed socially and intellectually.

By many accounts, creating a print room was, at first, a leisurely pastime taken up by aristocratic women who spent hours cutting up prints and frames on rainy days, though men were also known to be involved in the creation of print rooms.[16] The Duke of Wellington was personally involved with the production of eight early nineteenth-century print rooms at Stratfield Saye. Between 1767 and 1768, Thomas Chippendale fitted the print room at Mersham-le-Hatch for Sir Edward Knatchbull, for which evidence remains in the form of an itemised bill. In 1771, Bromwich is said to have fitted up the billiard room at Fawley Court.[17] In 1782, R. Parker created the print room at Woodhall Park for Sir Thomas Rumbold. Print rooms were a unique way of decorating a mixed-company space, and because every choice involved was determined by the preferences of the collector, there were endless possibilities for the print room to display print culture.

The earliest mention in England of decorating rooms with collections of prints was in the form of a set of specific instructions devised by Hannah Woolley in 1674.[18] Woolley was an English writer and medical practitioner who published books on household management and was one of the first women to make a living as an author, becoming a household name in the process.[19] In her book, *A Supplement to the Queen-like Closet, or, a Little of Everything: Presented to all Ingenious Ladies and Gentlewomen*, in a section titled, 'To Adorn a Room with Prints', Woolley writes of using cut up prints and pasting them in scenes onto the wall. She recommends, 'buy of your Prints only Black and White, of sorts what are good, and cut them very exactly with a small pair of Cissers from the paper'.[20] It is unclear from the instructions how much she recommends the prints are to be cut, whether that means cutting out individual

figures or scenes or simply trimming off the text, which was commonly done in the eighteenth-century print rooms. Woolley does, however, discuss the art of making stories from the prints:

> observe to put them in proper places, or else it will be ridiculous; be sure to put the things flying above, and the walking and creeping things below; let the Houses and Tress be set sensibly, as also Water with Ships sailing, as you put them on, observe that they have relation to one another. If you employ your fancy well, you may make fine stories, which will be very delightful and commendable; also Gardens and Forrests, Landskips, or indeed any thing you can imagine; for there is not any to be named, but you may find it in Prints.[21]

The suggestion of making stories from the prints implies that there should be some consideration of how the prints fit together as a whole. By arranging the prints in a way that shows that logical consideration has been given to their placement, print room creators demonstrate their artistic ability and strategic planning skills.

It was common to use black and white prints in the design of the print room. Woolley, in fact, advised against using coloured prints on the grounds that they would be too garish.[22] The preference for only using black and white prints continues even into the following century. Woolley recommended plain 'Deal' walls with the wainscot fashion of wood panelling covering the lower portion and for the walls to be 'painted all over with White-lead and Linseed Oil, ground together, and some little streaks imitating Marble'.[23] By having plain walls prepared with soft colours, the prints will be the main focus of the room, for bright colours would overpower the delicate nature of the prints.

Woolley also discussed at length the way in which prints should be applied to the walls. After the prints have been cut,

> lay your Prints upon a smooth-board with the wrong-sides upwards; then with a knife take some Gum-Dragon, steeped well in fair water, spread them all over as thin as you can, and still as you do them, take them up with your knife, and so turn them into your hand, and clap them upon the Wainscot; but let it be dry first close them well on with your fingers that they be not hollow in any place.[24]

These instructions are clear enough to replicate when preparing to paste up a print room, and it seems clear that Woolley's recommendations were one of the key influences on the growth of the eighteenth-century print room trend in the British Isles.

Although print rooms existed in Europe several decades before the trend sparked in the British Isles, as evidenced by those found in France, Czech Republic, and Sweden, the earliest eighteenth-century print rooms in England were created in 1752 at Russel Farm and Cassiobury. Comparatively, the earliest known reference to a print room in Ireland dates from 1750. It was Mrs. Mary Delany (née Granville, 1700–1788), another print room enthusiast, designer, and friend of Lady Louisa's, who wrote of this early Irish print room.[25] Mrs. Delaney 'described how she and other guests whiled away many pleasurable hours "cutting up frames for prints" on a wet day spent at Lucan House, Co. Down'.[26] In some cases, creating a print room became quite the social affair, with many hands at work cutting up prints. It would have been very beneficial having help for the sheer number of them to be altered. As seen in Lady Louisa's

print room at Castletown House, there are an immense number of carefully cut elements, which would have taken many months to get through if cutting them alone. Having company while undertaking such a large task would have made it enjoyable, as well as intellectually stimulating. Once completed, print rooms inspired intellectual discussions due to the removal of the identification details at the bottom of the prints.

Lady Louisa was a member of the Bluestocking Circle, which was founded in the 1750s and held by hostesses Elizabeth Montagu, Elizabeth Vesey and Frances Boscawen in London.[27] It was a social, scholarly and literary discussion group for women which had the 'desire to create a form of society consisting of smaller groups with scope for sensible conservation, dominated by neither cards nor gossip'.[28] Lady Louisa and other print room enthusiasts, such as Mrs. Delaney, both attended the gatherings in Dublin, and print rooms were an ideal location for socializing with other well-educated women.

Lady Louisa's Print Room

On 24 February 1762, Lady Louisa wrote to her sister Lady Sarah: 'I always forget to thank you my Dear for the Prints you sent me. I hope you got them of Mrs. Regnier, for I have a bill here, the two little ones that you admired so, are the very things I wanted, that of Helen is charming. I have not had time to do my Print room yet'.[29] By all accounts, Lady Louisa had been collecting prints for several years before she settled, in 1768, on the arrangement that we can see today.[30] After numerous renovations, alterations were made before the prints were installed, showing that forethought was clearly given to how the prints themselves would fit within the dimensions of the room.[31] It is believed that Lady Louisa's print room was finished by 1769, because in her diary, Lady Shelburne described 'a Print Room on the palest paper I ever saw and the prettiest of its kind' after visiting Castletown (Plate 9).[32]

Lady Louisa's print room was likely inspired by other print rooms she had visited and helped to decorate. It is likely during her time living at Carton House that she assisted her sister Emily with the two Chinese paper rooms and four print rooms that once existed there.[33] Before her print room was completed, she also helped cut paper borders for Lady Clanbrassil at Cypress Grove House, Templeogue, Co. Dublin. In a letter to Lady Sarah Bunbury dated 3 July 1767 Lady Louisa wrote: 'I am with Lady Clanbrassil, who desires a thousand loves to you she has employ'd me in cutting out a border to go round your Print which she has put up in her Closet, it was a pleasant work for me, as I look'd at your Dear fiz: all the time, my sweet Sally I begin to long to see you vastly, I propose great pleasure in the thought of seeing you next Spring'.[34] The print discussed here is the mezzotint of *Lady Sarah Bunbury Sacrificing to the Graces* (1766) by Edward Fisher after Joshua Reynolds (Plate 10). This print was clearly loved by Lady Louisa and is a focal point of her print room (Plate 9).[35] This fact highlights the role of personal relationships in the design of the space. Additionally, Lady Louisa's act of helping Lady Clanbrassil prepare prints for her closet suggests that collecting prints and using them in this way was not just about the end result, but the friendships formed in the process.

After the cutting and resizing, Lady Louisa pasted the prints, borders, and decorative elements onto sheets of pale-coloured paper before attaching these sheets to the wall. The walls were prepared by hanging cloth over battens, to which the paper was

then adhered. Constructing the print room by use of a large table in the saloon seems most likely, due to the fact that one of the prints shows a substantial amount of hand paint added to enlarge the image so that it matches the scale of the pair.[36] This process would have required hours of work, so the use of the saloon table would limit the hazards of painting at such a height on a ladder.[37]

Lady Louisa was an active collector who obtained the prints decorating her print room from a variety of sources. Family members, such as her sister Lady Sarah and her nephew William Fitzgerald, purchased prints for her. Lady Louisa herself would have also had the opportunity to purchase prints on her many trips to Paris or London. In London she purchased prints from the Mercier family who owned several print shops and also from Mr. Margas's shop in 1766.[38] In Dublin, 'there were five print sellers . . . between 1761 and 1769, but none other than Bushell are mentioned in any of the Castletown House records'.[39] In Lady Louisa's personal account book, held at Trinity College Dublin, the following entries recording her purchase of prints can be found:

April 11, 1766	Paid Mr Bashell for Prints £1 2s 2½d
August 1771	Paid to a subscription for a print 11s 4½d
October 1771	Paid to a subscription for some Prints of Mrs Fisher's of Carlingford Bay £1 2s 9d
June 1772	Paid Lord Kildare the remainder of my subscription to Mrs Fisher's prints 11s 4½d[40]

While the 1771–1772 purchases may not have resulted in the prints being displayed in the print room, it does suggest that Lady Louisa enjoyed collecting prints, and may have used them in some of the aforementioned smaller rooms and closets. Additionally, a number of the mythologically themed prints may have been brought to Lady Louisa by a friend traveling through Rome.[41] Some of these prints sent by William from Rome could be the ones on display in the print room, as there are a group of mythologically themed prints on the south wall, including several images of Venus.[42]

The journey from collecting the prints to their final arrangement in the print room was a long, well-thought-out one, and the more time one spends in the print room today, the more one can appreciate the vast amount of work that Lady Louisa put into the creation of this design. There are 103 framed prints in the print room, ranging in shape and size and with a variety of borders and decorative elements, which are themselves made up of printed components. To enhance the design, Lady Louisa 'changed the original rectangular format of forty-six of the images to either an octagonal, oval or circular outer shape or to a rectangle with a convex top'.[43] Furthermore, Lady Louisa went to great lengths to make curved frames by overlapping small printed fragments, despite such frames being available for purchase from printmakers at the time.[44] She planned the placement of prints in relation to one another, thus creating a mirroring effect in the room. She achieved this by positioning pairs of serial prints, prints with similar subjects and themes, and others with the same decorative element and/or matching frame shapes opposite one another. As such, Lady Louisa combined her artistic skills with scientific principles, using precise measurements and geometry to complete her artistic vision. In this instance, art and science go hand in hand, for one without the other would have resulted in a less precise and imaginative design.

Lady Louisa even went so far as to tailor the frames to the subject matter of the prints, as is succinctly illuminated by Dr Ruth Johnstone:

> There is an ordered element of classification in the small images. The different shapes of the smaller frames indicate separate classifications. Images of domestic and skilled labour have oval foliated frames, religious subjects have slim round frames, classical subjects have round and oval frames of classical architectural design, landscapes have round frames and interior scenes of the leisured classes have octagonal frames. All of these prints have been substantially trimmed so that they fit this ordered classification. While the larger images are contained by a rectangular frame, the more central images on each wall are decorated with the most ornate frames. These images have a closer connection to Lady Louisa's life and family, and to her own class.[45]

Many scholars agree that the success of a print room rests on the symmetrical composition of the prints and their relationship to one another, the use of borders and decorative embellishments, and variety in their shapes and placement. As noted by Joanna Banham, 'eighteenth-century print rooms obeyed few rules and part of their original appeal lay in their individuality and variety'.[46] Lady Louisa's print room is certainly a fine example of a unique design.[47]

The prints Lady Louisa chose for her room display her knowledge, her relationships, and her interests. The subject matter of the prints included moral themes mixed in with activities she enjoyed, such as playing cards. There are classical allusions, sheep herding and equestrian scenes, biblical themes and religious figures, domestic interiors, theatrical images, and hunting motifs displayed in the room, and these are not only represented in the prints themselves, but extend to the decorative elements. The aforementioned centrally positioned portrait of Lady Sarah Bunbury on the south wall is displayed opposite the engraving *Charles Prince of Wales, James Duke of York and Princess Mary; Children of King Charles I* (c.1754–65) by Robert Strange after Antony Van Dyck.[48] In prime place on the east and west walls are mezzotints of Lady Louisa's favourite actor: *Mr. Garrick, Between two Muses of Tragedy and Comedy* (1762) by Edward Fisher after Joshua Reynolds, and *Mr. Garrick and Mrs. Cibber in the Characters of Jaffier and Belvidera* (1764) by James McArdell after Johan Joseph Zoffany. Another notable print is the mezzotint and letterpress of *The Right Honourable William Pitt, Esqr* (1761) by Richard Houston after William Hoare on the west wall, which is one of the two prints in the room that has the original text that follows. Lady Louisa and her family were acquainted with William Pitt Senior, who is the only political figure incorporated into the design. Most of the prints in the print room are French, which alludes to Lady Louisa's heritage and her connections abroad. The remaining prints are fashionable Flemish, Dutch, English, and Irish pictures by engravers such as Jacques-Philippe Le Bas, Claude-Henri Watelet, Jean Daullé, Pierre-François Basan, and Jean Ouvrier after artists such as Rembrandt van Rijn, Jean-Baptiste Greuze, Giovanni Paolo Panini, François Boucher, Philips Wouwerman, Jan Steen, Guido Reni, and Nicolas Poussin. The intentional removal of the text below the prints, which would have facilitated their identification and attribution, not only made the design more pleasing, but may have been a device Lady Louisa used to test the knowledge of her contemporaries.

Lady Louisa's print room is a fascinating time capsule, transporting viewers today back to the 1760s. This paper-based art gallery has survived changes in ownership of the house, as well as changes in decorative styles of the decades that followed. It is important to keep this room intact for future generations to admire. Looking at the print

room from a conservation perspective provides further insight into how the room has survived, and can guide how we think about preserving collections like this in the future.

Contemporary Science and the Collection: Conserving the Castletown Print Room

After Lady Louisa's death in 1821, the house and demesne were inherited by Edward Pakenham, Thomas Conolly's grandnephew. Conolly's will stipulated that any successor was required to change his name to Conolly, which Edward did.[49] In 1848, Edward's son, Tom, inherited Castletown, and it was he who converted the print room into a billiards room. After Tom's death in 1876, Tom's eldest son Thomas succeeded him until his death in 1900, then his brother Major Edward Conolly took care of Castletown until 1956. Major Conolly's nephew, Lord Carew, who became Conolly-Carew, inherited the estate, but the family 'were unable to afford the upkeep of the house, which needed extensive repair work, and put the house up for sale in 1965.... [The] contents were auctioned in April 1966'.[50] Castletown was bought with the purpose of splitting up and developing the estate. 'For two years, the house stood empty—lead was stolen off the roof, windows smashed'.[51] Two years later, Desmond Guinness bought the house and the 120 acre demesne to save it from further damage and vandalism, and to 'fight for the preservation of what is left of Georgian architecture in Ireland'.[52] The house was used as the headquarters for the Irish Georgian Society, who began restoring the historic property. Castletown's care and upkeep was taken over by the Castletown Foundation, which was established in 1979 to manage and conserve the house and demesne, as well as the Georgian furniture and art, ensuring its preservation for future generations. In 1994, the upkeep of the house and parkland was transferred to the Office of Public Works, who still look after the property.

Over the centuries, some of the prints in the print room had started to come loose, and many became discoloured. In general, the print room had survived well, but required some intervention. In 2001, the print room was conserved. Loose pieces of borders and other elements were re-adhered with conservation-grade starch paste. Nine prints that were only partially attached to the wall, along with a large swag above the fireplace, were removed from the wall. The animal glue on the back of the prints was removed, and the prints were lined onto a Japanese 'Shoji' paper before being reinstalled. Pencilled numbers were found on the backs of the prints. In the conservation report, it was noted that there were hundreds of repairs previously made over the centuries, some more subtle than others. During conservation, a large number of missing pieces of border were added in to improve the visual aesthetic of the room. These were applied with a reversible paste and are easily identifiable under UV light.

While the prints were being conserved, it was found that there were additional layers of paint underneath the top ivory layer. Under each print, border and decorative element was not only the ivory-coloured paint that currently covers the original wallpaper, but a layer of pale yellow. It was surmised in the report that if the original colour was of a yellow ground, then all the printed elements had to have been removed, the wallpaper painted over with ivory, and then the printed elements reinstalled. It is, however, unclear whether the original configuration was changed. It is possible that during the repainting process the numbers were added to the back of each printed element after removal, to assist in the reinstallation process. It is evident that the reinstallation of the printed elements, after the wallpaper was repainted, was not done with the attention to detail typically shown by Lady Louisa when executing her design. Some of the borders are clearly misaligned, although the

mirroring of the printed elements remains, which suggests that they were reinstalled in the original configuration, despite not being done with the diligence Lady Louisa so clearly exercised. Considering that creating the print room took Lady Louisa at least seven years from collecting the prints to the completion of the room, it seems out of character for the final result to be less than perfect. This makes it reasonable to conclude that the prints were reinstalled after repainting by someone else. The original pale, yellow paint was chosen with care by Lady Louisa to accentuate the prints, and in contrast to the ivory present today, which complements the prints in a soft, delicate manner, it would have had a different visual effect. As theorised in the conservation report, it is likely that the animal glue used in the original installation process failed and the opportunity to repaint the wallpaper was taken. If any further conservation was decided upon, the removal of this animal glue was recommended in the conservation report due to its brittle and discoloured state. However, as mentioned in the report, some borders and decorative elements may be too vulnerable for such a treatment.[53]

When it comes to preventive conservation, along with controlling the light levels by keeping the blinds down, the staff monitor the print room for insects and pests by using Museum Traps. They also have a Hanwell device that automatically adjusts the temperature and relative humidity to the ideal conditions of the room. During regular inspections of the print room, if any build-up of dust is noticed, a gentle dusting is carried out. Further conservation beyond what was carried out in 2001 to stabilize the room would be possible. In a conversation about interventive treatments for print rooms more generally with Allyson McDermott, conservator of the Uppark House and Woodhall Park print rooms, it seems to me that many of the methods she employs could also be carried out at the Casteltown House print room, in the future if necessary. These would involve, but are not limited to: a comprehensive survey using photographs and detailed sketches for precise documentation, in situ surface cleaning to reduce the spread of dirt before moving the prints from the walls for repairs, and washing and alkalising the prints (to reduce yellow discolouration and strengthen the paper). Additionally, strips of Japanese paper could be employed to act as a barrier between the prints and walls and to address any cracks in the prints while also reinforcing the overlaps between the prints and borders. This would add support, and at this point of intervention any misaligned borders could be reconfigured. The prints could then be returned to the wall in their original configuration. Yet, the important question remains, is this level of intervention necessary? The Casteltown print room is currently in good, stable condition, and if any print room is deconstructed, some of the original archaeological evidence of the scheme will inevitably be lost, so the question of whether conservation is actually appropriate should be thoroughly considered. Every part of a print room tells a story about the period in which it was created, as well as the methods used to produce the print room, and it is this information that ought to remain intact wherever possible. Although not necessary at the time of this publication, these suggested treatments might be considered for future conservation.

While viewing the print room in 2019, it was clear there were some minor cracks to the wallpaper and that some obvious retouching had been done, unrelated to the 2001 conservation, to two of the missing oval-shaped frames on the west wall (Figure 13.2). Some prints had small losses, and many of the prints were discoloured (Plate 10), yet, overall, the print room has survived considerably well with the original eighteenth-century prints, frames and decorative elements mostly intact. The walls of this space, creatively and precisely framed by Lady Louisa, serve as windows into her eighteenth-century world.

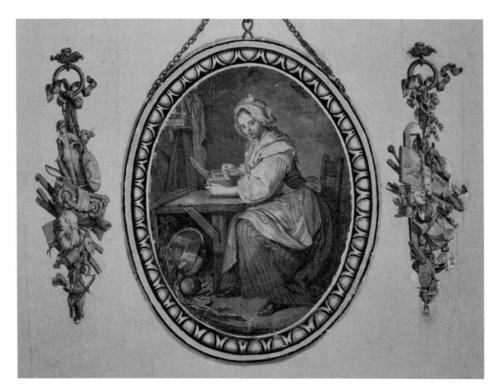

Figure 13.2 One of two hand-painted frames around a print on the west wall. This photograph also shows how the paper sheets were joined around the decorative elements.

Source: © Anna Frances O'Regan. Photograph taken in November 2019.

The End of an Era

Following Thomas Conolly's death in 1803, Lady Louisa lived on a more modest scale. She sold off other properties belonging to the Conollys' so that she could afford to stay at Castletown. She remained there for the rest of her life, taking care of her tenants and attending to the upkeep of the estate. Lady Louisa died in the August of 1821. As was her expressed wish, she spent her final hours comfortably resting in a tent situated on the lawn, looking up at her beloved Castletown House.[54] Lady Louisa's alterations to Castletown, of which her print room is the jewel in the crown, are a testament to her creative collecting talents, as well as to her love for the estate. Under the care of the Office of Public Works, this significant collection can survive for future generations.

The creation of Lady Louisa's print room was a labour of love. She was assiduous in her collecting, cutting, and arranging of prints for display, and the result is the only surviving example of an eighteenth-century print room in Ireland. The painstaking way in which Lady Louisa planned and executed every detail of this room, from the mirroring of prints to the use of differently shaped borders to contain different themes,

is astonishing. The she chose to hang and her collecting methodologies makes known her interest in the classics, science, and connoisseurship, and this was evident to her contemporaries. Her print room attests her creativity, as well as the patience required to execute her design, but its cultural legacy as a time capsule of the social and intellectual life and aesthetic values in eighteenth-century Ireland makes the effort to conserve the Castletown print room paramount.[55]

Notes

1. Lady Louisa 'may not have been successful in acquiring these prints which were of large village gatherings. Only the medium sized prints by Jacques-Philippe Le Bas after David Teniers were used, their scale being more suited to the scale of other prints in the room', Ruth Johnstone, 'Revisiting the Print Room' (RMIT, Doctor of Philosophy by Project, 2004), 40.
2. Lady Louisa spent a great deal of time riding her horse around Carton House. When exploring new trails in the woods, she would use the obelisk known as 'Conolly Folly' as her landmark, which marked the boundary between the Carton and Castletown demesnes. As described by Brian Fitzgerald, Lady Louisa would often admire Castletown House from afar, until one day she happened to meet young Tom Conolly while they were both riding near the boundary of the two properties. They met again frequently, and Lady Louisa soon discovered Tom's fondness for her. While she had many admirers and at least one other marriage proposal, she accepted Tom's offer of marriage in the autumn of 1758. Brian Fitzgerald, *Correspondence of Emily, Duchess of Leinster (1731–1814) Volume III: Letters of Lady Louisa Conolly and William, Marquis of Kildare (2nd Duke of Leinster)* (Dublin: Irish Manuscripts Commission. Stationary Office, 1957), 16–17.
3. Gillian Byrne, 'The Redecoration and Alteration of Castletown House by Lady Louisa Conolly 1759–76', Master's Thesis, National University of Ireland Maynooth, 1997, 54.
4. Byrne, *The Redecoration of Castletown House*, 54. 'In her correspondence, apart from her references to being "busy papering some closets," she described having India paper in one, new pictures in another, and in 1768 she wrote "at present busy with a new work . . . pasting flowers with the stamps I get at Paris on a white satin with which I intend to hang a little Closet, it goes on amazingly well"'. Christopher Moore, 'Lady Louisa Conolly: Mistress of Castletown 1759–1821', in Jane Fenlon, Nicola Figgis and Catherine Marshall (eds.), *New Perspectives: Studies in Art History in Honour of Anne Crookshank* (Dublin: Irish Academic Press, 1987), 131.
5. Stella Tillyard, *Aristocrats: Caroline, Emily, Louisa and Sarah Lennox 1740–1832* (London: Chatto & Windus, 1994).
6. Tillyard, *Aristocrats*, 201.
7. Tillyard, *Aristocrats*, 90.
8. It is said that 'Speaker' Conolly 'held morning levees in royal fashion' in this antechamber. Tillyard, *Aristocrats*, 202.
9. Mark Girouard, *Life in the English Country House: A Social and Architectural History* (London: The Folio Society Ltd, 2019), 225–226.
10. Girouard, *Life in the English Country House*, 216.
11. Girouard, *Life in the English Country House*, 193–194.
12. Girouard, *Life in the English Country House*, 228.
13. From the National Library of Ireland, The Fitzgerald Correspondence, Ms 612, 57b as cited by Byrne, *The Redecoration of Castletown House*, 60.
14. From an undated letter written by Lady Sarah to her friend, Lady Susan O'Brien, from the Castletown House letters as cited by Byrne, *The Redecoration of Castletown House*, 60.
15. For a detailed list of the print rooms that are known to have existed, see appendix 1 in Anna O'Regan, 'Eighteenth-Century Print Rooms—Issues with Adhering Prints Directly to Walls and Identifying Best Practice for Their Conservation', Master's dissertation, Northumbria U, 2018. It is available for download from www.annafrancesoregan.co.uk/publishedworks.

16. Joanna Banham, 'Room to View', *Antique Collector* 65, no. 3 (1994); S. Calloway, 'Engraving Schemes', *Country Life* 185, no. 16 (1991): 102.

17. Emily J. Climenson, *Passages from the Diaries of Mrs. Philip Lybbe Powys of Hardwick House, Oxon: A.D. 1756 to 1808* (London: Longmans, Green and Co., 1899).

18. Sometimes spelled Wolley.

19. David B. Goldstein, 'A Guide to Ladies: Hannah Woolley's Missing Book Emerges from the Archives', *Shakespeare & Beyond* (blog), 29 March 2019, https://shakespeareandbeyond. folger.edu/2019/03/29/a-guide-to-ladies-hannah-woolley-missing-book/.

20. Hannah Woolley, *A Supplement to the Queen-Like Closet, or, a Little of Everything: Presented to All Ingenious Ladies and Gentlewomen* (London: Printed by T.R. for Richard Lownds, and Are to Be Sold at the Sign of the White Lion, 1674), 70.

21. Woolley, *A Supplement to the Queen-Like Closet, or, a Little of Everything*, 71.

22. 'As for those in Colours I do not esteem for this purpose, for they look Childishly, and too gay. If you mean to make Stories, you must buy good store of Figures; the coloured ones are good to put white Plates and Flower-pots for Closets'. Woolley, *A Supplement to the Queen-Like Closet, or, a Little of Everything*, 71.

23. Woolley, *A Supplement to the Queen-Like Closet, or, a Little of Everything*, 70.

24. Woolley, *A Supplement to the Queen-Like Closet, or, a Little of Everything*, 70.

25. See Kohleen Reeder, 'The "Paper Mosaick" Practice of Mrs. Delany & Her Circle', in Mark Laird and Alicia Weisberg-Roberts (eds.), *Mrs. Delany & Her Circle* (London: Yale UP, 2009), 224–235. Mrs. Delany installed a print room of her own at Delville House, c. 1751, which, like the one at Lucan House, unfortunately did not survive.

26. Ada K. Longfield, 'Print Rooms', *Journal of the Co. Kildare Archaeology Society* 14, no. 5 (1970): 570.

27. In 1773, Lady Louisa mentioned the Blue Stocking circle in a letter, proclaiming that 'Mrs Vesey is delightful, if I am in Town I am to go next Wednesday; to a blue stocking meeting at her House'. Johnstone, 'Revisiting the Print Room', 31.

28. Clarissa Campbell Orr, 'Mrs. Delany & The Court', in Mark Laird and Alicia Weisberg-Roberts (eds.), *Mrs. Delany & Her Circle* (London: Yale UP, 2009), 40–65, 60.

29. Castletown House letters. Conolly Archive. Castletown House, County Kildare.

30. C. Archer, 'Festoons of Flowers for Fitting up Print Rooms', *Apollo: The International Magazine of the Arts* 334 (1989): 386.

31. David J. Griffin, *Castletown, Co. Kildare; an Architectural Report Prepared for the Office of Public Works: Volume III: Main Block Ground Floor Rooms 0/1–0/16* (Dublin: Irish Architectural Archive, 1994); Johnstone, 'Revisiting the Print Room', 37; Ruth Johnstone, 'Lady Louisa Conolly's Print Room at Castletown House', in Elizabeth Mayes (ed.), *Castletown Decorative Arts* (The Castletown Foundation, Co. Meath, The Office of Public Works, 2011).

32. Moore, 'Lady Louisa Conolly', 131.

33. Byrne, *The Redecoration of Castletown House*; Julie Fitzgerald, 'The Georgian Print-Room Explored', *The Wallpaper History Review* (2008): 14–16; Desmond Guinness and William Ryan, *Irish Houses and Castles* (London: Thames and Hudson, 1971); Johnstone, 'Revisiting the Print Room'; Jacqueline O'Brien and Desmond Guinness, *Great Irish Houses and Castles* (London: George Weidenfeld & Nicolson Ltd, 1992).

34. Castletown House letters.

35. Lady Louisa purchased this print in 1766 while she was in London. 'It was purchased, according to the Castletown "London Accounts", on the 4th November and cost £1 1s. In a letter of 1st January 1769 from Lady Louisa Conolly to Lady Sarah Bunbury further purchases of copies of the print for family and friends are mentioned "Lady Clanbrassil is so much obliged to you, for your Print, as also is Emily, and Cecilia, Mr Hussey has not yet got yours, I will send it to him by the first opportunity"'. Johnstone, 'Revisiting the Print Room', 43.

36. Johnstone, 'Revisiting the Print Room', 37.

37. Johnstone, 'Revisiting the Print Room', 37.

38. Johnstone, 'Revisiting the Print Room'.

39. Johnstone, 'Revisiting the Print Room', 40.

40. The Conolly Papers. MS 3966 (1766–75) Personal Account Book of Lady Louisa Augusta Conolly, Trinity College Dublin.
41. Fitzgerald, *Correspondence of Emily, Duchess of Leinster*, 471.
42. Johnstone, *Lady Louisa Conolly's Print Room at Castletown*, 69.
43. Johnstone, *Lady Louisa Conolly's Print Room at Castletown*, 74.
44. Johnstone, *Lady Louisa Conolly's Print Room at Castletown*.
45. Johnstone, *Lady Louisa Conolly's Print Room at Castletown*, 75.
46. Banham, *Room to View*, 71.
47. In contrast, the print room at Calke Abbey is poorly aligned and has a 'confused arrangement' with no symmetry whatsoever. Antony Griffiths, *The Print Before Photography: an Introduction to European Printmaking 1550–1820* (London: The British Museum Press, 2016), 417. The hand-coloured caricatures by the likes of Rowlandson, Gillray, and Cruikshank are displayed haphazardly, and do not result in an impressive, well-thought-out design.
48. Charles II of England and his mistress Louise de Kérouaille were Lady Louisa's great-grandparents.
49. 'The Conolly Family and Castletown: From Donegal to Kildare', *Castletown*, http://castletown.ie/the-conolly-family-and-castletown/ (accessed 17 December 2019).
50. 'The Conolly Family and Castletown', *Castletown*.
51. Guinness and Ryan, *Irish Houses and Castles*.
52. Frank McDonald, '1950s Dublin: Saving Grand Old Houses from The Politicians Who Hated Them: How the Georgian Society Stopped the Demolition of Derelict Properties', *The Irish Times*, 3 March 2018.
53. *Castletown Print Room*, unpublished conservation report, 18 August 2001.
54. Fitzgerald, *Correspondence of Emily, Duchess of Leinster*, xi.
55. I would like to thank Arlene Leis and Kacie L. Wills for inviting me to contribute a chapter to this wonderful compendium. I would also like to thank the following people for their assistance and advice during the creation of this chapter: Jean Brown from Northumbria University; David Hartley and Celine Hanratty from Castletown House; Allyson McDermott for imparting her knowledge on print room conservation; Nicola Wingate-Saul; Aisling Dunne from the Irish Architecture Archive; Aisling Lockhart from the Trinity College Dublin Manuscript and Archives Research Library; Ruth Sheehy from Trinity College Dublin's Department of the History of Art and Architecture and TRIARC; Genevieve McGuirk from the Institute of Professional Auctioneers & Valuers; Gillian Byrne; and fellow print room enthusiasts Dr Ruth Johnstone, Louise Voll Box and Dr Kate Retford.

Bibliography

Archer, C., 'Festoons of Flowers for Fitting Up Print Rooms', *Apollo: The International Magazine of the Arts* 334 (1989): 386–391.

Banham, Joanna, 'Room to View', *Antique Collector* 65, no. 3 (1994): 66–71.

Byrne, Gillian, 'The Redecoration and Alteration of Castletown House by Lady Louisa Conolly 1759–76', Master's Thesis, National University of Ireland Maynooth, 1997.

Calloway, S., 'Engraving Schemes', *Country Life* 185, no. 16 (1991): 102–105.

Castletown House letters. Conolly Archive. Castletown House, County Kildare.

Climenson, Emily J., *Passages from the Diaries of Mrs. Philip Lybbe Powys of Hardwick House, Oxon: A.D. 1756 to 1808*, London: Longmans, Green and Co, 1899.

The Conolly Papers, MS 3966 (1766–75) Personal Account Book of Lady Louisa Augusta Conolly, Trinity College Dublin.

Fitzgerald, Brian, *Correspondence of Emily, Duchess of Leinster (1731–1814) Volume III: Letters of Lady Louisa Conolly and William, Marquis of Kildare (2nd Duke of Leinster)*, Dublin: Irish Manuscripts Commission, 1957.

Fitzgerald, Julie, 'The Georgian Print-Room Explored', *The Wallpaper History Review* (2008): 14–16.

Girouard, Mark, *Life in the English Country House: A Social and Architectural History*, London: The Folio Society Ltd, 2019.

Griffin, David J., *Castletown, Co. Kildare; an Architectural Report Prepared for the Office of Public Works: Volume III: Main Block Ground Floor Rooms 0/1–0/16*, Dublin: Irish Architectural Archive, 1994.

Griffiths, Antony, *The Print Before Photography: An Introduction to European Printmaking 1550–1820*, London: The British Museum Press, 2016.

Guinness, Desmond and William Ryan, *Irish Houses and Castles*, London: Thames and Hudson, 1971.

Johnstone, Ruth, 'Lady Louisa Conolly's Print Room at Castletown House', in Elizabeth Mayes (ed.), *Castletown Decorative Arts*, Meath: The Castletown Foundation, Co., The Office of Public Works, 2011, 66–77.

Johnstone, Ruth, 'Revisiting the Print Room', Doctor of Philosophy by Project, RMIT, 2004.

Laird, Mark and Alicia Weisberg-Roberts, *Mrs. Delany & Her Circle*, London: Yale UP, 2009.

Longfield, Ada K., 'Print Rooms', *Journal of the Co. Kildare Archaeology Society* 14, no. 5 (1970): 568–575.

McDonald, Frank, '1950s Dublin: Saving Grand Old Houses from the Politicians Who Hated Them: How the Georgian Society Stopped the Demolition of Derelict Properties', *The Irish Times*, 3 March 2018, www.irishtimes.com/culture/art-and-design/1950s-dublin-saving-grand-old-houses-from-the-politicians-who-hated-them-1.3409327.

Moore, Christopher, 'Lady Louisa Conolly: Mistress of Castletown 1759–1821', in Jane Fenlon, Nicola Figgis and Catherine Marshall (eds.), *New Perspectives: Studies in Art History in Honour of Anne Crookshank*, Dublin: Irish Academic Press, 1987, 123–141.

O'Brien, Jacqueline and Desmond Guinness, *Great Irish Houses and Castles*, London: George Weidenfeld & Nicolson Ltd, 1992.

Office of Public Works, 'The Conolly Family and Castletown: from Donegal to Kildare', *Castletown*, http://castletown.ie/the-conolly-family-and-castletown/ (accessed 17 December 2019).

Reeder, Kohleen, 'The "Paper Mosaick" Practice of Mrs. Delany & Her Circle', in Mark Laird and Alicia Weisberg-Roberts (eds.), *Mrs. Delany & Her Circle*, London: Yale UP, 2009, 224–235.

Tillyard, Stella, *Aristocrats: Caroline, Emily, Louisa and Sarah Lennox 1740–1832*, London: Chatto & Windus, 1994.

Weisberg-Roberts, Alicia, 'Introduction: Mrs. Delany from Source to Subject', in Mark Laird and Alicia Weisberg-Roberts (eds.), *Mrs. Delany & Her Circle*, London: Yale UP, 2009, 1–19.

Woolley, Hannah, *A Supplement to the Queen-Like Closet, or, a Little of Everything: Presented to All Ingenious Ladies and Gentlewomen*, London: Printed by T.R. for Richard Lownds, and Are to be Sold at the Sign of the White Lion, 1674.

14 Olivia Lanza di Mazzarino (1893–1970): A Lady's Collection of Eighteenth-Century Folding Fans[1]

Arlene Leis

No object conjures notions of eighteenth-century European feminine artifice and sexuality like the hand-held fan. Although fans provided practical functions, such as cooling, they were also considered fashionable accessories, supplying elegance with delicate fabrics, painted pictures, and appliqués. The fan's exquisite detailing and high levels of craftsmanship turned them into luxury objects worn by aristocratic women. In addition, eighteenth-century European fans endowed their beholders with distinct gender identities. More than items creating a breeze, fans played a prominent role in fashioning a woman's persona, thus placing the object within a complex web of social, cultural and political practices.[2] Furthermore, women cunningly handled, unfurled, and fluttered them to communicate a wide range of messages and emotions. As this chapter will demonstrate, this graceful and feminine accessory *par excellence* also served as a weapon in the battle of love. However, for the woman I will discuss here, who preserved her collection of fans in display cases in her home, the fans were no longer weapons of romantic love; instead, they became momentos for the love she lost and her nostalgia for a lost era. Like her fans, Vivina spent much of her early life on display awaiting a good marriage; this display occurred through the various works of art through which her identity was strategically fashioned. The display of her collection of fans in her home reflected her own personal experiences and enabled her to contemplate them from a safe distance.

On display in the Conference Suite at the Tomasi Di Lampedusa Family Museum at 28 Palazzo Butero in Palermo, Sicily is a stunning collection of thirty-eight Louis XIV French handheld fans. Olivia Lanza di Mazzarino (1891–1970), duchess of Sagro, nicknamed Vivina, garnered the collection during the twentieth century. Today, the folding fans form part of the museum's fascinating family collections, where they are displayed in specially-designed showcases, built directly into three walls of the aforementioned suite. What motivated Vivina to amass this splendid collection of eighteenth-century fans in the twentieth century? What significance did these particular objects hold for her? This chapter will take as a study Vivina's collection of folding fans in order to explore eighteenth-century material culture in collections beyond the eighteenth-century period. I will examine Vivina's family, her social group, and her way of life. Additionally, I will consider how the collection is systematized today and the meanings that emerge from its display.

Self-Fashioning Within an Artistic Network

Vivina lived in Italy during a time of great political and social change. After many years of Italian political revolutions and wars taking place throughout the nineteenth

century, known as the *Risorgimento*, in 1871 the region was finally transformed from many small principalities, each with its own laws and traditions, into one nation with Rome as its capital. After the unification, however, Italy still faced many problems. Liberals and Socialists continued to disagree on many matters, and Northern and Southern Italians held different visions regarding the economic development of the country. Importantly, however, the old ruling class, to which Vivina belonged, never really accepted the revolutionary ideas that trickled down from France's revolution, and which formed the foundations of Italy's new-founded unified nation. The old aristocracy began losing their monopoly on political power and the legal rights of their patrimonies. New rising industrialists and banking fortunes, many of which were buying noble titles with their new money, were slowly replacing the old order.

To better understand Vivina's collection, it is important to consider her aristocratic origins against this social and political background, as well as the fundamental role art and fashion played in her own self-promotion within a specific social circle. Vivina was born in Palermo on 3 February 1893, into one of the highest-placed noble families of an ancient aristocratic heritage. Dating back to as far as the sixteenth century, they held rule over many domains. Her father was Don Giuseppe, Count Lanza, and her mother was Donna Luisa Sara Ruffo, Duchessa di Bagnara.[3] Vivina was the middle of three surviving children, with one older brother, Don Giuseppe Fabrizio, and a younger sister, Donna Lucia. Her early years were spent living with her family in Palermo at their Palazzo Mazzarino.

As a child, Vivina was already considered a 'great beauty', and her parents commissioned Modern artists from all over Europe to capture different stages of her youth. Her beauty and high social standing positioned her as desirable in an elite marriage market as the goal for a young, aristocratic woman was to make a good marriage and to continue the family bloodline. One pastel portrait, dating 1896, by the well-known Sicilian artist Ettore De Maria Bergler portrays her alongside her brother and sister. This group picture seems to record the children's first professional sitting, but the way the figures slightly overlap against a greyish, bare background suggests that they were sketched separately. Vivina and Lucia wear matching fancy, white dresses, but in contrast to Lucia's short hair and earrings, Vivina's long locks are pinned up in a big pink bow. Giuseppe Fabrizio wears a sailor-type shirt. Overall, the children are depicted as formal and dignified. Giuseppe Fabrizio, looks straight at the viewer; his soft eyes and slightly opened mouth convey tenderness. Lucia looks off to the side and appears to focus on a particular point. Positioned in the middle of her siblings, Vivina looks directly at the viewer with a somewhat serious and reserved look; she is a young girl ready to play by elite society's rules.

In 1903, when Vivina was ten, the German painter Tini Rupprecht, known for his idealized portraits of noble women and society ladies, produced a large-scale, three-quarter picture of Vivina. The medium is pastel. She is depicted outdoors, standing next to a tree with the sea—most likely the Mediterranean—behind her. The front of her hair is pinned up into a loose bun, while a mass of untied hair cascades around her shoulders and spills down her arms to below her waist. She looks off to the side, lost in a daydream, a pose that emphasizes her fine facial features. One hand is raised, lightly touching her heart. Glittering on her finger is a large gold and pearl ring. Her romantic, dream-like stance and innocence capture the viewer's attention. In contrast to her natural surroundings, Vivina wears an elegant white dress cut with long billowing sleeves, trimmed with inlays of light blue gauze fabric, adorned with delicate lace and dotted with a few strategically pinned ribbons. Vivina's family wealth and her youthful, ideal beauty and cultivated grace found pictorial expression in Rupprecht's romantic-style

portrait. In the portrait, art—in the form of a young girl's self-consciously constructed image of elite femininity—and nature intermingle side by side. The pictorial representation suggests Vivina's parents' concern with making a good match for their daughter and the effort that was put into furthering one.

Perhaps Vivina's most important artistic collaboration occurred a few years later, in 1908, when her family moved from their palace in Palermo to the Palazzo Boncompagni Corcos on the Via dell'Governo Vecchia (Old Government Road), Rome.[4] The palazzo is situated at the end of the Piazza dell'Orologio (the Clock Plaza) and across from the Torre dell'Orologio (the Clock Tower) at the back of the Oratorio dei Filippini, designed by the Baroque architect Francesco Borromini. One of Europe's most internationally recognized sculptors, the Italian Pietro Canonica, produced her bust. Importantly, Canonica was known for his traditional and idealized-style marble sculptures, and his work was instrumental in shaping Italy's national identity during its unification. He produced important monuments and designed some of Italy's coinage. Both Italian and European nobility and diplomats commissioned his work. While visiting Palermo in 1904, Canonica met Vivina's family, and as a result of this trip he also created contacts that resulted in the commissioning of important portraits.[5] Keeping abreast with current artistic trends, Don Giuseppe and Donna Luisa would have noticed the praise Canonica's busts of noble women received, and a few years later, he produced Vivina's bust. Unfortunately, no records of this commission survive, so Canonica's process is uncertain. Most likely, Vivina visited his smaller Roman studio, recently opened in 1904.[6] As was custom, nobility commissioned portraits of young women as a way of introducing them into society. For a fifteen-year-old whose parents would have been keen on making a grand entrance for their daughter, and possibly securing a good marriage, a portrait bust sculpted by an internationally recognized artist like Canonica announced Vivina's impressive foray into an exclusive social group, while such a commission would have further consolidated the artist's fame.

As a young woman, Vivina's celebrity knew no bounds. Newspapers and magazines provide a measure of Vivina's lifestyle, reporting regularly on her dress and whereabouts. Sometimes she was pictured on the cover of magazines.[7] She travelled in cosmopolitan circles, visiting and living in various European capitals, including Paris. Perhaps unsurprisingly, these notices seem to escalate around the same time her family moved to Rome and Canonica produced the aforementioned bust. *La Republica* newspaper holds an archive reporting Palermo's annual springtime festival *Corso dei Fiori*, in which she participated in 1908; she also frequented the city's elite members club, The Sport Club.[8] The international culture and leisure magazine *The Smart Set: Revue du Mond Èlégant*, synonymous with high society and Italian glamour, closely followed her whereabouts, and her name can be found among its 'International Events' lists almost every month.[9]

On 25 November 1909, *The Smart Set* published an image of a beautifully sculpted terracotta medallion with a relief portrait of Vivina by the sculptor Luigi De Feo[10] (Figure 14.1). The work is executed with the greatest care. As women increasingly played a crucial role in the collecting, promotion, and consumption of decorative arts, medallions became popular objects aimed at a broader audience, and De Feo's piece presents the viewer with a clear presentation of how fashionable performance and aristocratic display were intertwined. Vivina is depicted as seated in profile. Her legs are crossed and one arm rests casually on her top leg, while her head rests lightly on her hand. Her other arm hangs loose alongside the chair. Her hair is all pinned up

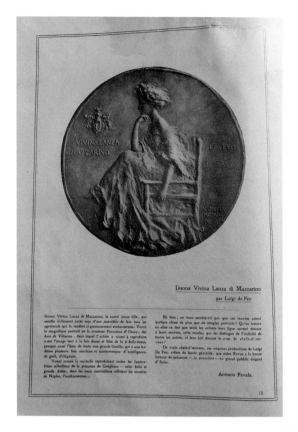

Figure 14.1 Image of Vivina Lanza di Mazzarino by Luigi De Feo, *Smart Set Revue*, 25 November 1909.

into a massive, curly bun showing off her dainty facial features, and the light-weight fabric of her dress is blowing around her feet like a cloud. The floating features of the garment add a romantic and 'historical' gloss to the work. Vivina is goddess-like, an idealized artistic vision, like many of the female deities the aforementioned Canonica depicted on his designs of coins at that time.

Alongside her image is Vivina's full name and her family's coat of arms. De Feo's name, the date he produced the work, and Venezia is also visible. Clearly, the artist was capitalizing on this format to promote himself in magazines. Below the image is a short textual description of Vivina, written in French by Antonio Favale, calling her a 'suave young woman who really seems to have received from a group of fairies all the attributes that make her so bewitching'.[11] Words like 'fairies' and 'bewitching' suggest that the beautiful and the magical are symbiotic, as if below the surface, Vivina possesses some type of mystical powers. In the same issue, two other medallion portraits of aristocratic women by the same artist are included, thus presenting a wider community of elites and the interdependence and exchange that operated within that group. The coin-like format alludes to wealth, even if the aristocracy's

economic status was diminishing in comparison to the rise of wealthy entrepreneurs and diplomats during that time. *The Smart Set* magazine's presentation of this series of medallions promotes noble women as leaders of cultural taste in the arts, as they were seen as arbitrating styles of consumption. At the same time that the members of the old ruling class were losing political power, their self-fashioned celebrity status, promoted through art and collected objects, was on the rise.

The highly visible *Smart Set* magazine frequently reported on Vivina's whereabouts. In 1909, Vivina and her mother attended an elaborate soirée at the Palazzo Colonna, given by Count Gianotti.[12] January 1910, she was guest at a grand party at the home of the Prince and Princess of Abamelek, for which they decorated the vestibule of their home with luxurious tapestries just for the occasion.[13] Vivina was also present at an important party hosted by the United States Ambassador to Italy, John Garrett, and his wife. The party of thirty-seven dined at the Grand Hotel Rome on two tables decorated with red roses and lilies; after dinner, the couple hosted a grand ball in the hall for diplomats and Roman society.[14] Such events were the best venues for young ladies to show off and encounter possible suitors. In addition to Vivina being featured in art, social events were another form of display. As the country's new capital, Rome was once again the gravitational center of culture and politics, and Vivina appears to have participated in socially significant public events and cultural activities.

Vivina's social celebrity was cultivated through an intentional education in art, history, and fashion. Browsing through the family library kept at the Palazzo Lampadusa, the books Vivina owned reveal a female education of history by way of fashion. Amongst the many titles are *The History of Women's Hair Styles, Women and Jewelry in Sicily: Medieval to the Renaissance, Nineteenth-Century (in France) Classes: Costumes and Inventions,* and the eighteenth-century *Les Gallerie des modes et le costume* and *Les Monuments du costume.*[15] Such texts, with their accompanying illustrations, enabled Vivina to practice an acceptable type of female connoisseurship. Vivina never attended school, but she studied from home. Apart from her family library, she also subscribed to libraries that sent her books on a monthly basis. Too much education, however, for a girl of her class, would have seemed unfeminine. Alternatively, books on the history of dress were appropriate for an inquisitive mind, as they revealed much about civilizations and an epoch's codes. Such books were instrumental in the diffusion of norms, patterns, processes, and styles, and they provided textual and pictorial sources for a lady of fashion, like Vivina, to study and incorporate into her own style performance, in order to find a suitable husband.

As Anthony Cardoza points out, despite their diminished economic status in the nineteenth and early twentieth centuries, the aristocracy still held influence in Italy through their social supremacy, as seen through networks of alliances, gentlemen agreements, debts of honor, long-standing rights, and heritage of commitments.[16] Vivina's cultivation of artistic and fashionable celebrity provides a feminine lens through which to view these same claims at political and social power. Specific traits held by the aristocracy, mainly their hold on historical agency through the influence of art, gave them a certain prestige that made them the most natural arbiters of elite conduct, education, and styles of consumption. For most of pre-war Italy, a world of large corporations, trade unions, and mass political parties, the Italian nobility continued to exercise a potentially strong influence on the values and aspirations of the newly rich and powerful.

Marriage, Loss, and Sorrow

Across Europe, political problems escalated, as the development of individual European nation-states—initially intended to create peace and harmony—backfired. Prevalent nationalism and rampant imperialism led to fierce competition. Countries relied on negotiated alliances, such as the Triple Alliance (comprised of Italy, Austro-Hungary, and Germany) to protect individual interests. Conflicts between the Triple Alliance and the Triple Entente (Russia, France, and Great Britain) escalated, and on July 1914, Austria-Hungary declared war on Serbia. The initial enthusiasms of the war effort were soon shattered when the realities of war became apparent. Millions of men were killed, and the introduction of new weapons and gases added to the horror of humankind's inhumanity. The devastation the war brought to Italy and the rest of Europe seemed irreparable: widespread misery, social disruptions, and economic collapse. In 1919, the Allied nations negotiated the official end of World War I. That same year, on September 11, Vivina married her social equal, the handsome Neapolitan Duke Riccardo di Sangro, Eighteenth Duke of Martina, and she became Duchess of Sangro.

The wedding was held in the luxurious Art Nouvo-style Grand Hotel at the fashionable resort town of Stresa, situated on Italy's Lake Maggiore in the Lake District of the Piedmont region. The local newspaper *Il Gazzatino* wrote a lengthy article celebrating the marriage: 'All the Italian aristocrats attended, including Prince Borromeo, Marchesi Pallavicino, Count Leonardi di Casalino, Conti Cantoni-Mamiani, Marchesi Dal Pozzo, Baroni Basile, etc. etc.'[17] The couple threw a magnificent reception with a beautifully decorated boat for bringing guests around the lake; they hired an orchestra that played into the wee hours. The local choir sang for them, and it is reported that Vivina made a generous monetary donation of thanks to the group.[18] Following the days of wedding festivities, the couple lived between the Duke's family residences of Palazzo Ruffo di Bagnara and Villa Ruffo di Bagnara in Naples.[19]

Initially, the couple seemed compatible and they appeared to be very much in love. Therefore, it came as a great surprise when after only six months, the Duke ran off with a Hungarian dancer.[20] The fling lasted only a few weeks, but he never returned to Vivina. Devastated and humiliated, Vivina stayed with her parents at the Palazzo Boncompagni Corcos. The shock was all the more difficult for her as, shortly thereafter, she found out she was pregnant, and from that point on, she moved in permanently with her family. On 3 February 1921, she gave birth to a son, Giuseppe, Conte de Sangro. On a personal level, the failure of her marriage influenced her emotional happiness, as during this time she appeared less in high society events. Unlike her sister Lucia, who became a staunch fascist supporter after World War I, Vivina eschewed politics completely and found her sister's enthusiasm tiring.

On 18 September 1926, Vivina's marriage was officially annulled with a sentence from the Tribune of Turin, but her son was granted his title, as Don Riccardo had no other heirs to the Sangro bloodline, and Giuseppe was his natural son.[21] That same year, Vivina's father purchased the Palazzo Buoncompagni, where her family had been living since 1908.[22] At the end of the war, shortly before his death in 1945, Don Giuseppe sold the entire palace in Rome to Vivina.[23] Vivina's son Giuseppe lived there with her. Vivina hoped to secure an advantageous marriage for her son, but he was never interested. On 14 July 1958, thirty-seven-year-old Giuseppe was killed in

a car accent.[24] Unmarried and with no children of his own, that branch of the Sangro bloodline became extinct with Giuseppe's death. Vivina had his body entombed in the exquisite *Presentation of the Virgin* chapel next to the high altar at the Church of Santa Maria in Vallicella, which is located directly across from the Palazzo Buoncompagni Coros, next to the aforementioned Torre dell' Orologio. Attending mass and visiting Giuseppe's tomb became part of her daily routine.

Against this backdrop of loss and sorrow, abandonment, annulment of her marriage, Italy's defeated position in WWII, the allied bombing of Italy that left her birthplace Sicily and the rest of Italy in ruins, and the death of her son, Vivina collected folding fans. Overwhelmed by her failed marriage, Vivina never remarried. Don Riccardo also remained single. He lived between Naples and Rome, in a palazzo about twenty minutes walking distance from hers at the Piazza SS. Apostoli, Rome. For the rest of her life, Vivina remained desperately attached to Don Riccardo and posed constant enquiries to her family of 'the Villain's' whereabouts, checking with whom 'the Villain' kept company.[25] After perpetual heartbreak, her collection became a memento for the love she lost and for the old aristocracy that was fading away with the passing of time. Next, we can turn to her assemblage and explore how Vivina's collection of eighteenth-century fans expressed the ideologies and preoccupations most connected to her twentieth-century world.

Preserving the Eighteenth Century in the Twentieth Century

According to author John Gay's mythological poem *The Fan*, first published in 1713, the fan was an invention to help a young man win the affections of his frigid beauty. The man pleaded with the goddess of love to create a 'bright toy' with which to attract his lover.[26] Venus flew to Cythera and called upon all the cupids living there to create a 'new machine'.[27] Some of the cupids were busy making 'fatal darts' and others were designing 'female toys' with 'glittering implements' with which women could adorn their bodies. Gay writes that the fan's design was based on a peacock's tail, thus symbolizing vanity and voyeurism, but also concealment and protection. The sticks holding the pleated fan together—so that it folds and unfolds—were constructed from cupids' arrows, enabling women to 'subdue mankind'. Gay used erotic language when praising this new invention, and also referred to the way women would play with fans, as Venus proclaims: 'So shall the fair her idle hand employ, and grace each motion with the restless toy'. She goes on to talk about those pure and unfortunate maids in antiquity referring to their 'unactive fingers'. Next, Venus asks the other gods and goddesses to assist in helping choose an appropriate image with which to decorate this 'fantastic engine'. Perhaps unsurprisingly, they all suggest various images of stories associated with the numerous emotions embodying love and passion. In Gay's playful text, the fan is an object embodying eighteenth-century branches of physical and natural sciences as well as the arts as it was bore out of mechanics, ornithology, and artistic expression. Vivina's collection of 'bright toys' certainly symbolizes the romantic and erotic passions of love. However, Vivina was no longer using them to lure men; her heart had been broken.

Vivina garnered a splendid collection of hand-held fans, befitting an elite woman of fashion and taste. Unfortunately, no accompanying catalogue, systematic classification systems, or notes recording how the collection was garnered survives. Additionally, Vivina kept no receipts or records of her purchases, so how she obtained and built exactly the collection is unknown. Most likely, she bought them at one of

the many local antique stores and friends and family may have also gifted them to her. The boxes in which the fans were kept show that some were encased in simple cardboard containers, while other boxes are sturdy, lined with satin and gold piping, and include tiny metal clasps to secure the fan safely in place. Further complicating our understanding of the collection is the fact that anonymous artists produced the fans she owned. This is typical, however, as during the eighteenth century, it was often the case that more than one person contributed to a fan's production and sometimes parts of fans came from different countries.[28] There are small tags remaining on several fans that may correspond to the prices she paid or that particular object's place in a previous collection. Importantly, although she may have previously worn some of the fans, or occasionally pulled one out to carry at a particularly special event, the presence of these tags reveals that most likely Vivina did not wear these highly conspicuous and public feminine accessories in public. As collectables, they no longer served as props to an intricate game of love. Encased and kept safe in her home, they became associated with an idealized, bygone era where such things would be worn and shown off.

The collection conveys the nostalgia for a particular time period, when French monarchs regained their power. The images are specific to the eighteenth century; they echo the types of rococo paintings produced during that time by French artists like François Boucher, Jean-Honoré Fragonard, and Antoine Watteau. These artists signal a time in history of French resurgence in aristocratic social, political, and economic power, a time when aristocrats reestablished their predominance as art patrons. As such, these painted fans enabled Vivina to display and promote fine art and to show off a feminine type of connoisseurship, looking closely at and talking about what was depicted on them.

The pictures on her fans are exquisitely hand-painted scenes. They show lively figures: groups of lovers, shepherdesses tending sheep like Marie Antoinette did at her Petite Trion, and Arcadian shepherds attending their flocks. Also depicted are dances, weddings, men and women gathering food into baskets, and women making sacrifices to Hymen, the god of love. The figures display a range of emotions, and besides the tender looks of love, they might also be pleading with one another, confessing, or adopting a far-away, disinterested gaze, thus leaving the picture open to more than one interpretation. These objects of desire Vivina collected do not celebrate any types of events taking place at that time or portray specific geographical vistas, such as that of Vesuvius, often collected by eighteenth-century tourists. Nor do they make known political slogans. Importantly, the subject of the French Revolution, which was often depicted on fans and very popular toward the end of the eighteenth century, is absent. Vivina's is a collection that rejects new social orders and champions the world of eighteenth-century French aristocratic society. In doing so, it excludes harsh realities, like those she recently experienced in modern Italy.

On the center of one of Vivina's fans is a scene depicting a reclining man under a leafy tree; he looks up, gazing languidly at a seated rosy-cheeked woman dressed in a pink dress with a yellow bodice and puffy white sleeves (Plate 11). The man is holding out his hand, professing his love to her; she takes it, returning his look with a coy smile. A man holding a cane sits next to them on the rocks; he looks down, smirking. The figures are in a park; on one side is a garden wall, and off to the left behind them is a slightly choppy sea with three ships. Two smaller pictures flank this central scene. On the left is a somewhat haunting empty park and building, and on the right are two small Asian figures in an oriental garden, thereby alluding to the influence of the

Chinese taste that was popular at French courts, particularly in the beginning of the eighteenth century. The fan's status as fashionable object is further suggested by way of hand-painted pieces of lace that zigzag from one scene to the next, encouraging the viewer's eye to dart left and right. This delicate fabric, often seen on Vivina's dresses, is one of the most difficult textiles to create; furthermore, lace is an ornamental fabric that symbolically represents both chastity and debauchery. The scenes puncture the fan's flat pink background and function as portals that lure the viewer inward yet suggest a separate inaccessible space. They are placed within asymmetrical *rocaille* frames, and gold flowers are also painted on the pink part of the fan. The ivory sticks are decorated with inlays of birds, alluding to ornithology and the fan's form, which resembles a peacock's tail or a bird's wing. The fan evokes the type of wallpaper seen in early eighteenth-century rococo palaces, and like those fancy interiors and their associations with the exotic, the fan also whispers of ambiguity and eroticism.

The fans Vivina collected were fashion props that elite women exploited as a way of displaying themselves, but fans also turned the language of intimacy into a playful entertainment. This is best illustrated in another fan in the collection, particularly interesting for the game it presents (Figure 14.2). When spread, the viewer is presented with an image of a chubby cupid seated on blue and grey clouds. He holds a banner on which the words L'ART DE DEVINER (the art of guessing) are written. Once a lady caught her love interest's attention, she could use this fan to play a guessing game—to better know her lover—by pointing to a question that was painted directly on the fan. For example, on each side of Cupid are two roundels. Within one of those roundels is the question, what are you thinking? Possible answers (the blonde, a concert, marriage, death) are listed in columns in the corresponding roundels. In other

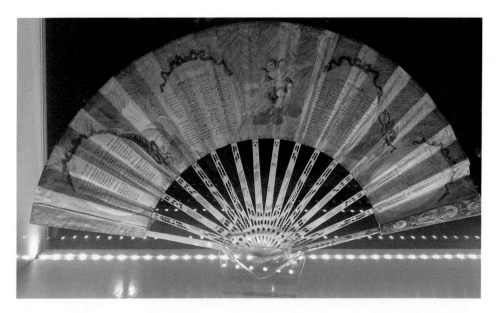

Figure 14.2 Eighteenth-century, French, folding fan. Tomasi Di Lapadusa Museum, Palazzo Butero 28, Palermo, Sicily.

roundels are columns of numbers and men and women's names. This fan encourages a more intimate form of communication besides finger moving and waves. The outer sticks—helping the fan to open and close—are made of ivory, and the protective outer sticks are decorated with mythological figures in gold and silver. On the fan's reverse, the central Cupid figure is replaced by Apollo, the god of music and poetry, alluding to the poetic harmony of two people in a romance. Cupid is an appropriate decoration for this weapon of love used to celebrate and enable physical pleasures. The game fan symbolizes and displays love as a game, one that can lead to success or failure. This swinging between suggestive game and failure is resolved, at least in part, through Vivina's collection, where she could surround herself with fans that sustained an image of herself as a playful enchantress without having to actually engage in any real love games.

During Vivina's life, the collection was kept at the Palazzo Boncapagna in an anteroom between the front reception room and the dining room with two small balconies opening onto the palazzo dell'Orologio,[29] This area was somewhat private, but could also be used for more intimate entertaining. She decorated this room especially with eighteenth-century furniture. The fans were displayed in glass cases, positioned next to Vivina's beloved harp, which, like the fans, required playing by trained fingers. Today, at the Palazzo Lanza Tomasi, there exists a small bronze statue of Vivina playing her harp, sculpted by an anonymous artist, as Vivina was known to be an excellent musician. In the anteroom of her palazzo, Vivina created a sacred space for looking, touching, and listening. The extremely beautiful and luxurious fan collection that she gathered and preserved in glass cabinets offered a comfortable ideal to see through the pain of her personal and social losses.[30] In this room, her fans enabled her to turn back the clock, to eighteenth-century aristocratic games of love, where she was once again 'suave' and 'bewitching', arousing attraction and possible suspicion, but at the same time she remained safe from any of courtship's painful realities.

The association of gender identity with fan collecting is complicated, however, if we consider the origins of the folding fan. In his study on colonialism and the Pacific encounter, Nicholas Thomas argues convincingly for the significant role material culture played in colonial entanglements. When considering the European appropriation of indigenous materials in the eighteenth century, he shows that the cultural dynamics of colonial encounters created new ways in which Islanders and Europeans made use of each other's material artefacts and the new identities they fashioned.[31] He convincingly supports this idea, which I will suggest here in terms of fans and gender: the meaning a collected object carries changes over time and with different cultural contexts. Although women carried fans in traditional China, for instance, fans were also symbols of the cultivated, literati gentleman. Elite gentlemen collected them; they cooled themselves off with them, they had their portraits painted holding them, and they hired artists to paint their fans with particular scenes and symbols that communicated an array of messages and ideas.[32] They, too, used them to communicate; when literati did not wish to speak with someone, they politely avoided them by simply holding up their fan. Like the elite men who collected fans in China, Vivina's domestic collection supports notions of personal identity, and her fans are as much extensions of the self as are the collections made by men. Elite European women used them to signal distinction and to identify themselves as members of a particular class.[33] Furthermore, in her material culture study of two souvenir fans garnered by the Duchess Anna Amalia of Sachsen-Weimar-Eisenach during her European grand tour, Christina

K. Lindeman has shown that the Duchess's fans, which she never accessorized in a feminine way, were unused souvenirs of her interest in traditionally masculine subjects like archeology and geography.[34] In Vivina's collection, however, these feminine objects enact to some degree what she went through personally, as she too was artistically displayed throughout her early life to attract a suitable marriage partner, and when that marriage dissolved and, later, her only son died, she could turn to the collection and its display for comfort.

Vivina's collection offers a clear pattern of how the gendering of women works in our society. Vivina suffered many emotional traumas during her life. It is difficult not to interpret her satisfaction with surrounding herself with a collection of hand-held fans, associated with seduction and games of love, with her own difficulties following her abandonment and the annulment of her marriage. Like the strategies of display that Vivina employed to secure a marriage, the collection of fans presents a noble idea of fashionable femininity and an acceptable face for aristocratic courtship and love: desirable, but well within the constraints of a woman of her status.

The Collection Today

When Vivina died in Rome on 7 March 1970, her body was laid to rest in the same chapel beside her son at Santa Maria in Vallicella. Given the chapel's dedication to the Presentation of the Blessed Virgin, an episode in the life of the Virgin Mary that marked the preparation for her role as the Mother of God, the chapel's subject may have held symbolic significance for Vivina following the annulment of her marriage and loss of her son. Soon after her death, her sister Lucia had most of Vivina's property, including her harp, sold privately by Vivina's husband's half-brother, the antique dealer Achille Lecca, Duke of Guevara.[35] However, recognizing their importance as ancestral record and for its sentimental value, Vivina's nephew Giuseppe Lanza, Count of Assaro, managed to keep the aforementioned portraits of Vivina and her fan collection. When Giuseppe died on 12 April 2013, these pieces were passed to his brother, Gioacchino Lanza Tomasi, Duke of Palma di Montechiaro, Count of Assaro, who now lives in the Palazzo Lanza Tomasi at 28 Butera in Palermo. Through this family exchange, the collection of fans remained intact. Earlier, in 1957, Giocchino had been adopted by Giuseppe Tomasi di Lampedusa, author of *The Leopard*, one of the most important Italian novels chronicling Sicilian society and the struggles of the aristocracy during the Italian unification. The author spent his last years, after WWII living at this palace, as bombings had completely destroyed his family residence. Without any heirs of his own to carry on this branch of his family's name, Tomasi di Lampadusa adopted Giocchino. Shortly after the author's death, the Duke moved into the palace, where he and his wife Nicoletta Lanza Tomasi, Duchess of Palma, continue to preserve both his family lineage and the author's intellectual heritage. The palace is the perfect theatre for displaying their ancestor's shared history.

Noting the fan collection's cultural and aesthetic value, the Duke and Duchess created a new viewing context for the fans. They designed and created special display windows on three walls of the conference suite solely for the exhibition of thirty-eight fans (Plate 12). These fans were chosen from the rest on the basis that they were in the best condition. The large central double vitrine is the size of the wall; it divides the entrance room from the conference hall. Inside this window, they have placed all the best fans that are fully decorated on both sides. The fans perch on small, clear plastic

stands, so they remain spread out. Arranged in rows on glass shelves, they are illumi-nated completely by way of tiny track lights aligning the shelves. When examining the fans from certain vantage points, the tiny lights reflecting off the double glass create a series of smaller reflections that appear to recede into infinity, a contemporary version of the mirrored infinity rooms seen in rococo interiors, suggesting the passing of time. Tiny lights also highlight the fans' fine craftsmanship, and the shimmer of luxurious materials like gold thread, spangles, gilded ivory, and translucent sequins can be easily seen. The fans with only one side decorated are showcased in two additional vitrines set on the sides of the conference room walls. The frescoed ceiling is decorated with scenes of *harems*, which, together with the fans, alludes to the exotic. Seen against plain white walls, however, the collection's installation looks contemporary in con-trast to the more traditional display of the other two rooms in the museum, which contain various objects (maps, portraits, telescopes, and manuscript drafts, amongst other items) that have been passed down from one generation to the next, displaying a fascinating family history. In contrast to the collection's display in Vivina's palace, where they were viewed and read in relation to other objects, the deliberate neutrality of the conference walls invites the viewer to focus on the individual fans.

Looking through the middle display window from the conference room, visitors are offered a glance of the total width of the palace sweeping over the entrance hall, the author's historical library, and the ballroom. The ballroom opens onto a terrace looking out to the Mediterranean Sea, and when the doors are open, the sea air drifts between the rooms, carrying with it the scent of the lush gardens below. The collec-tion's ability to transcend time and space is now emphasized. In this new space, dedi-cated to keeping the memory of an old aristocracy alive, the collection can provide a narrative to Vivina's life and to the wider world. The fascinating material culture of the upper classes, otherwise unobtainable, is displayed to have social and cultural value, guiding visitors to become cultured connoisseurs.

Notes

1. I am indebted to Gioacchino Lanza Tomasi, Duke of Palma di Montechiaro, Count of Assaro and his wife Nicoletta Lanza Tomasi, Duchess of Palma for their hospitality during my sojourn at the charming 28 Palazzo Butera apartments and their generosity in sharing their collections, expertise and time with me. I dedicate this chapter to them both. I am also grateful to Elena Mastrota at ARTTOUR LLC for introducing me to the Duke and Duchess, thereby making this research possible. Many thanks also to Asia Croce for kindly assisting with museum photos. Archivists, librarians, and curators have also shown their support for the project, including Dr. Alberto Bianco at the Archivio Congregazione Ora-torio Roma, Mario Scalini, Art Historian and Director at Polo Museale Emilia Romagna, and the archivists and staff at the Museum Pietro Canonica Roma, Bibiotecca Nazionale de Firenze, Jacob Moss at the Fan Museum, London and Flandina di Cuto for taking the time to share her family history with me.
2. See, for example, Edith Standen, 'Instruments for Agitating the Air', *Metropolitan Museum of Art Bulletin* 23 (March 1965): 243–257; Pamela Cowen, *A Fanfare for the Sun King: Unfolding Fans for Louis XIV* (London: Third Millennium Publishing, 2013); Angela Rosenthal, 'Unfolding Gender: Women and the "Secret" Sign Language of the Fan in Hog-arth's Work', in Bernadette Fort and Angela Rosenthal (eds.), *The Other Hogarth: Aes-thetics of Difference* (Princeton and Oxford: Princeton UP, 2001); Valerie Steele, *The Fan: Fashion and Femininity Unfolded* (New York: Rizzoli International Publications, 2002).
3. Lanza Branchiforte e Lanza Filingeri, 'Libro d'Oro della Nobiltà Mediterranea', www. genmarenostrum.com/pagine-lettere/letteral/Lancia-Lanza/trabia.html (accessed 2 Febru-ary 2020).

4. Laura Gigli and Eliana Uttaro, *Palazzo Boncompagni Corcos a Monte Giordano: Una storia di un aspetto di Roma barocca* (Roma: Gangemi, 2003).

5. Carla Scicchitano, 'Pietro Canonica e la Sicilia', in Bianca Maria Santese and Carla Scicchitano (eds.), *La Bellezza Scolpita: Franca Florio nel ritratto di Pietro Canonica storie e restauro* (Rome: Gangemi, 2017), 35–41.

6. Bianca Maria Santese, *Pietro Canonica Museum at Villa Borghese* (Rome: Diano Libri, srl, 2017), 19.

7. *The Smart Set: Revue du Mond Èlégant* (Palermo) 25 November 1909.

8. Giuseppe Passarello, 'Il corso dei fiori rose e sfilate di un secolo fa', *La Repubblica Archivio* 17 October 2006. The festival started in 1906 as the result of an incident between Vivina's mother and Kaiser Wilhelm II, Emperor of Germany, when the Countess playfully threw flowers into the Emperor's carriage, but she missed and they fell to the floor. Two years later 'In 1908, on vintage carriages made available by collectors and aristocratic families, the young aristocratic girls took seats for a parade that added a further touch of glamour'.

9. *The Smart Set: Revue du Mond Èlégant* (Palermo). See issues from the years 1909 and 1910.

10. *The Smart Set: Revue du Mond Èlégant* (Palermo) 25 November 1909.

11. *The Smart Set: Revue du Mond Èlégant* (Palermo) 25 November 1909.

12. *The Smart Set: Revue du Mond Èlégant* (Palermo) 25 January 1909.

13. *The Smart Set: Revue du Monde Èlégant* (Palarmo) 25 January 1910.

14. *The Smart Set: Revue du Monde Èlégant* (Palarmo) 25 February–10 March 1910.

15. These titles have been translated from the original language. Pietro Lanza Di Scalea, *Donne E Gioelli in Sicilia: Medio Evo E Nel Rinascimento* (Palermo-Torino: Carlo Clausen, 1892); John Grand-Carteret, *XIX Siècle (en France) Classes-Moeurs-Usages: Costumes-Inventions* (Paris: Librairie de Firmin-Didot Et., 1893); Anonymous, *Histoire de la Coiffure Féminine* (Bruxelles: Ad, Mertens, Imprimeur-Editeur, 1891); Anonymous, *Les Gallerie des modes et le costume* (Paris: Esnault et Rapilly, 1779), Tome Premier, *Les Monuments du Costume* (Paris: Giles Dilly, 1790).

16. Anthony L Cardoza, 'The Enduring Power of Aristocracy: Enoblement in Liberal Italy (1861–1914)', in *Les Nobelesses Européennes Au XIXé Siècle* (Rome: Collection De LÈcole Française De Rome, 1998), 595–605.

17. 'Nozze Cospicue al Grand Hotel', *Il Gazzettino Stresa*, 20 Settembre 1919.

18. 'Nozze Cospicue al Grand Hotel.'

19. Gioacchino Lanza Tomasi, Duke of Palma di Montechiaro, Count of Assaro, Tomasi di Lampedusa Family Museum, archive, 2 March 2020.

20. Gioacchino Lanza Tomasi, Duke of Palma di Montechiaro, Count of Assaro, Tomasi di Lampedusa Family Museum, archive, 2 March 2020.

21. Lanza Branchiforte e Lanza Filingeri, 'Libro d'Oro della Nobilità Mediterranea', www.genmarenostrum.com/pagine-lettere/letteral/Lancia-Lanza/trabia.html (accessed 2 February 2020).

22. Laura Gigli and Eliana Uttaro, *Palazzo Boncompagni Corcos a Monte Giordano: Una storia di un aspetto di Roma barocca* (Roma: Gangemi, 2003), 25.

23. Laura Gigli and Eliana Uttaro, *Palazzo Boncompagni Corcos a Monte Giordano: Una storia di un aspetto di Roma barocca* (Roma: Gangemi, 2003), 25.

24. Death Certificate of Guiseppe de Sangro, Archives of the Church of Santa Maria in Vallicella, Rome, Italy.

25. Gioacchino Lanza Tomasi, Duke of Palma di Montechiaro, Count of Assaro, Tomasi di Lampedusa Family Museum, 15 October 2019.

26. Valerie Steel, *The Fan: Fashion and Femininity Unfolded* (New York: Rizzoli Publications, 2002), introduction.

27. John Gay, *The Fan* (1713), reprinted in *Collected Works* (London, 1740). See also, Alexander Pope, *On the Fan of the Author's Design* (1712) reprinted in *The Works of Mr. Alexander Pope* (London), p. 403. 'In *Delia's* hand this toy is fatal found, Nor could that fabled dart more surly wound'.

28. Avril Hart and Emma Taylor, *Fans* (London: Victoria and Albert, 1998).

29. Gioacchino Lanza Tomasi, Duke of Palma di Montechiaro, Count of Assaro, Tomasi di Lampedusa Family Museum, 15 October 2019.

30. Katie Scott, 'Introduction', in Melissa Lee Hyde and Katie Scott (eds.), *Rococo Echo: Art, History and Historiography From Cochin to Coppola* (Oxford: Voltaire Foundation, 2014), 7–8.

 When considering Vivina's collection of Rococo objects in a historical and emotional context, we can see something similar to Katie Scott's idea of the 'Rococo echo'. In her study of Rococo revivals, Katie Scott addresses the viewer's emotions and aesthetic pleasures in relation to the way eighteenth-century Rococo collections were formed and experienced in the late nineteenth century. Scott claims such collections represent 'history as echo'. She argues that for the nineteenth-century imagination, collecting the Rococo marked the interval between past and present and transcended it by recognizing the decisive moment of revolution and omitting the trauma of it by reaching beyond to an ideal world enlivened by empathetic identification.

31. Nicholas Thomas, *Entangled Objects: Exchange, Material Culture, and Colonialism in the Pacific* (Cambridge: Harvard UP, 1991).

32. V & A Publications, *Fans from the East*, exh. cat. (London: Victoria & Albert, 1978), 50–52.

33. Anne Higonnet, 'Irregular Rococo Impressionism', in Melissa Lee Hyde and Katie Scott (eds.), *Rococo Echo: Art, History and Historiography From Cochin to Coppola* (Oxford: Voltaire Foundation, 2014), 149–166.

34. Christina K. Lindeman, 'Gendered Souvenirs: Anna Amalia's Grand Tourist *vedute* Fans', in J.G. German and H.A. Strobel (eds.), *Materializing Gender in Eighteenth-Century Europe* (Surrey and Burlington: Ashgate, 2016), 51–66.

35. Gioacchino Lanza Tomasi, Duke of Palma di Montechiaro, Count of Assaro, Tomasi di Lampedusa Family Museum, 15 October 2019.

Bibliography

Cardoza, Anthony L., 'The Enduring Power of Aristocracy: Enoblement in Liberal Italy (1861–1914)', in *Les Nobelesses Européennes Au XIXé Siècle*, Rome: Collection De LÈcole Française De Rome, 1998.

Cowen, Pamela, *A Fanfare for the Sun King: Unfolding Fans for Louis XIV*, London: Third Millennium Publishing, 2013.

Death Certificate of Guiseppe de Sangro, Archives of the Church of Santa Maria in Vallicella, Rome, Italy.

Fans from the East, exh. cat., London: Victoria & Albert in association with The Fan Circle, 1978.

Gay, John, *The Fan* (1713), reprinted in *Collected Works*, London, 1740.

Gigli, Laura and Eliana Uttaro, *Palazzo Boncompagni Corcos a Monte Giordano: Una storia di un aspetto di Roma barocca*, Roma: Gangemi, 2003.

Grand-Carteret, John, *XIX Siècle (en France) Classes-Moeurs-Usages: Costumes-Inventions*, Paris: Librairie de Firmin-Didot Et., 1893.

Hart, Avril and Emma Taylor, *Fans*, London: Victoria and Albert, 1998.

Higonnet, Anne, 'Irregular Rococo Impressionism', in Melissa Lee Hyde and Katie Scott (eds.), *Rococo Echo: Art, History and Historiography From Cochin to Coppola*, Oxford: Voltaire Foundation, 2014, 149–166.

Histoire de la Coiffure Féminine, Bruxelles: Ad, Mertens, Imprimeur-Editeur, 1891.

Lanza Branchiforte e Lanza Filingeri, 'Libro d'Oro della Nobiltà Mediterranea', www.genmarenostrum.com/pagine-lettere/letteral/Lancia-Lanza/trabia.html (accessed 2 February 2020).

Lanza Di Scalea, Pietro, *Donne E Gioelli in Sicilia: Medio Evo E Nel Rinascimento*, Palermo-Torino: Carlo Clausen, 1892.

Les Gallerie des modes et le costume, Paris: Esnault et Rapilly, 1779.

Lindeman, Christina K., 'Gendered Souvenirs: Anna Amalia's Grand Tourist *vedute* Fans', in J. G. German and H. A. Strobel (eds.), *Materializing Gender in Eighteenth-Century Europe*, Surrey and Burlington: Ashgate, 2016.

'Nozze Cospicue al Grand Hotel', *Il Gazzettino Stresa*, 20 Settembre 1919.

Passarello, Giuseppe, 'Il corso dei fiori rose e sfilate di un secolo fa', *La Repubblica Archivio*, 17 October 2006.

Pope, Alcxander, *On the Fan of the the Author's Design*, London, 1712, reprinted in *The Works of Mr. Alexander Pope*.

Premier, Tome, *Les Monuments du Costume*, Paris: Giles Dilly, 1790.

Rosenthal, Angela, 'Unfolding Gender: Women and the "Secret" Sign Language of the Fan in Hogarth's Work', in Bernadette Fort and Angela Rosenthal (eds.), *The Other Hogarth: Aesthetics of Difference*, Princeton and Oxford: Princeton UP, 2001.

Santese, Bianca Maria, *Pietro Canonica Museum at Villa Borghese*, Rome: Diano Libri, srl, 2017.

Scicchitano, Carla, 'Pietro Canonica e la Sicilia', in Bianca Maria Santese and Carla Scicchitano (eds.), *La Bellezza Scolpita: Franca Florio nel ritratto di Pietro Canonica storie e restauro*, Rome: Gangemi, 2017.

Scott, Katie, 'Introduction', in Melissa Lee Hyde and Katie Scott (eds.), *Rocco Echo: Art, History and Historiography From Cochin to Coppola*, Oxford: Voltaire Foundation, 2014, 1–30.

Standen, Edith, 'Instruments for Agitating the Air', *Metropolitan Museum of Art Bulletin* 23 (March 1965).

Steele, Valerie, *The Fan: Fashion and Femininity Unfolded*, New York: Rizzoli International Publications, 2002.

The Smart Set: Revue du Mond Èlégant (Palermo) 25 January 1909.

The Smart Set: Revue du Mond Èlégant (Palermo) 25 November 1909.

The Smart Set: Revue du Monde Èlegant (Palarmo) 25 February–10 March 1910.

The Smart Set: Revue du Monde Èlegant (Palarmo) 25 January 1910.

Thomas, Nicholas, *Entangled Objects: Exchange, Material Culture, and Colonialism in the Pacific*, Cambridge: Harvard UP, 1991.

Index

Note: page numbers in *italic* indicate a figure and page numbers in **bold** indicate a table on the corresponding page. Page numbers preceded by *p* indicate a colour plate.